M000201260

Tastemaker

# House Beautiful

APRIL · 50c

How you will live
in the <u>next</u> America

Monica Penick

# Tastemaker

Elizabeth Gordon, *House Beautiful,* and the Postwar American Home

Yale University Press
New Haven and London

yalebooks.com/art

Designed by Yve Ludwig
Set in Chronicle Text and Avenir by Yve Ludwig
Printed in China by Regent Publishing Services Limited

Library of Congress Control Number: 2016940999
ISBN 978-0-300-22176-3

A catalogue record for this book is available from the British Library.

This paper meets the requirements of ANSI/NISO Z39.48-1992
(Permanence of Paper).

10 9 8 7 6 5 4 3 2 1

Frontispiece: Cover of *House Beautiful* (April 1953). Reprinted
with permission of *House Beautiful* copyright © 1953.

Page vi: Cover of *House Beautiful* (October 1952). Reprinted
with permission of *House Beautiful* copyright © 1952.

# House Beautiful

OCTOBER 50c

WHAT'S HAPPENING TO AMERICAN TASTE?

# Preface

When I began the long adventure of writing *Tastemaker,* I was interested in the evolution of the postwar American house, with its multiplicity of modern forms and cultural meanings. I was fascinated by the range of characters involved: architects, designers, craftsmen, builders, manufacturers, retailers, and real estate developers who had left their mark, however distinct or faint, on the American landscape. But as I worked—in a subject area and time period that were still virtually undiscovered—I began to look beyond what I *thought* was the heart of the story, beyond the house itself, beyond its designers, beyond its makers. What I found there, on the periphery, was an entirely new plot and a new cast of characters. Chief among them were the consumers (most often the American family) for whom the postwar house was built, and the popular home or "shelter" magazines that promoted and indeed sold the idea of the postwar house and its domestic trappings to the public.

The question then became not what happened to the American house in the two decades that followed the Second World War, but *who* (or what) really made that something happen? This opened still another broad, cultural question: Why do Americans like what they like, buy what they buy, and build what they build?[1]

This was not, of course, a new question. In the United States, questions of consumer desire, taste, and choice were posed as early as the 1920s by professionals engaged in the emerging field of consumer study and market research. Among the most influential were two figures who appear briefly in this book, Edward Bernays and Christine McGaffey Frederick. Their lines of inquiry took a variety of forms and served many purposes. The goal was generally threefold: to investigate consumers' needs, wants, and actions; to test new products against consumer interest; and (eventually) to use this feedback to inform the design, production, sales, and consumption of products.

The protagonist of this book, former *House Beautiful* editor-in-chief Elizabeth Gordon, was equally engaged in the quest to understand and influence consumer choice, specifically in the realm of domestic architecture and design. She was fascinated by American taste—or as she put it, "*why* you like what you like, and *what* you are probably going to like in the future."[2] She asked this very question, most directly in 1946, from the vantage point of a shelter magazine editor in need of perspective and some monthly content; I asked it, decades later, as a historian curious about how Gordon answered, and what her experience might tell us about the process of taste formation, design consumption, design production, and design mediation that remains in place even today within contemporary shelter magazines such as *Dwell,* or multimedia outlets such as HGTV.

Gordon's questioning, and my own that followed, suggested an alternative way to unpack the history of the postwar American house. Perhaps architect George Nelson, writing in 1948, saw it most clearly: "Most of what happens to architecture is out of the hands of the architects."[3] There were "other forces" at play, forces that, as Nelson suggested, profoundly shaped architecture—including

contemporary design discourse, social attitudes, consumer power (both in terms of buying practices and market influence), personal taste, individual identity, and an emerging sense of a collective "Americanness." I argue here that the shelter press, led by powerful editors such as Gordon, informed and influenced all of these forces.

What follows is a design history, in the inclusive if still-evolving meaning of that term: it is the study of postwar American design, with culture, politics, and economics as backdrop; it is an architectural history, with architects and houses as star players; it is a critical biography, with a magazine editor as protagonist; and it is a study of a creative process, with print representation, cross-media methods, and editorial tactics as evidence.[4] In the broadest sense, though, this is a story about influence.

From her offices on Madison Avenue, Elizabeth Gordon navigated a design revolution that spanned the hopeful (if restrained) war years, the optimistic postwar period, and the anxious Cold War decades. Her story, set against this changing historical backdrop, pivots at significant moments when Gordon responded, with lightning speed, to this shifting world. The narrative arc of this book is possible, in part, because Gordon's own editorials traversed a national crisis of culture, politics, and economics—and she embedded her editorial campaigns and critiques within this larger contemporary context.

Gordon's story is fascinating and at moments truly theatrical because she worked so many angles: she was a reporter, editor, advocate, critic, trendsetter, and tastemaker. She worked on behalf of the American public (which paralleled her magazine's commercial interest) to forge a common cause for good design. In this struggle, she did not work alone. She united consumers, designers, manufacturers, and retailers in her cause. She navigated and bridged all four worlds, and for many years held a comfortable place on the sidelines of design discourse and practice.

This all changed in 1953. Her scandalous editorial "The Threat to the Next America" was the watershed moment. The "Threat" episode (which I recount in Chapter 8) is the moment for which she was both celebrated and detested. But this is only a small part of her story, and the only chapter that design history has, up to now, recorded. The rest of her story, told for the first time in this book, spans two full decades and scores of pioneering editorial projects.

Because Gordon became such a galvanizing figure, her influence on American taste and American design—and, with it, the role of the shelter press that she represents—has been difficult to assess critically. With this book, I have tried to do both.

Gordon's editorship and her role within American design offer a compelling case study with larger implications for the history of American architecture and design. First, while many scholars have examined the contributions of individual architects and designers, few have assessed those of the professionals who popularized and sold design to the American public. Gordon was one of those figures, significant because she exerted influence from a position often considered peripheral, and from a "popular" platform often deemed inconsequential by some architects, historians, and critics of her time and ours. Perhaps more remarkably, Gordon often worked in opposition (sometimes with open antagonism) to the dominant cultural institutions and professional journals that historically controlled matters of design taste and design production. This book, then, broadens our understanding of the power players who have shaped the world of architecture and design.

Second, because Gordon positioned herself as a mediator among the design profession, the building and home furnishings industry, and the consumer (her readers), this study of her methods considers design evolution and design tastes from the intersection of all of these groups.

Third, the designs (including houses, furnishings, textiles, and other household objects) that Gordon used to convey her message have been eclipsed by a small set of well-studied examples—for example *Arts & Architecture*'s Case Study Houses. This has limited and skewed our understanding of design history. The evidence that I use in this book, drawn from the pages of *House Beautiful,* opens a dialogue about the full range of what was created, published, sold, and bought in America during the postwar years.

Last, my use of Gordon's *House Beautiful* as an object of study and as a material archive expands design scholarship in terms of both content and method. Architectural historians often focus on buildings, architects, or, more recently, professional architectural journals; my work examines a new set of sources that may have been on the fringes of the design profession but—especially with regard to public opinion—were equally significant. *House Beautiful* becomes a perfect case study precisely

because it was a popular "shelter" magazine (this term was used sparingly in the late 1940s, coming into vogue only recently), one that dealt exclusively with domestic architecture, interiors, home furnishings, gardening, and, most importantly, domestic life; "family life" was the implied subject, but child-rearing, for example, was rarely an editorial focus. With this comprehensive programming, *House Beautiful*'s audience was broad; it was not just for women or housewives, it was for all Americans (designers included) interested in "bettering" their home lives. The magazine, architectural yet free from professional pretension, could show American design from the vantage point of editors, critics, retailers, and consumers. And it could, by 1965, reach more than a million people every month. Until recently, shelter magazines have been underutilized, undervalued, or simply ignored. My work establishes the value of examining design from this alternative perspective.

## On Sources, Method, and Structure

When I began this project in 2001, the literature on postwar designers and the postwar house—in any style or for any demographic—was scant, studies of architecture and the media were scarce (though Beatriz Colomina has done much to remedy this), and histories of the shelter press were nonexistent. In recent years, scholarship on postwar design has rapidly expanded. The first efforts were positioned within a relatively narrow cultural framework, or drew from a small body of canonical works (for example, the Case Study Houses), or remained focused on well-known figures (for example, Mies van der Rohe). More recent studies have pushed these boundaries, including the works of historians such as Alice T. Friedman, Dianne Harris, Andrew Shanken, and, more recently, Barbara Miller Lane and James A. Jacobs. With these exemplary studies in the background, I hope to open a new window that frames postwar design within a shifting cultural moment colored by tense politics, burgeoning (and problematic) consumerism, fluid tastes, and contested identities.

I chose to study *House Beautiful* for two reasons: the magazine itself, and its editor. Though my focus was narrow, my research was expansive. I augmented my close reading of *House Beautiful* (twenty-five years of back issues) with substantial archival digging that traversed fifteen repositories across the United States. My goal was to construct an untold narrative of American design, but a good deal of my effort was spent trying to "find" Elizabeth Gordon. Along the way—a sixteen-year journey that started with my doctoral dissertation and culminates with this book—a few other scholars have picked up the trail and uncovered valuable materials including, most notably, Kathleen Corbett, whose 2010 dissertation examines Gordon's "The Threat to the Next America," and Jennifer A. Watts, whose edited volume on the photographer Maynard L. Parker frames Gordon in light of the postwar American dream, much of which she developed alongside her favorite photographer, Parker.[5]

Still, Gordon was an elusive figure. Her papers have not been collected, outside the small *shibui* collection held at the Smithsonian's Freer Sackler Archive. Her personal life remains shrouded in mystery. We may never know why she loved Adrian suits and Robert Dudley hats, why she kept an apartment in Manhattan in the mid-1950s (other than to ease the daily commute from her home in Dobbs Ferry), why she and her husband, Carl, never had children, or how she spent her leisure time (other than reading voraciously, collecting handcrafted pottery, and assembling an impressive assortment of Japanese design). Her personal story may remain private, buried with the many friends and colleagues who passed away before her, but her professional story is here for the reading.

Much of the book's narrative, then, pivots on Gordon and her professional life. She was a dynamic and controversial figure who navigated a complicated moment in the history of American design. She edited *House Beautiful* during the entire postwar period, from 1941 to 1964; her long tenure, so unusual in her field, allowed me to fully examine the evolution of domestic architecture, contemporary debates surrounding modernism, changing notions of domesticity and lifestyle, and shifting design tastes, all from within the framework of one publication. Though the magazine evolved and its content changed, Gordon was remarkably consistent: she established her editorial agenda early on (by 1943) and spent two decades supporting it. She did so with foresight, intelligence, discernment, and dexterity—and this translated to tremendous professional power.

My approach is, of course, not without shortcomings. As with any detailed study of a singular subject or person, there are limits. A comparative study of all American shelter magazines or all of the editors working in the postwar period would be compelling. But that would take

another decade and another book. What I hope to provide here is but one example that offers insight and opens a broader range of questions for future scholars.

I have arranged the chapters of this book to align roughly with the chronology of Gordon's career, punctuated by a series of significant editorial programs that responded to (or, in a few cases, provoked) contemporary architectural, cultural, and social issues. Gordon's programs were not, however, neatly sequential. Some were short-lived and ended before the next big effort started, some ended after another program began, and some overlapped considerably. To preserve narrative flow, and to make the case for Gordon's role in the evolution of American domestic design, I have focused on beginnings and a few pivotal moments.

As historians, we all must assume some interpretive risk. We cast some players in leading roles and others as support; we move some events to the background and some to the foreground; we spotlight a few moments as definitive and others as trivial (yet nonetheless fascinating). What I have attempted to capture here is momentum: a sense of the unrelenting drive with which Gordon moved through the postwar decades, always learning, always searching, always moving America toward the better future that she envisioned.

## On Terminology

Gordon's vision, and the copy she presented to her readers, relied on rhetoric and an often-repeated set of terms and phrases. Over the course of two decades, key words emerged, disappeared, and reemerged in slightly altered forms: "taste," "good design" and its opposite, "bad design," "modern" (and all its derivatives), "livable," and, for a short period, Frank Lloyd Wright's proprietary term "organic." I have used these same terms in my own narrative, testing Gordon's understanding against both contemporary conceptions and the definitions that have been developed—by architects, designers, theorists, historians, critics, and the public—in the five decades since she retired. Though much of the book that follows explores these very terms, a brief discussion of a few is warranted here.

Gordon was dedicated, throughout her entire career, to shaping American taste. She was, as I suggest from the title of this book forward, a tastemaker. I use this term, borrowed from Russell Lynes's 1949 book *The Tastemakers,* to frame the core of Gordon's editorial agenda: to observe, inform, elevate, control, and even manipulate American taste in matters of design and lifestyle during a period in which, as Lynes wrote, "taste became everybody's business and not just the business of a cultured few."[6] Though an entire literature on taste, taste formation, and taste-making has developed since Gordon's time, pioneered by figures such as Pierre Bourdieu and Herbert Gans, I have specifically chosen to work within the concept of "taste" as Gordon understood and used it. The exception here is the interlude when I focus on Lynes, who, in addition to publishing his own books, wrote serially on taste for *Harper's* magazine (including his famous piece "Highbrow, Lowbrow, and Middlebrow," from February 1949). Lynes's history of taste (to about 1949) greatly influenced Gordon's thinking, and she commissioned him to contribute to *House Beautiful*—and so he becomes a minor figure here.

As a tastemaker, Gordon's job was to comment upon what people liked (or what they *should* like), what designers made (or what they *should have* made), and what retailers brought to market (or what they *should* have). She could well be called simply a critic, or even an "activist" critic, but that would miss a vital component of her editing: as a taste*maker,* she reported on taste, critiqued trends, fought for reform, and—most significantly—made or commissioned "better" alternatives for the consuming public.[7]

My goal, while exploring the mid-century meanings of taste, was to remain close to the source and to preserve Gordon's perspective. This helps, I believe, to reconstruct the logic in her editorials and advice. It also underscores her own accomplishment: without the assistance of sociological theory, but with the help of proto-sociological methods (including consumer surveys, questionnaires, and quantitative data), she developed her own sophisticated model of taste, taste formation, and influence. Her understanding drove her editorial decisions and the magazine's content, and so an unmitigated resurrection of her ideas is useful.

Gordon was particularly concerned with taste as it related to domestic design. This was, in fact, the very subject of an unfinished and unpublished manuscript that she wrote in the late 1980s. Her concept of taste, and how Americans developed and applied it, evolved from her first musings in the early 1940s; by 1949, she had a fully formulated theory (though this shifted considerably during the last years of her career, as she discovered the Japanese aesthetic concept of shibui). Her best description—both narrative and pictorial—appeared in

*House Beautiful* as the "River of Taste" (which I discuss at length in Chapter 6). Her key point was that social, cultural, economic, and technologic forces influence personal taste, and just as these forces change over time, so might personal taste (the latter part of her logic was, of course, quite convenient for an editor whose job was to sell emerging trends and new domestic products).

Gordon's idea of "good taste" encompassed the notion of discrimination, which she termed "judgment." Good taste was the ability to see, or to "judge" (another of Gordon's favored terms), and to select the best in terms of aesthetics and quality.[8] "Quality" typically referred to materials, craftsmanship, and durability. For Gordon, good taste was individually cultivated; it was not specifically tied to any aesthetic style (as it might have been for, say, Elsie de Wolfe), any national tradition (though she favored Scandinavian and Japanese design for craftsmanship and intrinsic goodness), or any traditional prescriptions (she asserted that "what was good enough for your grandfather *isn't* good enough for you").[9]

Gordon was also involved, throughout most of the 1940s and 1950s, in the struggle to define "modern" design. In this, she joined a broad professional discourse. Some of her contemporaries, including the critics Sigfried Giedion, Lewis Mumford, and Esther McCoy, exerted a lasting and recognized influence. Alongside these figures, Gordon contributed her own significant theories and, with the help of collaborators, corresponding designed objects. What we learn from Gordon, however, was that the meaning of "modern" was hotly contested. It shifted, depending on who used it, how they used it, where they used it, and when. To some, it meant *pilotis* and a flat roof; to others it meant a California ranch house; to still others, it implied a Cape Cod outfitted with an oversized picture window and the latest kitchen appliances. Modern was sometimes an aesthetic concept, sometimes spatial, sometimes functional. Many people used the term "modern" to describe certain architectural characteristics or elements, most often the open plan and the reduction or elimination of ornament. For others, like Gordon, modern was a blended design tradition, a mixing of past and present. But more importantly for Gordon, modern was an attitude and way of living in tune with the times.

Gordon's campaign to promote "good" modern, one that provided a "humanistic" alternative to the "clinical" International Style, was without question her greatest battle. Over the course of twenty-three years, she used many watchwords to describe the same design ideas (here, in chronological order): "humanized modern," "warm modern" (as opposed to "cold modern"), "naturalism," "the New Look," "the American Look," "the American Style," "humanism," and finally, after 1953, "organic." This last term is perhaps the most ambiguous, and loaded.

In defining "organic" as a concept and a mode of modern design, if not a nascent architectural movement, I was less concerned with what "organic" had been (the history of the use of the term) than with what it became in the 1950s when Gordon began to use it. Her understanding was directly linked to her relationship with Frank Lloyd Wright, which warmed after 1953 (and is the subject of the latter half of this book). Throughout his many publications, Wright's articulation of his organic theory shifted and evolved. For the rest of the architectural profession, and especially those who wrote about organic design in the postwar period, the definition of "organic" remained elusive.

Robert Twombly, writing in 1979, offered perhaps the best definition on Wright's behalf: "An organic structure is built according to nature's principles: harmonious in all its parts and with the environment, it expresses and unifies all the factors calling it into being—site, materials, client needs and architect's philosophy, construction methods, its culture, and the nature of the problem. An organic structure defines and prophecies life, grows along with those who use it, states an idea about a social reality, and, by including everything necessary and nothing unnecessary for its purpose, is as unified and economical as nature itself."[10] This is close to Gordon's understanding. But she also used "organic" as a term of opposition, which could at any given moment be summoned in the service of fighting a dominant and wayward mainstream.

This point of opposition was pivotal for Gordon in the mid-1950s, when her interest in a "softer" version of modern design led her to collect a group of designers who, more or less, subscribed to Wrightian ideas. Bruno Zevi, with whom Gordon formed a lasting friendship, eloquently characterized these practitioners as "maniacally individualistic."[11] This perfectly describes the cast whom Gordon brought into the story that follows—and perhaps none more so than Gordon herself. During her twenty-three years as editor at *House Beautiful,* she became a tremendous force within American design culture; her story helps us understand why, in the world of domestic architecture and design, Americans liked what they liked, bought what they bought, and built what they built.

**1.** Elizabeth Gordon at
Taliesin West, Scottsdale,
Arizona, ca. 1946.

# Prologue

"I've called my talk for this afternoon 'The Responsibility of an Editor,'" announced Elizabeth Gordon. "It could have been called 'The Responsibility of the Press,' but that might have given you the notion that something heavy and thunderous would follow such a pleasant lunch. Heaven knows," she continued, "I have thundered enough and I have certainly invited the lightning!"[1]

It was 22 June 1953, a rainy Monday afternoon in Chicago, and Gordon, then the editor-in-chief of *House Beautiful* magazine, had just stepped to the podium to address the Press Club Luncheon at the American Furniture Mart. The "thunder" was her April 1953 editorial, "The Threat to the Next America," a scathing critique of the International Style that shook America that spring and would reverberate for three more decades; the "lightning" was the highly charged and very public reaction from those who opposed her point of view.

With a few short pages of text, Gordon had provoked (or, more precisely, recharged) the ultimate architectural conflict of the decade. In short, she had declared war. Her battleground was "the home front"—quite literally, the American family home.[2] Her weapons were political, cultural, social, and aesthetic. The enemy—the national "threat" that she declared—was "bad modern": the line of "totalitarian" design promoted as the International Style by prominent cultural institutions, specifically the Museum of Modern Art, and practiced by foreign "dictator" architects, including the immensely popular Mies van der Rohe, Walter Gropius, and Le Corbusier. The

heroic opposition—Gordon's side—was "good modern": a line of "home-grown," "democratic" design called the American Style (a term that she coined) and practiced by Frank Lloyd Wright, Harwell Hamilton Harris, Cliff May, and a handful of other lesser-known figures (whom, of course, she published in *House Beautiful*).[3] The struggle between good modern and bad modern, as Gordon defined it, involved yet moved beyond issues of aesthetic style, lifestyle, and personal taste. This was a battle of national significance and "social consequence."[4]

Gordon's "Threat" essay (and her October 1953 follow-up article, "Does Design Have Social Significance?") was loaded with her own brand of propaganda and McCarthy-era rhetoric, and it was galvanizing. Overnight, she became the most political, polemical, and audacious editor in the business. She was instantly detested by her detractors and simultaneously celebrated by her supporters.

So when Gordon stepped up to the Press Club microphone that day in 1953, she certainly had everyone's attention. The controversial events of the preceding months guaranteed that. But she was, under any circumstance, a commanding figure—tall, attractive, with lively blue eyes, upswept dark hair, and a sharply tailored suit often topped by a fashionable hat—who conveyed what the *New York Times* described as a "regal presence."[5] She spoke with conviction and urgency, and with the bearing of a woman at the height of her fame (or infamy) and power.

She urged her lunch companions, a roomful of reporters and editors, to consider their "social responsibility."

The American family home, and all of its trappings, had become the "center of the terrible conflict that threaten[ed] to split the world apart." The press had the power, she argued, to mediate, to advocate for "design for living" and a "democratic architecture for a democratic society." They could offer three crucial "services": reporting objectively; publishing architecture, furnishing, and decorative arts objects that were "*both* new *and* good"; and teaching "laymen" readers to "judge" matters of taste and quality for themselves, giving them the critical power of "informed individualism" (guided, of course, by the responsible editor).[6] This was, after all, precisely what she had been doing at *House Beautiful* for more than a decade.

So why, in 1953, did Gordon sound the alarm? Why set up such a clear opposition between bad and good modern design, and between foreign and native designers (at the great risk of appearing hysterical and xenophobic)? Why attack admired architects and respected institutions, and with such aggression? And why was she convinced that home-furnishing editors—her colleagues—could and *should* wage this war?

The answer was simple: for Gordon, home design was an extension of freedom, a basic value and right. Defending it was a "matter of cultural—and social—life and death." At that "fateful fork in the road," she would champion the cause.[7] Her task would not be easy, and she would take great risks to get results.

This book is the story of that design crusade, full of hazard and reward, from the vantage point of one "responsible" editor who was determined to shape the future of the modern American house.

# Chapter 1

# Beginnings

Two decades after she retired from *House Beautiful,* Elizabeth Gordon sat down at her typewriter to capture the essence of her long career. The results were a partial book manuscript and a fragmented autobiography. In these two unpublished works, she posed two pivotal questions: "What constitutes good taste?" and "How did I get to be me?"[1] These questions were a framing device, perfectly composed by a practiced editor who hoped to reveal far more than a simple set of answers. She had a bigger story to tell, an exclusive, a scoop. She focused on her beginnings starting in 1941, when she took *House Beautiful* and the magazine world by storm. She was a force to be reckoned with from the start, when she was (as *House Beautiful* staffer Marion Gough later recalled) "an irrepressible 35 [years of age], in a checked Adrian suit and a black hat with red pom-poms on it . . . full of curiosity and drive and zeal to get at the bottom of things."[2] The problem with Gordon's own recounting of her story, however, was that she started partway through the action.

Elizabeth Gordon was born on 8 August 1906, and spent her first eighteen years in Logansport, Indiana, in a world constrained by geography, traditions, and family (fig. 2). Logansport was typical of a large midwestern town, one of the ten largest in the state (with a 1906 population of approximately twenty thousand), whose fortunes turned with farming and the railroad. It awoke with the Wabash and Erie Canal in the 1840s, boomed with the arrival of the Lake Michigan, Logansport, and Ohio River Railroad

in 1848, grew in the 1880s, busted in the 1890s, recovered in the 1910s, and continued to expand through the First World War and into the mid-1920s. It served as a waypoint (for crops, raw materials, and passengers) between Detroit, Chicago, and St. Louis, and a center for railcar maintenance and engine manufacturing. By 1925, the railroad had become the city's biggest industry, with over two hundred trains and three thousand workers cycling through every day.[3]

Gordon grew up between the river and the railroad, under what she described as simultaneously "ordinary" and "tumultuous" circumstances. She was an only child and lived with her father, Byron (who worked for the railroad as a draughtsman and scale inspector), her mother, Angeline (who worked, intermittently, as a teacher and shop clerk), and her maternal grandmother, Anna E. Ball. They were a devout Methodist family, and Gordon's grandmother enforced a strict adherence to the *Book of Discipline*. Ordinary as her life was, Gordon was unhappy and struggled to live according to her family's "obsolete" nineteenth-century values.[4]

Gordon's family lived in a two-story Carpenter Gothic house built from stock plans, likely by her paternal grandfather. Their neighborhood stretched along East Broadway in Logansport and was filled with comparable homes owned or rented by railroad men: conductors, engineers, freight clerks, baggage masters, and mechanics.[5] Gordon claimed that as a young girl she had been completely unaware of "architecture," yet she described her family

2. Gordon, photographed at home, Dobbs Ferry, New York, ca. 1941.

home in a way that suggested otherwise. She recalled the house vividly as a building "best seen from outside," because the inside, with its corner turret, was full of "bastard" spaces that were "mainly a place to dust."[6] Certainly this early exposure to cluttered, inefficient interiors had some bearing on her later crusade for better homes and better living.

Gordon attended elementary and secondary school in Logansport and graduated from Logansport High School in 1923. She enrolled briefly at Northwestern University in Evanston, Illinois, but her tenure there was brief, as her parents removed her from school during her first semester, after she was caught attending a dance—in blatant defiance of Methodist doctrine.[7] Under her family's careful watch, she was forced to continue her college education through correspondence courses.

This arrangement did not last. Gordon was willful and independent, and she protested until her parents allowed her to return to collegiate life. In 1924, she enrolled at the University of Chicago. Unaware of the school's "freethinking" liberal reputation, her family selected the school for her because they believed (erroneously) that it lacked an established sorority system that might contribute to her "wickedness." To further guarantee Gordon's good behavior, her mother accompanied her as a permanent "chaperone." Angeline was ever present until she, too, began to take classes; this was a major turning point for Gordon, as her mother's "schoolwork became more interesting to her than [Gordon's] soul's salvation." After nearly twenty years in strict confines, her family's influence had finally begun to fade, especially that of her grandmother. Gordon recalled years later that in this moment, she finally felt "free."[8]

Chicago's lively atmosphere surely contributed to Gordon's feeling of liberation. She must have witnessed the Progressive-era social reforms initiated by Jane Addams, Ellen Gates Starr, and Mary McDowell (who ran the university's Settlement House from 1894); the architectural rebellion launched by Louis Sullivan (made visible at his Transportation Building for the 1893 World's Columbian Exhibition) and Frank Lloyd Wright; and the

"good taste" crusades announced in new home magazines such as *House Beautiful* (founded in Chicago in 1896).

When Gordon arrived in Chicago, the Progressive era had left its imprint, but had yielded to a new age. The 1920s were a time of tension and transition, and she arrived at the zenith. Chicago in 1924 was in many ways a dirty city, plagued by poverty, government corruption, "moral depravity" (a term contemporaries used to refer to prostitution, gambling, and illegal drinking), and organized crime (Al Capone was a prominent boss based in the city in these years). But it had its "roaring" side, too, especially for a young university student isolated from many of the harsh realities of urban life. Gordon must have experienced firsthand the dramatic changes in lifestyle and speed of life that characterized the period: her new world was filled with fast cars, speed trains, boisterous music (broadcast over new radios or jukeboxes), dance halls (the Aragon was a popular spot), speakeasies, quick-service or "fast" food (though White Castle would not open until 1929), movie theaters, chain stores, ready-to-wear short skirts, electric washing machines, and Frigidaire refrigerators.

It is unclear whether Gordon identified with the emerging flapper culture of the 1920s, but she was, in most regards, a "new woman." She enrolled in university, bobbed her hair, worked (at least temporarily, for the

university's Oriental Institute), could vote, and learned to drive (fig. 3).

At the University of Chicago, Gordon found a progressive and "modernized" community, which was radically different from her home life in Indiana. Established in 1890, in the midst of the broad social, cultural, and intellectual reforms of the late nineteenth century, the university was young and ambitious. It owed its beginnings, broadly, to a wave of expansion in American higher education, and, specifically, to the philanthropical interests of John D. Rockefeller, the American Baptist Education Society, and Marshall Field. Financed by America's industrial success, the school "brought into focus the spirit of the age"; it was a beacon of hope, dedicated to the pursuit of knowledge and truth. The school was nonsectarian, coeducational from its inception, committed to the Progressive ideals of civic engagement, and—importantly for Gordon—modeled after "research" universities in Germany. It was, as historian Frederick Rudolph has noted, the new "model American university."[9]

Gordon took full advantage of this new model and thrived under the university's broad liberal tradition. Her life was balanced between academics and extracurricular activities: she was active in theater, the YWCA, the Women's Athletic Association, and Phi Beta Delta. She developed an interest in journalism and served on the staff of the semiweekly newspaper *Maroon,* the monthly magazine *Phoenix,* and the yearbook, *Cap and Gown.*[10]

Her studies were rigorous, and she quickly developed a passion for knowledge. She enjoyed and excelled in most of her studies, particularly history and cultural courses. Most importantly, she learned to conduct research "fast and carefully," a skill that would serve her well in her long career.[11] For Gordon, like most women who came of age in the 1920s, this kind of education, alongside the right to vote, translated into independence and freedom. Knowledge became an asset that was, as she wrote, "better than riches." The sense that information could bring power was seminal to her own approach to personal development, and later became the philosophical foundation of her efforts to educate and embolden the American consumer through magazine reporting.[12]

But that power was slow to come. American women earned thirty to forty percent of all bachelor's degrees conferred between 1920 and 1930, yet their career paths remained narrow. Three-quarters became teachers or nurses.[13] In 1927, when Gordon graduated with a bachelor of philosophy degree, she surrendered to familial and financial pressures and spent her first postgraduate year as a teacher. With her degree in hand, Gordon moved one hundred miles north to teach high school English in the small Wisconsin town of Janesville. She did not stay long. After a year, she had saved enough money to move on. In 1928, she left Wisconsin for New York and a new career. She was determined to pursue another kind of work "that would be useful to the world."[14]

Inspired by the Pulitzer Prize–winning author Edna Ferber, Gordon modeled her new life after a fictional "newspaper" girl. She believed that reporting offered something that teaching did not: a way to constantly expand her knowledge, and that of others. This was, she believed, a "learning" route.[15] She certainly did not suspect that after she left teaching, she would still become, by way of her editing style, an unrivaled educator.

**3.** Gordon (bottom row, center), *Cap and Gown* yearbook, University of Chicago, 1927.

On Christmas Eve 1928, shortly after she moved to New York, Gordon married fellow University of Chicago student Carl Hafey Norcross (fig. 4).[16] Norcross held a master's degree in engineering from Columbia and studied economics at Chicago, the discipline in which he would earn a doctorate from Columbia in 1937. Like Gordon, he translated his considerable expertise to journalism, and just before the Second World War he became the managing editor of McGraw-Hill's *Aviation* magazine. In 1942, he enlisted in the U.S. Air Force and was deployed to England (where he served as the director of intelligence for the Third Air Division). After the war, and a brief post at the U.S. Strategic Bombing Analysis Group, he returned to his career in magazine publishing. From this point forward, his career would run parallel to his wife's. Norcross went to work for Time, Inc., where he served first as an associate editor at *Fortune,* and from 1952 to 1963—the peak of Gordon's career at the Hearst Corporation's *House Beautiful*—as executive editor of *House & Home.*

## Building Expertise

Newly married and still using her maiden name (apparently to her husband's chagrin), Gordon began to work as a freelance copywriter. Though she was a skilled writer, she was frustrated by the lack of prestige and challenge that her role brought. She believed the shortest route to professional satisfaction was content specialization.

Determined to become an "expert" in something, she chose the American family home.

Gordon began by writing "home columns" for Joseph Pulitzer's *New York World,* and subsequently for William Randolph Hearst's *New York Journal.* By 1931, she had left the *Journal* for a more prominent post as a freelance columnist for the *New York Herald Tribune.* For $100 a week, she wrote stories about the housing market and domestic goods; these columns were syndicated nationally by 1937. She excelled at quick and thorough "detective work," and she believed that she could "write clearly about anything—given enough time to do good research that would make me an expert in that subject." Her newspaper assignments offered her the chance to develop broad expertise on consumer-interest topics, but she was not satisfied. She was "just making a living," but she wanted more.[17]

She found work as a copywriter and later an account executive at Blaker, a New York advertising agency. Her advertising projects were diverse, as she worked on everything from high fashion to plumbing, though her ads for American Standard were less than glamorous. But her clients, including Hearst's *Good Housekeeping,* saw her talent. She was smart, determined, creative, and articulate—and she worked "wonders for circulation and advertising."[18]

This was a good job, but it was an even better educational opportunity. She was certainly affected by the burgeoning fields of consumer research and market analysis, perhaps most directly by Christine McGaffey Frederick's 1929 book *Selling Mrs. Consumer;* this laid the groundwork

**4.** Gordon and her husband, Carl Norcross.

**5.** Julius Gregory, Gordon-Norcross House, Dobbs Ferry, New York, ca. 1941.

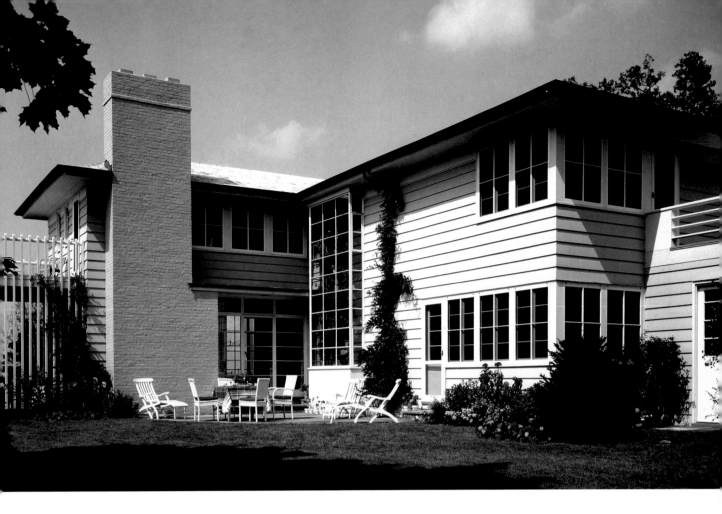

for understanding women's purchasing power, habits, and psychology—all new and vital information for copywriters such as Gordon. Frederick likewise provided advice on how to navigate "Mrs. Consumer's Attitude Toward Advertising," encouraging "education" through ads; though she did not credit Frederick, this was a strategy Gordon embraced.[19] She may have also discovered Edward Bernays, whose advocacy for market research, ad work for Ivory soap, and consultancies for Hearst would have caught her attention. More importantly, though, Gordon (in her role as *House Beautiful* editor) would later adopt techniques that he had pioneered, including the use of "third party authorities" to promote products, multichannel marketing, and product "tie-ins."[20]

One of her most satisfied advertising clients was *Good Housekeeping,* a monthly women's magazine owned by the Hearst Corporation. In about 1936, she began to propose stories to the editor, on a consulting basis. She was hired full-time and promoted to the magazine's permanent editorial staff, in charge of building and decorating.[21] Though she lacked a formal education in architecture or design, Gordon soon became an expert on all things domestic. Her articles covered a range of topics,

from design to construction, remodeling, home maintenance and repair, and household products. Under the supervision of Helen Koues (whom Gordon claimed she got "fired") and later Dorothy Draper, she was "self-generating": she initiated her own original story ideas, wrote articles, and commissioned illustrative material. She proved to be a reliable reporter who "knew the facts" and conveyed knowledge simply and directly through well-chosen photographs and drawings.[22]

By 1937, Gordon had become a recognized authority on "good" houses. Through her reporting, she also became an advocate for reform. She was determined to change what she viewed as a substandard housing market. She believed that builders' houses of the 1930s—the house-for-sale market—offered "average" living in average homes; she wanted to teach the American public that it could have more.[23]

Gordon's beliefs, and her recognition of a significant knowledge gap, came directly out of her personal experience. She had been writing articles about housing, but at the same moment, she and her husband were hunting for land and looking to build a house (fig. 5). She must have used her own experience, both good and bad, as a case

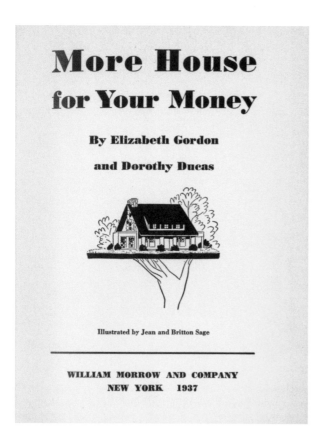

# More House
# for Your Money

### By Elizabeth Gordon
### and Dorothy Ducas

Illustrated by Jean and Britton Sage

WILLIAM MORROW AND COMPANY
NEW YORK 1937

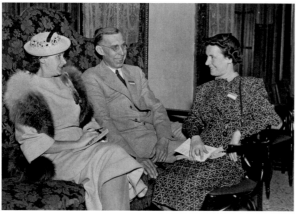

**6.** Gordon and Dorothy Ducas, *More House for Your Money* (1937), frontispiece.

**7.** Gordon, Paul E. Stark, and Dorothy Ducas (left to right), attending the Real Estate Convention, New York, May 1937.

study for her book *More House for Your Money* (fig. 6). Coauthored in 1937 with Dorothy Ducas, this "how-to" manual was launched in the midst of the Depression and a decline in American housing starts, but was based on the optimistic premise that, when armed with knowledge, the American family could one day "build a better house."[24] In fifteen short chapters, Gordon and Ducas offered practical advice for Americans looking to build a new home. They gave advice on the complete process, from analyzing needs and desires to planning, financing, purchasing land, designing, building, and finishing the interior. This was a nontechnical manual for a lay audience, filled with "facts about *how* to build, and how to get what you want for what you can pay."[25]

Architectural style was of no concern to the authors, and they must have believed it was of little concern to their readers. Instead, they prioritized personal requirements, individual taste, economy, and comfort. But more importantly, they advanced one significant idea: an *informed* householder—as a consumer of domestic products—could exert complete control over the process and the product. Gordon and Ducas believed that, with the right information and the right house, even an average American could become "king for a day" and could live like a "monarch of a small domain . . . guiding the activities of a small army of subjects who are building according to your every wish."[26] They presented far more than an advice book: *More House for Your Money* was a roadmap to a self-determined domestic future (fig. 7).

After a decade in New York, Gordon had established an impressive professional portfolio. In 1941, when the architect and planner Kenneth K. Stowell left *House Beautiful* for *Architectural Record,* Gordon moved into his position as editor-in-chief. Within this male-dominated professional sphere, Gordon became one of the few women to control a mass-circulation magazine, and the only woman to head a publication that focused on architecture and the American home. Many of her counterparts believed— or hoped—that her tenure would last only through the Second World War. She surprised them all: she led *House Beautiful* for the next twenty-three years.

# Good Taste and Better Living

On 17 October 1941, the *New York Times* announced a new editor-in-chief at *House Beautiful* magazine: Miss Elizabeth Gordon. This article was a short piece, submitted by the magazine's vice president, Richard A. Hoefer, and sandwiched between the paper's plea for female volunteers to defend "democracy" against "nazism" and a report on the "progress" in birth control.[1] The *Times* ran forty-four words, but *House Beautiful* made even less of its change in leadership. The only hint of transition was the appearance of Gordon's name on the masthead, and this didn't happen until three months later, in January 1942. *House Beautiful*'s editors, it seemed, were an invisible force. Gordon would soon change all of that.

When she arrived at her new office on Madison Avenue, Gordon stepped into a position of authority, yet two factors tempered her editorial control: the established agenda of the magazine, and the looming crisis of world war. She responded to both with an appropriate degree of acquiescence, but quickly began to develop her own plan "for the duration."

## At *House Beautiful*

*The House Beautiful* (shortened to *House Beautiful* in 1925) began in 1896 as a modest monthly, rooted in Progressive-era ideals of domestic reform (fig. 8).[2] It was founded by the Chicago engineer Eugene Klapp, intellectual Henry Blodgett Harvey, and publisher Herbert Stuart Stone. Klapp and Stone had the greatest lasting influence on the magazine's philosophy and content: Harvey moved on after one year; Stone assumed sole editorship in 1898; and Klapp continued as a contributor under the pen name Oliver Coleman.

From the magazine's inception, Klapp and Stone joined like-minded housing "crusaders" of their time; they envisioned the magazine as a pulpit from which they could preach the "gospel" of good domestic design. By improving the quality of American homes, they believed they were "reforming the world."[3] Their focus was residential architecture, interiors, and the applied domestic arts, and their mission was to "lead the American people toward good taste, utility, and simplicity in their homes." Within the first few years, they claimed to be the "American Authority on Household Art."[4]

Early on, they adopted the philosophy of William C. Gannett, the Unitarian minister from whom they borrowed the magazine's title (with a nod to Robert Louis Stevenson).[5] In his 1895 "The House Beautiful" sermon series, printed by W. H. Winslow and illustrated by Frank Lloyd Wright, Gannett denounced the "encrusted homes" of the Gilded Age and the bad taste of those who owned them (fig. 9). He encouraged instead a move toward the "ideal of beauty," characterized by greater "simplicity and repose." *House Beautiful*'s editors, like Gannett, believed that bad taste encouraged bad design, which in turn degraded the quality of domestic architecture and home life. They argued, like Gannett, that for the greater good of society, houses should be "dedicated to the needs of

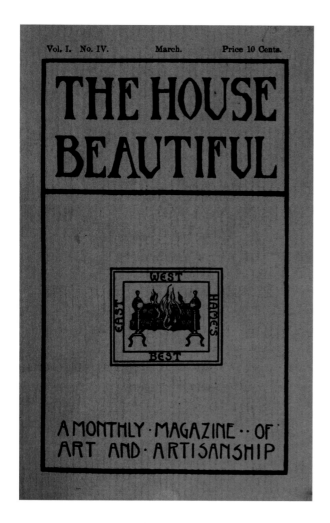

human beings instead of to show-off ostentation."[6] The rhetoric of beauty, taste, and needs would remain operative throughout the magazine's early years—and, indeed, throughout Gordon's editorship.

Klapp and Stone were not alone in their critique of contemporary domestic design. They were joined by a host of prominent designers and thinkers, including William Morris (who died the same year the magazine launched), John Ruskin, and C. R. Ashbee, all of whom were noted in the magazine's first issues. Among contemporary American figures, Elsie de Wolfe was an equally vocal critic. Though Wolfe's seminal *The House in Good Taste* would not appear until 1913, some of its contents were published previously in serial form; her examples focused on historicized trends, departing significantly from *House Beautiful*'s Arts and Crafts preferences, but her emphasis on "simplicity" and "suitability" as the hallmarks of good taste paralleled the magazine's direction.[7]

Klapp and Stone positioned their magazine as an arbiter of taste for the "intelligent amateur," both male and female. They recognized a significant market void, and felt there were few publications that addressed this audience, despite the rapid expansion of print media during these years. Newsstands were filled with ladies' magazines, professional architectural journals, and art magazines, but these were either too naïve or too "technical." The editors instead sought a middle ground. They embraced a popular (if not populist) stance and positioned *House Beautiful* as a home magazine that could be a "rival of the architectural publications."[8] Their competition, as they saw it, ranged from *Architectural Record* (founded in 1891) and the *Architectural Review and American Builders' Journal* (1868) to *Ladies' Home Journal* (1883) and *Good Housekeeping* (1885).

*House Beautiful* was what the industry considered a "class magazine" aimed at an "average" yet educated audience of means, or what would have been considered in the 1890s and certainly in the 1950s as upper-middle class. (National household income data was not collected before 1929, when "middle-income" families averaged $15,000 per annum, and the average home construction

**8.** Cover, *The House Beautiful* magazine, vol. 1 (March 1897).

**9.** Frank Lloyd Wright, Illustration for William C. Gannett, *The House Beautiful* (1897), Chapter 3.

cost was $4,800.[9]) Though they had a target audience, the editors hoped to inform and inspire a wider demographic. In this sense, their magazine was an aspirational publication. The cover price reflected this aim: it was a moderate ten cents, with an annual subscription rate of one dollar—the same price as *Ladies' Home Journal* and *Good Housekeeping.* The monthly and yearly cost doubled in 1900 along with the page count, which grew from twenty-nine to an average of fifty-eight pages per issue, including advertisements. The editors further delivered on their egalitarian promise by featuring a broad range of "successful" houses, showcasing "expensive" homes but also covering "inexpensive dwellings" with equal enthusiasm. For example, they featured an 1898 competition for the best small house constructed for under $3,000 (which exceeded the national average of $2,200), with first prize going to a brick and half-timbered cottage designed by Milwaukee architect Richard Philipp.[10]

Into the 1900s, *House Beautiful* continued to publish "modest" houses and increasingly censured the "execrable taste" of the wealthy.[11] Writing in 1946, former editor Virginia Robie attested that "then, as now, *House Beautiful* was not in the least awed or impressed by Society, the Social Register, and Money.... When we published expensive houses, it was because they were expressions of the principles we were preaching, certainly never because they might have a sensational snob appeal." The magazine did, however, recognize that the taste of the wealthy influenced that of the "less wealthy." Yet the editors were critical of the suspect choices made by many affluent Americans, reminding their readers that "taste goes farther than money."[12]

The process of defining and illustrating both good taste and good design was the chief work of the magazine. The text was short, illustrated with a few halftone images of houses, interiors, furniture, and decorative objects. A careful reader would have noted the magazine's early bias toward English and American Arts and Crafts. During the magazine's first decade, when it was published in Chicago (and briefly out of Burnham and Root's Monadnock Building), *House Beautiful* regularly featured, among others, Frank Lloyd Wright, Gustav Stickley, and Charles Rennie Mackintosh. The editors also introduced up-and-coming Chicago architects, including Howard Van Doren Shaw, Arthur Heun, Charles White, Robert C. Spencer, and William A. Otis. Alongside houses, furniture, and textiles, they also published, from their first issue forward, Japanese ceramics and prints (an interest that Gordon rekindled in 1960).

The magazine's interests and content shifted only slightly in 1910, when its offices moved to New York, then briefly to Boston, then to Philadelphia, and back to New York. In March 1913, Herbert Stone withdrew from the magazine and left his responsibilities to Virginia Robie, who had been on staff since 1900.[13] The transition was smooth, though Robie took a greater interest in "modern" architecture and fine art. Her biggest departure was perhaps her review of the *International Exhibition of Modern Art* (the Armory Show), which opened in New York. Robie showed only a passing interest in the avant-garde, and described the pieces on display in New York as "freakish . . . but wonderful, nevertheless." She was, however, supportive of "real progress" and sought to report on what the magazine considered the "best" in contemporary work.[14]

The magazine flourished throughout the first three decades of the twentieth century. By the 1930s, it was considered a "high-class, well-produced monthly book," noted for its one-hundred-page count, lavish illustrations, and broad circulation of over one hundred thousand copies.[15] Subsequent editors, all of them with short tenures and most of them women, continued this upward trajectory: Mabel Kent (1915–16), Grace Atkinson Kimball (1916–17), Mabel Rollins (1918–20), Charlotte Lewis (1921), Ellery Sedgwick (1921–22), Ethel B. Power (1923–33), and Arthur H. Samuels (1934–36).

In 1934, the International Magazines Company—a division of the Hearst Corporation—purchased *House Beautiful.* The new president, Richard E. Berlin, merged the magazine with the Hearst-owned *Home and Field,* keeping the *House Beautiful* name intact (with *Home and Field* as a subtitle through October 1943). The new editor, Arthur Samuels, brought impressive experience from his time at *Home and Field,* the *New Yorker,* and *Harper's Bazaar,* but was not on staff long enough to effect real change.

Kenneth K. Stowell, who was editor from 1936 to 1941, stepped in during a difficult period in the magazine's history: the Depression, high editorial turnover, magazine mergers, and changes of ownership had taken their toll. Stowell held the post for five years, the longest tenure in decades. Aside from the magazine's founders, who had left a strong legacy of reform and taste-making, he had the greatest influence on Gordon's first years;

he would in fact stay on as an architectural consultant through March 1942.

Stowell was a Harvard-trained architect who had previously worked as an editor at *Architectural Forum* and *American Architect.* Like Gordon, he was a published author: his 1935 book, *Modernizing Buildings for Profit,* written as a guide for the design profession and building industry (including commercial tenants), had established his authority.[16] He also understood architecture from a practical perspective—its economics, its technics, and its aesthetics. This was all good grounding for an editor. At *Forum,* he established a reputation as a supporter of both architects and manufacturers, most notably through his advisory work on architectural competitions (including, for example, Libbey-Owens-Ford's 1935 competition to "Modernize Main Street").[17] He brought status and experience with him to *House Beautiful* in 1936, where in a few short years, he lifted the quality of a number of key programs, including *House Beautiful*'s series of Bride's Houses and the annual "Small Homes" competition. The latter was of particular import: it attracted many of the best American architects working in that period; it forged a lasting relationship between the magazine and its contributing designers; it converted many of these architects into regular readers; and, through this process, it opened a symbiotic dialogue between the magazine, architects, and their would-be clients, the American public.

Stowell brought architectural expertise to *House Beautiful* and established a momentum that Gordon, his immediate successor, would carry with zeal. When Stowell resigned in 1941 to become editor-in-chief at *Architectural Record* (a post he held from January 1942 through August 1949), he left the magazine in capable hands. Gordon came directly from *Good Housekeeping,* ready to grow *House Beautiful* into a powerhouse publication. Over the next two decades, she tripled the magazine's page count, gave new meaning to—and set the industry standard for—the term "lavishly illustrated," and introduced full-color, full-page photo spreads. She oversaw a few increases in cover price, from thirty-five cents in 1935, with a brief wartime dip to twenty-five cents between 1940 and 1941, to fifty cents in 1948, to sixty cents in 1960 (which corresponded to an increase in national postage rates and an industry-wide hike). Most importantly, though, Gordon expanded the reach of the magazine: under her editorship, *House Beautiful*'s circulation grew from 226,304 in 1940 to almost one million in 1964.[18]

It did, however, take Gordon time to find her stride. She had inherited a powerful editorial legacy: Stowell's architectural program, with an emphasis on practical and "modest" houses; the tradition of editing for good taste, by whatever the contemporary definition was; and the founders' mission to become a "positive force for good in America."[19] This was a weighty bequest, but Gordon was the perfect heir. She found Stowell's editing of the Bride's House and "Small Homes" competitions relevant, and in fact would convert his 1941 contest into her own platform for promoting home design in a "style that truly expresses our modern American way of life."[20] Like Stowell, she was well-versed in practical issues, though perhaps showed a greater interest in consumer welfare (as demonstrated by her own recent book, *More House for Your Money*). She readily adopted the magazine's original platform of good taste and its critical view of "the rich." Most importantly, she had the right temperament: she was confident and decisive, and ready for a cause.

The content of her first issues, published at the end of 1941, suggests she was satisfied—or simply forced—to carry out plans laid by her predecessor. Because *House Beautiful*'s publishing cycle was long and editorials were planned well in advance (in some cases, up to a year), she had little opportunity to do otherwise. But Gordon quickly recognized that the world was undergoing "sweeping change." It was her job to make sure *House Beautiful* changed with it. As she wrote in April 1942, she would support the "nature of Democracy" and fulfill her citizen's "responsibility" of forging "new theories, new materials, new methods, new surroundings, and new opportunities, suitable for our moment in history." *House Beautiful* could no longer operate, she reminded her readers, under "business as usual." She wrote, reflecting later on that pivotal moment, that "time and taste cannot stand still. Change is inevitable."[21]

## Editing the War

For Gordon, "change" came suddenly. In December of 1941, just two months after she became editor, Japan bombed Pearl Harbor, and the United States was then officially at war. Though war had been under way in Europe since 1939, Pearl Harbor escalated efforts on the American home front. The "emergency," as *House Beautiful* initially termed it, had profound implications for Americans and the American shelter press.

Between January 1942 and late 1945, the War Production Board and the U.S. Office of Price Administration (OPA) imposed rationing of commodities and consumer products. As goods were diverted to the war effort, or their production was curtailed altogether, the list of unavailable and controlled products expanded to include not just rubber tires (the first item to be rationed), but cars, bicycles, stoves, farm equipment, gasoline, fuel oil, shoes, nylons, sugar, coffee, meats, canned goods, and other foodstuffs. Typewriters, paper, and film—all vital to the magazine business—were also in short supply, dispensed to those who were "engaged in work essential to the prosecution of the war."[22]

Controls and shortages affected most homes and businesses, and Gordon, like so many Americans, learned to "make do." When paper was scarce, as she frequently reminded her readers, she kept *House Beautiful*'s page count low (under one hundred pages). When film quantities were limited, she published fewer photographs. Even if film allotments were plentiful, the shortage of civilian automobiles, tires, and gasoline—and even lowered speed limits—restricted travel to photo shoots for Gordon's favorite freelance photographer, Maynard L. Parker (whom she used frequently after January 1942). Gordon was able, on occasion, to get supplemental rations, but reporting in the shelter press was not always considered essential to the war effort.[23]

As the OPA controlled what Americans bought, the Office of War Information (OWI) controlled what Americans read. Most of what Gordon published was of no concern to the Office of Censorship, established to manage wartime news in 1941, but the OWI still "suggested" specific content for print publications. The Magazine Bureau, formed in June 1942 as a special office of the OWI, issued guidelines for both magazine copy and illustrative material. Gordon would have been particularly attuned to this agency, as her co-author and frequent *House Beautiful* contributor Dorothy Ducas was its head.[24]

Ducas's *Magazine War Guide,* published twice monthly, outlined themes that would help magazine editors build an "ideological framework" for a nation at war. As historian Maureen Honey has argued, this was a large and well-organized propaganda effort: the *Magazine War Guide* circulated to over six hundred magazines and thousands of freelance writers, all of whom were encouraged to print "accurate information" alongside "emotional patriotic appeals." Questionnaire data, gathered and compiled by the Magazine Bureau, revealed that most magazine editors welcomed assistance and considered the *Magazine War Guide* "helpful."[25]

The degree to which editors adhered to the Magazine Bureau's guidelines, or simply reported on relevant topics using their own rhetorical instincts, is difficult to assess, but there was a notable similarity in the content of wartime magazines. Gordon printed stories that paralleled her competitors, from *Good Housekeeping* to *Better Homes and Gardens, American Home,* and *House & Garden.* They all focused on common themes: the home-front effort, decorating for defense, defense houses, dwelling practices for the "duration," man-power shortages, materials rationing, tight budgets, salvaging, thriftiness, boom town living (in defense-related communities), housing for war brides and returning veterans, patriotism, and "All-American" designs. As early as 1942, many magazines, including *House Beautiful,* began to promote houses designed for "victory" and homes designed for that anticipated moment "postwar."[26]

Gordon was not one to be manipulated or controlled, but she did use the informed advice of the Magazine Bureau. She surely trusted that Ducas understood the pressures of publishing, the power of reliable information, and the value of crafting a unified national message. Gordon adhered to many of the suggestions issued through the *Magazine War Guide,* including, for example, her endorsement of war bonds. In article-length advertisements that ran between 1942 and 1945, she encouraged Americans to buy bonds primarily as an act of patriotism, "because you have surplus money (and because you want to win the war)," and secondarily for "selfish reasons." She acknowledged, in 1943, that there were "personal advantages" to buying bonds, as these were a savings investment, to be repaid with interest. But they would put Americans in a "solvent position" after the war, ready to "indulge in the most gigantic buying spree in the history of civilization" (fig. 10).[27]

The Magazine Bureau surely influenced some of *House Beautiful*'s editorials, and to a lesser degree, the magazine's image content. Gordon was firmly in control, but submitted (perhaps on the urging of her publisher and corporate bosses at Hearst) to some requests. For example, in 1943, the *Magazine War Guide* asked editors to publish specific patriotic photographs. This was part of a larger effort by the OWI to combat "public complacency" toward the war. In this same year, the OWI allowed *Life*

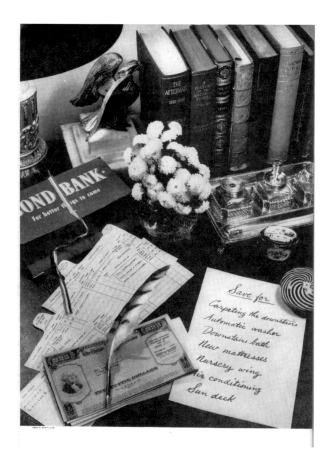

magazine to publish the first image of fallen troops: photojournalist George Strock's haunting full-page photograph, captioned as "three dead Americans on the beach at Buna."[28] Gordon's media niche did not justify such dramatic imagery, but the Magazine Bureau suggested that "all magazines . . . use flags on July covers again this year."[29] *Life* magazine ran an image of American soldiers carrying a flag-draped coffin; Gordon selected an image of a colonial-revival house with a white picket fence, accented by red and white roses (fig. 11).

Gordon had the photo's content staged specifically for the "patriotic" cover. In March 1943, she telegrammed Maynard Parker and asked him to incorporate a flag into a planned photo shoot. They had already selected Allen Siple's home in Beverly Hills as the subject of the month's feature story. The house, Gordon thought, had a flagpole. Parker likely hung the flag (from the porch rather than a pole), brought in potted flowers, and placed them on the home's front porch and in the yard. These were certainly Gordon's direct instructions, as she often demanded the installation of props and color-coordinated plantings to underscore her editorial theme (here, red, white, and blue). *House Beautiful*'s July cover indicates that Gordon complied with the bureau's request, but her private correspondence suggests that she might have bristled at interference with her calculated editing: she explained to Parker that she would "like to do it well and not too obtrusively."[30]

*House Beautiful*'s advertisers and advertisements were subject to similar controls, guided by the War Advertising Council (a self-appointed coalition of advertising professionals) and the OWI's Bureau of Campaigns Advertising Division. Their efforts were at times haphazard, but these two groups nonetheless coordinated print promotions of key wartime themes.[31] Campaign guidelines were issued monthly to advertisers and publishers in the *Guide to Wartime Advertising*. The goal, parallel to that of the Magazine Bureau, was to deliver a cohesive message to the American public. Advertising, so the Ad Council and the OWI argued, could be a "powerful tool of democracy," used to promote government activities, support

American soldiers, and encourage home-front participation.[32] Guidelines suggested that ad campaigns, whether for radios, soap, or glass, should share common imagery: soldiers, brides, and family homes were typical. Ad copy likewise shared a common rhetoric. The ads' creators adopted terms and phrases that tied consumer products to bigger ideas, both tangible and intangible, including the war effort, the home front, salvage, conservation (energy and resources), patriotism, victory, and peace. These ads often reflected the frequent conversion of American manufacturing to war production, and by 1944, promoted the difficult process of reconversion after the war.

The control of advertising—or, more specifically, the establishment of a shared advertising message—was a critical strategy for many American manufacturers and retailers. The challenge was one of economics: with wartime conversions and shortages, consumer sales were on the decline. Americans, many of whom were back at work for the first time since the Depression, had money to spend but little to buy. Businesses needed to survive the slump, and so transformed their promotional campaigns into public relations placeholders; if companies could not sell products, they could sell ideas. They hoped

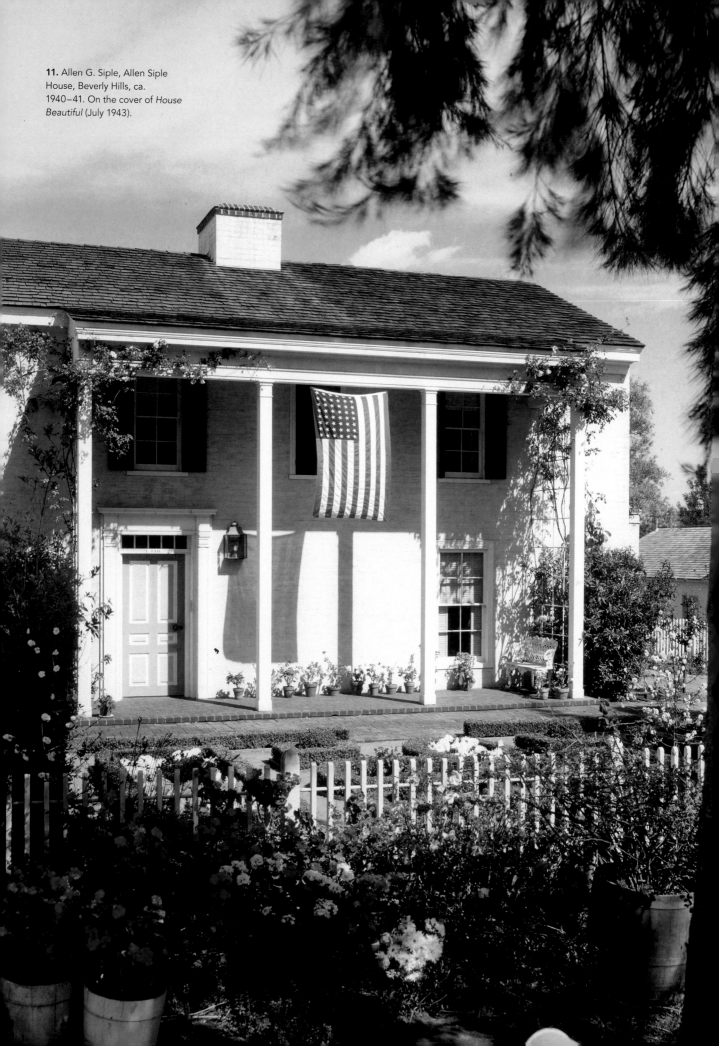

**11.** Allen G. Siple, Allen Siple House, Beverly Hills, ca. 1940–41. On the cover of *House Beautiful* (July 1943).

a cultivated image of patriotism would translate to post-war sales. Their success is difficult to gauge, but as historian Inger L. Stole recounts, it "was monitored through public opinion surveys conducted by the OWI Bureau of Intelligence."[33]

A more important measure of success for Gordon, however, was whether companies continued to advertise at all. *House Beautiful* was supported in large part by advertising revenues, and so a crisis in advertising was therefore a potential crisis for the magazine. Gordon, like her advertisers, bridged this crisis by looking forward. She focused on living well within current restraints—but, more importantly, on planning for "better things to come."[34]

## Needs and Desires

By early 1942, Gordon had formed a fledgling editorial agenda that reflected two war-born strategies. To keep *House Beautiful* relevant, useful, and practical, she would ascertain her readers' "needs," and she would also encourage planning for a "vastly improved" life. For this, she would need to edit beyond the current moment. She would move forward with aspirations in mind, and cultivate readers' future wants. Even with a war on, she was not content to simply report on the passing "taste procession"; she wanted to lead it.[35]

In February 1942, Gordon made the first of many proclamations: "In keeping with the times," she declared, "*House Beautiful* has been re-dedicated to the business of living!"[36] She assured her readers that the magazine would provide reliable information about domestic products and design, so that the readers could build the "best way of life." Her emphasis was "house beautiful *but* practical," a pun that incorporated the magazine's name with the idea that functional and beautiful home design could be achieved through "*practical* means, not glamorous theory."[37] In a statement that recalled *House Beautiful*'s nineteenth-century beginnings, Gordon emphasized a key concept: simplicity.

In what served as the readers' introduction to their new editor and her visual methods, Gordon outlined her "re-dedication" strategy in concise, easy-to-read bullet points. She promised to report "cost," to provide "actual photographic solutions to trying common problems," to advise on both housekeeping and decorating (with a cross-reference to her new Housekeeping Recipes

Department), and to describe products in terms of "performance" and "value" rather than "style." The final two points must have resonated with the American public, just recovering from the Depression and living in what Gordon would continue to describe as "the emergency." Cognizant of economic realities, she promised to dispense with the "pretense that people re-decorate all at once," and to help her readers "live well on what they make."[38]

Gordon's emphasis on domesticity—on homes and homemaking—paralleled yet did not replicate that of her competitors. Other popular publications, including women's magazines such as *Good Housekeeping, Ladies' Home Journal,* and *McCall's,* and shelter magazines such as *Better Homes and Gardens* or *House & Garden,* provided useful bits of advice for the American woman in her traditional role as wife and mother. Gordon, however, expanded the typically gendered topics of housekeeping, product shopping, home decorating, cooking, and entertaining to encompass the broad concept of "good living." This was an elusive yet alluring term, and it would take Gordon decades to construct its full meaning. In the early 1940s, she used it to describe the real and aspirant qualities of the American family home and domestic life: tasteful, practical, affordable, value-packed, and worry-free.

As she began to design her own editorial programs, most of them were aimed at these ends. She tested a range of approaches, content, and visual schemes, so that her early program formats varied. With this, the magazine's appearance varied. Of absolute importance, though, was *House Beautiful*'s chain of command, with Gordon controlling everything. Though she reported to her publisher, magazine decisions were not made by committee or in large staff meetings (although she did eventually come to trust the judgment of certain staff members and consultants). She firmly believed that whatever *she* liked would "please" her readers, too.[39]

Among Gordon's early editorial experiments, three programs showed immediate success and had long-term implications: the "People Who Influence Your Life" series; the "Desires Research" surveys; and the "Better Your Home, Better Your Living" campaign.

In February 1942, Gordon coordinated a recurring series titled, informally, "Meet a Decorator." She used most of these features, including the inaugural story on decorator Gilbert Mason, to establish strategies by which readers might improve their home decoration. Among the most important strategies were educating the eye

(by reading *House Beautiful*) and hiring a decorator. Gordon used the "Decorator" series to report on contemporary design trends, from "modern" to historicist (or, as she termed it, "period" revival). Though she showcased a range, she quickly began to cultivate a preferred aesthetic, one that she variably called modern, American, or Twentieth-Century Style. *House Beautiful* readers learned about the "free and informal way" in which Americans could develop their own style not only from Gordon and her staff, but from trusted expert designers such as Mason, who "doesn't believe in Period," and Tom Douglas, who "doesn't believe in [decorating] rules."[40]

Gordon formalized the "Decorator" series in March 1945, under the new title "People Who Influence Your Life." The spread was typically two pages, with a one-page personal profile facing a full-page, black-and-white portrait shot by the masterful Canadian photographer Yousuf Karsh. The layout was deliberate and engaging, intended to make the reader believe that she had just

"added important new friends to [her] life."[41] Edward Wormley was the first designer featured, lauded for his ability to move "with greater assurance among both modern and period traditions than any other living furniture designer" (fig. 12).[42] Over the next year, Gordon introduced Dorothy Liebes (April 1945), Russel Wright (May 1945), William Wurster (June 1945), Harwell Hamilton Harris (July 1945), Henry Dreyfuss (August 1945), Edward Durell Stone (September 1945), Gardner Dailey (October 1945), Samuel Marx (November 1945), William Pahlmann (January 1946), Samuel and Victorine Homsey (February 1946), and T. H. Robsjohn-Gibbings (April 1946). In June 1946, Gordon published the final profile, featuring Frank Lloyd Wright as "the greatest architect who ever lived."[43] Though Gordon rarely published Wright's houses in the 1940s, this early endorsement was a harbinger of things to come.

Gordon launched and edited the "People" series with evident purpose: with the war nearing its close, she

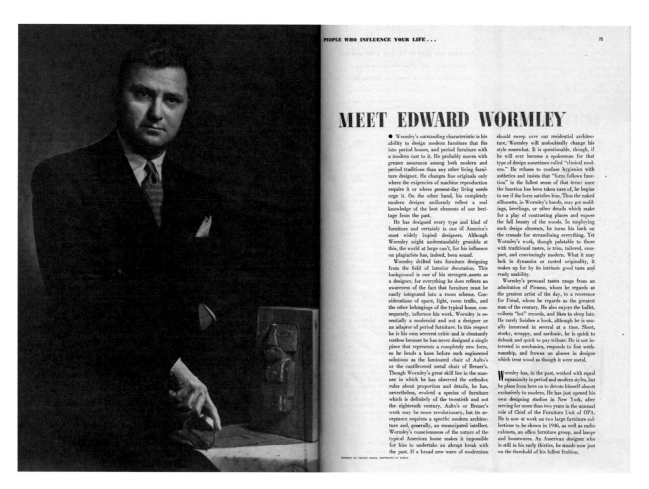

**12.** "People Who Influence Your Life" series, featuring Edward Wormley, *House Beautiful* (March 1945).

wanted *House Beautiful* readers to "meet" architects and designers who were, in her estimation, designing for the future. Her selections were carefully curated, revealing her personal preferences and her evolving definition of modern and good design. She favored designers whose work was a decidedly "soft" version of modern that paralleled other "clinical" interpretations.[44] This distinction would become all-important by 1950.

Her selections also revealed a developing agenda: Gordon was eager to discover and promote "essentially indigenous" American design.[45] She had published a variety of designs under the label "American" since early 1942, but as the "People" series demonstrated, she was increasingly inclined to stage a rift between design that she determined was "homegrown" or "domestic" and design that she deemed "imported" or "foreign." Her definitions of who or what was American remained fluid, as when she endorsed British-born T. H. Robsjohn-Gibbings and his interpretation of Greco-Roman forms.[46] In some instances, as with Robsjohn-Gibbings, Gordon ignored non-American birthplaces and design precedents; in other cases, as with Mies van der Rohe, she was highly critical of the émigré designer's effort to "Americanize" his work. Despite a sometimes-contradictory stance, Gordon's desire to sort and promote design according to nationality was significant. Her position, somewhat innocuous in 1945, would become considerably more contentious by 1950.

While the "People" series privileged the viewpoint of the modern designer, *House Beautiful*'s "Reader Questionnaire" series and "Desires Research" contests targeted that of the reader (fig. 13).[47] By early 1944, Gordon had identified what she believed was a significant gap in design knowledge: no one really knew how Americans wanted to live, or what style of home they preferred. She argued that the Second World War "may have sharply accelerated our constantly shifting national tastes and desires.... It is impossible to say with authority, at this time."[48] She wanted *House Beautiful* to become the authority. In this, she was positioned among the many professionals whose visions for the future were formed during a long process of wartime exploration, planning, and data collection.

Gordon's "Reader Questionnaires" and "Desires Research" surveys were not the first to query the public's needs, expectations, desires, or tastes. Her magazine-based programs were situated among housing research or consumer studies conducted under the auspices of government agencies, independent institutes, professional journals, and popular magazines. The broad and ostensibly egalitarian effort to survey consumer interests began in the 1920s and early 1930s, emerging out of fact-gathering projects through which government leaders, social scientists, historians, journalists, and the public at large sought to understand American people, life, and culture. Among these, Robert and Helen Lynd's 1929 and 1937 "Middletown" studies and George Gallup's and Elmo Roper's opinion polls (launched in 1935) were the best known and most influential. As historian Sarah E. Igo has argued, none of these surveys truly captured a "representative" portrait of the American public with its socioeconomic, cultural, racial, and geographic diversity, but each tried to "sketch the collective whole of society, to profile the mainstream."[49]

The effort to understand "average" Americans and their life experiences was at the heart of domestic desires research, including Gordon's. Specialized studies (beyond what Christine McGaffey Frederick had provided in 1929) began to appear as early as 1936, with the bulk of the findings published between 1949 and 1952—after *House Beautiful*'s own projects were in full swing. Government agencies and research institutions led the charge. The Building Research Advisory Board, the National Housing Agency, the Federal Housing Administration (FHA), the Survey Research Center, the Institute for Social Research at the University of Michigan, the Small Homes Council at the University of Illinois, the National Research Council, the National Academy of Sciences, John D. Rockefeller Jr.'s Institute of Social and Religious Research, and the John B. Pierce Foundation were among the most noted contributors. Builders and real estate developers—those who benefitted financially from the acquired information—were not to be left out of the research frenzy. Fritz B. Burns and Levitt and Sons both had in-house research and development departments, which collected data to guide their design and development choices.

Magazines and journals also designed reader questionnaires and published the results. Professional magazines, including *Architectural Record, Architectural Forum,* and *Merchant House Builder,* surveyed thousands of families between 1936 and 1950. Within the popular press, *House Beautiful* was one of the first to begin questionnaire research, with two significant efforts in 1944.

Within the image:

HOUSE BEAUTIFUL *Announces* a Series of Research Contests to Determine HOW AMERICA *wants* TO LIVE

What Do You Want in a Dining Room . . . . and WHY?

You Compete in a Contest to Win the Furnishings of a Room. House Beautiful Learns What You Want from the Competition Letters and Questionnaires

Nothing matters more to America's post-war future than our economic good health. If American industry is able to convert from making war-time goods to peace-time goods, quickly and sure-footedly, we will all enjoy an improving standard of living for years to come.

Biggest stumbling block and blind spot is that Industry in general does not *really* know what the Public wants. The time honored system has been to manufacture what the Public *theoretically* wants, offer it for sale, and wait to see how it succeeds, measured in terms of sales volume. This process, though sure, is slow and wasteful, and it causes money to be lost through bad judgment. For in most cases there has been nothing but opinion to guide designers and manufacturers until those delayed sales figures were secured. Right now,

too, the war may have sharply accelerated our constantly shifting national tastes and desires. The cessation of so much civilian manufacture has removed even the usual references that Industry is accustomed to plan by. It is impossible to say with authority, at this time, how America wants to live.

HOUSE BEAUTIFUL, therefore, starts in this issue a program of reader research to try to take the measurements of public desire. To make it worth your while to tell us what we want to know, we have built this program as a series of contests. You will have the fun of competing for the basic furnishings of a room. We will have the great privilege of actually *knowing* what you want and what you deem important. The statistical findings, tabulated from all the series, will be made available to Industry and to our readers.

BY ELIZABETH GORDON, EDITOR

Maybe you *don't* want a dining room. If you don't, that is just as valuable to know as the fact that you do want one. IF you *do* want such a room, how do you want it equipped, how do you want it to serve you, and how would you like it to look? If you *don't* want a dining room, we want to know just as ardently where instead you want to eat your meals. For how you want to live, during the next five or ten years, holds the key to America's economic well-being.

On the next four pages we show you a dining room embodying many principles which have been controversially discussed during the last ten years. At no point do we tell you what we think of this room, or imply what you *ought* to think of it. (For neither of these points matters.) We merely explain how it performs, leaving to you the right to decide whether you would like to embody those same principles in your own home.

In short, we invite you to evaluate the performance of this dining room in terms of the way of life you intend to follow after the war. Your critical and considered judgment is what we want, regardless of whether it is negative or positive.

The writer of the letter that best analyzes and rationalizes this room will win the furniture, rug, and fabrics shown in the following four pages:

HOUSE BEAUTIFUL, JUNE, 1945

**13.** "Desires Research," *House Beautiful* (June 1945).

The first resulted in Gordon's article "What People Say They Want"; the second polled American soldiers abroad through *Stars and Stripes* to ask "what the GI wants in his postwar house."[50] *McCall's* followed shortly thereafter when it queried 18,580 families in 1945 to produce the report *American Woman's Home of Tomorrow* and several other surveys that illustrated specifically "what women want." At least three studies followed in 1946: *Better Homes and Gardens* surveyed 4,900 families in 1946 and published *Behind the Blueprints; Collier's* surveyed 1,837 readers and recorded the findings in *Collier's Families Report Their Housing Plans for Tomorrow* (which was followed by a second survey in 1949); and *Woman's Home Companion* surveyed 1,935 families in the same year, with much the same results.

Magazines—including *House Beautiful*—were an important source of information for both consumers and retailers. Their fluid publishing schedules allowed them to run survey results quickly, whereas government agencies and research institutes often delivered their findings years later and in summary form (and ostensibly for the benefit of builders). Two such publications were key: *A Survey of Housing Research in the United States* (1952) and Edward T. Paxton's *What People Want When They Buy a House: A Guide for Architects and Builders* (1955).[51]

Though consumer desires research was becoming an established practice, Gordon's strategy was more engaging than most, as she collected her data through a series of contests. For example, in her 1944 questionnaire for American soldiers, she sought their "best" answers and offered prize money for the top five responses. She published all of the winners in the magazine (with their names included), alongside her own assessment, in which she acknowledged that "*House Beautiful* cannot present

a statistical cross-section of GI opinion," but the hundreds of response letters indicated that soldiers returning home from the war would expect "change, progress, and a breaking of the shackles of sentimentality in design."[52]

By 1945, she had come to value her readers' "critical and considered judgment," whether "negative or positive."[53] Surveying their opinions, she wrote, allowed her to "take the measurements of public desire." She continued to solicit reader opinions in the form of letters and questionnaires, but in June of that year, she launched a high-stakes competition under the title "Desires Research Contest." In order to make reader participation "worth your while," the magazine registered each respondent to win the contents of a specific room that was pictured in the magazine alongside the questionnaire. Professional decorators were not eligible to participate.[54]

The mechanism of exchange—data for the possibility of a prize—provided strong psychological motivation for people to participate. The significance of the program, though, was in Gordon's judging rubric. The contest winner in February 1946, for example, was selected on "the basis of how intelligently you evaluate and rationalize the livability and performance of the room" pictured in the magazine.[55] Gordon was not just looking for "like/dislike" answers to basic questionnaires—though she got these, too—but for the reader's critical opinion.

Gordon's approach demonstrated a growing faith in her readership. She believed that her audience was both knowledgeable and intelligent, and that they could, with some editorial assistance, articulate their preferences. Her method shifted power to the consumer as an informed participant in the process of design development. It also allowed her to gather information directly from her readers, to be used for her benefit and theirs. While other magazines released their data to architects and builders, Gordon used her survey results to inform her own projects. The "Desires Research" program, though short in duration, provided a substantial foundation from which Gordon could launch *House Beautiful*–sponsored design initiatives.

## Better Homes and Better Living

In January 1942—the first magazine issue in which Gordon was identified as editor-in-chief—she published "Resolutions for Better Living in 1942."[56] This ran as part of a minor column, but its content was part of Gordon's

major concern: better living. She demonstrated, even during her first six months as editor, that she understood the challenges of living well, especially during wartime. She made it *House Beautiful*'s job to identify such problems. The solutions, she argued, would improve daily life and domestic design, resulting in what she called "better homes." Her choice of the word "better" was operative. It indicated both an awareness and critique of current living conditions, and the possibility—again, with an editor's coaching—of improving upon these unsatisfactory domestic conditions.

Gordon did not coin the phrase "better homes" or its parallel, "better living." She was likely inspired by the "Better Homes in America" campaign, an initiative launched to "modernize" housing and housework across the United States. In 1922, the organization constructed the National Better Home on the Mall in Washington, D.C., a model house intended, as historian Janet Hutchinson has argued, "to educate the American viewers" on matters related to home design, construction, decoration, furnishings, technology (in the form of new domestic goods), housework, and maintenance.[57] The Better Homes group went on to sponsor annual model home competitions in communities nationwide, and in 1934 opened America's Little House at Park Avenue and Thirty-Ninth Street in Manhattan. This second model, much like its predecessor, targeted "the needs of the average home owner with a moderate income." Gordon would have certainly been aware of the "Better Homes" campaign, and would have read about (if she did not visit) the model in New York in any number of news sources, from *Architectural Forum* to *Parents* magazine to the *New York Times*.[58]

The "Better Homes" campaign was directly tied to notions of household reform (through the verb "bettering") and to a national concern for improving American ways of living. This "better living" rhetoric came into vogue in 1935, just as America's Little House opened to the public. As architectural historian Andrew Shanken has established, DuPont pioneered the slogan "better living" as part of a 1935 advertising and public relations campaign.[59] The DuPont campaign, sometimes in its longer form of "better living through chemistry," ran in the *Saturday Evening Post* (among other media venues) and accompanied the company's exhibitions in 1937 at the New York Museum of Science and Industry and in 1939 at the New York World's Fair. After 1939, scores of other companies (including Kelvinator, General Electric,

# If YOU BETTER YOUR HOME
## YOU'LL BETTER YOUR LIVING

by
*Elizabeth Gordon*

It took a war to reveal to 20 or 30 million of our adult population that Home and Family are the most important things on earth.

This sharply reverses a prewar tendency to get away from home—anywhere away. At various social and income levels, the getting away took different forms—from pool halls and drug stores to country clubs and night clubs. Home was commonly referred to as "a place to sleep and keep one's clothes."

But now life's values have been brought into sharper, truer focus. The millions of people in the military services and their relatives whose lives have been changed by their absence, and the other millions who disrupted their lives to go to war jobs—all these people now know the real truth. They know a home is more than a place to keep your clothes and take a bath.

They know that making a home is man's way of establishing his dignity among his fellow men. They know that the better the home, the better the life. A home gives meaning to our lives, even more than a fine job or riches. For the job or the riches are not ends in themselves, but means to something else. A good home offers more rewards in satisfaction, personal fulfillment and family happiness than any other of life's goals. John Ruskin put it very well: "Home is the place of peace; a shelter from all terror, doubt, and division." It is the only place we can be truly ourselves.

On the following 31 pages are specific suggestions of ways to better your home during 1946. They range from the food you will eat and the furniture you will buy to the civic action you must take. Heed them and you will have a better home—and a better life.

**14.** Introduction to the "Better Your Home, Better Your Living" program, *House Beautiful* (January 1946).

Westinghouse, and Revere Copper and Brass) adopted the phrase to stand for, as Shanken describes, both the "home-front anticipation of postwar plenty" and the consumer boom that followed.[60]

By the early 1940s, "better living" became a common catchphrase, closely associated with domestic improvements and rising standards of living, often achieved through new products and new technologies. It was within this context that Gordon first appropriated the term. She used it often throughout the magazine, and in September 1944, serialized the concept with a regular guest feature written by Dorothy Ducas, titled "Better Tomorrows."[61]

In 1946, in line with advertising and publishing rhetoric that had become popular, Gordon formalized the discourse on better living in which she had long been engaged. In January of that year, she introduced the "Better Your Home, Better Your Living" program (fig. 14).[62] This series promoted houses, landscape, furniture, appliances, food, at-home hobbies, and civic actions—all the stuff of domesticity. If designs, products, or activities were deemed "good" by the *House Beautiful* staff, these

were stamped with the official "Better Your Home, Better Your Living" seal of approval. The "Better Your Home" seal, a silhouetted house-and-tree encircled by the slogan, was akin to the *Good Housekeeping* Seal of Approval established in 1909, though without the *Good Housekeeping* guarantee of "replacement or refund if defective."[63] *Good Housekeeping* certainly set the precedent; it is no coincidence that Gordon had written for the publication in the early 1930s, and was at least tangentially involved with "testing" consumer products and issuing magazine-sanctioned approval. The link between the two seals had one further dimension: the Hearst Corporation owned both magazines.

In the context of Gordon's expanding editorial agenda, the importance of the "Better Your Home" series was threefold. First, she launched the program in 1946 as both a criticism and a provocation. She had assessed the range of available architecture and domestic goods, and found both lacking. The program was a venue in which she could provide critique, with the hope that her readers would themselves become discerning enough to seek the best of what could be bought. Gordon firmly believed that if she could teach readers what was good, then they would *buy* what was good. This would translate to better homes and better lives. Second, the "Better Your Home" seal, when printed adjacent to products featured in editorial essays or in advertisements, became *House Beautiful*'s shorthand for good quality and good taste. Any design or product that bore the stamp was understood to have passed the judgment of the discerning editor, and thus was worthy of the reader's attention. Gordon was clear about her criteria for stamping a product: function, utility, and beauty were of the utmost importance. Lastly, the "Better Your Home" program, with its recognizable seal, marked the beginning of a long series of branding initiatives. With this, Gordon began to build a set of slogans and a distinct graphic identity that would remain the legacy of her editorship.

In her first few years as editor at *House Beautiful,* Gordon established a pattern that would endure throughout her career: she paid close attention to the changing world around her, by choice and by necessity, and she edited the magazine's content accordingly. Her programs were, in this sense, reactive; but she responded in a way that provided her readers with trustworthy guidance and a definitive path forward to good taste and better living.

# Chapter 3

# The Postwar House

In January 1943, Elizabeth Gordon published *"House Beautiful's* Creed for Americans in 1943." In this half-page advertisement, printed on a white background dotted with red stars, she declared a set of "beliefs" that would guide the magazine through the remainder of the Second World War (fig. 15). She made eight proclamations; four specifically referenced the American family home. She reminded her readers that "good homes are essential to a good life," but that in wartime, the stakes were much higher. Responsible home management (for example, through energy conservation) was essential to victory. With this, Gordon linked home to nation: "We believe in our homes as the first bulwark of democracy, and we accept the responsibility vested in us to keep them the source of our power and glory."[1] Gordon's "creed," published with patriotic rhetoric and imagery, underscored the growing importance of the home as both a national symbol and a personal place of shelter. At this moment, however, that place was under pressure.

## The Housing Crisis

During the early 1940s, *House Beautiful* printed articles (however nuanced) that revealed a national housing crisis. The employment crunch and economic decline of the Depression years had deeply affected Americans' ability to house themselves, though the magazine's target middle-income readership may have fared better than their working- and lower-class counterparts. In the best

of bad circumstances, homeowners deferred improvement projects and halted new housing starts.[2] In worse situations, less fortunate Americans lost their homes to foreclosure or were evicted from rental units (homelessness often followed joblessness). Hundreds of thousands of people found shelter as squatters in vacant buildings, crowded houses, substandard shacks, shantytowns, and Hoovervilles. Even before the Second World War began, the need for adequate housing was desperate; the demand for good housing was even greater.

Housing needs changed after 1939, as the war in Europe loomed and President Franklin D. Roosevelt declared the United States a partner in its allies' defense. The American economy surged as Roosevelt recast the nation as a "great arsenal of democracy" ready to assist with a steady flow of food, equipment, materials, and weaponry.[3] With a boost from the Lend-Lease Act of March 1941, defense- and war-related industries boomed, and support communities emerged across the nation. These communities—what *House Beautiful* and the popular press called boomtowns—were equipped to build bombs and aircraft, but unprepared to shelter the millions of workers who flooded in to take up new jobs and new lives. After Pearl Harbor, the need to house new defense workers accelerated almost as quickly as the fighting.

The war had triggered one of the largest building campaigns in American history: an estimated 1.9 million units of defense housing were constructed between the signing of the Lanham Act in October 1940 (which provided $150

**15.** *"House Beautiful*'s Creed for Americans in 1943," *House Beautiful* (January 1943).

million in federal funding) and the pivot point of the war in 1943.[4] There were, however, significant limits on these defense homes. With material restrictions and mortgage controls in place, most single-family units averaged under one thousand square feet and sold for under $6,000 (or rented for under $50 per month).[5]

During the war and shortly afterward, the speed at which American builders produced these new houses—predominantly small, single-family, detached, and suburban—was unprecedented. The defense housing boom, supported by the emergence of federal financing structures

and a nationwide mortgage lending system, spread a culture of technological advancement and modernization farther and faster than previously imaginable. A new class of "merchant builders," including Levitt and Sons, Henry J. Kaiser, David D. Bohannon, Fred Trump, and Fritz B. Burns, led the charge. As a rule, they operated on a larger scale and with greater efficiency than publicly funded programs (though notably, many of these builders worked initially under federal sponsorship). They were pioneers and entrepreneurs motivated to quickly build the millions of homes that Americans needed, and they were enormously

successful. For example, Kaiser's "assembly-line" method (developed in partnership with Bohannon for wartime shipyard workers in Richmond, California) reportedly produced seven hundred houses in 693 hours.[6]

Architects, like builders, scrambled to find their place in a new world of instant housing. For professionals who had largely been engaged in the time- and cost-intensive practice of custom design, the transition was not easy. But the Depression had curtailed most of their professional opportunities, and wartime building offered, for some, the only available prospect. The designers who tried their hand at defense housing varied widely, from respected and established modernists such as Frank Lloyd Wright, Walter Gropius, and Richard Neutra to emerging figures such as Louis Kahn, Buckminster Fuller, and the firm Skidmore, Owings and Merrill.[7] Many of them viewed war housing and its successor, victory building, as a testing ground. This was the arena in which designers and builders could work out what the *Saturday Evening Post* called, in 1943, a "postwar blueprint."[8]

As the fortunes of war turned in favor of an Allied victory, Americans anticipated relief from war-related rationing, the "conversion" (if not the abrupt halt) of their wartime work, and the return of millions of servicemen. But most significantly, Americans—and the popular press—expected a radical shift in national dwelling habits. *House Beautiful* primed its readers for this transition, readying them for "when Johnny comes marching home."[9]

Two years before the Second World War ended, it seemed that everyone was talking about the "postwar house." (Gordon had started the conversation a full year earlier in *House Beautiful*.[10]) Articles and advertisements ran in local papers, popular magazines, trade gazettes, and architectural journals. Americans could get information and inspiration nearly everywhere: general interest monthlies that ran housing features, such as *Life, Time,* and *Fortune;* weeklies attached to local newspapers, such as the *New York Times Magazine* or the *Los Angeles Times Home Magazine;* women's magazines that had "home" and "decoration" departments, such as *Ladies' Home Journal, McCall's,* and *Woman's Home Companion;* and dedicated home or shelter magazines, such as *American Home, Better Homes and Gardens, House & Garden,* and *House Beautiful.*

Editors and reporters who wrote about the postwar house, including Gordon, her colleagues, counterparts, and competition, asked three fundamental questions: What would the postwar house look like? How much would it cost? And, most importantly, what did the customer want?[11]

By asking and answering such fundamental questions, these "editor-experts" (as *Architectural Forum* described them) became national authorities on postwar residential design, consumer desires, and American domestic lifestyles. Most of them, like Gordon, developed a wide range of methods to answer their queries, and to "convert" the wartime "need" for basic shelter into a postwar "demand" for better houses.[12] They researched and reported on consumer needs and desires, surveyed public opinion, sponsored design competitions, and sold stock plans. They used hard data (quantitative information gained from, for example, sales numbers, questionnaire results, building statistics, or government-generated housing facts) and published tables and graphs; they used soft data (qualitative information garnered through, for example, opinion polls, interviews, critical interpretations, or "gut feelings") and ran feature stories crowded with anecdotes, testimonials, and personal snapshots.

Most editors, including Gordon, focused on "average" American householders who would benefit from the predicted postwar prosperity, including current homeowners looking to remodel or trade up as well as potential home buyers looking for a new start. Though the needs of these two groups varied and each magazine served a specific market, most editors, including Gordon, wrote for a broad demographic: generally, householders ranged from members of the aspiring working class to the upper-middle class; most were white; and many were (at the beginning of the postwar period) young marrieds with growing families. Editors wrote for "average" Americans who, as these popular magazines suggested, sought their own suburban house with a two-car garage, a carefully landscaped (and fenced) yard, and the leisure to enjoy a more relaxed life in the postwar period.

The concept of an average American was, of course, deeply flawed. Editors, however, were eager to report within the framework of what historians have now confirmed as broad yet socioeconomically limited postwar trends: young wives making their first homes (marriage age had lowered across all racial and socioeconomic groups); war brides anticipating the return of their husbands (who would qualify them for a veteran's home loan); expanding families in need of more space (couples

not only married younger but divorced less frequently and had more children); and families searching out new homes in the suburbs (the term "white flight" was not used until 1967).[13]

These editors, perceptive as they were, painted what *House Beautiful* described, in 1942, as a "relatively rosy picture" of wartime and early postwar America.[14] They ignored the complex realities and dirty undercurrents of American culture. For example, though women were targeted as postwar consumers, many wives could not obtain credit in their own names; the Federal Housing Administration (FHA) granted home loans, but in many cases denied funding for "modern" houses it deemed as unreliable investments; mortgage discrimination made it difficult if not impossible for minorities to obtain loans; and restrictive covenants often blocked ownership for specific cultural or racial groups in certain neighborhoods (this was particularly true for African Americans).

Though magazine editors reported changing social and cultural norms, their perspectives were just that: edited. In a world starved for good news, they explored safe topics that included what historian Elaine Tyler May has characterized as "secure jobs, secure homes, and secure marriages in a secure country." Editors were surely not blind to the postwar practices of gender and racial discrimination, suburban segregation, or class divisions, but as a group, they perpetuated the idea of a sanitized America.[15]

In this "clean" version, Gordon and her fellow editors (especially her closest competitor, Albert Kornfeld at *House & Garden*) encouraged their readers to dream. Yet they were, for the most part, pragmatic. They were ultimately constrained by the economics of their own medium, kept in check by what *Architectural Forum* called the "persistent warning signal of the newsstand till." Regardless, these editor-experts became significant mediators in the American housing crisis. They were the "leavening influence" between homeowners, potential buyers, architects, and builders.[16]

## Planning for Postwar

From 1943 forward, Gordon helped readers sort through the difficult issue at hand: "Your Home and the War and the Future." She recognized that "for the duration, we seem to have declared a moratorium on better living," but there were indications of "progress."[17] The progress was bounded, temporarily, by labor shortages, materials shortages, and government limits on household spending (about $500 per year on any project). This had been the case since 1942, when the War Production Board and Civilian Production Administration imposed building restrictions through a series of "limitation orders," some of which remained in place through 1947. Despite these barriers, Gordon assured her readers that redecoration and repairs were still a necessity, and that even the "government wants you to keep your house in order."[18] This statement was, in part, a justification for *House Beautiful*'s continued existence: Gordon was poised to help Americans—and their houses—survive the "duration," even if spending money to improve "our standard of living just now is unpatriotic, uneconomic, and harmful to the war effort."[19] She made this statement in the context of a *House Beautiful* advertisement for war bonds (a monthly occurrence in the war years), but her emphasis on "saving" and "planning" for the postwar future was decisive.

Gordon continued to publish articles to help her readers maintain, or finally achieve, what she called "the American Standard of Living," but she soon shifted her editorials toward postwar preparation.[20] By mid-1943, she had recast *House Beautiful* as a reliable planning guide, where her readers learned how "practical" dreams could be dreamt and realities could be built. In August 1943, Gordon launched an ambitious editorial program designed specifically to these ends: the "Home Planner's Study Course" (fig. 16). In the first installment, she encouraged her readers to "save and plan" for new homes they could build (or buy or renovate) after the war. She knew the American public needed something good to anticipate, and believed that "the vision" for a better future would "sustain [them] through hard work, anxiety, and reduced living standards."[21] Whether they could afford to build anew, remodel, or simply redecorate, she was adamant—much as she had been in her 1937 book— that they should get "more house for [their] money." The only way to do this was to become, just as she had, a "student of housing." She established *House Beautiful*'s Home Study Department to provide the necessary course of instruction.[22]

Gordon's intention was to publish material that was inspirational, aspirational, and educational. But, as she boldly announced, she fully intended to offer criticism, however "shocking" and unpopular her opinions might have been. It was, she declared, "time for straight thinking

and plain speaking—and resolutions." She outlined a central problem, one that she believed would deteriorate after the war: in the past, new houses were built only a "little better" than old homes. Progress was slow. Even in the 1940s, new houses failed to "provide the fullest measure of better living possible in our times."[23] She laid the blame squarely on homeowners. Counting herself among the guilty, she conceded, "We have been content with adequacy when we should have been demanding perfection." She argued that consumer wants and tastes remained "crude and primitive," and far behind the "technological capabilities" of the mid-twentieth century. Homeowners, it seemed, were guilty of "sentimentality and resigned acceptance" and lacked "critical awareness."[24]

True to her promise, Gordon wrote frankly and offered resolutions. She hoped to activate future homeowners as the "front line," warning them that "if we don't demand a better house the professions and the trades serving us are not likely to give it to us."[25] This set up an opposition: on the one side, designers and the building industry; on the other side, consumers. Gordon positioned herself, and House Beautiful, somewhere in between. The magazine simultaneously represented its own interests, those of its advertisers (on whose revenue she depended), those of the consumer or home-owning public, and those of the professions, trades, and industries that provided both content and financial sponsorship (often through advertising) for the publication. This could have been a precarious position, but she made it her business—what she declared the "business of better living"—to unite these opposing forces.

In her introduction to the "Home Planner's Study Course," Gordon pledged to publish the "best material . . . on the subject of acquiring a new house," "technical and product developments," the "thinking of the foremost designers, architects, and industry leaders," and the "top houses." She believed that it was through this shared information—through "knowing the best"—that American homes and American lives would get "better." This knowledge, which would accumulate over two decades, was to become the foundation for the critical awareness that Gordon had thus far found lacking in the average American consumer. She promised to remedy this through the magazine: "We [House Beautiful] will try to help you translate your budget, your vision, your personal likes and dislikes, your hope of a better life into tangible, personal form. For we know that owning a perfect home ranks among life's riches."[26]

With her goals laid out, Gordon and her staff presented the first "Home Planner's Study Course" within a distinctive graphic package (fig. 17). The magazine's art editor, Russell Rypsam, modeled the layout on a tabbed school notebook or a stack of file folders and placed story content within each folder as a concise segment. Each carefully constructed feature carried a didactic message, complemented by graphic illustrations and snapshots. The inaugural installment was fourteen pages long and contained three lessons on what Gordon called "livability," a loose term for design features and characteristics that contributed to comfortable, practical, and beautiful homes. She instructed the reader to study interior floor plans, demonstrations of proper site orientation (to take advantage of "windbreaks" and "sunpockets"), and House Beautiful's predictions about the future of the American home.

HOUSE BEAUTIFUL'S
HOME PLANNER'S
STUDY COURSE

One sure by-product of fighting a war is a universal increase in our love of our homes. This is particularly so in this war. We'll leave to the psychologists the job of explaining why this is so and get on with the problem of helping you, who are pining for a new home, to get more house for your money. Saving and planning for your new home is a fitting and proper wartime pursuit, the vision of which can sustain you through hard work, anxiety, and reduced living standards. Here's to your future home! And good dreaming!

**16.** Debut of the "Home Planner's Study Course," *House Beautiful* (August 1943).

*Overleaf*
**17.** "Home Planner's Study Course," *House Beautiful* (August 1943).

PAPER WEIGHT COURTESY OF C. W. LYON

# There is NO SU

# and study in

**Whether you acquire your house ready-built or custom
built, you aren't likely to get your full money's worth
unless you make yourself a student of housing. Tha
is why we present this new home study departmen**

### By The Editor

Ever since I became a passionate devotee and observer of
housing and its twin, good living, a shocking realization has
been growing in me. I never dared put it into words before
I wouldn't now, were it not for the fact that the present "building
freeze" has caused a break with the customs and standards of
the past. For when we begin to build again we'll have a real
new chance.

This shocking opinion of mine won't be popular. But now, if
ever, is the time for straight thinking and plain speaking—and
resolutions.

I contend that *most of the new houses that have been built
in the past have not been enough better than old houses.* They
have been a *little* better. But apart from fine kitchens, baths,
and heating plants (and insulation, of course) they have had
little else to recommend them but newness and cleanness. Other
aspects of new houses have not been as thoughtfully improved.
Life in our most recent new houses has not provided the fullest
measure of better living possible in our times.

Home Study Course

# TITUTE for time

# ome ownership

We have been content with adequacy when we should have
n demanding perfection. While our technological capacities
e been growing by leaps and bounds, our wants and sensi-
ities have remained relatively crude and primitive. Sentimen-
ty and resigned acceptance mark the most characteristic
tude we have shown toward houses—rather than critical
areness. As a result we have failed to utilize technical ad-
ces waiting for our pleasure.

This lag in home building progress is primarily the fault of
home owner. If *we* don't demand a better house the profes-
ns and trades serving us are not likely to give it to us. They,
, are frequently handicapped by not having experienced life
a perfect house. Too frequently their horizons are as limited
the home owners'. The blind cannot lead the blind.

So we believe it is none too early to start publishing all the
st material we can find on the subject of acquiring a new house.
will keep you informed on all the technical and product
elopments—and they will be legion. We will bring before
the thinking of the foremost designers, architects, and indus-
leaders. Best of all, we will show you the top houses, repre-
ting the best in planning, designing, and materials, that have
n built in the last few years. For it is only by knowing the
st that we can do better. Last, but not least, we will try to help
u translate your budget, your vision, your personal likes and
likes, your hope of a better life into tangible, personal form.
r we know that owning a perfect home ranks among life's
hes, along with marriage and parenthood.

PHOTOMONTAGE BY PAUL D'OME

Gordon summarized the main points of the first study course on the final two-page spread, where salient points were transferred into a tangible take-away with illustrated "details worth remembering for your own house."[27]

This layout, and Gordon's critical and forward-looking content, remained in place throughout the war years. She used the "Home Planner's Study Course" as promised: it became a framework for reader education. In this format, Gordon introduced new ideas and new technologies that reinforced her view of what people *should* want in a good postwar house, and how they could get it. Her "courses" were, in most respects, sensible if not yet buildable. During the war years, she and her staff offered key lessons in evolving solar technology (for which she used her own "solar" home as an example), neighborhood zoning restrictions, garage design, engineered storage, land use and site planning, and building codes. Gordon revealed a preference for custom-built homes, but featured, on occasion, advice on ready-builts and prefabricated homes. Though she was hesitant to endorse prefabrication—primarily on the basis of untested quality and limitations on individual "character"—she would have been remiss if she did not engage this hot topic, which in the mid-1940s was discussed with interest everywhere from *Architectural Forum* to *Architectural Record,* the *Saturday Evening Post, Life, Business Week, Popular Science, Popular Mechanics, Ladies' Home Journal, House & Garden,* and the *New York Times.*[28]

The "Home Planner's Study Course" also provided guidance on "money matters." For this, Gordon hired Miles Colean. Colean was a leading expert in housing finance and a great asset to *House Beautiful*'s consulting staff. He began his career in 1922 as an architect with Holabird and Root in Chicago, before moving to Washington, D.C., in 1934 to help create the FHA, of which he became assistant administrator. He also directed research for the Twentieth Century Fund's Housing Survey and wrote (by 1944) four books on defense housing, housing economics, home-building, and home-buying. After the war, he went on to advise presidents Eisenhower and Nixon, and was credited with coining the term "urban renewal" in his 1953 book *Renewing Our Cities.*[29] He consulted for other journals and magazines throughout this period, including *Banking,* but his writings were regularly published in *House Beautiful* after November 1944. He made steady contributions throughout Gordon's tenure. Most of his articles offered financial "planning"

advice on home-related topics, including: the house as an investment (November 1944); real estate pricing and the "time" to buy (January and February 1945); mortgage lending (April, May, and June 1945); home ownership for veterans (May 1945); the cost benefits of buying, building, or remodeling (August 1945); custom building versus ready-builts (September 1945); and the release of wartime building restrictions (December 1945).

The "Home Planner's Study Course" provided an accessible format for Colean's "practical" information, but Gordon also tackled the more problematic issues of taste and style. In these two categories, she again offered a "down-to-earth" course of study for her readers. Gordon was certain that most Americans had not carefully assessed the quality of their own taste. A considered knowledge of personal likes and dislikes, she argued, was vital to good decision-making in all housing matters. Taste, and especially good taste, was something to study and develop. After all, she posited, "good houses don't just happen."[30] Though taste was a slippery concept, she gave her readers specific "exercises" to develop their own "architectural" taste. One such lesson depicted "right" and "wrong" choices for scaling a house in terms of its surroundings ("flat" houses were the right choice in a flat terrain), parts to the whole (for example, right choices for windows, doors, and chimneys), purposeful features (turrets on a small house were a wrong choice), and purposeful materials (long, horizontal siding was the right choice for a long, horizontal house).[31]

Gordon also used the "Home Planner's Study Course" to educate her readers about architectural style. Style—a matter of good design and personal taste—was equally problematic but essential for readers to understand "before [they] can acquire a house." Gordon tackled this problem head-on in the October 1943 edition of the "Home Planner's Study Course," under the provocative headline "Your House Is a Statement of Your Life." In a dramatic proclamation, certainly intended to convey the social and cultural importance of style preferences, Gordon wrote: "Architecture is like Religion. There are many faiths. . . . The architectural faith that you adopt is, in a way, a symbol of your life." She laid out a series of choices for her readers: Did they want one of the three "architectural faiths" that she had identified? Would they choose "the modern or traditional schools of thought," or "compromise between the two extremes"? (She would profess, in the next month's issue, that she had long been "slugging

away on the Modern team").[32] Within *House Beautiful*'s multipage October spread, each style "faith" was labeled as modern, traditional, or compromise; each was illustrated with a built example and described in a short caption, ready for readers to "vote" their preference. Gordon did, however, eventually hedge her bets on the standing of any given style, asserting in April 1944 that "styles are architectural fashions and, like all fashions, are subject to constant shifts in popularity. But good architectural design goes on forever, whether or not it can be marked with the tag of any definable Style."[33]

These lessons and preferences reappeared in *House Beautiful* over the subsequent twenty years, but the first two years of the "Home Planner's Study Course" anticipated three predominant themes: Gordon's position within an evolving modern design movement; her growing opposition to the "International School" of modernism; and her belief that personal taste and individual choice were tied to larger national "responsibilities," including that of propagating an emerging "American" identity.

## The Postwar House

Gordon positioned the "Home Planner's Study Course" as an educational series, but it doubled as a barometer of things to come. This was particularly true for the postwar house. In August 1943, she commissioned noted modernist designer Walter Dorwin Teague to make "A Sane Prediction about the House You'll Live in after the War." Teague predicted that the "house of 194X"—using the popular term coined by *Architectural Forum* to indicate that yet-unidentified moment at war's end—would favor modern architecture over period styles. Yet postwar modern would cease to be what he described as the "cult" that it was before the Second World War. Modernism, in order to survive, would need to evolve. Perfectly reflecting Gordon's views and foreshadowing her campaigns of the 1950s, he wrote: "One thing we'll turn thumbs down on is the 'International' conformity of modern design. Any domestic architecture worth a tinker's damn has been not only *national,* it has been *regional* in character. For many reasons: Climate . . . local materials available . . . local folkways."[34] With this final statement, he captured the essence of Gordon's emerging agenda.

Gordon followed Teague's article with at least four prototypes for the postwar house, each of them elaborations on Teague's prediction. Because some of these were unbuilt projects—true projections of the future—they were published in sketch form, in drawings rather than photographs. Most of these prototypes were designed by Gordon and the *House Beautiful* staff or by a few select architects (for example, Allen Siple designed the fourth in the series). All were syntheses of "what people want in postwar houses," understood through data that Gordon had collected from research contests, questionnaires, and "thousands" of readers' letters.[35] Though she did not acknowledge the full range of her sources, she certainly utilized the growing body of national housing research.

*House Beautiful*'s "paper projects" for postwar houses and dream houses, published through 1945, predicted one version of the house of 194X; the model houses built by real estate developers and merchant builders predicted another. In the mid-1940s, builders across the United States, from New York to Illinois to California, began to test their postwar plans, building model homes where potential buyers could come to "shop" the possible offerings. As the war ended, most major tract developers (for example, the Levitts, Fritz B. Burns, and David Bohannon) and some minor developers used the model house as a sales lure and marketing pitch.[36]

In May 1946, Gordon published a developer's model home within the "Home Planner's Study Course": Burns's Los Angeles prototype, dubbed the First Postwar House (fig. 18).[37] The irony of *House Beautiful*'s title was, of course, that the magazine had been promoting "postwar houses" for three years. Despite this contradiction, Gordon published the house with enthusiasm as the "first" realization of the postwar dream. Gordon was not the first or the last to publish Burns's model. In March 1946, Beatrice Lamb of the *Los Angeles Times* reviewed it as the "Post War Wonder House"; the *New York Post* covered the story that same month, as did *Architectural Forum*. *Architectural Record* followed in April, *Life* in May, *Popular Science* in June, and *Popular Mechanics* in July. Most reports conveyed a palpable sense of excitement, praising Burns's house as the fulfillment of wartime promise and the harbinger of designs to come.[38]

The house, sponsored by merchant builder and real estate developer Burns, opened on 17 March 1946, on a prominent lot at the corner of Wilshire Boulevard and Highland Avenue in Los Angeles.[39] Burns built the house for show rather than for sale, as an "educational exhibit" and a research laboratory for new architectural solutions and new domestic products.[40] With this project, he

# HOUSE BEAUTIFUL

MAY
35¢

THE
FIRST POSTWAR
HOUSE

wanted to attract a curious public and test people's reactions. Burns charged a one-dollar admission fee (later lowered to thirty-five cents); even with this, he hosted over one million visitors.[41]

As a developer who had been building in Los Angeles since the early 1940s, Burns was acutely aware of the nationwide need for affordable, high-quality housing. Yet he, like Gordon, believed that the greatest unfilled demand was for "modernization." His goal was to clarify what "modern" and "modern living" meant. He was wary of the "confusion already created in the public mind" through the publication of "unrealistic and fantastic 'houses from Mars.'" As he encouraged "architects and builders to get down to earth," and to build a more realistic form of the "modern" house, he sorted through, and summarily rejected, the more radical experiments of the late 1930s and 1940s, which included Konrad

**18.** Walter Wurdeman and Welton Becket for Fritz B. Burns, The First Postwar House, Los Angeles, California, 1946. On the cover of *House Beautiful* (May 1946).

**19.** Wurdeman and Becket for Fritz B. Burns, The First Postwar House.

Wachsmann and Walter Gropius's Packaged House, Buckminster Fuller's Dymaxion House, and *Arts & Architecture*'s Case Study Houses.[42] In these examples, architects presented modernization through, among other things, industrial building materials and prefabrication processes. Burns, however, focused on modernization in terms of efficient space planning, consumer technology, and contemporary, yet fairly conservative, architectural styles (what Gordon might have termed "compromise").

Burns, like his architects, Walter Wurdeman and Welton Becket, hoped to forge a contemporary "California" style; their Postwar House was a step in this evolution. Their design was not revolutionary, but it was far removed from the historicized prewar (and wartime) Cape Cods that Gordon and other critics (including, famously, Joseph Hudnut) lamented.[43] The Postwar House—especially through the lens of the popular press—seemed fresh. What most people were unwilling to say was that this "first" was not entirely new: the interiors were piecemeal (at best), and the exterior recalled prewar experiments, including Cliff May's ranch houses, with its low-pitched roof, redwood cladding, natural stone accents, and dominant fireplace mass (fig. 19).

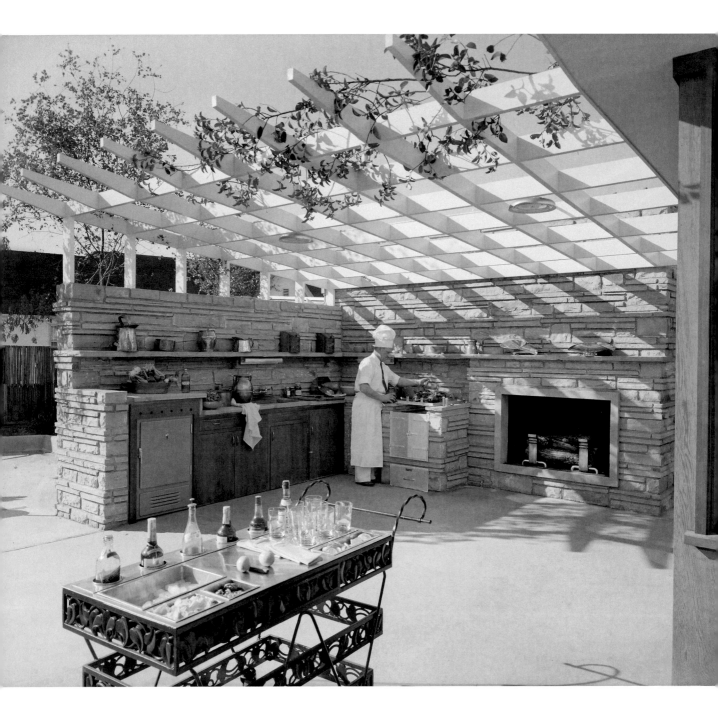

**20.** Wurdeman and Becket for Fritz B. Burns, The First Postwar House. Barbecue terrace and backyard patio.

Burns had, it seemed, tempered his desire for aesthetic and formal innovation with his business-driven need for marketable design. His conservative stance was due, in part, to the dominant postwar finance structure: many of his potential buyers were constrained not just by their personal tastes but by their mortgage lender's design guidelines. For example, the FHA, which guaranteed home loans for veterans and other borrowers, adhered to a strict rating system against which its architectural inspectors judged the viability of a loan; the inspector could reject a "nonconforming" house, whether because of structure, plan, livability, ventilation, marketability, or "architectural attractiveness." The FHA did not refuse contemporary or modern design outright, yet was wary of "novelty" and fads that might threaten the stability of its program.[44] Still, as Gwendolyn Wright has suggested, FHA evaluators may have been "instructed to lower the rating score of houses with conspicuously modern designs because they were not considered a sound investment."[45] Significantly, this rating system was supported by the Southern California FHA district office—of which Burns's business partner, Fred Marlow, was the first director.[46] Burns was certainly influenced by the perceived investment value of his homes, but he was more concerned with currying consumer favor. His strategy was to build "livable homes"—what he described in 1943 as "easy to look at, easy to live in, easy to pay for."[47] This was where his concept of modernization—and his vision for the postwar house—most closely aligned with Gordon's. This was the message that he hoped she would help him disseminate to a broader public.

For Burns, the Postwar House was, without doubt, a productive research project and a lucrative marketing opportunity; for Gordon and *House Beautiful,* it was a compelling prototype that was, to use the magazine's wartime slogan, "beautiful but practical."[48] Gordon acknowledged that the First Postwar House offered a terrific window-shopping opportunity, but she saw greater significance in the project. Though her interpretation was far from critical, and closer to boosterish, her support for Burns's model is telling: she carefully positioned the house as one of the "best" of its time, a model for the future, and, perhaps most importantly, the embodiment of the postwar American dream.

For Gordon, the Postwar House was a showcase for "better living"—a built example of the concept she had been describing for at least three years.[49] Her intent with publishing the house, and featuring it within the "Home Planner's Study Course," was didactic. She recognized that with wartime budgets and some building restrictions still in place, many readers could not afford to buy or build the house that Burns had presented (estimated, by some sources, at $75,000, at least three times the cost of a high-end, single-family home).[50] To counter the widespread myth that these "better houses" had to come at a steeper price, Gordon encouraged the new homebuyer to find ways to be selective. She promoted the vast range of options available—"some 350 ideas"—for a modernized postwar life. Yet she urged her readers to view the house for "the meaning of its parts, rather than as a whole."[51] Readers could add parts over time, as their finances allowed. Everything was phase-able: new exterior styling, a new floor plan, a new color scheme, a new refrigerator, new furnishings. Gordon's recognition of these economic realities is revealing. From the vantage point of 1946, the postwar "future" that so many had predicted was realized in slow waves. Modernization was indeed incremental.

Gordon's coverage of the house, like the house itself, wrestled with these emerging conceptions of modernization. The patio was perhaps the most successful modernized element. Accessible through floor-to-ceiling sliding doors, the patio extended the home's living space outward. This was a "livable" design and very much part of the emerging discourse on how postwar life should be lived. The patio enabled valued leisure activities, with its space to relax, play, entertain, and barbecue. *House Beautiful* suggested each of these in its published coverage, though most photographs were interrupted action shots devoid of people. The one exception was an image of a cook grilling on the patio; though Gordon did not publish this shot as part of the magazine's original spread, she did use it two months later (in what would become standard practice) as part of a separate feature promoting outdoor kitchens (fig. 20). A similar image was published in May 1946 in *Life,* and was presumably part of Burns's (rather than Gordon's or her photographer Maynard Parker's) staging technique: that shot included a hired model family "living" in the house.[52]

Though Gordon shamelessly promoted the house as a showcase of ideas and products, she failed to acknowledge the formative role of consumer desires (desires established, in part, through her own research and survey efforts). Burns clearly conceived the Postwar House out of an astute analysis of market forces, and he designed the

house to incorporate specific elements that led the list of consumer demands, such as a modernized kitchen with expansive cabinetry and engineered space for the latest appliances; a futuristic and low-maintenance Plexiglas bathroom fitted with a Remington-Rand electric shaver, a Hall electric toothbrush, and monogrammed towels featuring "PWH" (for the "Post War House") (fig. 21); and a large master bedroom suite fitted with Bullock's custom bed for "bedtime readers," with pull-down armrests and a "control panel" headboard for telephone, intercom, and hi-fi equipment. This nod toward consumer comfort—or, really, technological pleasure—reflected the growing influence of the mass-market consumer. This indicated a cultural shift: the postwar house, no longer the singular creation of the designer, was decidedly shaped by other "experts" privy to scientifically acquired data far outside the realm of aesthetics. The public acceptance and encouragement of this new approach to design was certainly on the heels of a new faith in science (including sociology). Possibly for the first time, popular architecture was defined by research and data rather than philosophical or aesthetic vision.

As a "laboratory for testing public tastes," as the *Los Angeles Times* so aptly described it, the First Postwar House was a tremendous success.[53] Burns was one of the first to apply the consumer desires research and data of the mid-1940s, and the Postwar House was the proving ground. Gordon's coverage of the project, too, was an experiment—and it, too, was a success. More than a million visitors toured the Postwar House in Los Angeles; nearly four hundred thousand more experienced it through the pages of *House Beautiful*. Gordon's "Home Planner's Study Course" had proved, again, to be an effective framework in which to introduce new designs, showcase consumer products, and "[convert] need to demand." Still, the house had greater success as an ephemeral advertisement than as a cohesive image of the future of American domestic architecture. The Postwar House had a limited moment of impact, but it was a pivotal moment for Gordon; this project, and her method of reporting it, would set a much larger editorial project into motion.[54]

# The Pace Setter House

With the publication of the First Postwar House in 1946, Elizabeth Gordon had proved, to herself and to the American public, that a "showcase house" could be a powerful vehicle for selling design and shaping public taste. But publishing these prototypes within the framework of *House Beautiful*'s "Home Planner's Study Course" had limits. In 1948, Gordon launched an ambitious initiative that would allow her to play a more decisive role; her new program would push established boundaries and set a new industry standard for magazine-sponsored "dream" houses. This was the Pace Setter House program.[1]

## The Magazine House

Demonstration houses and model homes—prototypes constructed, furnished, and decorated to demonstrate specific innovations, or to attract prospective buyers—grew in popularity during the 1920s, with impetus from the "Better Homes in America" campaign. These became increasingly prevalent after the *Homes of Tomorrow* exhibition at the 1933 Chicago Century of Progress International Exposition (where twelve futuristic model homes, including George Fred Keck's well-publicized House of Tomorrow, debuted). The 1939 World's Fair in New York gave the model home another boost. This event featured the suburban Town of Tomorrow, populated by fifteen single-family model homes built to showcase the latest advancements in architectural design, construction methods, technologies (including electricity), materials,

space planning, furnishings, and household consumer goods. World's Fairs were not the only venues in which Americans could see such "dream houses"; universities, museums, department stores, materials manufacturers, architectural journals, and the popular press all began to build their own versions.[2]

The popular press, led by venerable publications such as *Life, Fortune,* and *Collier's,* set a powerful precedent for building magazine-sponsored model homes. These houses were promoted under a variety of labels, including "demonstration house," "model house," "exhibition house," "showcase house," "idea house," and "dream house," but most had the same goal: to display ideas, and to inspire consumers to buy them (in one form or another). Three early examples sponsored by general-interest weeklies received notable acclaim, both from the public and from design professionals: *Life* magazine's 1938 *Life* Houses, designed in collaboration with "famous American architects," including Richard Koch, Edward Durell Stone, H. Roy Kelley, William Wilson Wurster, Royal Barry Wills, Frank Lloyd Wright, Aymar Embury II, and Wallace K. Harrison and J. André Fouilhoux; the 1940 *Life* Village in Boston, with eight houses built in collaboration with *Architectural Forum;* and *Collier's* 1940 House of Ideas, designed by Edward Durell Stone and built in Rockefeller Center.[3] Women's magazines likewise sponsored model homes—for example, *Ladies' Home Journal*'s 1937 House of Tomorrow, designed by Wallace K. Harrison and built in Madison

Square Garden (the magazine sponsored subsequent "dream house" projects between 1941 and 1946).[4]

By the early 1940s, home magazines—including *House Beautiful* and its nearest competitors, *Better Homes and Gardens* and *House & Garden*—began to offer a range of model homes. Most were designed to promote "better" postwar living. *Better Homes and Gardens,* with which *House Beautiful* often competed for content, ran two long-term programs: the Five Star Homes and the Idea Home of the Year, which were both promoted through print publication and public tours. The Five Star Homes series began in the 1930s as a short monthly feature, written (in the 1940s) by architect and building editor John Normile. Each house was numbered sequentially (for example, Cliff May's 1948 Five Star was No. 1805; his 1950 example was No. 2004) and published in a two- to six-page spread (fig. 22). The feature typically included one full-page exterior photograph, small interior shots, the home's floor plan (with labels and dimensions), and short descriptive text. In September 1954, *Better Homes and Gardens* launched the annual "Home for All America" program, later renamed the "Idea Home of the Year." This model home program was unusual: it was the "off-spring" of the Five Star program, but the model home was built in multiples. For example, readers could visit iterations of the 1954 home, based on Five Star No. 2409, in one hundred cities across the United States and Canada.[5] *Better Homes and Gardens* published one model in the magazine and listed the addresses for all other locations. As with each Five Star Home, *Better Homes and Gardens* sold a complete set of "Idea Home" architectural plans, working drawings and specifications, a materials' cost list, and a builder-owner contract template.

The Five Star Homes ranged in architectural style and innovation, owing in part to sheer numbers; they were "comfortable," if not conservative. Many of them, as Normile attested, were attentive to consumer demands reported in "desires" surveys. He described one such example with the Idea Home of 1955, a 1,626-square-foot ranch house designed by Hugh Stubbins Associates: this was a "realistic" and "versatile" model.[6]

*House & Garden* (a Condé Nast publication) launched a similar program in July 1951 under the title "House of Ideas."[7] Though the magazine had sponsored research competitions since 1945, this was its largest endeavor in more than a decade. The House of Ideas, like its *Better Homes and Gardens* counterpart, was promoted as "realistic, down-to-earth" and "really livable." Architect John Callender designed the inaugural house for a family of four, on a two-acre suburban lot on Long Island (fig. 23). The house was larger than average, at four bedrooms and 2,600 square feet, and more expensive: the construction cost was estimated at over $45,000, excluding fees, land, kitchen equipment, and landscaping. The editors (unnamed, but certainly building editor Will Mehlhorn and building consultant Katherine Morrow Ford) claimed that the home cost was reasonable, as it represented "2 1/2 times an annual income of $18,000, an average for many *H&G* readers."[8] Comparatively, *House Beautiful*'s featured Pace Setter House of this same year was estimated at "a shade more than $50,000," for a family with an average income between $20,000 and $25,000.[9] *House & Garden* was a competitor, though its examples and audience were closer to a true "average."

*House & Garden*'s editors refrained from promoting this first House of Ideas as "tomorrow's dream house"; they emphasized that it was designed to be built "right now," according to what readers "tell us that you want."[10] Like *Better Homes and Gardens* and *House Beautiful, House & Garden* relied extensively on survey data, national averages, and editors' observations. The result was a one-story ranch house planned around a "private" patio, built to "a new standard of comfort through convenience," and loaded with the latest "work-saving" household products and "easy-to-maintain" materials.[11] Recalling Elizabeth Gordon's typical rhetoric, recurrent in *House Beautiful* since at least 1946, *House & Garden* positioned its model as a "yardstick for your own building plans, whether you use its ideas in part or as a whole."[12] Gordon set the industry standard, and as Condé Nast's corporate correspondence proves, *House & Garden* had been watching her and emulating her strategies since at least 1943.[13]

If *House & Garden* provided a close analogue to *House Beautiful, Arts & Architecture* provided a different point of comparison. The Case Study House program, conceived and published within the framework of *Arts & Architecture,* a Los Angeles–based avant-garde monthly owned and edited by John Entenza, became a vital testing ground for progressive design ideas.[14] Entenza was the driving force behind the project, and his journal funded the project directly. His goal was to create a better postwar house, through a series of "low-cost, experimental modern prototypes."[15] Entenza wanted to encourage the design of good modern homes, but his definition of "modern" was

fluid. He professed no allegiance to a particular aesthetic, but he did have his eye (as his longtime colleague Esther McCoy wrote) "focused toward Europe rather than on the native organic architecture of Frank Lloyd Wright."[16] His recruits, for the most part, shared his preferences. Their work was nonetheless diverse, united by their relationship with Entenza and their shared mission to advance the cause of postwar housing. Entenza's roster included young men (and one woman) at the start of their design careers. Most of the Case Study architects would become leading figures in postwar architecture, including, for example, Charles and Ray Eames, Eero Saarinen, and Pierre Koenig.

Entenza's goal with the Case Study House program was to encourage innovation and creative thinking in house design. Like the editors at *House Beautiful,* and, later, *Better Homes and Gardens* and *House & Garden,* he wanted to find practical solutions to the mounting housing crisis, and he hoped to use "war-born techniques and materials best suited to the expression of man's life in the modern world," so far as the "average" American could

afford.[17] He offered a set of solutions with the Case Study Houses, thirty-six in all.[18] Designed and constructed over a period of twenty-one years, from 1945 to 1966, the houses represented an evolving view of modern aesthetics and modern living. The designs were diverse, but all were dedicated to the possibilities of rational planning, standardization, and prefabrication.

The Case Study architects' concerns, along with Entenza's, were at once social, economic, architectural, aesthetic, and technological. The prototypes were typically small, single-family homes with two bedrooms and two baths. Their clientele was middle class and "modern," which in Los Angeles in the mid-1940s meant professional, suburban, servantless, and, in some cases, childless. Some of the houses were built for known clients, such as Case Study #8 (designed by and for Charles and Ray Eames) and Case Study #9 (designed by Charles Eames and Eero Saarinen for Entenza); others were built on speculation, aimed at a client with an "average" budget and an "average" building lot.

In the end, Entenza and his designers found it difficult to meet the lofty goals they had set. While the first houses, such as William Wurster's Case Study #3, were designed with standard wood framing and traditional details, and may have remained within an average cost budget (which, in 1945, was $4,625), the more unconventional materials and experimental construction techniques of later houses, such as Pierre Koenig's Case Study #22, resulted in hefty price tags that made many of the Case Studies inaccessible to the truly average home buyer (fig. 24). The Case Study aesthetic, too, was a hard sell for Americans with traditional taste. There was little indication that Entenza relied on the same market research that his cohorts had used. Yet his vision of a modern home for a middle-class market was timely and appealing. If cost and the look of the Case Studies were too radical, the message was not.

Through *Arts & Architecture*'s media coverage, Entenza encouraged the dissemination of his architectural and social message to a broad public. As the financial sponsor and publicist, he held tremendous influence: his funding

**22.** Cliff May, *Better Homes and Gardens* Five Star Home No. 2004, Los Angeles, California, 1950.

**23.** John Callender, 1951 House of Ideas, Upper Brookville (Long Island), New York, ca. 1951. *House & Garden* (July 1951).

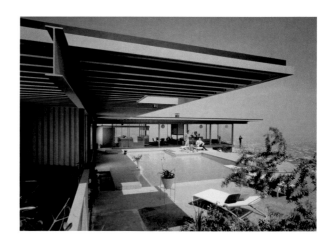

**24.** Pierre Koenig, Case Study House #22 (Stahl House), Los Angeles, California, 1959–60.

and solicitation of industry partners or donors assured the completion of progressive projects that might not have otherwise come to fruition, and his guaranteed print coverage assured the spread of the approved architectural message. The publicity was key. Though *Arts & Architecture* had a limited circulation, the journal got the word out; as McCoy later suggested, its legacy was "out of proportion to the length of [its] survival or the number of subscribers."[19]

The Case Study tour schedule provided parallel publicity. Upon its completion, each house was opened for six to eight weeks. These houses, unlike other exhibition projects (including the highly publicized *Collier's* House of Ideas), were fully developed and move-in ready. Visitors could experience the complete domestic package, which included designed landscapes, advanced mechanical systems, state-of-the-art appliance packages, and modernist furnishings (some designed by the Case Study architects) and decorative arts objects. Part of Entenza's objective, as the tours emphasized, was to debunk the myth of the modern house as an austere, unlivable, "existence minimum" dwelling.

From her post at *House Beautiful,* Gordon must have observed Entenza's serial experiment with much interest. She did not comment on Entenza's project directly, but she would have known about the Case Study Houses through media sources and her personal connections in California. None of the Case Study architects participated in *House Beautiful*'s analogous Pace Setter House program, and very few of these men were ever published in *House Beautiful.* There were a few exceptions: William Wurster, A. Quincy Jones, Frederick Emmons, and Craig Ellwood. Notably, *House Beautiful* later featured Ellwood's remodeled Case Study as a lesson on how to inject warmth into a "cold" modern house.

Still, Entenza and Gordon shared a concern with living well in postwar America, and both were interested in exploring new house solutions that experimented with form, function, and space. From Gordon's point of view, Entenza's efforts to reach the mainstream were surely doomed to fail, frustrated by the Case Studies' minimalist aesthetics and inflated construction costs. Gordon, on the other hand, believed she was positioned to create more successful models that would suit a middle-class market. Her strategy was to combine Fritz Burns's consumer-driven model, exemplified in the First Postwar House, with John Entenza's architect-controlled prototype.

## Cliff May and the Ranch House Classic

Like Entenza, Gordon wanted to encourage Americans to design, build, and live in modern houses. But she believed that the avant-garde forms that were being promoted by magazines like *Arts & Architecture* were too radical. On the other end of the spectrum, she found the projects featured in magazines like *Better Homes and Gardens* far too pedestrian. Her challenge was to find a version of modern that was somewhere in the middle.

She found an ideal partner in Cliff May. May was a sixth-generation Californian and a self-taught designer. He began his career in San Diego, crafting Mission-style furniture; by 1932, he was building "*rancheria*" houses on speculation.[20] He refined his design ideas and skills gradually over the years, working to blend an understated modernist form language and new technologies with Southern California's Spanish-Colonial past. May's rancherias were indeed modern, by his definition. His houses appealed to California clients who sought affordable, flexible, and comfortable places to live. As he built more of these homes, regional print media paid attention, most notably *Arts & Architecture*'s predecessor, *California Arts & Architecture,* and *Sunset* magazine (which published at least thirty-four of his projects between 1936 and 1965). With May's move to Los Angeles and the completion of his own home in 1939, major architectural journals, including *Architectural Forum* and *Architectural Record,* began to

take note. His work was featured in national shelter magazines such as *The American Home* (from 1935), *House & Garden* (from 1940), and *Better Homes and Gardens* (from 1944); in builders' magazines such as *Western Building* (from 1940); and in popular magazines such as *Life* (from 1945). *House Beautiful* was one of the first popular magazines with nationwide circulation to feature his designs (and would publish at least thirty-six of his projects).[21]

Gordon met May in 1942, through their mutual professional ties to the photographer Maynard L. Parker. She was immediately convinced that May's approach to design, his "modern planning . . . clothed in the dress of traditional styles," pointed the way forward.[22] In 1946, just as Gordon was ramping up her campaign in support of the softer and specifically "American" forms of modern architecture, May published *Western Ranch Houses.* This short volume was an immediate hit and eventually sold over fifty thousand copies.[23] It reached the American public just as wartime building restrictions and material rations were lifted, and just as the Cape Cod house and the "modernist box" were pitted against one another as viable solutions to postwar housing problems.

May's book presented his version of modern architecture, in the form of his traditional-yet-modern ranch house. The ranch house, both romantic and pragmatic, seemed a viable middle ground. May's persuasive argument, however, was not about modern architecture: he instead emphasized modern *lifestyle.* This tactic set him apart from other designers, but aligned him with the message circulating in popular magazines and the shelter press, especially *House Beautiful.*

May conceded that he could not and did not want to define a "ranch house style," in part because the label was haphazardly and mistakenly applied to "almost any house that provides for an informal type of living and is not definitely marked by unmistakable style symbols."[24] Instead, he offered a clear typology. He traced his version of the twentieth-century ranch house to its vernacular precedents, specifically the Spanish-Colonial buildings found in the American West. The low silhouette, rambling "L"- or "U"-shaped plan (which was infinitely adaptable), expansive patios, and fluid indoor-outdoor spaces were all part of a continued design tradition. The ranch house aesthetic depended on these forms, in combination with the application of simple, natural materials such as wood or adobe.

With this, he offered a model that asserted the vitality of architecture's past and the relevance, in the West

at least, of vernacular prototypes. In doing so, he positioned himself in opposition to some of the most powerful forces in Los Angeles—and American—modernism. This included most of the architects who designed *Arts & Architecture*'s Case Study Houses. May disapproved of most of them—of the "architects that go out and spend all their time making 'boxes for living' [to] look good—All Façade. No Plan. No Function. No out-of-door living."[25] He actively experimented with new materials and new building technologies, but sought modern design that functioned without being "functionalist." His version of modern retained key qualities that critics such as Gordon believed were sacrificed in competing "hard" versions: practicality, comfort, individuality, and livability.

*House Beautiful* published May's Los Angeles home, dubbed (by May) the Ranch House Classic, in April 1946.[26] One part promotional and one part aspirational, the magazine feature hawked May's practice, his new book, and Gordon's emerging views on modern domesticity. By 1946, May's Ranch House Classic was, in some circles, old news. Completed seven years earlier, the house had appeared in at least fifteen magazines and professional journals, in May's *Western Ranch Houses,* and, in June 1944, on the cover of *House Beautiful.*[27] The house had received positive press, but most of the stories were short or focused on singular aspects of the design. *House Beautiful*'s 1944 coverage, for example, was limited to the magazine's cover shot of a young man in casual slacks and sandals, holding a puppy and lounging on the private rear patio (fig. 25). The credit line, buried in the June issue's table of contents, commented only on the scene as one of "solid contentment."[28] Readers could buy this contentment, so the magazine implied, along with the indoor-outdoor "amphibious" furniture on which the model posed.[29] Selling the idea of relaxed modern living was the priority, even if selling May's name was not.

In 1946, though, Gordon set out to fully explore the Ranch House Classic from a new angle, as it became one installment of the magazine's monthly "crusade" to model a "happy, well-adjusted family life," all set within a "good home environment."[30] *House Beautiful* dedicated twenty-six pages of its April 1946 issue to May's house, all stamped with the "Better Your Home, Better Your Living" seal. The full feature included fifteen separate articles, fifty-five photos (seven in color), and six drawings. Gordon's aim was clear: she wanted to promote both the modern ranch house typology and the modern ranch lifestyle.

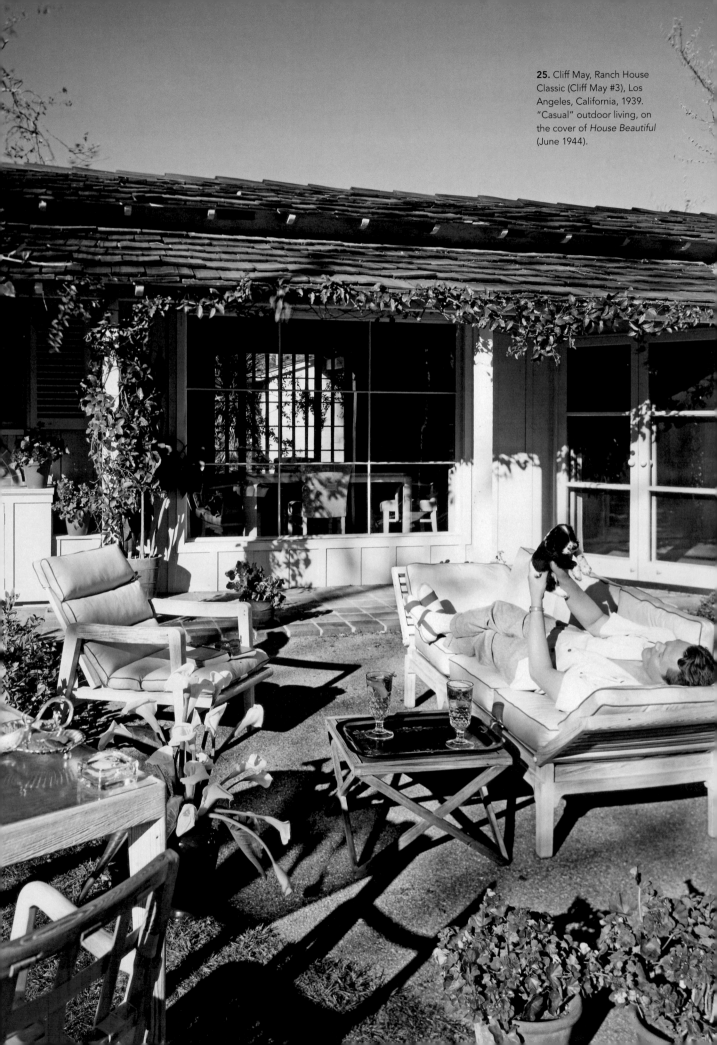

**25.** Cliff May, Ranch House Classic (Cliff May #3), Los Angeles, California, 1939. "Casual" outdoor living, on the cover of *House Beautiful* (June 1944).

Though the story was presumably about the Ranch House Classic, Gordon's editorial approach was only vaguely architectural. It was, rather, social and cultural.

Patricia Guinan's opening essay, "Nice People Come from Nice Homes," established the central argument: the single-family home contained *and* conveyed personal character. But, she argued (or, more likely, Gordon writing under Guinan's name argued), this character was expressed not by a "wardrobe" of architectural style, but by "the way you and your family live in your home."[31] A "nice" home, then, offered more than just shelter for people and material possessions: it was the frame for a way of life.

*House Beautiful*'s Helen Weigel Brown introduced Cliff May on the next page. He was not, however, the center of the story. In fact, his role as designer was secondary to his role as dweller; his profession was mentioned almost in passing halfway through the article. Brown presented a story that would resonate with the magazine's readership: a portrait of a "real family" that "really knows how to live."[32] The leading photograph captured the May family (Cliff, Mrs. May, their two daughters) in an intimate, if staged, moment in which they are posed, relaxed and smiling, while gazing out of their open window (fig. 26).

**26.** May, Ranch House Classic (Cliff May #3). May with his family, *House Beautiful* (April 1946).

This first image set the tone for the feature, which implied that the Mays, like their living room window, were open and transparent; the focal point of the story, like that of the photo, would be the family. Readers could surely relate to the handsome man in his suit and tie, with one hand propped casually on the window frame, flanked by his daughter (perched on the window with the family cat) and his lovely young wife holding a smiling baby girl. The magazine article, or so Brown claimed, presented an "unretouched picture" of how the family "actually" lived, day to day. The family was the focus of the story not just because May designed a good house, but because he created a "thoughtfully designed" lifestyle.[33]

Brown, who hoped to convince *House Beautiful*'s readers that the Mays were likable and plausible role models, underscored three facts: May was a "family man," his family was not wealthy (but rather belonged to the "upper middle income bracket"), and he and his wife "shared equally" in creating their home.[34] These essential private details framed the magazine's presentation of the house, asserting that the May family, their lifestyle, and their house were "successful" models for study (fig. 27).[35]

Adopting the same strategy she used in the "Home Planner's Study Course," Gordon provided a study guide to the Mays' "good" life; the annotated site and floor plans offered the first glimpse of his house and lot, what she equated to a "whole kingdom."[36] Spread across two pages, the magazine presented the plans not as builder's instructions (though they were dimensioned and detailed enough to be used as such), but as a reader's map for living (fig. 28). The magazine, without apology, detailed the expansive, if not regal, amenities, but simultaneously suggested that this self-contained empire was ordinary. The plan, surely a source of reader envy, showcased the aspirational and livable features of the compound. The one-acre site was large enough to accommodate a 3,800-square-foot house and six outdoor living spaces: a private family garden, complete with a rose garden and grove of fruit trees; a children's play yard, including a badminton court, a tennis court, a ping-pong court, gymnastic equipment, swings, and a

**27.** May, Ranch House Classic (Cliff May #3). Children posing "at play," photographed ca. 1943.

*2***8.** May, Ranch House Classic (Cliff May #3). Site plan, *House Beautiful* (April 1946).

sand court; a master suite's private patio; a main yard and motor court; a paddock with adjacent horse stalls and bridle path; and a service court (a "public area" for guest parking and deliveries).[37]

Gordon, who directed both the content and layout of the entire May feature, wanted to present the house as a prototype that any American family could replicate. Given the expansiveness of May's design, this was surely a challenge. To persuade her readership that they wanted and could obtain this life, she relied on two strategies: first-person narration and focused interpretation. Gordon's use of first-person narration was both engaging

and convincing. She allowed the May family to tell their own story in their own words, or so the reader was led to believe. Of the fifteen articles, Cliff and Jean May (either separately, together, paraphrased, or in full quotation) wrote ten. Only two *House Beautiful* staff authors received direct byline credits. Gordon's contributions were unacknowledged, as was the magazine's convention, though she frequently wrote (or entirely revised) text that ran under other authors' names. The effect, in this feature, was that the May family relayed Gordon's editorial message, winning over the audience with their homespun charm and impartiality.

Mrs. May, rarely "Jean" in print, was a key player. She, rather than Gordon or *House Beautiful,* declared the ranch house modest (when it clearly was not). She, rather than Gordon, implied that the house was a critique of competing designs, stating in her article of the same name, "We don't like pretentious architecture."[38] She declared that at the Ranch House Classic, she and Cliff were interested in creating a home, not a name-brand piece of architecture. This aligned with May's insistence, in *Western Ranch Houses,* that he designed houses to support a lifestyle rather than to adhere to an architectural style. Gordon must have pressed Mrs. May to make a definitive statement, if only to promote her husband's new book and trademark ranch houses. Mrs. May conceded (with an evident *House Beautiful* accent): "If you *must* put an architectural label on our house, it would be 'California Ranch.' But strictly speaking, it is not that. . . . It's really a contemporary version of the California ranch style."[39]

Mrs. May was surely conscious of the sociocultural defiance present in her husband's design and in their chosen way of life, and she defended both: "We are just as

proud of our home as the people who have awesome porticos and impressive front doors. Anyway, an impressive façade is no guarantee of good living inside. Our friends come to enjoy themselves—not to be impressed."[40] Mrs. May, with some help from Cliff and a boost from family snapshots, described the "inducements" that made their house so attractive and, whether intentional or not, impressive: the storage freezer filled with ice cream, the outdoor barbecue for "weiner and hamburger fests," a gym, a paddock with a pony, a Novachord (the first polyphonic synthesizer, introduced in 1939), a radio-phonograph and record collection, a movie projection room (for "home-taken and rented ones"), and a personal phone line for the oldest daughter (fig. 29).[41]

Her testimony was accompanied by *House Beautiful*'s subtle interpretative system, revealed through pull quotes and short captions. Gordon paired pictures that could have been interpreted as "showy" with text that suggested an underlying modesty, though it is perhaps unconvincing to today's reader. In an article titled "Here's How We Get along without Servants," May's expansive and fully modernized kitchen—pictured with its engineered storage,

electric mixer, electric dishwasher, garbage disposal, washer-and-dryer set (one of the first home units), electric ironing press, and walk-in freezer in which bulk food had been stored during wartime rationing—was tagged with the line "with modern housekeeping aids, we don't need a full-time servant. We get by nicely with a day-worker twice a week" (fig. 30).[42] A separate caption explained, paradoxically, that the floor plan included a "maid's room," which doubled as a guest room.[43] Technological "helpers," still an extravagance in most postwar homes, were similarly featured, yet captions rationalized their inclusion: "Science, in automatic heating plants, water softener, garage door opener . . . saves the Mays many a personal chore, hours of time—yet none of these helpers is in the 'luxury class.'"[44] Whether or not the *House Beautiful* reader believed the Mays were average Americans who "got by" without help, Gordon, through her editing methods, transformed their

house into a symbol of postwar democratization, where the servantless life was made possible by good design and better consumption.

Gordon's work with Cliff May set an important precedent. The Ranch House Classic provided her with both a publishable prototype for postwar living and a prototype for postwar editing. With this house, she developed new criteria for in-depth coverage (both for page count and content), photographic representation, focused interpretation, and non-staff narration. This, Gordon believed, was the recipe for credible reporting.

## A House to Set the Pace

Even before the Ranch House Classic went to print, May started to design his next project. He wanted to build a house on speculation, based on conceptual drawings

published in 1946 in *Western Ranch Houses* (fig. 31).[45] In 1946 or early 1947, he started to look for partners. *Sunset,* which had previously been a willing collaborator, rejected his proposition; editor Walter Doty wanted nothing to do with the construction phase and told May that "publishing was their business and not building houses."[46] Gordon, however, *was* interested.

She recognized that May's new design, originally dubbed the After the War House, set the forward pace for postwar building, perhaps more so than his Ranch House Classic had.[47] She also knew that if *House Beautiful* signed on as the principal sponsor, she could influence design decisions from the start. She could shape the physical house, not just its printed image, to fit her own agenda. In a pivotal moment, Gordon made it *House Beautiful*'s business to publish *and* build houses.

Gordon's role would become that of patron, though *House Beautiful* could not provide direct financing. May's longtime partner, John A. Smith of the First National Finance Corporation (for whom he designed a home in 1937), would provide the financial backing. As a sponsor and the publisher, though, Gordon could suggest design direction. She could also lend her interior decorating staff, commission the photography work, and stage the photo shoot. She could recruit industry partners from among her loyal base of *House Beautiful* advertisers to donate building materials, domestic products, decorative accessories, and furnishings, in exchange for product placement. This allowed her to control, to a great degree, the look and finish of the house. Gordon guaranteed that the magazine would credit designers, decorators, and sponsors in print; she catalogued all objects, appliances, and

**29.** May, Ranch House Classic (Cliff May #3). "Inducements" at the ranch house, photographed ca. 1943.

**30.** May, Ranch House Classic (Cliff May #3). The servantless lifestyle, *House Beautiful* (April 1946).

**31.** Cliff May, Conceptual
drawings for the After the
War House, ca. 1945. Interiors
by Paul Frankl.

materials that were donated or loaned and published an extensive list (room by room) in the magazine. She knew this recognition was valuable to vendors, and it helped her readers "shop." It also helped her surpass her competitors, especially *Better Homes and Gardens,* which did not always give designers credit or provide product references.[48] Gordon's sponsorship scheme was a shrewd financial move: it reduced construction costs for May and increased advertising revenues for the magazine. And *House Beautiful* could publish the project in full, with the guarantee that it would conform to Gordon's high standards.

May and Gordon both understood that publicity was essential, and the magazine's 1946 coverage of the Ranch House Classic provided a perfect model and prologue. By 1948, the *House Beautiful* staff and the magazine's audience were already primed for a pace-setting project. Gordon knew, from both readers' mail and circulation data, that her in-depth reporting on domestic design was popular. Her stories resonated with the postwar public. Her pioneering methods of print presentation, both in graphic layout and photography, had also proved effective. Her strategies worked, and her competitors were taking note—and they were getting nervous. In fact, *House & Garden* staff declared (in internal editorial analysis) that "*House Beautiful* has, for some time, been stealing the editorial leadership from *House & Garden.*"[49]

For May's "After the War" project, Gordon intended to use the same interpretative approach and visual schemes that she had been developing since the early 1940s, but she wanted to add a new element: a brand name. Many of her rivals, and even those who competed with *House Beautiful* indirectly, had launched successful named or branded programs, foremost among them *Better Homes and Gardens'* Five Star Homes and *Arts & Architecture*'s Case Study Houses. In 1948, she launched a branded exhibition house program of her own: *House Beautiful*'s Pace Setter Houses. She renamed May's After the War House, calling it the first Pace Setter House in an annual recurring series (fig. 32).

The Pace Setter House program was, at one level, a design showcase. But Gordon also saw this as an opportunity to inject criticism and, to use her words, improve readers' "judgment." She believed it was her responsibility as an editor, and *House Beautiful*'s responsibility as a "service magazine," to provide not just a catalogue of what was new, but an objective report of what was "*both new and* good."[50] With this in mind, she offered the Pace

Setter House as a prototype that demonstrated two key points: design choices relayed social values, and function, beauty, and cost were of prime importance. From the outset, Gordon developed the Pace Setter program around three components: the house itself; *House Beautiful*'s print publicity; and a public exhibition of the finished project. She envisioned the Pace Setter Houses as multilayered and multimedia experiences, aimed squarely at educating the American public and elevating the quality of postwar domestic design.

## The Pace Setter Design: Collaborations and Veto Power

With the inaugural Pace Setter, Gordon and May established a working method for the design, decoration, photography, and publication of all of *House Beautiful*'s successive sponsored projects. May supplied a "finished" set of architectural plans, including the site plan, exterior scheme, and floor plan. Gordon "edited" these plans—everything from the exterior plantings to the interior color scheme and the furnishings—to conform her vision of good and sellable design. Her suggestions significantly shaped the house, and she maintained the "power of veto."[51]

May designed the Pace Setter as a postwar prototype for an "average" American family. His initial architectural scheme, however, suggested a house that was far from ordinary: when completed at approximately 5,570 total square feet (including ancillary spaces), it was five times the average size (1,100 square feet), and at $50,000, it was five times the median cost (about $9,000) of a typical postwar house. This home would have hardly been affordable on an average annual family income (approximately $2,700 in 1948).[52] May, Gordon, and *House Beautiful,* it seemed, were going to redefine "average."

Together, they wanted to explore the limits of the ranch house type, and what May described as the "full possibilities of ranch-house living."[53] He sited the house within his Riviera Ranch development, on a half-acre corner lot. He proposed 4,000 square feet of enclosed living space and another 1,570 square feet of garages, porches, and patios. His sprawling plan recalled that of his Ranch House Classic, with an equally expansive motor court, a garden room with "controlled weather," a swimming pool and terrace, a bedroom patio, an enclosed drying yard, and a front lawn, which he added for "convention" rather than use.[54]

To complete the project, May relied on collaborations with *House Beautiful* and outside design consultants. His partners were many: Doug Baylis designed the site and landscape (while he was concurrently reworking the landscape at May's Ranch House Classic); Paul Frankl, with whom May had worked since 1938, designed a portion of the interior and offered sound advice on "how to bring indoors outdoors"; *House Beautiful* staff, led by Laura Tanner, completed the interior decoration; William Manker, the magazine's consulting colorist, advised on the color styling of the interior; and Edward Wormley, whom Gordon had favored since she featured him in 1945, designed much of the furniture, installing an extension of his Dunbar line. Together, they worked to transform May's conceptual drawings into a finished Pace Setter.[55]

May actively sought Gordon's input, and the original blueprints record their ongoing conversation in handwritten notes. Their views were compatible, but Gordon continually pushed him to revise his work to better align with her own standards of good design. The finished product reflected both May's developing aesthetic and Gordon's established preference for "livable" materials, textures, colors, and decoration.[56] Gordon's greatest contribution to the project came in the form of her published interpretations. Through *House Beautiful,* she created a cohesive and sophisticated identity for the house and positioned May's work as perhaps the most likable form of modern design on the postwar market.

## The Pace Setter in Print

Seldom is there a house so well thought out and so soundly executed that HOUSE BEAUTIFUL feels enthusiastic enough to sponsor it, decorate it, and exhibit it. But here is just such a house. It embodies basic principles which epitomize the best thinking of our times. These principles, if scaled down in size or slightly adopted in plan or specification, can apply to all pocketbooks, all climates. Study how it can better your living. Above all, try to visualize the social values that such a house represents. For houses and people are inseparable.[57]

—*House Beautiful* (February 1948)

*House Beautiful* debuted the Pace Setter in February 1948. The magazine's cover, photographed by Maynard L. Parker, allowed the reader just a glimpse of the house (see fig. 32). The camera focused on the double front door, painted a vivid yellow and adorned with an oversized Spanish escutcheon. A well-placed sign announced "*House Beautiful*'s Pace-Setter House, Designed and Built by Cliff May." The cover photo, though closely cropped, showed the home's signature features: a low, horizontal roofline, wood-shake shingles, exposed rafters, board-and-batten siding (painted salmon-pink), and themed décor. The next image of the house, sixty-one pages into the magazine, widened the view, but only slightly (fig. 33). The photograph was full page and full color, but Parker's camera angle remained oblique and the scene tightly framed. He foregrounded a bed of pink and white flowers, which Gordon's staff had deliberately installed to match the home's color scheme and frame the front façade. The flowerbed led the reader's eye down the front patio to the front door, an entry nearly obscured by the low eaves and massive stucco chimney. The fenced yard and adjacent street were barely visible in the background. With these purposefully composed images, *House Beautiful* enticed the reader to come in, and to view the modern ranch house that "set the pace."[58]

Gordon, in a short foreword, introduced the house as a model of "the best thinking of our times," both architecturally and socially. She wanted her readers to study the house, regardless of where they lived or the size of their budgets, to learn how they might "better [their] living."[59] Like any good teacher, and any determined editor, she retained firm control of the "facts" and filtered everything that her students would read and see.[60] She carefully crafted the text for study and curated the photographic views. And she only told the story that she wanted to tell. She discovered that her audience was willing to listen, specifically because her arguments, criticisms, and approbations reflected thoughts that were already circulating through the public consciousness.

In the pages that followed Gordon's introduction, *House Beautiful* delivered its message clearly and concisely: May's house represented new architectural

**32.** Cliff May, 1948 Pace Setter House, Los Angeles, California, 1947. On the cover of *House Beautiful* (February 1948).

# House Beautiful

House Beautiful's
## PACE-SETTER HOUSE
Designed and Built by Cliff May

**FEBRUARY**
**50c**

# A house to set the pace

## ...in all climates
## ...for all budgets

**Seldom is** there a house so well thought out and so soundly executed that HOUSE BEAUTIFUL feels enthusiastic enough to sponsor it, decorate it, and exhibit it. But here is just such a house. It embodies basic principles which epitomize the best thinking of our times. These principles, if scaled down in size or slightly adapted in plan or specification, can apply to all pocketbooks, all climates. Study how it can better your living. Above all, try to visualize the social values that such a house represents. For houses and people are inseparable.

concepts and a "new way of life."[61] Gordon summarized these key points in one article, "Why This House Is a Pace-Setter." In list format, one of her favored editorial devices, she argued that the house set the pace in twelve ways (fig. 34). These fell roughly within three broad categories: planned privacy, both indoors and out; new modes of indoor-outdoor living made possible through "weather control"; and contemporary style, a blend of traditional with "Modern" that incorporated landscaping, color, and decorative motifs. The list and, more directly, the accompanying floor plan hinted at one other area of innovation (important for the magazine's advertisers)—that of "advanced" domestic equipment. Gordon and her staff expanded these themes throughout the issue, using visual evidence to prove that the Pace Setter embraced new "principles" that any American could replicate, "in all cost brackets, and in all climates."[62]

Design for privacy remained central among these new principles, and in the postwar suburban setting that Gordon imagined, two factors threatened personal privacy: audibility and visibility. She knew that her readers would increasingly live in small houses built on tight city lots and near busy streets, where the sound of the "motor age" could be deafening. Because designers were increasingly able to modernize postwar houses by inserting large picture windows or walls of glass, Gordon worried that the combination of crowded lots and expansive glass would force families to live "like fish in an aquarium" (fig. 35).[63] Families would be exposed to unrelenting traffic noise, unpleasant views of city streets, and the gaze of nosy neighbors—none of which were "worth bringing in as a constant companion at our fireside."[64]

Gordon advocated for, and May provided, a design solution that embraced new concepts of visual expansion, transparency, and fluid indoor-outdoor spaces, "without sacrificing our privacy."[65] May's house "turned [its] back" on the city street and offered a blank public face pierced by a small bank of three kitchen windows (what the magazine described as keeping "eyes in the back of your head").[66] The front façade was seemingly impenetrable, and the front entrance became an obscured and opaque barrier. The aesthetic, admired by *House Beautiful,* was "non-committal."[67]

The magazine acknowledged that the trend toward reverse siting had deep roots; it was not truly new, but its "American" lineage was part of its appeal. Gordon certainly had Frank Lloyd Wright's designs in mind (some of

which she had featured two years earlier), though she did not reference him or any other architect directly. *House Beautiful* instead presented May as a postwar leader of this progressive movement—though he was in truth only one of many participants—in which the single-family house abandoned its front porch, obscured the main entrance portal and removed its glazing, and demoted the front façade from its former prominence.

The effort to separate the house from its suburban surroundings, to create a "little private kingdom . . . remote from the world," continued with the site plan. With Gordon's urging and collaboration from landscape designer Doug Baylis, May encircled the sides of the house with garden walls, fences, and hedges; these surrounded May's signature patio spaces, screened his window walls, and provided another layer of protection from unwanted views in and out. He was thus able to create interior spaces that extended visually and physically into the out-of-doors, a simple design strategy that increased the home's usable living space.[68]

Gordon praised the livability of May's design, yet noted many other "advantages of turning your back on the world." First among these was "a new attitude about what a house ought to do for its owners. We began to think it mattered more to make our houses good for us to live in, rather than look imposing for others." With this statement, Gordon applauded May and criticized other architects (though which ones was not clear) who created, either for their own vanity or that of their clients, "ostentatious façades" that offered "no guarantee of good living for the occupants inside." The "imposing façades," she argued, were engineered to "impress the world with your wealth, your ancestry, your social leadership, and your taste for historical antiquity." These "fancy façades" were no more than "a snare and a delusion."[69] Gordon clearly positioned the Pace Setter, and all of May's work, as an architectural statement about shifting social values. This marked, for *House Beautiful,* a move toward frank, unpretentious design.

Gordon continued to advocate for practical architecture that was buildable anywhere in America, and May's

**33.** May, 1948 Pace Setter. "A House to Set the Pace . . . ," *House Beautiful* (February 1948).

*Overleaf*
**34.** May, 1948 Pace Setter. Site plan, and "Why This House Is a Pace-Setter," *House Beautiful* (February 1948).

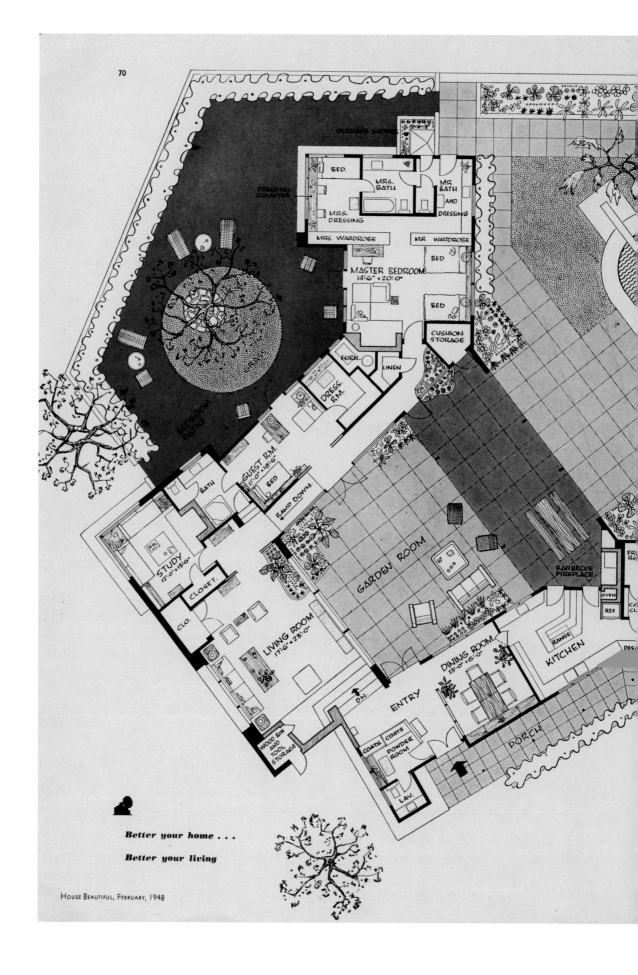

OUTDOOR SHOWER

BED.

MRS. BATH

MR BATH AND DRESSING

DRESSING COUNTER

MRS. DRESSING

MRS. WARDROBE

MR WARDROBE

BED

MASTER BEDROOM
14'-6" × 20'-0"

BED

CUSHION STORAGE

FURN.

LINEN

GRASS

BEDROOM PATIO

DRESS. RM.

GUEST RM.
11'-0" × 18'-6"

BED

RAMP DOWN

BATH

STUDY
12'-0" × 15'-0"

CLOSET.

CLO.

LIVING ROOM
17'-6" × 23'-0"

GARDEN ROOM

BARBECUE FIREPLACE

FR. RM.

OVEN

REF

RANGE

KITCHEN

DES.

DINING ROOM
13'-0" × 15'-0"

DN.

ENTRY

WOOD BIN AND TOOL STORAGE

COATS

COATS

POWDER ROOM

PORCH

LAV.

*Better your home . . .*

*Better your living*

GRASS

WATER SOFTENER

GARAGE

MAID'S RM.
13'-0"x13'-0"

DRYING YARD

DRIVEWAY
ENTRANCE

**1.** Because it presents a new way of life that recognizes the deep changes brought about by the motor age, which has turned our streets into nuisances and robbed our home sites of their privacy. (See page 68.)

**2.** Because it shows how we may accomplish some very positive, tangible control over the outdoor weather, to permit us to extend our season for outdoor living. (See page 72.)

**3.** Because it sets two new style patterns, showing how old architectural forms and traditional decorating motifs may be blended with Modern. It shows that we CAN have a contemporary look without throwing away the old, loved things from our past.

**4.** Because it shows how color may be used to make a house more beautiful, less static, and more a fluid, breathing, many-faceted personality. (See page 74.)

**5.** Because it shows how landscape plantings, in any climate, can be designed with such taste and beauty that the results can be worthy of being brought, visually, right into our rooms and used as prominently as our furnishings. (See page 86.)

**6.** Because it provides off-street parking, by a motor court, a definite new trend in property planning. (See page 68.)

**7.** Because it provides for private outdoor living on a city lot.

**8.** Because it achieves privacy indoors—even though a great deal of glass is used.

**9.** Because the site planning has recognized and provided for all the utilitarian functions, such as the drying yard, deliveries, etc., yet has kept them unseen and unheard from the living areas.

**10.** Because the house has a new kind of outdoor room, usable for outdoor living more times a year than a porch or a terrace, yet visually always a part of the indoors even in winter.

**11.** Because of its advanced, but definitely not experimental, lighting, no general light fixture can be seen. Rather, the house itself is the fixture, illumination coming from unseen, built-in sources. Types of lighting used are strip, cove, soffit, flood, cold cathode, drapery pocket lighting, indirect garden lighting.

**12.** Because the principles of this Pace-Setter House apply to houses in all cost brackets, and in all climates. For these ideas are basic to good living in America in this Twentieth Century.

# WHY This House Is A Pace-Setter

Pace Setter exemplified an effort to design for various climates—what she called in 1948 "weather control."[70] Weather control, as she defined it, allowed homeowners to expand their livable space beyond the building envelope, an important strategy in a time when houses were both shrinking and becoming more expensive. May, like some of his contemporaries, worked to develop effective methods to bring "the outdoors inside."[71] He conceived the Pace Setter as an indoor-outdoor house and installed architectural features that exerted what Gordon called "some very positive, tangible control over the outdoor weather."[72]

Among the weather-control devices installed at the Pace Setter, Gordon featured the "Garden Room" as the "answer to many problems."[73] This central garden court at the heart of the house functioned as an outdoor room. It also added usable, semi-enclosed square footage to the floor plan. Because it was protected on all sides, it could become a "sunpocket or a windbreak or both." This, as *House Beautiful* argued, added months of outdoor living "when your neighbors are driven indoors because they are too hot or too cold." The Pace Setter garden room included two "revolutionary," if still experimental, architectural devices: the wind shutter and the sky shade. May installed both of these to "extend [the] season for outdoor living."[74] The sky shade, a movable canvas hung on piano wires over the courtyard area, shaded the courtyard and served as a heat blanket in cool temperatures (fig. 36). The wind shutters hinged at the top, suspended, so that they functioned as an awning when propped up, and as a dividing screen between the pool and garden room when lowered.

*House Beautiful* revisited May's weather control devices when it asked in a subsequent article, "Could You Build the Pace-Setter House in a Cold Climate?"[75] As a native of the Midwest, Gordon recognized that indoor-outdoor living was not possible or at least not comfortable in colder climates, and she acknowledged that readers who lived "far north," or even just outside of Southern California, might "find it hard to believe that this house would work for you." Using her own experience of living in a "glass house on an exposed hill in the latitude of New York" as evidence, Gordon argued that multiclimate design could be achieved through the use of "modern materials, properly used" and "minor changes . . . in the Pace-Setter's specifications and design." The Pace Setter and, by extension, May's ranch house type, was put forward as a national housing solution made viable in any region through its flexible weather control methods.

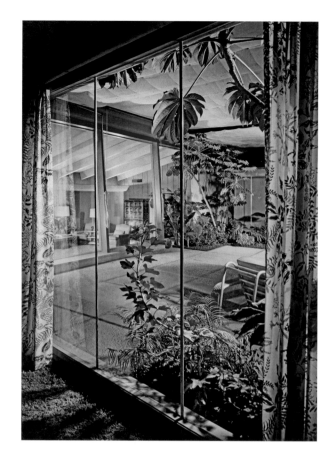

*House Beautiful* provided an adapted floor plan and a list of nine suggestions for "changes for a cold climate."[76] These included attention to siting (so that the house was oriented to take advantage of passive solar), an enlarged heating plant, better insulation, weather-stripping, insulated glass and storm sashes, indoor laundry (rather than May's outdoor drying yard), screened outdoor living areas, and in-floor radiant heating (both indoors and outdoors). As proof, the article claimed that a cold-climate Pace Setter was under construction in Wichita, Kansas; a second version was built in 1952 in Lubbock, Texas.

As *House Beautiful* demonstrated that the Pace Setter could adapt to any climate, Gordon implied that it also could appeal to a broad range of tastes. She advertised the Pace Setter as "modern," as a "ranch house," and as "contemporary." In early 1948, these terms were all far from neutral. She did, however, mitigate any sort of controversy over aesthetic style, and any public hesitance to abandon "old architectural forms" or "traditional decorating" in favor of modern design. She presented the Pace Setter as a house that merged a "contemporary look" with the "old, loved things from our past."[77] As Gordon would learn, this moderate point of view would prove critical in winning a

broader audience over to pace-setting domestic design.

The implicit argument—and criticism of other design viewpoints—was this: contemporary design need not be ahistorical, and those who sought to "modernize" need not start from scratch or abandon "decorating" traditions that pleased them. So Gordon sold the Pace Setter as a blended aesthetic, and instructed her team to decorate the interiors accordingly. *House Beautiful* staff, led by Laura Tanner, worked with the goal of "continuity and cohesiveness." The idea, as the magazine wrote, was to "play a counterpoint of old against a modern tempo." Gordon's inspiration was sixteenth-century Spain. Because May worked from historical precedent—specifically, California's Spanish-Colonial vernacular—she encouraged him to express this connection through "Spanish" motifs. She and her staff used this as the starting point for an elaborate decorative scheme, detailed in the illustrated article "How a House Develops a Theme Song."[78] They selected antique furnishings, light fixtures, and hand-wrought Spanish ironwork (including the escutcheons on the front door) as key pieces—and each of these inspired the custom motif that May and his magazine collaborators would develop for the house. In what would become standard Pace Setter practice, *House Beautiful* staff designed a monogram and embroidered this on bed linens and towels, all photographed and featured prominently in the magazine (fig. 37).

Gordon also used the Pace Setter to tackle another thorny style debate of the moment: color. As modernists seemingly railed against color-coordination and decoration (or, in truth, as critics misrepresented their arguments), May's house offered an opportunity to explore the use of both. His design language and material palette of stucco and wood worked well with color. The decorating challenge, as Gordon defined it, was how to color a house with an open plan and rooms that "flowed" together through glass walls. Because multiple rooms were on view at once, she had the chance to experiment with a complex color plan. She wanted to "speed up the trend to use more color" in postwar homes. Her advocacy was linked, no doubt, to her support of and partnerships with paint and textile industries, but it was also a critique of contemporary design that, as she would later write, lacked excitement and character. A colorful Pace Setter, on the other hand, was "living, breathing personality— different every time you look at it."[79]

Gordon never hesitated to make such proclamations, and presented the Pace Setter process with absolute conviction. *House Beautiful* again offered a study guide and a set of instructions for the reader to "copy" (the magazine's term), but underscored that color-planning was a "job for a professional."[80] Much of the magazine's Pace Setter content, then, served a dual purpose: to cultivate a public understanding of and appreciation for good contemporary design, and to encourage its newly educated readers to hire a designer.

Gordon's staff, led in this task by the color stylist William Manker, had full control of the Pace Setter's interior

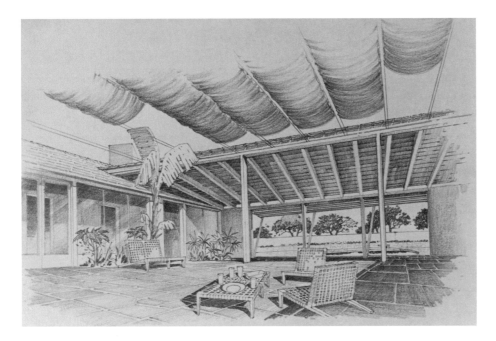

**35.** May, 1948 Pace Setter. Bringing the outdoors in, *House Beautiful* (February 1948).

**36.** May, 1948 Pace Setter. Sketch of the "sky shade."

scheme. They produced what was in their view "the most important house ever built . . . color wise." The house was an empty palette. Manker used sixty-four paints to create a "composition of colors . . . as intricate as a Beethoven symphony." He was able to achieve, so the magazine argued, "magical color coordinating" in a "'glass house' where you could look out of any room, across an exterior patio into several other rooms."[81]

Coordinated color was central to *House Beautiful*'s concept of beauty, and it was important that color was used well. Gordon acknowledged that synchronization was a daunting task, but assured her readers that, with a "starting point" and a plan, it would be "easy" to establish a successful scheme. The starting point at May's Pace Setter was fabric. In "Fabrics Set the Color Pace," the decorating staff described the "surprising" process of selecting a family of fabrics (twenty-four separate designs) in two short hours—a task that typically would have taken days. The magazine encouraged a new decorating shortcut, the "color-coordinated group of home fabrics" launched recently by Celanese. The article gushed about the "phenomenon" pioneered by the fabric company (not named directly, but rather credited in the back of the magazine), which had made it so effortless to style an extensive range of colors, patterns, and textures.[82]

The magazine advised its readers, and proved with ten full-color photographs, that "no opportunity was missed to make color perform" (fig. 38). In a telling anecdote, the magazine posed a key problem with floor coverings: "We decided that, vertically, the house was so exciting that the floors had better be kept quiet and unobtrusive." The solution was to clad floors in the main living areas in a "grayish wooly-green to echo the foliage outside," except the study, "which has little relationship with the outdoors." The color plan was comprehensive, so that linens, dishware, and "even the insides of cupboards, drawers, and cabinets were colored to be interesting when opened."[83]

The segment on color-styling, composed of less than a dozen pages, had far-reaching consequences. The magazine's colorful photographs sold ideas *and* products. May wrote to Gordon in May 1948 to confirm both. In just two

examples from his long report of "the wonderful things that have happened" since the Pace Setter debuted, he wrote that the "entire membership" of the American Institute of Decorators had toured the house during their annual convention, and that the local agent for Martin-Senour Paints had "never had so many calls before on any house" (and in subsequent years, Martin-Senour reported running out of the Pace Setter colors).[84]

Gordon succeeded not only in increasing the public demand for color but in building a desire for other "interior benefits." She published utilitarian spaces, including the kitchen and the laundry, with enthusiasm. The Pace Setter kitchen received special attention, advertised as "advanced . . . in equipment . . . in planning . . . in waste disposal . . . in storage space . . . in ventilation . . . in lighting . . . in ironing . . . in pre-designed storage . . . in equipment . . . in having a planning center."[85] The magazine promoted May's efficient space plans, hailing the kitchen equipment as both "labor-saving" and "easy-to-use-and-care-for." *House Beautiful* aimed at a particular audience and asked (rhetorically), "What woman doesn't want such" stuff?[86] Like the paints by Martin-Senour and fabrics by Celanese, kitchen appliances and domestic gadgets

**37.** May, 1948 Pace Setter. Pace Setter motifs, *House Beautiful* (February 1948).

**38.** May, 1948 Pace Setter. Living room, with color styling by William Manker.

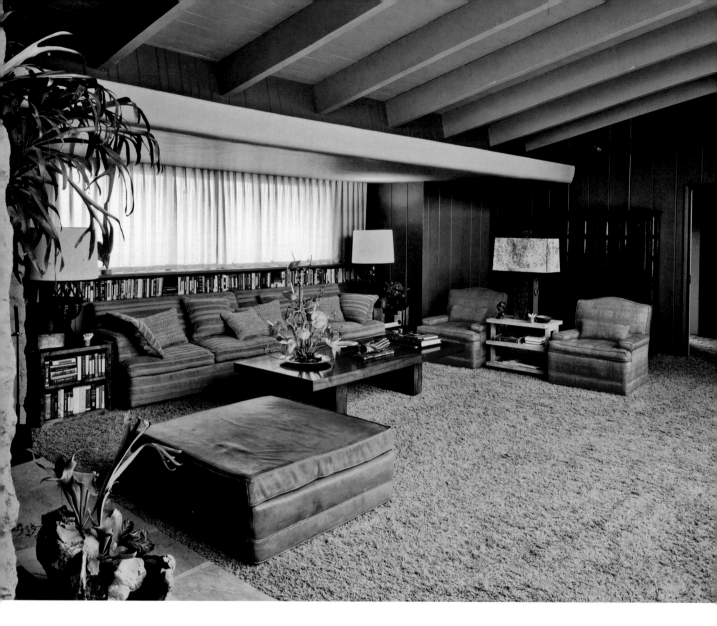

advertised in association with the Pace Setter flew off the store shelves. May kept Gordon apprised of the local market, making special note that Trade-Wind Fans were "swamped," and Thermador "had a great increase in their electric range and remote oven business; in fact, they were going to shift more production into this unit."[87] The Pace Setter was a success for everyone: May, the associated designers (including Manker and Baylis), *House Beautiful,* and scores of industry partners all reaped the benefits of Gordon's comprehensive marketing campaign.

## The Pace Setter on Tour

*House Beautiful* circulated pace-setting ideas to approximately 521,665 regular subscribers, and the reach of the Pace Setter House expanded even more when it opened for tours during October and November 1947.[88] Gordon

(with assistance from May, her staff, and photographer Maynard Parker) personally directed the process by which the house was staged, photographed, and toured. Her "institutional prestige" was at stake, and she wanted to create a first-rate experience.

She planned a public launch for October 1947, four months before *House Beautiful* would print the Pace Setter story. This was a grand production and required a host of collaborators, all working under Gordon's direction. Her vision was exacting, and she seemed to specify every detail of the project. Her methods of control were unswerving, even as she dealt with partners on the project. In a phone call to John Smith of the First National Finance Corporation (who helped to finance the Pace Setter), Gordon chastised him for the poor quality of the public signage he had provided. Specifically, Smith had forgotten to credit *House Beautiful* as a sponsor. Gordon

threatened to remove all of the furniture that the magazine had secured and staged if Smith did not remedy the problem. He fixed it (fig. 39).[89]

*House Beautiful* and Smith's First National Finance Corporation hosted the first of three launch events on 7 October 1947. The first party was for the members of the press, industry partners, and designers. More than four hundred people came on the first night, and all proudly signed the Pace Setter guest book.[90] The first guests to arrive were Mrs. Donald Ayres and Donald Ayres (of Frank H. Ayres and Son, a land development company in Los Angeles). Other attendees included staff from *Architectural Forum, Fortune,* the *Los Angeles Times Home Magazine,* and CBS. Partygoers included *House Beautiful*'s partners and advertisers, such as representatives from Celanese, Bendix, Revere Copper and Brass, U.S. Gypsum, Brown Saltman, Barker Brothers, and Bullock's. Gordon invited local and national designers, both those who contributed to the project and others who were not associated. The guest list included some of the most noted designers of the period: Paul Frankl, Edward Wormley, T. H. Robsjohn-Gibbings, John Lautner, Hendrik van Keppel, and Taylor Green were among those in attendance. Some of Gordon's past and future collaborators, including artist Millard Sheets and architect Roger Rasbach, were also there. Gordon hosted a second party on 8 October, with about half the number of guests of the first evening. Most of the attendees were designers or from design-related industries. *House Beautiful* gave a third party shortly after, as an event for the "society" of Los Angeles, who May hoped might become clients.[91] Indeed, some did, and a few of his past and future clients left their signatures on record.

The public launch of May's Pace Setter generated a great deal of excitement within the design community, and there was a large demand for tours. *House Beautiful* opened the Pace Setter to the public during November and December of 1947, from one to nine o'clock p.m. daily. The admission price was one dollar, and all proceeds were donated to charity.[92] At the end of the tours, and following the release of the *House Beautiful* Pace Setter issue, May put the house up for sale. It sold quickly, to Mr. and Mrs. Neil Monroe (Mr. Monroe worked for RIT Dye), who were trading up from their first Cliff May home in Riviera Ranch.

## A Pace Setter Postscript

The publication of the 1948 Pace Setter was a pivotal moment in May's career. An estimated one million people viewed the house either in person or in the pages of *House Beautiful.* He subsequently received hundreds of letters from across the nation, with potential clients inquiring about his ranch house designs. Many magazine readers wrote to ask if they could buy the floor plan, which they could not (but, as of January 1948, they could buy Ready-to-Builds through *House Beautiful*'s new stock plan program).[93] Others wanted to hire him directly as their architect, which they could and did.[94] May became increasingly popular, as did his Pace Setter prototype. With Gordon's help, he began to disseminate the Pace Setter idea, and his ranch house typology, across the United States and abroad. May and Gordon, with this first Pace Setter project, were instrumental in both the development of and the popularization of what would become recognized as the "California Ranch House" and the "California style."

As early as August 1948, May wrote to Gordon that he had at least six "Pace-Setters" under contract or under construction.[95] Over the course of the next two decades, he would build nine spin-offs of the first Pace Setter. All were based on the 1948 prototype, but none was identical. Derivatives appeared in Southern California (including a neighboring Riviera Ranch house, built for May's friend Austin Peterson, who was a producer for the television show *You Asked for It*); Cincinnati, Ohio; Knoxville, Tennessee; Bartlesville, Oklahoma (for K. S. "Boots"

**39.** May, 1948 Pace Setter. Road sign advertising Pace Setter House tours, held in October and November 1947.

**40.** Cliff May, David Stone House, Lubbock, Texas, 1952.

Adams, of Phillips Petroleum); Lubbock, Texas (fig. 40); and Pendelton, Oregon. *House Beautiful* and May worked together on other models, including a "Pacesetter House for All Climates" and a "Pacesetter House for Limited Budgets," the latter of which was advertised in the *Los Angeles Times* as the "Pricesetter."[96] Just as *House Beautiful* predicted, the design ideas exemplified in the first Pace Setter could indeed be applied to "houses in all cost brackets, and in all climates. For these ideas are basic to good living in America in this Twentieth Century."[97]

May's Pace Setter House, and all of his California ranch houses, represented an effort to transform architecture for the average into more than just "average" architecture. May and Gordon both recognized the potential to create individualized or personalized homes, even when building for a mass market. They viewed the ranch house type as progressive and modern, and representative of a postwar mindset that Gordon was eager to promote. As Gordon and *House Beautiful* spread May's "western" ideas eastward, an entire generation of rising architects and a welcoming public began to embrace a new pace-setting brand of modern design.

# Chapter 5

# Climate Control

When Elizabeth Gordon launched the Pace Setter House program in 1948, she had advertised Cliff May's inaugural example as a "house to set the pace . . . in all climates"; a year and five months later, she launched an ambitious editorial program to help architects and homeowners across the United States achieve the same kind of architectural flexibility.[1] Gordon debuted *House Beautiful*'s Climate Control Project in October 1949, parallel to the Pace Setter program, and as part of her "better homes, better living" agenda (fig. 41).[2] With this new initiative, she promised her readers a "whole new world," filled with both "better living and better health."[3] But what did climate have to do with health and housing?

Gordon had already connected the pursuit of better homes to the result of better living. With the Climate Control Project, she translated these into a parallel vocabulary of building performance and human comfort, or simply "well-being." Performance and comfort were familiar themes transferred from her early career writings—for example, from her 1937 article for *Pictorial Review* titled "Keeping Weather in Its Place," or her 1937 book *More House for Your Money,* written with Dorothy Ducas. The latter included a chapter on "Weatherproofing," a practical (if facile) guide to installing "weather-control" features to supplement a home's mechanical heating and cooling system. Ducas and Gordon only discussed two contemporary "state-of-the-art" building techniques, insulation and weather-stripping. Still, their limited scope expressed an attitude that stuck with

Gordon for decades: technical systems alone could not exert enough "control" to create a comfortable home, and designers and homeowners needed to combine architectural design, materials, products, *and* technology.[4]

In this same period, from the late 1930s through the Second World War, Gordon observed a host of climate-related architectural experiments aimed at increasing comfort and decreasing costs. She was certainly aware of George Fred Keck's 1933 House of Tomorrow on display at the Century of Progress International Exposition in Chicago, and his pioneering 1940 "solar house" built for Howard Sloan in the Chicago suburb of Glenview.[5] Both were built to take advantage of sunlight, though each in a different way. As architectural historian Anthony Denzer has argued, Keck's "discovery" of solar heat at the House of Tomorrow was "accidental," but the "solar" engineering at the Sloan House was deliberate.[6] Keck's solar house experiments continued to press the limits of architecture and technology with an essential effort to "harness" the sun, and Gordon began to report on these efforts when she joined *House Beautiful*. Most of these first articles combined her 1930s discussion of weather control with an increasingly sophisticated understanding of climatically responsive design, advanced by architects such as Keck. All of her stories were didactic, aimed at teaching

**41.** "Introducing . . . Climate Control," *House Beautiful* (October 1949).

*Introducing House Beautiful's*

*newest effort*

*to better your living...*

## CLIMATE CONTROL

...a continuing project to show you how
to manipulate the design and materials of
old or new houses to reduce the stresses and
strains of climate on Man and Materials

her readers the value of design "principles" such as wind-breaks, sunpockets, solar geometry, and site orientation. After August 1943, most of these topics appeared within the "Home Planner's Study Course."[7]

*House Beautiful*'s September 1943 feature on the "home-planning science" of "solar radiation" was significant. Gordon introduced this key concept to her readers alongside emerging equipment, including solar windows, through a close examination of her own ca. 1940 home in Dobbs Ferry, designed by Julius Gregory (whom Gordon appointed *House Beautiful*'s consulting architect from 1942 to 1952). She informed her reader that over the past thirty months, she had "personally tested" the viability of a "solar house." Her experience, chronicled through a series of solar studies and illustrated in the magazine, "proved, to [her] own satisfaction, that home builders of the future can successfully harness one of nature's most powerful elements to make their homes more comfortable—even in rigorous climates."[8] With this article, and many that would follow, Gordon revealed two significant things: she was a thorough investigator who frequently tested emerging concepts and products herself; and she was uncompromising—she only published ideas, including designs and designers, that she judged to be truly "good."

*House Beautiful* was a chief proponent of the "solar house," but it was not the only magazine fascinated with the possibilities. After 1944, stories appeared in general-interest publications, shelter magazines, and architectural journals, from *Newsweek* to *Life, Collier's, Reader's Digest, Parents, Ladies' Home Journal, Better Homes and Gardens, House & Garden, Progressive Architecture,* and, most frequently, *Architectural Forum.* The *Forum* was, alongside *House Beautiful,* perhaps the greatest champion of solar homes, presumably because of the influence of one of the journal's editors, Henry N. Wright. Wright, with his coauthor (and fellow *Forum* staffer), George Nelson, had established expertise in solar heating, and many other postwar housing concerns, in the book *Tomorrow's House* (1945). The *New York Times,* the *Washington Post,* and the *Chicago Tribune,* all daily newspapers, also joined in the discourse.[9]

Most authors and editors focused on the same three themes: comfort, cost savings, and fuel scarcity. At *House Beautiful,* Gordon frequently tackled the issue of comfort, or how architectural design might mitigate the distress caused by, for example, new "window walls" that turned a home into a greenhouse in summer or an ice box in the winter. During the war years, when the discourse on the solar house was at its peak, cost savings were a great motivator. Gordon, too, reported on this. She had followed architectural and engineering developments and firmly believed (as she wrote to her audience in 1945) that "no idea of the last thirty years has so fired the imagination of the American public as the one of letting Old Sol reduce the winter fuel bill."[10] This second theme of budgeting was connected to the third: Americans needed to find an alternative means to heat their homes as national supplies of coal and oil dwindled and, during the escalation of the Second World War, were rationed.[11] The nationwide interest in solar energy would, however, decline in the late 1940s as the energy crisis abated, only to reemerge in the 1970s under an equally dire fuel crisis.

During the early 1940s, though, Gordon became a major force in promoting solar energy and the solar house. She was enthusiastic about the design innovations that she observed, most notably large expanses of glass, but she understood that her readers were anxious about the practicality of these contemporary trends. In helping her readers to justify solar, she drew considerably from the writings of Henry Wright. Among Gordon's articles in support of the solar house was her expansive 1945 coverage of George Fred Keck's model house for developer Ed Green, built as part of his Ready-Built Homes project (the model was erected in Rockford, Illinois; fig. 42).[12] Gordon, like other editors (including those at *Forum*) who published this same model house, praised Keck's "flexible system" that prioritized "orientation to the sun." She did, however, make her opinion clear: Keck's thoughtful design, though prefabricated, was a marked and necessary improvement over the typically deplorable "stock plan and standardized look" offered by other prefabricators (she did not name names).[13]

Gordon's frequent reporting on the benefits of solar design established her expertise in the field, and in 1944, Libbey-Owens-Ford recruited her to join its national campaign to design and promote a series of solar homes. In the hopes of boosting public knowledge, the interest of professional designers (and builders), *and* sales numbers for its recently released Thermopane glass, the company devised a "program sponsoring the creation of designs for sound, acceptable solar houses which could be demonstrated to the public under a wide variety of climatic or geographical conditions." To select the architects for

**42.** George Fred Keck, Model for developer Ed Green's Ready-Built Homes, Rockford, Illinois, 1945. *House Beautiful* (November 1945).

these houses, and to remain seemingly "impartial" in its selections, Libbey-Owens-Ford convened a panel of leading architects, designers, design educators, critics, and magazine editors united in the "cause of better housing and fuller living."[14]

The list included thirty-eight "famous authorities." Among the influential architects (many of whom were educators) were George Howe, Joseph Hudnut, and William W. Wurster. Gordon, too, was an authority, serving on the jury alongside many of her editorial colleagues and competitors: Walter Doty of *Sunset;* Dorothy Draper, formerly of *Good Housekeeping;* John Entenza of *Arts & Architecture;* Katherine Morrow Ford of *House & Garden;* Edward Gavin of *American Builder;* Mary Davis Gillies, the interiors and architecture editor at *McCall's;* Caleb Hornbostel of *Woman's Home Companion;* Dexter Johnson of *Western Building;* Maxine Livingston of *Parents;* Howard Myers of *Architectural Forum;* John Normile,

the building editor at *Better Homes and Gardens;* Richard Pratt of *Ladies' Home Journal;* Kenneth Reid at *Progressive Architecture;* Harold H. Rosenberg of *Practical Builder;* Henry H. Saylor of the *Journal of the American Institute of Architects;* Francis de N. Schroeder of *Interiors;* and Gordon's predecessor at *House Beautiful,* Kenneth K. Stowell of *Architectural Record.*[15]

With the aid of its "nominating panel," Libbey-Owens-Ford assembled an impressive list of architects to submit designs (one for each state within the United States at the time), including Edward Durell Stone, Oscar Stonorov and Louis Kahn, Alden B. Dow, George Fred Keck, O'Neil Ford, John Gaw Meem, Paul Thiry, Pietro Belluschi, and Harwell Hamilton Harris; yet the company's goal of building forty-eight solar houses proved untenable. Libbey-Owens-Ford did, however, make a lasting contribution to publishing American architecture, in the form of its 1947 book, *Your Solar House.*

Within the 128-page publication, illustrated with architectural renderings and floor plans for forty-nine solar houses (arranged by region and state, including one for the District of Columbia), editor Maron J. Simon provided a summary of the concept of the solar house, its history, its integral technologies, including Thermopane, and its early testing scenarios. A star example of the latter was the highly publicized 1943 project out of the Illinois Institute of Technology in Chicago, where engineering faculty and students observed a suburban solar house for one year to measure the dwellers' "comfort" and fuel expenditures. (Simon did not mention the architect by name, but this was George Fred Keck's 1941 house for Hugh Duncan, and the tests were sponsored by Libbey-Owens-Ford.[16]) Importantly, Simon also defined "solar house" for the American public, describing it as "a house designed to attain more efficient use of the sun for heat and natural daylight, and to achieve better vision." Each of the forty-nine houses that followed fit loosely within that definition; each of the designers, so Simon stated, was likewise "inspired by his own locality, the characteristics of its people, its climate, its topography."[17] The goal of *Your Solar House,* as articulated by Simon (and, ultimately, by the book's corporate sponsor), was to increase the ability of designers, contractors, and householders to envision and build solar houses everywhere. Historian Anthony Denzer has noted the book's ultimate failure, arguing that it offered very little in terms of technical instruction for architects and even less as a "pattern book" for homeowners. The book and the solar house designs contained within it were, Denzer argues, "a meek symbolic response to an ill-defined problem."[18]

If, as Denzer has suggested, Libbey-Owens-Ford failed to launch the solar house movement, Gordon capitalized on its momentum. In the exact moment that Libbey-Owens-Ford published *Your Solar House,* she translated the project's salient themes into her own in-house research initiative.

## House Beautiful's Climate Control Project

In the winter of 1947 and 1948, a shortage of heating oil pushed many Americans into crisis, and again (replaying anxieties felt during the Second World War) forced many to reconsider domestic energy consumption and conservation.[19] For Gordon, energy efficiency in the American home—whether energy was provided by coal, oil, or solar power—was a "better living" problem. Though she lost interest in the "solar house" as editorial content, she was still attentive to how weather and climate might influence the quality of American homes and American living. She was convinced, too, that climate was linked to larger cultural concerns, namely man's social, cultural, economic, and political "progress." Drawing heavily from the works of British politician and historian S. F. Markham (whose 1944 book *Climate and the Energy of Nations* linked the rise and fall of great nations to climate and climate control) and that of Clarence A. Mills (whose 1942 book *Climate Makes the Man* presented scientific and ethnographic evidence likewise linking civilization to climate), Gordon alerted her *House Beautiful* readers to a new idea: climate profoundly affected their well-being.[20] She concluded, backed by scientific and statistical evidence cited in Markham's and Mills's work, that difficulties with general health, disposition, energy, metabolism, blood pressure, ambition, intelligence, culture, prosperity, and standard of living were all directly linked to natural and man-made environments left unchecked.[21] "Your house," she advised, could be a "chief weapon" of defense, or, as her staff writer Wolfgang Langewiesche continued, a "major obstacle."[22]

Gordon revealed a significant problem: the majority of American homes, both old and new, provided adequate lodging but failed to offer "comfortable" shelter from natural elements, including cold wind and intense sun. These houses were "woefully inept" at what she then termed "climate control," as they lacked design characteristics and technologies that could mitigate weather and its potential discomforts. Her critique was aimed at both architects and builders, and to some degree at uninformed dwellers who had prioritized aesthetics over function. Together, they had all failed to address the "sting of climate" with anything more sophisticated than "central heating, insulation, and weather-stripping." The fundamental problem, or so Gordon believed, was a lack of knowledge. Technologies, methods, and products existed—and companies such as Libbey-Owens-Ford brought them to market with increasing frequency in the postwar years—but Americans still had a poor understanding of how to use these effectively. Home builders also lacked the expertise needed to build comfortable homes throughout the wide range of "local conditions" or climatological zones across the country. Gordon viewed this as a substantial new postwar problem, worsened by increasing numbers of national tract developments (for

example, Levittowns). This, Gordon argued, was the "biggest thing holding up housing progress in America."[23]

Gordon hoped to forward that progress. In late 1947, she orchestrated an expansive and likely expensive twenty-three-month research initiative, titled simply *House Beautiful*'s Climate Control Project. Her goal was to gather existing national climatological facts, provided by the U.S. Weather Bureau, which had collected information for the armed services since at least 1935. She would then use this data to advise Americans on how to build the "perfect house for the place in which it was to be built."[24]

Gordon again proved to be a systematic investigator, wise enough to assemble an accomplished staff and a team of specialists to assist with the momentous task ahead. She appointed anthropologist and Yale professor Ralph Linton to lead the panel of outside experts. Linton's role was vital and, in fact, team member Dr. Paul Siple suggested that Linton had "seeded the idea" for the project. Regardless of who generated the concept, Gordon's "imagination was kindled, and with her amazing energy and enthusiasm" she formed the Climate Control team, raised funding (through Hearst), and established the long-term project plan.[25] Her esteemed company of scientists came to include Siple, a climatologist, biological geographer, U.S. Army researcher, and chief of the Climatology and Environmental Protection Section for the Office of the Quartermaster General; Dr. Helmut E. Landsberg, a micro-climatologist and former chief at the U.S. Weather Bureau; Dr. L. P. Herrington, a physiologist and director of research at the John B. Pierce Foundation; Walter A. Taylor, an architect and director of education and research for the American Institute of Architects (AIA); Miles L. Colean, an economist and *House Beautiful* building consultant; Dr. Dana Coman, a medical-geographer and scientific adviser to the U.S. Army; and Wolfgang Langewiesche, a technical writer, aircraft pilot, and "student of weather" who would become a regular contributor to the magazine. Henry N. Wright was not a member of the original team, but he contributed many articles to *House Beautiful*'s published account of the Climate Control Project (this shortly after he left his post as editor at *Architectural Forum*).[26]

*House Beautiful*'s new building editor, James Marston Fitch, who joined the magazine staff in early 1949, played a decisive role in the project. He had studied with Henry Wright and was deeply influenced by Lewis Mumford, whom he knew well. Through these men, and his brief posts at the Tennessee Valley Authority and the Federal Housing Administration, he became keenly aware of the "social and political aspects of building." He came to *House Beautiful* with substantial experience in architectural writing and editing: he had worked as an editor for *Architectural Record* from 1936 to 1942 and, after brief wartime service in the Army, wrote for *Architectural Forum* from 1947 to 1949 (where he reportedly had an office next to the now-famous critic and his subsequent lifelong friend, Jane Jacobs).[27]

Gordon would have known Fitch's work for *Forum*, including his article on "Microclimatology," but it was his 1947 book, *American Building: The Forces That Shape It,* that piqued her interest.[28] Fitch's book revealed that he shared Gordon's motivations and worries. The proof was in this line, which could have been written by Gordon herself: "American building today shows immense potentials; it also has great deficiencies.... For here, as elsewhere, an informed public is the prerequisite to closing the gap between what we *could* do and what we *are* doing."[29] His book also demonstrated deep knowledge of three themes that Gordon privileged: the history of "American" design; popular taste (and its crises); and climate control. He, like Gordon, wrote about building performance, "environmental factors," "building design and the micro-climate," and "harnessing the sun."[30]

Fitch joined the *House Beautiful* staff after the Climate Control research had commenced, but the rest of the team had been working diligently for more than a year. Gordon's goal for the project was to "use existing knowledge of climate, man, and building to produce more comfortable homes in America."[31] The group hoped to produce what Colean described as "very practical recommendations" to benefit three constituencies: *House Beautiful*'s average reader (the homeowner—or aspiring home buyer—who composed the magazine's popular audience); architects and landscape designers; and home builders.[32]

In a 1950 speech at the Building Research Advisory Board's Research Correlation Conference, Siple described the Climate Control research program in detail for the audience, explaining that their process had been one of trial and error.[33] They had hoped, initially, to use existing Weather Bureau data to "map" all of the climatic zones in the United States; they would, in turn, develop house designs appropriate for each of these zones (fig. 43). As Siple revealed, the team quickly recognized the immensity (and impossibility) of this task. In a revised plan, they selected fifteen urban centers, or areas with a high

population density, for which they would perform three tasks: "measure the climate"; determine "what each climate means in terms of human comfort"; and create a "set of *performance specifications* for comfortable houses (new or old)."[34] The team understood that these specifications would vary according to the homesite's distance from the group's point of data collection, and so devised a system of secondary and tertiary climatic zones to accompany the original fifteen primary zones. These additional zones allowed temperature and precipitation variances of five percent to ten percent from the center's average, to which architects could respond with "climatically necessitated alterations" to the "ideal designs."[35] Siple, and Gordon, admitted the team was "in a quandary as to whether the 5% and 10% zones [were] significant values architecturally," but offered this as a starting point.[36]

The Climate Control team explored five elements for its climatic analysis: thermal, solar, wind, precipitation, and humidity. With data from each of these categories, the climatologists could then determine, with input from

the team's architect, what "impact" each might have on a home's form, siting (or orientation on its lot), construction methods, construction materials, foundation, basement, walls, roof, fenestration, and mechanical systems.[37] The results, in terms of what *House Beautiful* would oversee and produce, were fifteen Regional Climate Analyses and fifteen Climate Control Houses, designed by "local" architects from each region. (This was not unlike the model developed by Libbey-Owens-Ford for its solar house project.) Gordon conceived each Climate Control House as a regional prototype, to be used in much the same way as the 1948 Pace Setter House—a model to be studied and adapted, rather than adopted outright. For Gordon, the Climate Control Houses represented yet another way to influence the postwar house toward her own evolving definition of good design.

In October 1949, after nearly two years of preparation, Gordon introduced her magazine readers to *House Beautiful*'s Climate Control Project (see fig. 41). This was the October cover story, and the issue was filled with

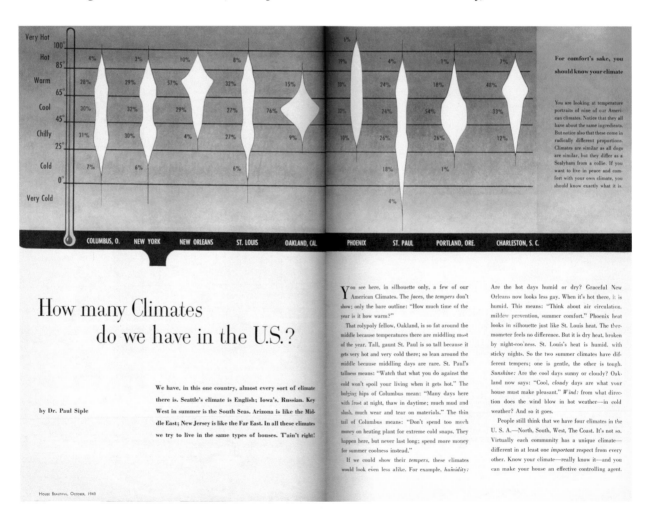

For comfort's sake, you should know your climate

You are looking at temperature portraits of nine of our American climates. Notice that they all have about the same ingredients. But notice also that these come in radically different proportions. Climates are similar as all dogs are similar, but they differ as a Sealyham from a collie. If you want to live in peace and comfort with your own climate, you should know exactly what it is.

## How many Climates do we have in the U.S.?

by Dr. Paul Siple

We have, in this one country, almost every sort of climate there is. Seattle's climate is English; Iowa's, Russian. Key West in summer is the South Seas. Arizona is like the Middle East; New Jersey is like the Far East. In all these climates we try to live in the same types of houses. T'ain't right!

You see here, in silhouette only, a few of our American Climates. The *faces*, the *tempers* don't show; only the bare outline: "How much time of the year is it how warm?"

That rolypoly fellow, Oakland, is so fat around the middle because temperatures there are middling most of the year. Tall, gaunt St. Paul is so tall because it gets very hot and very cold there; so lean around the middle because middling days are rare. St. Paul's tallness means: "Watch that what you do against the cold won't spoil your living when it gets hot." The bulging hips of Columbus mean: "Many days here with frost at night, thaw in daytime; much mud and slush, much wear and tear on materials." The thin tail of Columbus means: "Don't spend too much money on heating plant for extreme cold snaps. They happen here, but never last long; spend more money for summer coolness instead."

If we could show their *tempers*, these climates would look even less alike. For example, *humidity*:

Are the hot days humid or dry? Graceful New Orleans now looks less gay. When it's hot there, it is humid. This means: "Think about air circulation, mildew prevention, summer comfort." Phoenix heat looks in silhouette just like St. Louis heat. The thermometer feels no difference. But it is dry heat, broken by night-coolness. St. Louis's heat is humid, with sticky nights. So the two summer climates have different tempers; one is gentle, the other is tough. *Sunshine:* Are the cool days sunny or cloudy? Oakland now says: "Cool, *cloudy* days are what your house must make pleasant." *Wind:* from what direction does the wind blow in hot weather—in cold weather? And so it goes.

People still think that we have four climates in the U. S. A.—North, South, West, The Coast. It's not so. Virtually each community has a unique climate—different in at least one *important* respect from every other. Know your climate—really know it—and you can make your house an effective controlling agent.

House Beautiful, October, 1949

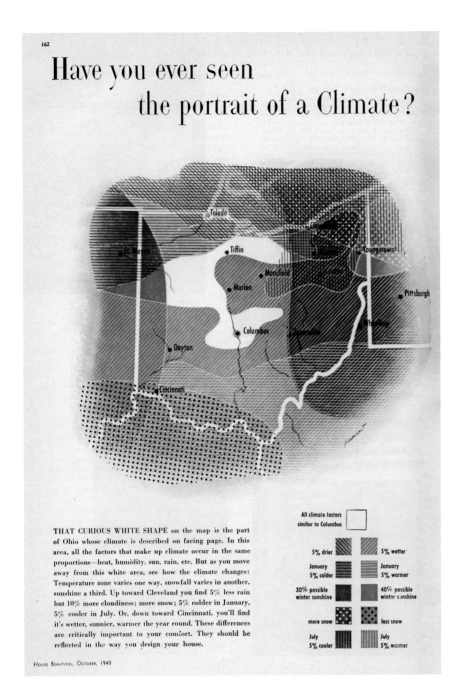

# Have you ever seen
## the portrait of a Climate?

THAT CURIOUS WHITE SHAPE on the map is the part of Ohio whose climate is described on facing page. In this area, all the factors that make up climate occur in the same proportions—heat, humidity, sun, rain, etc. But as you move away from this white area, see how the climate changes: Temperature zone varies one way, snowfall varies in another, sunshine a third. Up toward Cleveland you find 5% less rain but 10% more cloudiness; more snow; 5% colder in January, 5% cooler in July. Or, down toward Cincinnati, you'll find it's wetter, sunnier, warmer the year round. These differences are critically important to your comfort. They should be reflected in the way you design your house.

HOUSE BEAUTIFUL, OCTOBER, 1949

| | | |
|---|---|---|
| All climate factors similar to Columbus | | |
| 5% drier | | 5% wetter |
| January 5% colder | | January 5% warmer |
| 30% possible winter sunshine | | 40% possible winter sunshine |
| more snow | | less snow |
| July 5% cooler | | July 5% warmer |

**43.** "How Many Climates Do We Have in the U.S.?" (Climate Control Project), *House Beautiful* (October 1949).

**44.** Climate Control portrait, *House Beautiful* (October 1949).

seventy-five pages of Climate Control–related content. From the introductory image that ran on the October magazine cover onward, Gordon worked to establish the Climate Control brand: she focused on the process of mitigating weather, which she carefully described using her emerging climate control vocabulary, and she used the term "Climate Control" (capitalized) specifically to refer to *House Beautiful*'s data-driven design recommendations. Within a month of the project's inaugural publication, she had transformed the October cover image of a celestial globe into a Climate Control Project logo, a visual

cue and an editorial seal of approval that would accompany every subsequent Climate Control editorial that Gordon published through her retirement in 1964.

The first Climate Control articles were based on findings from the team's pilot study for Columbus, Ohio. For its inaugural October issue, *House Beautiful* ran key components of the project: a Regional Climate Analysis for Columbus, a climate "portrait" of the area, and designs for a climate-wise Ohio house (fig. 44). Fourteen houses for fourteen other cities would follow, published in identical format, between 1949 and 1952; other Climate

Control Houses would be introduced (and stamped with the Climate Control logo) in subsequent years. In tandem with *House Beautiful*'s coverage, the AIA (under the guidance of Walter A. Taylor, a Climate Control team member and then-director of AIA Education and Research) published the unabridged climate data, tables, charts, and full expert analyses in bimonthly installments of the *Bulletin of the American Institute of Architects;* reprints were available to anyone for fifty cents each (fig. 45).[38] The logic was that *House Beautiful*'s popular audience would not want to be "burdened" by methodical details, but architects, builders, and materials manufacturers would reap the benefits of an expanded technical discussion (fig. 46).[39] Notably, the *Bulletin* mentioned the fifteen Climate Control Houses and their architects only briefly; the full interpretation and illustrative material appeared exclusively in *House Beautiful*.

Gordon edited *House Beautiful*'s inaugural Climate Control issue with her popular audience in mind. She designed a series of articles, to be written by her staff and the Climate Control team, to make three conclusive points: climate could affect dwelling comfort; comfort could be attained in any house, in any location; and climate could be controlled, through good data-driven design.[40]

Fitch proved his worth as the magazine's new architectural editor in his introductory article, "How You Can Use *House Beautiful*'s Climate Control Project." In just one page, he explained the value of the project to the magazine's readers, arguing that climatological data, when applied to home-building, could inform good design. *House Beautiful*'s goal was to provide and interpret the data so that readers (or their architects) could design "comfortable houses" responsive to their specific region. With the magazine's help, each homeowner could "tame" climate and make it "work *for* you instead of against *you*." He concluded his remarks with an important reminder—and a boast: "Climate Control is no *substitute* for good architecture and good engineering, but it is the most significant *supplement* to them made during the Twentieth Century."[41]

In this same magazine issue, Miles Colean, a longtime contributor to *House Beautiful,* underscored the financial value of the project for homeowners. It was his job to prove that climate control offered cost savings and that its strategies were affordable, even for householders on a modest budget. His advice, informed by the "hard-boiled viewpoint of housing economics," was certainly a hedge against pending criticisms. Colean delivered a simple and persuasive message: if readers followed *House Beautiful*'s "very practical recommendations," they could "save money." Specifically, he argued, homeowners could use pertinent regional "weather-facts" to inform design and maintenance decisions—for example, about good window placement, proper drainage, and appropriate solar technology. This "know-how," Colean argued, could "increase [household] comfort without adding cost."[42]

Gordon and her staff—with particular expertise from Climate Control team member Wolfgang Langewiesche—offered other practical lessons in climate control, two of which focused on teaching readers to use Climate Control Project data. The first lesson was aimed at homeowners whose houses and lots were not designed or selected with climate in mind. The magazine insisted that all was not lost: readers could "fix" their existing

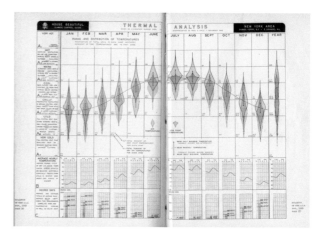

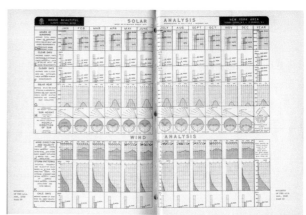

**45.** *House Beautiful*'s "Climate Control Guide: Thermal Analysis," *Bulletin of the American Institute of Architects* (November 1949).

**46.** *House Beautiful*'s "Climate Control Guide: Solar Analysis," *Bulletin of the American Institute of Architects* (November 1949).

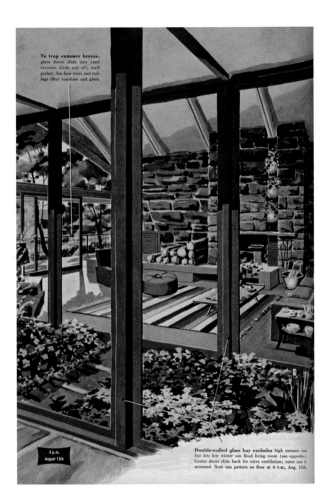

To trap summer breeze, glass doors slide into (and screens slide *out* of) wall pocket. See how trees and trellage filter sunshine and glare.

4 p.m.
August 15th

Double-walled glass bay excludes high summer sun but lets low winter sun flood living room (see opposite). Center doors slide back for extra ventilation; outer one is screened. Note sun pattern on floor at 4 P.M., Aug. 15th.

**47.** "A Lesson in Climate Control," *House Beautiful* (October 1949).

"private climate," the characteristics of which were, presumably, to be explained in *House Beautiful*'s Regional Climate Analyses. In a twelve-page essay, illustrated with "how-to" diagrams and photographs from the magazine's archive—notably of Gordon's own home and Cliff May's 1948 Pace Setter—Langewiesche recommended a series of inexpensive climate-controlling "tools": a trellis to buffer wind; a canopy to shade windows; plantings, trees, and "deciduous overhangs" (in the absence of structural roof overhangs) to shade walls; garden walls to form "sunpockets"; white roofs to reflect heat and glare; and "wet" walls to provide an evaporative cooling system (reminiscent of George Fred Keck's 1944 wet roof).[43]

In the second lesson, Gordon offered guidance useful to prospective homeowners—those readers who had yet to design or build a new house. This advice came simply as "A Lesson in Climate Control," and showcased the first of *House Beautiful*'s Climate Control Houses. The prototype, designed by Ohio architects T. W. Brooks and Gilbert Coddington, drew from data summarized elsewhere in the October issue of the magazine. *House Beautiful*

published renderings of the house, but no photographs, for the reader to "study." These illustrated guides included a floor plan, captioned to underscore the climate control features; an elevation of the home's façade, annotated to show various climatic devices; interior elevations, labeled to demonstrate the performance of mechanical systems (radiant heating, air conditioning) and building materials (insulated glass, concrete floors) at certain times of the day and months of the year; a roof plan, diagrammed to indicate ventilation methods; and a site plan, drawn to emphasize proper orientation and landscaping choices (fig. 47).[44]

*House Beautiful*'s Climate Control Project, with its regional analyses and building prototypes, was hailed an immediate success. Issues of the magazine sold out quickly, and the AIA reprints were in equal demand. The project was also in the industry spotlight, as it was the focus of the Building Research Advisory Board's 1950 Research Correlation Conference in Washington, D.C. The purpose of this gathering, as reported in its published proceedings (underwritten, in part, by *House Beautiful*), was to share knowledge about "climatology today and the relationship between climatology and the building industry."[45] Gordon, Linton, Siple, and Fitch all gave talks. The convener and scores of other speakers openly acknowledged *House Beautiful*'s—and specifically Gordon's—contribution to American architecture and building, including the magazine's sponsorship of the conference and its published proceedings.[46] One commentator, Buford Pickens from Tulane University, offered his appreciation, along with a particularly salient critique of "mass taste" in American house design: "Since the press, and particularly the home magazines, have been at least partly responsible for selling us Cape Cod all over the place, someone here should give credit to Elizabeth Gordon, who is the Editor, and to her associates at *House Beautiful* Magazine, that they are now the first of these original sinners to explore and publicize climate control and the regional distinctions that are apt to stem from it."[47]

*House Beautiful* continued to share knowledge with architects and the building industry, and presented the

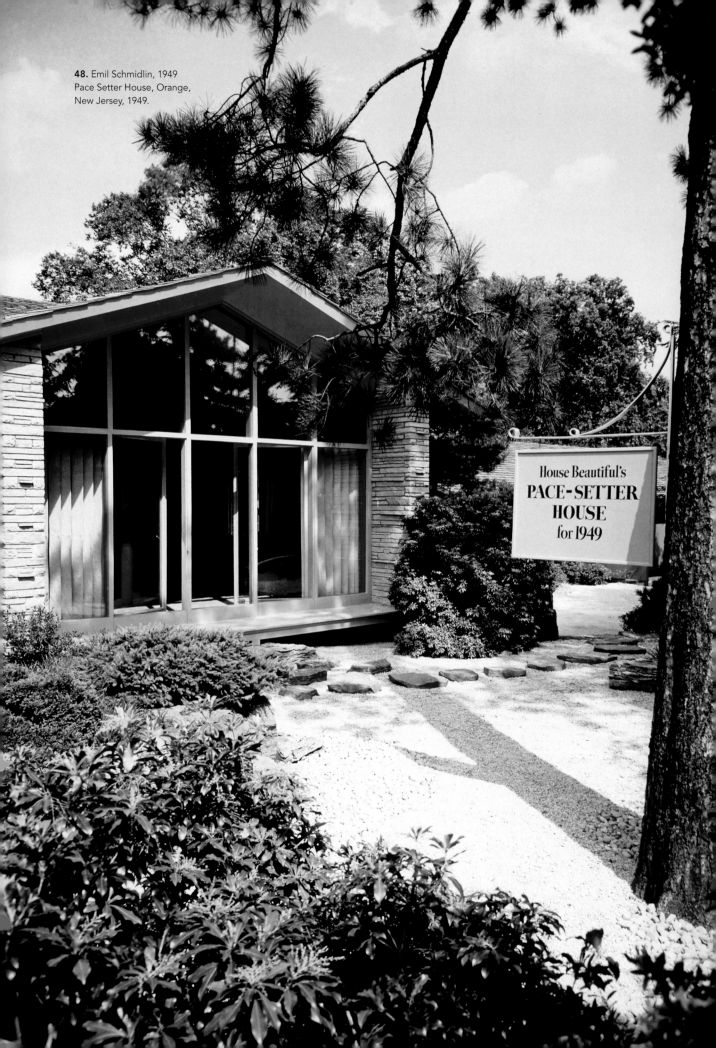

**48.** Emil Schmidlin, 1949
Pace Setter House, Orange,
New Jersey, 1949.

project to, among others, the Producers' Council (for building materials manufacturers) and regional chapters of the AIA.[48] Gordon would continue to collaborate on climate control projects with research groups and builders, most notably in a joint venture with the Texas Engineering Experiment Station at Texas A&M University in College Station, Texas; together, they built an experimental room to test "natural ventilation of houses."[49]

Notably, other magazines began to adopt Gordon's language of climate control, albeit slowly. As just one example, *House & Garden*—always with its eye on Gordon—followed *House Beautiful*'s lead in publishing designs that accommodated local and regional climate variations. Its 1951 House of Ideas was a case in point. If *House & Garden* did not use Gordon's specific rhetoric of "regional climates," the editors (who, at that time, included former *House Beautiful* building editor Will Mehlhorn) did offer advice, with language that paralleled Gordon's, on how to "make your house more comfortable the year round" by incorporating appropriate ventilation, radiant heating, insulation, and roof overhangs.[50]

## Better Living in Any Climate: The Second Pace Setter House

For the Climate Control launch in October 1949, Gordon could only print sketches of the "ideal" climate-wise house. By November, she was ready to reveal a built example (fig. 48). She recruited architect Emil A. Schmidlin, Swiss-born and New York–educated, to design a house that could merge ideas from the Climate Control Project with the established Pace Setter program. Schmidlin's house, which became *House Beautiful*'s second Pace Setter, was important on three levels: it explored the practicality of better living outside the mild and informal climate of the American West, promoted so successfully in Cliff May's 1948 Pace Setter; it utilized *House Beautiful*'s new Regional Climate Analyses (published alongside the house); and it represented both of Gordon's two big editorial brands, Climate Control and Pace Setter.

Schmidlin's Pace Setter opened for tours in Orange,

New Jersey, in November 1949 (fig. 49).[51] Clearly referencing May's California ranch houses, Schmidlin anchored his low-pitched design with native stone and a massive fireplace. His main emphasis, and that of *House Beautiful*'s coverage, was on the principles that drove the design. Whereas May considered his Pace Setter House an enabler of a better and more modern way of life, Schmidlin used his Pace Setter to showcase better living through control of climate. May certainly addressed similar issues, though in Los Angeles he faced fewer

FOR STORY OF WHY SNOW HAS MELTED SEE PAGE 205

**49.** Schmidlin, 1949 Pace Setter. "Presenting *House Beautiful*'s Pace-Setter House for 1949," *House Beautiful* (November 1949).

**50.** Schmidlin, 1949 Pace Setter. "How to Look at a Pace-Setter House," shaped by Climate Control, *House Beautiful* (November 1949).

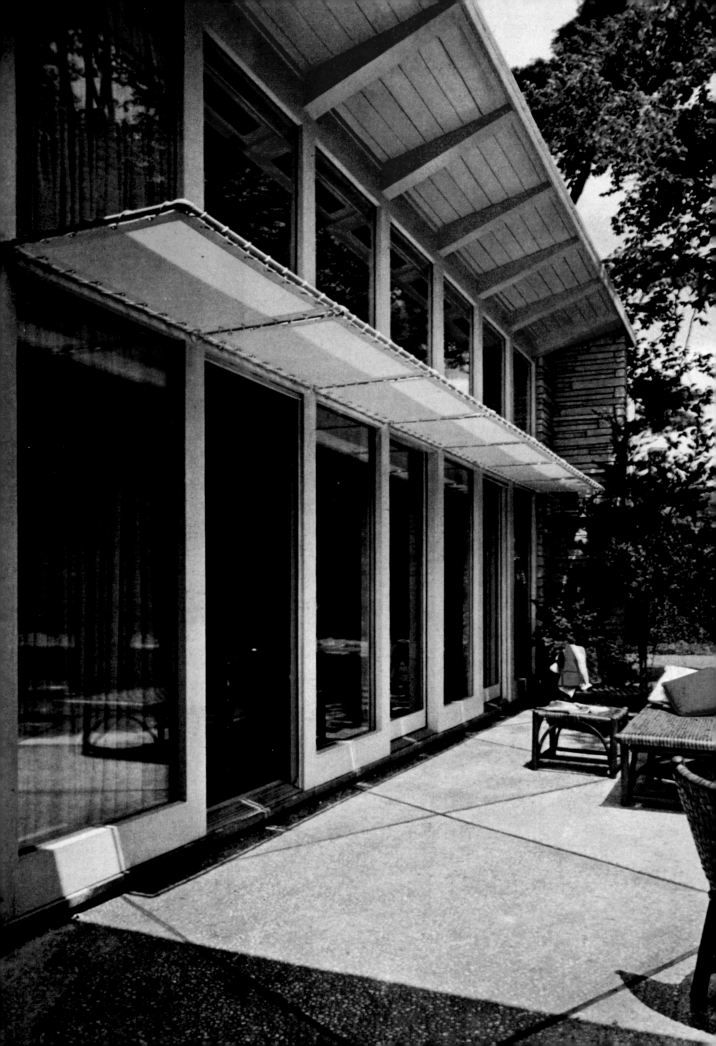

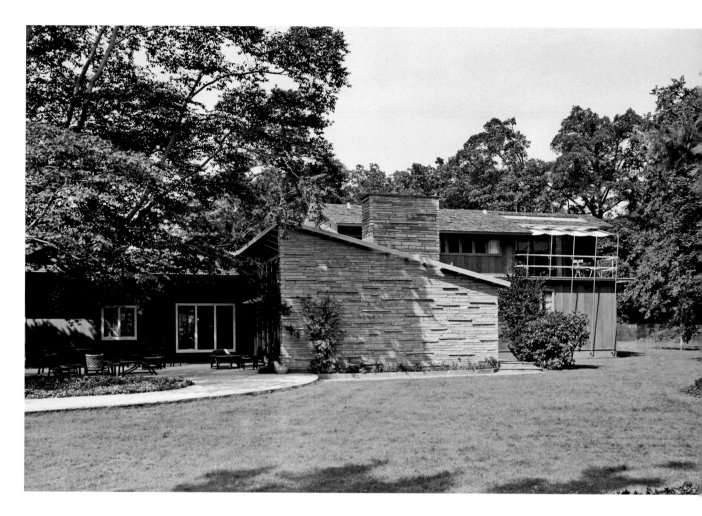

climatic extremes. Like May, Schmidlin was attentive to architectural features that provided for comfortable living indoors and outdoors, such as appropriate siting and shading mechanisms. His attention to regional climate and his use of climate control features demonstrated that an informal, outdoor lifestyle was indeed achievable outside of the temperate western climates.

*House Beautiful*'s concept of Climate Control was formative in Schmidlin's design, and Gordon published the relevant data (accompanied by the Climate Control logo) alongside his 1949 Pace Setter (fig. 50). He employed specific architectural solutions that allowed May's California lifestyle and ranch-type architecture to move east, particularly "winter-proof" glass walls and "sun control" devices.[52] These were prominent in the Pace Setter's "Great Room," a "new kind of informal living room, designed for year-round entertaining." Schmidlin's inclusion of "solar windows"—a bank of glazing designed to exclude midday summer sun and capture the heat and light in December—was crucial to the Pace Setter's year-round livability. The window-wall achieved further

flexibility with integrated screens that could be rolled out of the transom bars to convert the room into a screened summer porch.[53]

Schmidlin incorporated a secondary climate-wise element: a roof overhang and canvas awning or "eyebrow" that both provided shade in the summer and allowed the winter sun to penetrate and warm the interior (fig. 51).[54] Cross-ventilation was likewise a large concern, particularly in New Jersey's humid summer months, and the architect was careful to place openings in opposite walls of the Great Room. Cool air, forced heat, and in-floor radiant heating further served to make the Pace Setter comfortable in all seasons. The adjacent terrace, advertised as an outdoor living room, provided a logical extension of living space, which Schmidlin and the magazine claimed could be used "three seasons out of four" (fig. 52).[55] The

**51.** Schmidlin, 1949 Pace Setter. Great Room overlooking a patio, with sun shading.

**52.** Schmidlin, 1949 Pace Setter. Rear elevation, with tree and patio to the far left.

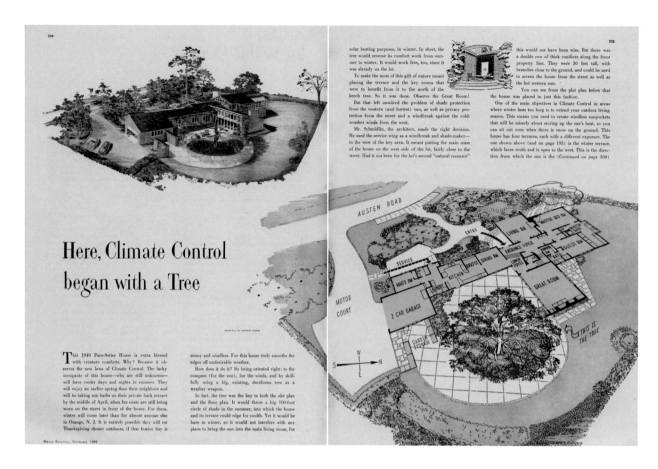

design of the entire house revolved around a large beech tree that provided both ambiance and much-needed shade (fig. 53).

Gordon was convinced that Schmidlin's Pace Setter House, with its reliance on good climatological data, would be an enviable success. Her greatest challenge, however, was to persuade her readers. Though she had used data to sell her viewpoint before—specifically "Desires Research" results—with the 1949 Pace Setter, architectural performance data, weather charts, climate maps, analytical sketches, and expert testimony played an unprecedented role.

While such "scientific" data may have been persuasive, Maynard L. Parker's photographs—which *appeared* to have been taken across four seasons—likely offered a more convincing argument. As several of Parker's unpublished images reveal, Gordon fabricated at least one of the Pace Setter's winter scenes by covering the entry and roof with "snow"; this was, in truth, not snow, but a roll of white felt laid by the magazine's staff (fig. 54). Other seasonal conditions were undoubtedly simulated for the benefit of Gordon's Climate Control polemic, but Parker's carefully cropped and selectively lit photos

never revealed the charade. Because Gordon's goal with the Pace Setter production was to sell ideas—here, a pace-setting house for any climate—the representation was always more important than the reality.

For Gordon, Schmidlin's Pace Setter made a grand statement about the flexibility of the California ranch house, an architectural trend that many critics had derided as strictly regional. Though the exterior aesthetic would have merged quietly into any neighborhood in Los Angeles, the 1949 Pace Setter was unusual (and remains so today) in its suburban New Jersey environment, which is replete with historicist revivals. Yet through extensive efforts to control the micro-climate, Schmidlin proved that this rather "casual," if not Western, modern architecture could become a comfortable domestic environment in any locale.

## Climate Control Postscript

Gordon had advocated for "designs for climate" from the launch of *House Beautiful*'s Climate Control Project in 1949, if not from the beginning of her writing career in 1937. By the early 1960s, she detected rumblings of a new

social and cultural interest in ecologically informed living. American values—and, by extension, design tastes—had shifted. Gordon was again on the front line. She was far ahead of the public and her media competition: the true beginning of the American environmental movement, spurred by the 1962 release of Rachel Carson's pivotal book, *Silent Spring,* was still at least two years away. Victor Olgyay's essential work in the field of architecture, *Design with Climate: Bioclimatic Approach to Architectural Regionalism* (1963), was likewise still on the horizon (and perhaps influenced by Gordon, as he was in the Washington, D.C., audience in 1950 when the Climate Control Project was discussed). The energy crisis of the 1970s, a great impetus for alternative energy experiments with solar and wind power, was still unthinkable.

In the early 1960s, as she forecasted the beginning of the American environmental movement, Gordon relied on a set of longtime *House Beautiful* contributors to explore emerging climatological issues. Chief among them was architect Roger Rasbach. Gordon met Rasbach sometime in the late 1940s, when he had begun to experiment with passive solar features, including reflective tile roofs. He had been raised in Southern California, and, in his architectural work, was influenced by Cliff May. Rasbach's early designs, so he claimed, were a continuation of May and a reaction to the "inefficiency of glass box modernism."[56] His relationship with Gordon was cemented when she sponsored and published his climate-wise "Good-Living House in San Antonio" in the March 1952 issue of *House Beautiful* (which roughly coincided with the Paley Commission's release of *Resources for Freedom,* a discussion of the declining stores of natural resources, overreliance on oil, and the potential of solar energy and other renewable energy sources).[57]

One year later, Rasbach debuted his passive and active climate control technology in what he called his Solar House, which Gordon published in 1953 as a *House Beautiful* Climate Control House.[58] For this and other projects (including his 1956 *House Beautiful* Climate Control House), he used data from the magazine's Climate Control program, and, later, climate studies produced by the Texas

A&M School of Architecture. His solutions focused in part on passive control elements, such as proper site orientation, walled patios, water features, and native plantings.

By 1961, conservation and environmentalism were becoming hot topics. Americans were talking about water and air pollution, oil shortages, and renewable energy (though it would take two more years for President John F. Kennedy, with Secretary of the Interior Stewart Udall, to pass significant conservation legislation).[59] In this shifting context, Rasbach designed yet another Climate Control House in San Antonio; this one doubled as *House Beautiful*'s 1961 Pace Setter (fig. 55). Gordon emphasized several themes with this house, including Rasbach's innovative space planning around a central atrium or garden room, as well as his capable incorporation of "traditional" Spanish design inflections that gave the house a regional "sense of place" and "individual flavor" (fig. 56), not unlike what Cliff May had done with his 1948 Pace Setter. But Rasbach's achievements in Climate Control dominated.[60]

Gordon, with the help of architectural consultant (and former apprentice to Frank Lloyd Wright) Curtis Besinger, reminded her readers that the climate in south

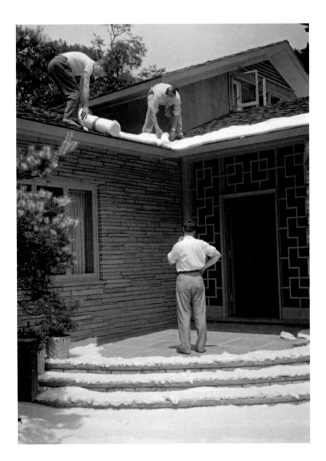

**53.** Schmidlin, 1949 Pace Setter. An architect-planned, climate-wise house built around existing landscape elements, including "the tree," *House Beautiful* (November 1949).

**54.** Schmidlin, 1949 Pace Setter. *House Beautiful* staffers spread "snow" (white felt) on the Pace Setter roof to stage a "winter" photo shoot.

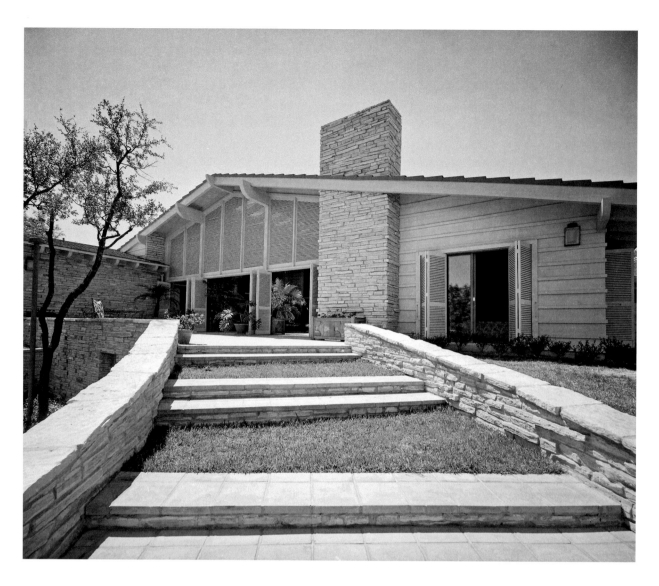

Texas was ferocious, and that Rasbach was mindful of these inherent challenges.[61] He designed the 1961 Pace Setter to be self-reliant; in San Antonio in the 1960s, this meant energy independent and climatically responsive. Rasbach relied on two technologies: passive systems for solar power and ventilation, and air conditioning. His method was to work with nature, not against it, though clearly his reliance on air conditioning was suspect. He packed the house full of familiar climate control systems such as overhanging eaves, louvered shutters for doors and windows, a ventilated and reflective roof, thick insulation, cladding in light colors, and a "buffer" of plantings.

Many of Rasbach's solutions were commonplace; a few were exceptional. The most dramatic among these was his garden room (fig. 57). This was at the center of the house, and its key feature was a sliding roof canopy (fig. 58). Propelled on rails, the canopy opened and closed at the push

of a button. This allowed significant air circulation, aided by ceiling fans during humid seasons. Rasbach included a small "atrium" pool in this space (this, too, fit into a popular trend of the 1960s). The house was spacious, elegant, and luxurious, and it set the pace for environmentally responsive architecture of the 1960s. Rasbach and Gordon were ahead of their time, and proved yet again that with Climate Control, *House Beautiful* was setting the pace for American architecture.

*House Beautiful*'s Climate Control Project, with its long history and longer legacy, underscores four important things about the forces that shaped American residential architecture at mid-century. First, design

**55.** Roger Rasbach, 1961 Pace Setter House, San Antonio, Texas, 1961.

**56.** Rasbach, 1961 Pace Setter. Living room.

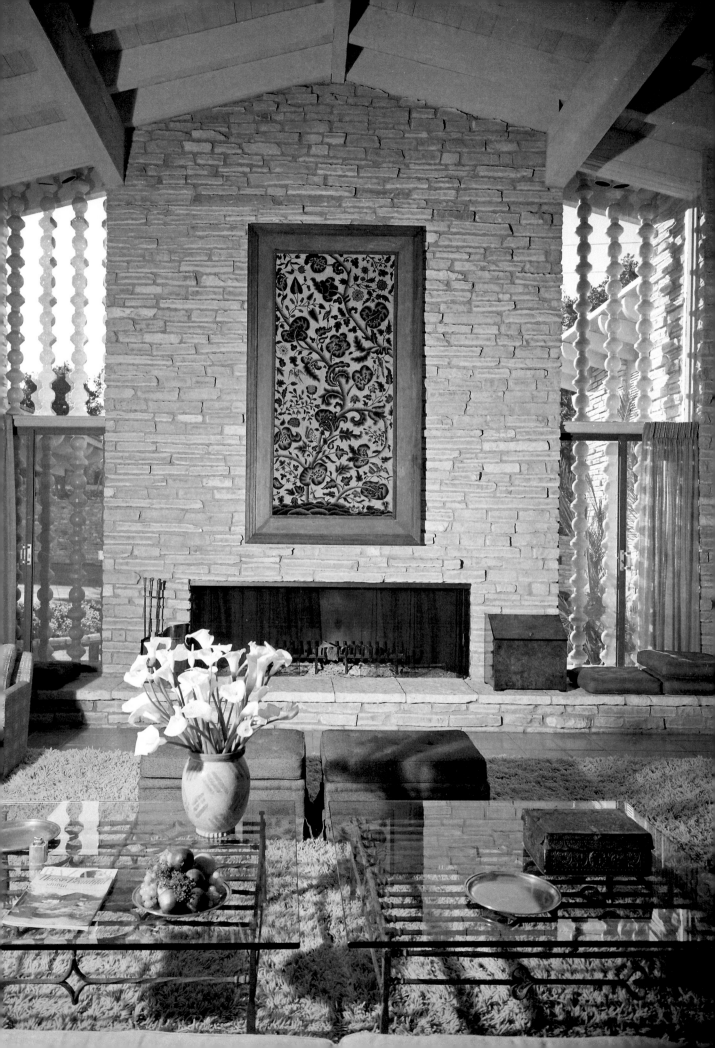

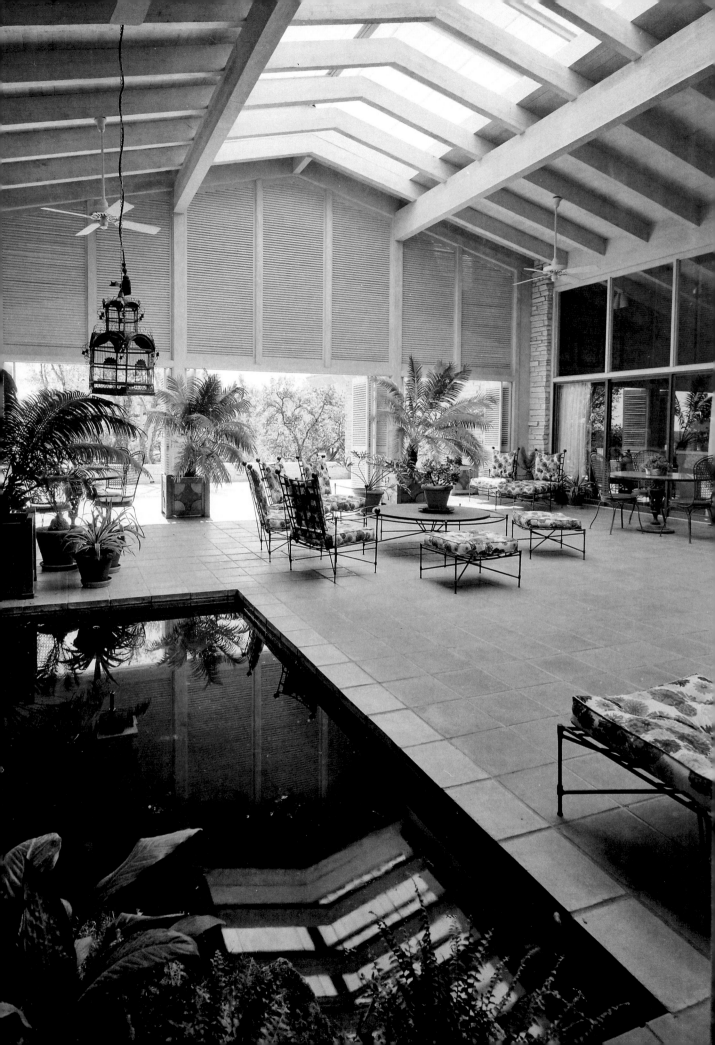

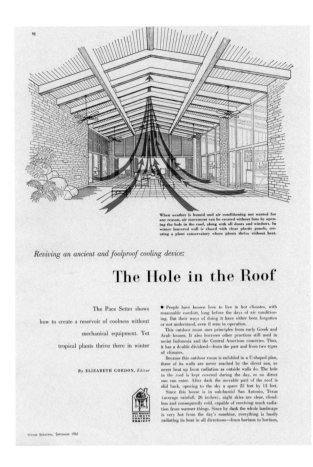

When weather is humid and air conditioning not wanted for any reason, air movement can be created without fans by opening the hole in the roof, along with all doors and windows. In winter louvered wall is closed with clear plastic panels, creating a plant conservatory where plants thrive without heat.

*Reviving an ancient and foolproof cooling device:*

## The Hole in the Roof

The Pace Setter shows how to create a reservoir of coolness without mechanical equipment. Yet tropical plants thrive there in winter

*By ELIZABETH GORDON, Editor*

● People have known how to live in hot climates, with reasonable comfort, long before the days of air conditioning. But their ways of doing it have either been forgotten or not understood, even if seen in operation.

This outdoor room uses principles from early Greek and Arab houses. It also borrows other practices still used in moist Indonesia and the Central American countries. Thus, it has a double dividend—from the past and from two types of climates.

Because this outdoor room is enfolded in a U-shaped plan, three of its walls are never reached by the direct sun, so never heat up from radiation as outside walls do. The hole in the roof is kept covered during the day, so no direct sun can enter. After dark the movable part of the roof is slid back, opening to the sky a space 25 feet by 13 feet.

Since this house is in sub-humid San Antonio, Texas (average rainfall, 26 inches), night skies are clear, cloudless and consequently cold, capable of receiving much radiation from warmer things. Since by dusk the whole landscape is very hot from the day's sunshine, everything is busily radiating its heat in all directions—from horizon to horizon,

HOUSE BEAUTIFUL, SEPTEMBER 1961

**57.** Rasbach, 1961 Pace Setter. Garden room and sliding roof canopy.

**58.** Rasbach, 1961 Pace Setter. Illustrations of the passive cooling device in the garden room, *House Beautiful* (September 1961).

movements were long in the making: "Tomorrow's House" became the solar house, the climate control house, the ecological house (of the late 1960s and 1970s), and perhaps today's "green" house. Second, a shifting American culture that prized data and information (not so different from today's) increasingly influenced design. Third, architects, builders, and homeowners benefitted, sometimes knowingly and sometimes not, from invisible alliances of unlikely partners: the Climate Control Project, a cooperative ideal, had many such collaborators, including the U.S. government (in its various research institutes), micro-climatologists,

the AIA, and a magazine editor. Lastly, and perhaps most importantly, the Climate Control Project pointed to a profound dissatisfaction with generic "mass taste" and inefficient mass design that inspired thinkers such as Gordon to search for scaleable "individual" or, here, regional alternatives.

The Climate Control Project also marks a decisive moment for Gordon: by 1947, she had become a recognized and respected player within the mid-century discourse on domestic architecture. She had learned how to craft and fund an influential research initiative and attract collaborative industry (and extra-industry) partners, both skills that she would utilize time and again over the coming two decades. She had also discovered methods of research and idea distribution that would move her editorial opinions beyond *House Beautiful*'s audience, to shape the direction of design from multiple vantage points. In this, Gordon's findings on climate became more influential than the magazine's regular offerings: these became part of a larger conversation about regionalism, modernism, and, ultimately, American design identity.

What remains fascinating about the Climate Control episode, which reached its peak popularity by 1952 but continued through the 1960s, is that Gordon's contribution remains relevant even today. Her Climate Control editorial program, which started as a small project to design better homes for comfortable living, was perhaps a seminal (and forgotten) early chapter in the evolving history of what we now understand as sustainable design.

# A New Look

A short year after *Vogue* introduced Christian Dior's transformative line of women's clothing, *House Beautiful* announced the "New Look" for postwar domestic architecture.[1] Just as fashion critics lauded Dior for his distinctive and liberating forms, Elizabeth Gordon praised architects for developing an "unmistakable style" that, for American design, stood for an emancipation from prewar and European precedents. For Gordon, the New Look in American housing was a cultural "Declaration of Independence."[2]

*House Beautiful*'s May 1948 "New Look" headline must have intrigued readers who eagerly awaited news of the latest design trends. Gordon used the New Look to convey innovation and modernity, but even she acknowledged that "the funny thing about 'the new look' [in architecture and home furnishings] is that it isn't really new."[3] What *House Beautiful* published as the New Look was instead a fusion of past and present design, with a contemporary or "modern" emphasis (fig. 59). The New Look was not simply modern, but an amalgam of both period styles and modern trends; it was a "melting pot" that, Gordon argued, had been adopted and adapted gradually over several decades. The aesthetic was important, but Gordon extended the New Look to convey a more comprehensive (and elusive) concept: it was both a style and a "way of thinking." In *House Beautiful,* the New Look became shorthand for both good design and a "modern state of mind."[4]

By packaging the New Look as both an attitude and an aesthetic, Gordon offered a pragmatic strategy to modernizing American domestic architecture. She specifically urged her readers to combine what they already had with what they could aspire to have. She reassured readers that they could apply the New Look to their homes in a slow and piecemeal manner without having to undertake an immediate or comprehensive design overhaul. Gordon advocated mixing traditional (the old and inherited) with modern (the new and up-to-date). She encouraged her readers to do so freely and at their own pace, so that their homes would reflect both the depth of their family's pocketbook and the breadth of their personal tastes.[5]

Gordon was not, however, willing to let those tastes develop untended. The New Look of 1948, subsequently recast as the New American Look and the American Style, was not just another report of trends-in-the-making. It was part of Gordon's larger effort to disseminate a modernist message, encourage what she defined as "good" modern living, and—most importantly—shape readers' design preferences. Her process was straightforward: she was quick to recognize, publicize, and capitalize on design change.

## The New Look and Modernization

Like many of her contemporaries, Gordon believed that design was shaped not so much by the "restless whim of single designers or groups of designers," but by larger "forces."[6] She introduced the New Look as an indicator of these forces. It expressed a domestic modernity layered with social, cultural, aesthetic, and technological dimen-

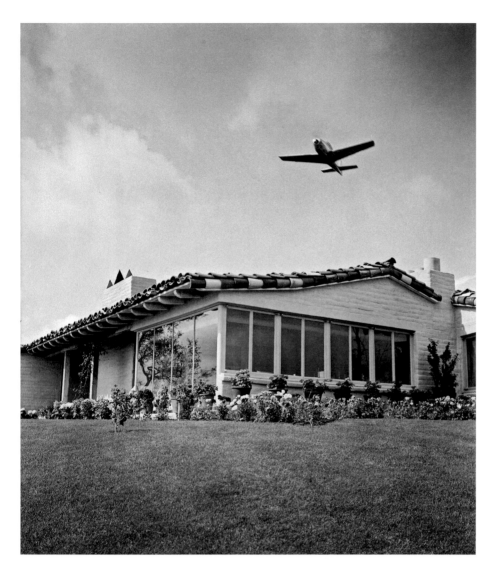

**59.** Cliff May, Garrett House, Valley Center, California, ca. 1948. May's house exemplified the fusion of "past and present" in *House Beautiful*'s New Look.

sions. In her editorials, she forged a strong link between the New Look and changing "national mental attitudes," shifting social values, and an emerging cultural desire for self-expression. These factors, coupled with advancing war-born technologies and modern materials (she singled out "glass and its serviceability in cold climates"), had the effect of, as she wrote, "speeding up change."[7] She used *House Beautiful* to chronicle this rapid transformation.

When journalists identified Dior's 1947 spring collection as a New Look, they signaled a shift in fashion from wartime utility to postwar luxury. This was the same sort of trend that Gordon projected for domestic design. Other editors, advertisers, and manufacturers had co-opted the term with enthusiasm, and she was no different. The "New Look" was, after all, a very good label. It seemed to capture just the right blend of optimism, novelty, indulgence, and vanity—all increasingly important for the postwar consumer.[8] From all vantage points, *House Beautiful*'s adoption of the New Look label was productive. It made for interesting and fresh copy, it attracted readers, and it guaranteed recurring advertisements from companies eager to promote their latest wares.

Though Gordon cast the New Look as "new," she did establish its historical lineage. In this, she had a twofold goal: first, to create a grounded paradigm for evolving trends and shifting tastes, both of which she hoped to influence; and second, to create an accessible body of design criticism that her readers could use to make their own informed design and purchasing decisions.

Over the course of two years, from 1948 to 1950, *House Beautiful* ran a series of articles that headlined the New Look. These showcased contemporary design, but also established a context and timeline (albeit subjective) for its evolution. Gordon wrote pithy editorials that

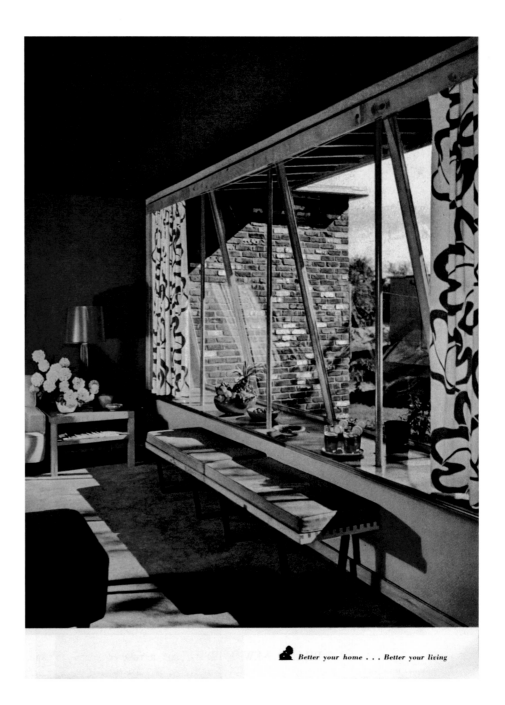

**60.** Technology, accessories, and the New Look, *House Beautiful* (March 1948).

*Better your home . . . Better your living*

connected broad changes in American life to extensive transformations in postwar design, though she rarely gave specific sociological data that quantified these shifts. For example, she linked the emergence of the residential "motor court" (a large, secluded driveway with attached garage) to the rise in automobile ownership and mass migration to the suburbs that "turned our streets into nuisances and robbed our home sites of their privacy."[9] Likewise, she tied the decline in "imposing" façades and front porches and the rise of obscured front entrances and private backyard patios (the new heart of the postwar house) to a growing need for unpretentious, private living.[10] She did, however, report some New Look trends without their social or economic triggers. For example, she could have explained the emergence of "engineered" and built-in storage in terms of a burgeoning (and unrestrained) consumer culture, the very foundation upon which the magazine's content was built; Gordon may have been critical of conspicuous consumption, but she happily promoted *continuous* consumption.

If Gordon provided an overgeneralized account of the cultural shifts that inspired the postwar design revolution,

she did offer substantive evidence of the New Look's technological modernity. While architectural journals of the same period covered new construction methods and structural technologies, *House Beautiful* frequently focused on new systems or products that could easily be placed in existing homes. The magazine ran scores of articles informing its readership about the latest advances in, for example, mechanical systems (especially radiant heating and centralized cooling), solar equipment, solar windows, and surface finishes. Gordon and her staff regularly reported on "well-engineered" storage space and furniture, "modern" appliances (dishwashers, "garbage grinders," and walk-in freezers), and low-priced but well-formed decorative accessories (fig. 60).[11] The magazine celebrated new goods for their technological capabilities, and simultaneously suggested both a social and cultural advance for the consumer: durable, cleanable products meant that less time and labor (either the homeowner's or paid domestic help's) were required to keep house. New household technologies provided, so the magazine implied, the quickest route to modernization.

## Americanness, Modernism, and the New Look

As part of the New Look campaign, Gordon created her own narrative history of modern design, inclined toward "American" accomplishments. The use of the label "American" as a parameter was problematic at best, and even Gordon recognized the amalgam of influences that had shaped contemporary design in the United States. Still, she insisted on using "American" as a geographical and cultural limiter, at least when constructing a history of residential architecture and domestic design. This brought certain designers and sub-movements to the foreground and shifted others to the background or, in many cases, fully out of the picture. In her version, "native geniuses," such as Frank Lloyd Wright, rather than émigré designers, such as Richard Neutra, Mies van der Rohe, or Walter Gropius, held particular sway.

Gordon's perspective was certainly biased, and her definitions were contradictory; yet her attempt to investigate the history of American modern design and share these findings (however flawed) with her readers was important. In this, she positioned herself alongside contemporary historians such as Henry-Russell Hitchcock and Sigfried Giedion, who were, at that same moment,

creating their own accounts of modernism's rise. Though Gordon offered little scholarly evidence, her tone was that of an expert who—as she so often wrote—had "seen it all."

With an eye toward the American Arts and Crafts movement and Frank Lloyd Wright, Gordon hinted at nineteenth-century "indigenous" roots for the postwar New Look, but she argued that critical moments of departure had occurred in the early twentieth century (with, for example, the work of Charles and Henry Greene). In a series of articles published between 1947 and 1948, she established the chronological development of New Look modern, with a starting point of 1927. This was the pivotal moment, she believed, when American architects dispensed with the front porch.[12] Though she went on to praise an emerging "technological culture" in design, she failed to mention a seminal event of that same year, one that was a focal point for historians and critics of European modern architecture: the Weissenhof-Siedlung in Stuttgart opened under the direction of Mies van der Rohe and the sponsorship of the Deutsche Werkbund, exhibiting modern single- and multi-family dwellings that would exemplify the emerging International Style. Most of these houses were, as Gordon would have noted, porchless.

This beginning date of 1927 was a seemingly trivial point, perhaps arbitrary, but it revealed Gordon's larger agenda. Her version of history rejected contemporary views that looked to Europe for modernism's beginnings, including the writings of Henry-Russell Hitchcock and Philip Johnson, who, in their 1932 book *The International Style,* had established 1922 as a pivotal moment. It remains telling that Gordon highlighted neither 1922 nor 1932 as a key date, apparently disregarding Hitchcock and Johnson's seminal text and accompanying *Modern Architecture: International Exhibition* at the Museum of Modern Art (MoMA).

If 1932 did not register for Gordon, the mid-1930s did. She recognized certain points in the design continuum where things began to shift—a constructed history based on, as she wrote, "houses which we [have] seen ourselves or read about in other magazines." She established 1935 as a turning point in her 1947 feature titled "The 12 Best Houses of the Last 12 Years." In this introductory editorial, she wrote of a "revolution that has taken place in the design of the American home," where, "for the first time in our history, a truly American and truly contemporary style has crystallized on a country-wide basis." She believed that "most Americans [were] unaware of this

revolution," significant as it was. Her goal, then, was to raise awareness: she dedicated an additional thirty-four pages and thirteen articles (including one for each of the "12 best houses") to doing just that. Gordon used four criteria as a "scoring system" to "judge" the revolutionary quality of the representative twelve houses: "good use of site"; "usefulness of interior spaces"; "pleasing design"; and "straightforward use of materials." Though each house scored well in each category, rated on a scale of zero to one hundred points, her choice to exclude all homes built before 1935 remained unconvincing. She wrote vaguely of "influences" that had waned, but gave little hard evidence that could pin a demise, or a rise, to a certain calendar date.[13] Why Gordon viewed 1935 as *the* watershed moment remains unclear—perhaps 1935 was simply an attractive date, an even dozen years from the article's publication. What is clear is that she seemed willing to select specific artificial moments for journalistic impact: a memorable headline mattered.

Just as Gordon recognized a change in the architectural landscape of the 1930s, she acknowledged that the "revolution" had stalled during the Second World War. In her New Look narrative, she noted the intermission and subsequent commencement. Design developments continued to flounder in the first two years after the war ended, but 1947 was, in Gordon's assessment, a national moment of "crystallization."[14] This was, even outside of *House Beautiful*'s account, a very big year. The U.S. Congress lifted wartime construction bans in June, and residential building recommenced.[15] In mid-1947, as the postwar housing boom came into full swing and was projected to continue well into the 1950s, *House Beautiful* began to actively encourage Americans to build anew or to remodel. Yet only a few months into her booster campaign, Gordon lamented that very few new homes truly reflected a design "revolution." Despite barriers to building good contemporary houses—including "bad examples," "unfriendly" bankers, and unfavorable zoning—she still remained optimistic that her well-informed readers could push the New Look into "maturity as a broad, nationally accepted form" of modern design.[16]

Though 1947 was a breakthrough year, Gordon believed that consumers and the building industry were still blocking modern design. She used her editorials to reprimand both. She prodded consumers to convert, asking dedicated readers of *House Beautiful* if they were "afraid to be different," or if they "really want[ed]

progress?"[17] She warned of the "dangers" of stagnation, of simply adopting the "narrow-minded" choices of friends or the inherited tastes of family. Instead, she encouraged each reader to "widen one's experience, to broaden one's present set of tastes, to seek new mental and visual experiences."[18] With these admonishments, she implied that *House Beautiful* was a positive and progressive influence. As a vehicle for introducing new "visuals" and new "experiences," the magazine's features from the immediate postwar years had an undeniable proselytizing tone.

*House Beautiful* partnered with designers, building professionals, developers, retailers, and manufacturers, and depended upon them for advertising income, yet Gordon openly criticized the building industry (just as she had denounced apathetic consumers). "The awful truth," she wrote, was that the building industry had thus far squandered "a God-given opportunity . . . to change the face of a nation." Americans suffered in outdated and unlivable homes because "reactionary, obstinate, restrictive, frightened of change, un-imaginative, profit-bent only, the building industry is turning out thousands of cracker boxes for thousands of veterans and non-veterans, all desperate and house-ignorant, clamoring solely for a roof over their heads, unmindful of their fearful destiny: the sickening realization a few years hence that they have mortgaged their incomes for houses which are ten to thirty years out of date—both in plan and materials."[19] With a projected one million houses to be built by 1948, Gordon pressed industry professionals to do better, and consumers to ask for more.

## Contested Modernism

In the context of new housing starts, *House Beautiful* examined the growth of New Look modern ("Is Modern Architecture Mature?") and surveyed its aesthetic content ("More a Way of Living Than a Style of Architecture").[20] The magazine undoubtedly promoted a modernist agenda, complete with a campaign focused on better living through good design, but Gordon still had to convince her readers that modern houses "belong to our way of living as much as maple sugar, Detroit automobiles, and a free education."[21] Though *House Beautiful* unabashedly used the term "modern" throughout the late 1940s, the magazine's text revealed an underlying public tension, manifested as an explicit "argument" between "Modern and Traditional styles."[22] Most home magazines, including *House & Garden* and *Better Homes*

and Gardens, also published stories on "traditional" versus "modern," but few engaged in controversy.[23] House Beautiful tackled the issue head-on, placating a seemingly anxious readership with adages such as "modern is not a style but a way of thinking."[24] By 1948, Gordon's audience was clearly questioning both the viability of the New Look and the livability of modern design.

In yet another watershed moment—one that received only a veiled reference in Gordon's editorials—the critical review of modern design registered as a full-scale professional debate in 1948. In the immediate postwar years, New York's MoMA was among the first to ask, "What Is Happening to Modern Architecture?"[25] In early 1948, MoMA Director Alfred H. Barr, Jr., hosted a public symposium in which this very question was posed to a select group of architects, scholars, and critics. Prompted by the 11 October 1947 installment of Lewis Mumford's column "The Sky Line," participants were invited to debate the purported development of modern architecture into two competing camps: the International Style, and what Mumford had termed the "new humanism of the 'Bay Region' school."[26] The panel, moderated by Mumford, included (among others) Henry-Russell Hitchcock, Philip Johnson, Walter Gropius, Marcel Breuer, Peter Blake, Edward Durell Stone, Eero Saarinen, and Edgar Kaufmann, Jr.

This group of influential architects and thinkers represented a vast range of irreconcilable viewpoints, and the symposium's hosts deemed the event a failure. The panelists could not successfully determine "what was happening," but they did define a new framework for debate: for many of the designers present, the question of "style" and "labels" was irrelevant. Gropius, founder of the Bauhaus School and a seminal figure in the development of the International Style, specifically urged his fellow architects to find a new approach rather than form a new "style." Others, including Bauhaus alum Breuer, argued that the "human" versus "functionalism" debate was likewise outdated by at least twenty-five years.[27] The real challenge for many of the panelists, including erstwhile opponents Hitchcock and Mumford, was far less adversarial: in a "society . . . in the process of a very profound transformation," modern architecture struggled to fulfill both personal and national needs for expression.[28]

The imperative debate, then, was not about a style or, as Mumford wrote, "any single mode of building," but about what form was culturally appropriate for postwar America. Even Hitchcock, moving past his formative role as the originator of the "International Style" label, anticipated "many possibilities of expression within the frame of reference of modern architecture." In an attempt to clarify Mumford's problematic definition of the Bay Region Style, Barr implied a middle ground: a "domestication of the International Style itself, a kind of *neue Gemütlichkeit* . . . to supercede the *neue Sachlichkeit* of the 1920's."[29]

Nevertheless, if only within the media hype, it seemed that two camps had emerged and would remain divided. On the one side, those who championed Mumford's Bay Region Style believed in an expressive American architecture rooted in native (or, rather, indigenous), human, regional, and emotive values, all executed in the democratic spirit and "romantic individualism" of Frank Lloyd Wright. Gordon was squarely in this camp. On the other side were those who supported the postwar International Style, a revised or "mellowed" form of 1920s European design that pioneered advances in mechanized, industrialized, functionalist modernism.

It remains unclear whether Gordon or her staff attended the MoMA symposium, though it is quite likely that they did. Whether she was present or not, the dialogue exchanged there reverberated within House Beautiful for years afterward. She had previously published articles that addressed a tension between "traditional," "modern," and "compromise" design, but content published shortly after the MoMA symposium confirmed both the rift between modernists and House Beautiful's own stance in the debate.

By mid-1948, House Beautiful was clearly aligned with Mumford's camp; after 1952, he became a semi-regular contributor to the magazine. His presence was a great boon, as he was a respected writer, historian, urban planner, and critic, known equally for his social musings and architectural critiques. He had, by 1952, written twenty-six books, including The Story of Utopias (1922), Sticks and Stones: A Study of American Architecture and Civilization (1924), The Brown Decades: A Study of the Arts in America, 1865–1895 (1931), Technics and Civilization (1934), and Roots of Contemporary Architecture (1952). His hundreds of articles (nearly 650 upon his retirement) appeared in a variety of periodicals, from the New Republic to Harper's, Scribner's, Fortune, Saturday Review of Literature, Good Housekeeping, the Journal of the American Institute of Architects, Architectural Record, and Pencil Points; the bulk of his writings, after 1929, appeared in his regular "The Sky Line" column for the New Yorker.[30]

*House Beautiful* staff writers co-opted Mumford's phrasing and echoed his assessment that "modern architecture is past its adolescent period, with its quixotic purities, its awkward self-consciousness, its assertive dogmatism."[31] *House Beautiful's* Jedd Reisner, writing "Modern but Not *Too* Modern" just a month after the MoMA symposium, used Mumford's very words: "House architecture has come a long way since Modern had the too clean-shaven look of adolescence. Now that it has approached maturity, developed character and warmth of personality, it is easier to live *with* as well as *in*."[32] Gordon, too, would use Mumford's language (such as "dogmatism") to describe the International Style—five years later.[33]

Within the larger architectural discourse of 1947 and 1948, *House Beautiful's* New Look took on a new meaning: it positioned the magazine and its editor firmly on one side of an increasingly heated debate over "modern." As the 1940s drew to a close, the fate (not to mention the look and content) of modern design remained highly contested. The 1948 MoMA symposium, and Gordon's response to it, was a divisive moment. Designers, critics, and the architectural media anticipated a real shift. They all recognized that powerful "social forces" were, more than ever, "shaping modern architecture," no matter whether it was termed New Look, Bay Region Style, or International Style.[34] In the subsequent years, science, technology, economics, politics, and, significantly, mass media and the popular press would come to play an even larger formative role. Gordon in particular would have appreciated George Nelson's concluding remarks at the MoMA symposium of 1948: "Most of what happens to architecture is out of the hands of architects."[35]

## The "River of Taste"

By 1949, "what was happening" to modern architecture seemed squarely in the hands of two forces: the shelter magazine and the American consumer. Architects and the professional press were still a part of this increasingly public dialogue, but the "likes and dislikes" of consumers, as expressed in popular print media, played an increasingly decisive role. Gordon was quick to recognize the importance of consumer backing. But, as *House Beautiful* features indicated, she must have suspected that her readers were hesitant to adopt modern architecture under any definition. Still, she remained adamant. She believed Mumford's "humanistic" and regionalized

version of modern was the way forward; at the close of the 1940s, she redoubled her efforts to convert the American public. Gordon implemented two new promotional strategies in 1949: a pictorial scheme to validate design change and further influence shifting public tastes, and the simultaneous re-branding of "modern" (and the New Look) as the presumably less contentious New American Look.

Gordon, who grew up in a household ruled by "obsolete" traditions and an overbearing grandmother, was clearly frustrated with a public who remained unwilling to shed "old" ideas and "familiar" designs.[36] She wanted progress. And she wanted the American public to want progress. To this end, Gordon and her staff encouraged readers to embrace the "incontrovertible force of change," writing that "what was good enough for your grandfather *isn't* good enough for you. Indeed, what is good enough for you today won't be good enough for you ten years from now."[37] This admonishment was meant to shake Americans from their entrenched ways, inspire them to explore new avenues (even if the unfamiliar was frightening), and, surely to the delight of *House Beautiful* advertisers, to buy new stuff. In an American culture recovering from two decades of scarcity, *House Beautiful* provided a rationale for acquiring new goods and, by extension, a justification for postwar consumption in general.

Gordon believed in the power of pictures, both hand-rendered and photographed. Under her editorship, *House Beautiful* became increasingly visual. The magazine employed large-scale images, sketches, charts, oversized headlines, and short captions that together conveyed messages that would have otherwise been embedded within lengthy blocks of text. In the February 1949 issue, she and her staff devised a graphic scheme intended to help *House Beautiful* readers cope with postwar change, navigate new design choices, and influence what designers and manufacturers brought to market. Implicit here was Gordon's desire to convince readers to adopt the New Look. Thus, in a powerful display of both pictorial persuasion and visual psychotherapy, *House Beautiful* published its own paean to "changing times": the "River of Taste" (fig. 61).[38]

Acting as one part psychologist, one part social scientist, and one part popular magazine editor, Gordon used the "River of Taste" to map readers' "likes and dislikes" to currents of social, technological, and personal influence.[39] This graphic, and the accompanying text, were surely meant to ease anxious minds and offer an explanation for

contemporary design developments. Gordon once again positioned *House Beautiful* as a trusted expert (and therapist), as if someone might show the two-page spread to her grandmother as justification for dispensing with the family's Sheraton sofa. The "River of Taste," published in a contrasting color scheme of white, gray, and turquoise, conveyed *House Beautiful*'s message: change is complex, inevitable, and to some degree beyond individual control. In light of this, so the magazine implied, it was perfectly acceptable to abandon outmoded traditions and to think, live, and buy in a modern way.[40] Gordon clearly believed that American consumers were apprehensive, fettered by inherited mindsets and paralyzed by what psychologist Barry Schwartz has since dubbed (in 2004) the "paradox of choice."[41] The content of the "River" was likely intended to both soothe and persuade readers. Whether or not it was successful, it demonstrated that, in 1949, Gordon and her staff had an unusually sophisticated understanding of the mechanisms of influence.

The "River of Taste," with its "tributary streams" of influence, synthesized arguments that Gordon had presented previously in the magazine: social, cultural, economic, and technologic forces shape personal taste. Gordon's "River of Taste" flowed into four main tributaries: science, the "state of the world," "psyche" or "personality makeup," and "daily living." The visual logic of the graphic was hierarchical. Larger branches of the river diverged, forming smaller streams and rivulets, just as broad conceptual categories such as the "state of the world" might yield subgroups such as "social and economic conditions of your time," "your family pattern," "results of war," "scarcity of household help," and "your relation to your community."[42]

These concepts, and particularly the words and phrases Gordon used to describe them, were carefully selected—and most could be linked to other *House Beautiful* features. In the same February 1949 issue, for example, "scarcity of household help" (which, in the "River of Taste," was part of the "state of the world" stream, and flowed into "you do your own work") provided the conceptual framework for three separate articles. In the subsequent ten pages, the magazine explained "what you need to know" about new labor-saving household appliances such as mechanical sinks, dishwashers, and garbage disposals.[43]

The visual signals present in the "River of Taste" were arguably as significant as the phrases used. In the "River" graphic, the text curved and wandered, so the visual metaphor of flowing water remained clear. Hierarchy was employed to express the significance of certain ideas: relative importance was indicated with alternating text colors, and the type size decreased as the most important ideas gave way to lesser "brooks and rills."[44] These, too, were visually coded to indicate hierarchical importance of the concept (or the category of impact on taste). The larger categorical concepts, such as "science" or "your daily living," were presented in large, boldface type; these flowed into secondary streams, indicated by smaller, white text. These in turn flowed into increasingly less important ideas in even smaller print. For example, the major branch of the river termed "your daily living" fed four smaller branches, and one of these was labeled "your contacts with other people's tastes." Off this branch, in decreasing type size, were "reading," "newspapers," "magazines," and (in the smallest type) "advertisements."

Every major and minor branch of the "River" would have been familiar to regular *House Beautiful* readers. The ideas organized within this system of taste appeared frequently, though not always in the same context, within the magazine. Readers would have recognized the "tributary streams of experience" in the broad category of science, as *House Beautiful* often wrote of an "engineered approach to living," "planning for weather and climate," "wind and sun studies," "the solar house," "planning for space and step-saving," "multi-purpose furniture," and the "compact kitchen." Or, in the tributary of "technology," readers would have been familiar with discussions of new materials (including advances in heating and lighting, plastics, new fabrics and finishes, and radiant heating) and electricity (including factory-made necessities, prefabricated parts, automobiles, radios, planes, telephones, and labor-saving devices). Readers might have also taken note of the flow of some channels and the termination of others. The "River of Taste" featured several "swamplands," which clearly indicated areas of contemporary life that *House Beautiful* believed were cultural dead ends: religion, ephemeral fashions, and passing fads.[45]

The "River of Taste" illustrated in simple graphic language Gordon's core belief that "influences change with the times."[46] For a popular magazine that lacked any

*Overleaf*
**61.** The "River of Taste," *House Beautiful* (February 1949).

# The one thing you can't change is change

by Marion Gough

*You can't stay set in your ways.
You might as well try to stop a
flowing river as to keep yourself
immune from the changing influences
that make you like what you like*

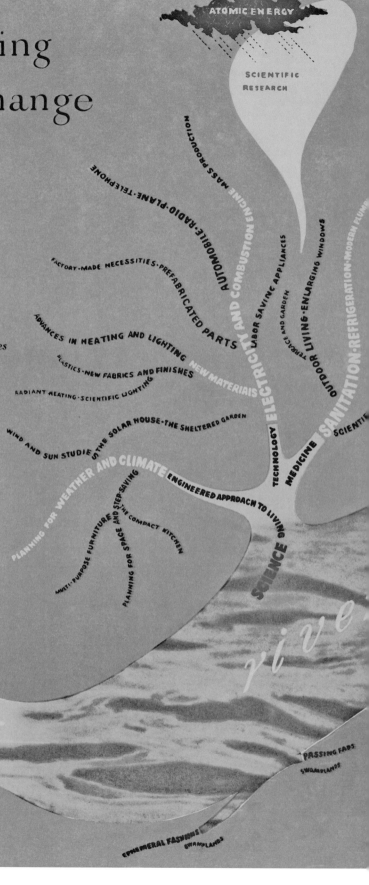

W hat was good enough for your grand-
father *isn't* good enough for you. Indeed, what
is good enough for you today won't be good
enough for you ten years from now. Because
you can't escape the incontrovertible force of
change. As the world changes, you change.
And whether or not you're conscious of it, you
are constantly accepting the new thinking and
living habits which change brings about.

That is why you cannot conscientiously say,
"I will have none of Modern." For Modern is
the world you are part of, the world of the
telephone, the automobile, penicillin, central
heating, buffet suppers, sun lamps. And you
have already proved that you *will* have Mod-
ern because you have accepted these products
of the changing times.

To give you an idea how all this comes about,
we picture your taste as a fluid river, fed by
countless tributary streams of experience. Note
these tributaries well. It would take a life-size
map of Texas and a course of psychoanalysis
to show you all of them and how they inter-
twine, influencing each other as well as you.
But our map will show you what the basic
influences are.

The broad rivulets indicate the influences
which, at any time, (Continued on page 115)

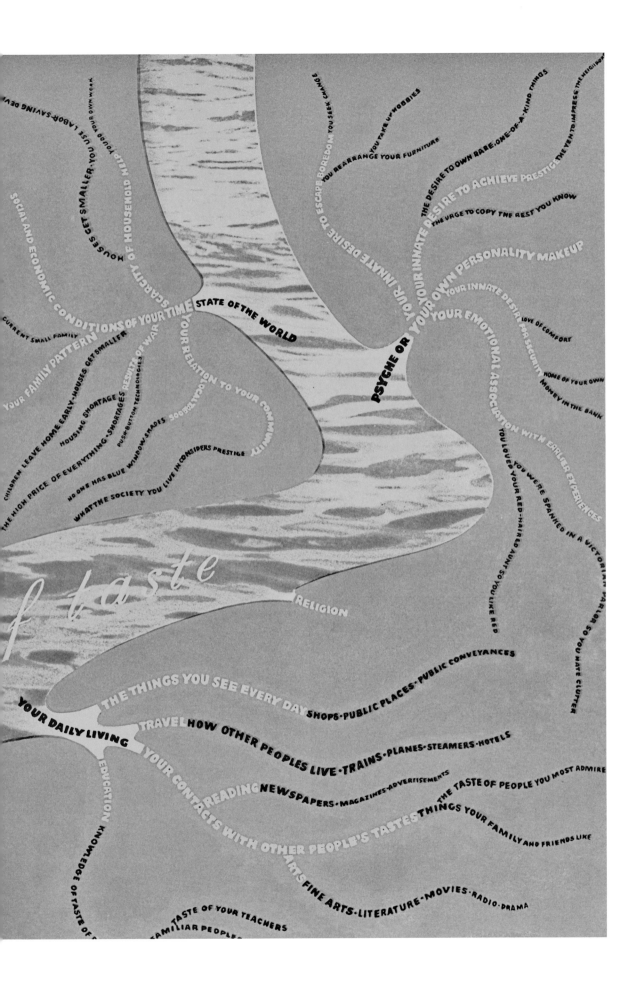

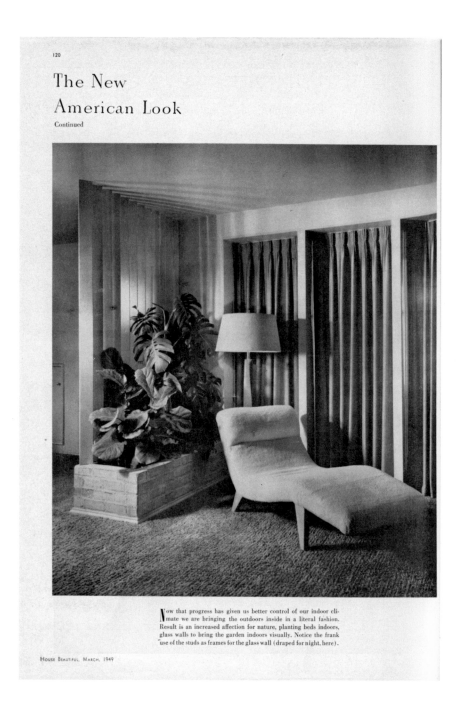

The New
American Look

Continued

Now that progress has given us better control of our indoor climate we are bringing the outdoors inside in a literal fashion. Result is an increased affection for nature, planting beds indoors, glass walls to bring the garden indoors visually. Notice the frank use of the studs as frames for the glass wall (draped for night, here).

HOUSE BEAUTIFUL, MARCH, 1949

**62.** "The New American Look" in interior design and furniture, *House Beautiful* (March 1949).

**63.** Allen Siple, Paul Trousdale House, Palm Springs, California, ca. 1947.

affiliation with the cultural avant-garde, *House Beautiful* projected a fairly progressive attitude toward change. The "River" was, on the one hand, an explanation of the ebb and flow of public taste. It was, on the other hand, a map—and perhaps a justification—for Gordon's style of reporting. It showed that she was conscious of the larger cultural forces, or streams, that affected design decisions and consumer choice. The significant features she published in this period were all mapped to one of the four main tributaries depicted in the "River of Taste." Science and technology, the "state of the world," personal "psyche," and "daily living" were all, in one form or another, present in the magazine's content.

Surprisingly, one of the smallest streams of the "River" was labeled "magazines." By this point, it was increasingly clear that under Gordon's leadership, *House Beautiful* was no longer a minor rivulet of the larger river of taste-making. Her magazine, if not others, was in fact becoming a physical repository in which readers might find the entire "River," and all of the forces that shaped contemporary society. And Gordon intended to use each of these forces to both inform and sway her readership.

## The New American Look

The "River of Taste" primed *House Beautiful*'s readers to understand and accept change, to welcome new influences, and to embrace new trends. In the very next monthly issue, March 1949, Gordon introduced one of these: the New American Look (fig. 62).[47] Though she declared that "a changed look is appearing on America's residential scene," in aesthetic terms the "new" style was indistinguishable from the previous year's New Look. What was new in the "look" for 1949 was the overt emphasis on "American."

The announcement of the New American Look was a re-branding. It was an attempt to excite readers and, in the wake of the "River of Taste," persuade them to notice and adopt current trends. There was, however, a sense within Gordon's rhetoric (the article was simply titled "The New American Look") that she was proceeding with editorial caution. She may have feared that the contemporary debate over both "new" and "modern" that had divided the architectural profession during the

MoMA symposium would alienate readers and deter consumers. She instead sought to avoid controversy by insisting that the New American Look was non-contentious, and that it "wins friends without argument." In this mediated description of the New American Look, she acknowledged a lack of precision in the moniker: she again suggested that the "new" was a fusion of "old and new architectural forms." She reprised the argument that had accompanied the announcement for the New Look in 1948, and again praised the "virtues" of combining "architectural inheritance" with the "good in Modern." She saw design as "evolutionary," as a continuous and uniquely American process summed up by her phrase "our melting pot is still melting."[48]

Alongside her article, Gordon offered her readers a built example of the New American Look in architect Allen Siple's home for Mr. and Mrs. Paul Trousdale in Palm Springs, with landscaping by Edward Huntsman-Trout and furniture by Greta Magnusson Grossman (fig. 63). The published images illustrated what would have been, by this point, a familiar architectural

# House Beautiful

NOVEMBER
50c

language. *House Beautiful* had showcased Siple's houses before and ran similar homes in the preceding three years, including Walter Wurdeman and Welton Becket's First Postwar House (1946), Cliff May's Pace Setter House (1948), and the houses that were published under the "New Look" headline. In fact, the Trousdale House appeared in *House Beautiful* prior to its use as an exemplar of the New American Look: it had been featured on the cover in November 1947 (fig. 64). If the "look" of the Trousdale House featured the familiar aesthetics of the low, rambling roofline with deep eaves, clean-lined structure, unadorned surfaces, and outside-inside spaces (with prerequisite large windows opening onto spacious patios and a swimming pool), what then was actually "new" or specifically "American" about this house?

The short answer lies not in the architectural content of the house, but in *House Beautiful*'s interpretation. Here, Gordon chose to foreground what she defined as the "Americanness" of the house. Employing a recurring layout strategy, she used large-scale images, short captions, and abbreviated text to suggest a "native" and simultaneously national context for Siple's design. To underscore the most important or "marked characteristics," she provided a full-page image in full color depicting the "beauty of our native building materials: stone, undressed wood boards, brick, textured concrete, rough framing lumber." In what would become an often-used phrase, she went on to proclaim that the Trousdale House was a premier example of "honest material, honestly used." She complimented American architects who adopted this mode of design for "forgetting the fakery of the early part of this century, when we tried to make one material look like another."[49] Though the Trousdale House clearly belonged to the burgeoning California ranch house movement (which Gordon had written about since at least 1946), she ascribed the building's low form to a broader tradition, the "farm-building idiom" that is "everywhere in rural America—regardless of climate or racial inheritance."[50]

With this statement, Gordon linked the ranch houses of California—the exemplars of regional or western tradition—to a shared national context for the development of a new architectural brand, what she called the New American Look in 1949, and by 1950, simply the American Style.

**64.** Siple, Trousdale House.
On the cover of *House Beautiful*
(November 1947).

# Chapter 7

# The American Style

At the beginning of the 1950s, American designers and consumers alike struggled to establish their individuality and simultaneously position themselves within an evolving national identity. In this context, Elizabeth Gordon shifted her editorials to address issues of "character" in a more studied manner. Between 1949 and 1950, she and her staff used *House Beautiful* to test two pivotal questions: "What makes us American?" and What is "characteristically American" about modern American design?[1] In this line of inquiry, she no longer used "American" and "modern" as mere stylistic labels, but as terms with serious architectural and social import.

As the debate over modern—specifically, the Bay Region Style versus the International Style—escalated within the professional press, Gordon continued to position herself as a proponent of what she termed "American" modernism. Her end goal remained much the same as it had been for years: to inform the consumer, shape taste, and influence design. But by 1950, her editorial strategies became far more complex, nuanced, and authoritative. Implicit in all of her new strategies was the notion of opposition, as Gordon positioned her definition of American modern design to directly challenge the International Style.

## What Is American about American Design?

Gordon had asked the question "What is American about American design?" in one form or another since the early 1940s. Even then, the question was not new. As historian Wanda Corn has shown, a group of artists and critics (both American and European) working in New York after the First World War began to "invent" and write about "a new art, distinctively modern and American."[2] The "roots" of the "American" question, then, rested in the discourse initiated by figures such as Alfred Stieglitz, Georgia O'Keeffe, Marcel Duchamp, and, importantly for architecture, Lewis Mumford. The conversation continued into the Depression years, forwarded by, among others, the "populist artists" associated with regionalist art.[3] Architects, too, worked to formulate their "Americanness," including, as architectural historian Christopher Long has argued, modern designers such as Paul Frankl.[4] By the 1940s, when Gordon started writing, cultural nationalism was again on the rise, surely spurred by, as Gordon suggested, yet another influx of artists, designers, and architects who threatened to supplant (some feared) the established Americanists—some of whom were born in the United States, and others who had immigrated during the first decades of the twentieth century. The Second World War and the ensuing Cold War again stirred the American question, this time embedded in a particularly charged nationalist rhetoric, and Gordon contributed significantly to this discourse.

It was at this moment, in May 1950, that Gordon announced "the emerging American Style" (fig. 65). This was, she declared, an "unmistakable" American design movement that had "finally matured."[5] She had

*House Beautiful*

MAY 1950

# The Emerging American Style

*The first completely rounded presentation*

*of the fact that American Design has*

*finally matured into an unmistakable style*

**65.** Gordon announces "The Emerging American Style," *House Beautiful* (May 1950).

published its nascent form for years, so that in the long thread of *House Beautiful* editorials, the American Style was a continuation and re-branding of her New Look or the New American Look. Yet in 1950, she emphasized the "national" viability of the style, a mature mode of design that could be tagged (to borrow a line from Ralph Barton Perry) as "characteristically American." Her definition of "American" was biased and convoluted, yet not uninformed, as she argued that specific "traits," rather than a cohesive aesthetic, made American design "American." Among the most important characteristics, all described and illustrated in the magazine, were performance, convenience, comfort, and informality.[6]

Gordon introduced the American Style as a national design language with social implications.[7] It was, she argued, the physical manifestation of the American way of life and American character, something that had developed gradually from "grass roots origins" and grew from "region to region, from social group to social group." For Gordon, the American Style was found in and applicable to most designed objects, from architecture to interior design, landscape design, and the decorative arts.[8] This

conclusion was, of course, conveniently aligned with the design content she regularly delivered in *House Beautiful* (including, for example, Edla Muir's Hall House in Los Angeles; fig. 66).

As Gordon defined the American Style in terms of design—embodied, in one article, by a Chrysler station wagon, a Cliff May ranch house, and Paul Frankl's "Station Wagon" furniture—she also illustrated the accompanying "way of life" (fig. 67).[9] She argued, often convincingly, that architecture framed a sociocultural value system, which in turn inspired architecture and design. Like many editors working in the 1950s, she was enamored with the romantic (and certainly romanticized) picture of suburban California living: happy families living gracious, carefree, leisured lives inside "worry-free" houses and outside on private backyard patios, all free from pretension (fig. 68).

For Gordon, the American Style was modern, yet part of a long lineage of design evolutions with deep roots in the late nineteenth and early twentieth centuries (fig. 69).[10] *House Beautiful*'s staff, including James Marston Fitch and Jean Murray Bangs, helped establish the origins of both the American Style "attitude" and its corresponding design aesthetic. Both writers pointed to a broad range of design sources, including the work of H. H. Richardson, Louis Sullivan, Frank Lloyd Wright, and the Greene brothers. Fitch further acknowledged the formative role of Japanese architecture and European modern design, including the work of Le Corbusier, Walter Gropius, Mies van der Rohe, and Alvar Aalto. These influences were, in his estimation, "profound," yet American design had continued to evolve through a "process of selection, adaptation and modification to the special conditions of American life." This transformative process had yielded a "new" version of modern American architecture that was, as Bangs later described, "freed . . . from the burden of having to use borrowed forms."[11] For Fitch and Bangs—and for Gordon, too—the American Style had become an autonomous line of modern architecture, and, importantly for the development of American cultural identity, served as a sort of "architectural Declaration of Independence" from the past "dominance" of European form.[12]

Though Fitch (more so than Bangs) wanted to establish a broad, international lineage for the American Style, Gordon generally promoted it as "native" and "regional"; as such, it became not only an alternative to but a criticism of what Gordon would later disparage as the "foreign" and "generic" modernism of the International Style.

Alongside Fitch's and Bangs's histories, Gordon offered succinct essays that taught her readers to "understand" and "recognize" the American Style; "What Makes Us Americans?" was particularly direct.[13] Gordon opened the story with an image of Ralph Barton Perry's book *Characteristically American* (1949), the source of her borrowed phrase; she went on to highlight eight character "traits" of American citizens that translated to qualities of American Style design:

> We believe in freedom from set rules or style dogmas; our idea of democracy is to level upward; we like to pack several functions into one product; we have a passion for convenience; we borrow ideas from the whole world, but alter them to be typically American; we have always tried to make housework easier; we have a talent for simplification; and we have high standards for physical comfort.[14]

**66.** Edla Muir, Zola Hall House, Los Angeles, California, ca. 1951. The Hall House exemplified "What the American Style House Looks Like," *House Beautiful* (November 1951).

**67.** "The Station Wagon Way of Life," photographed at a Cliff May ranch house, Los Angeles, California. *House Beautiful* (June 1950).

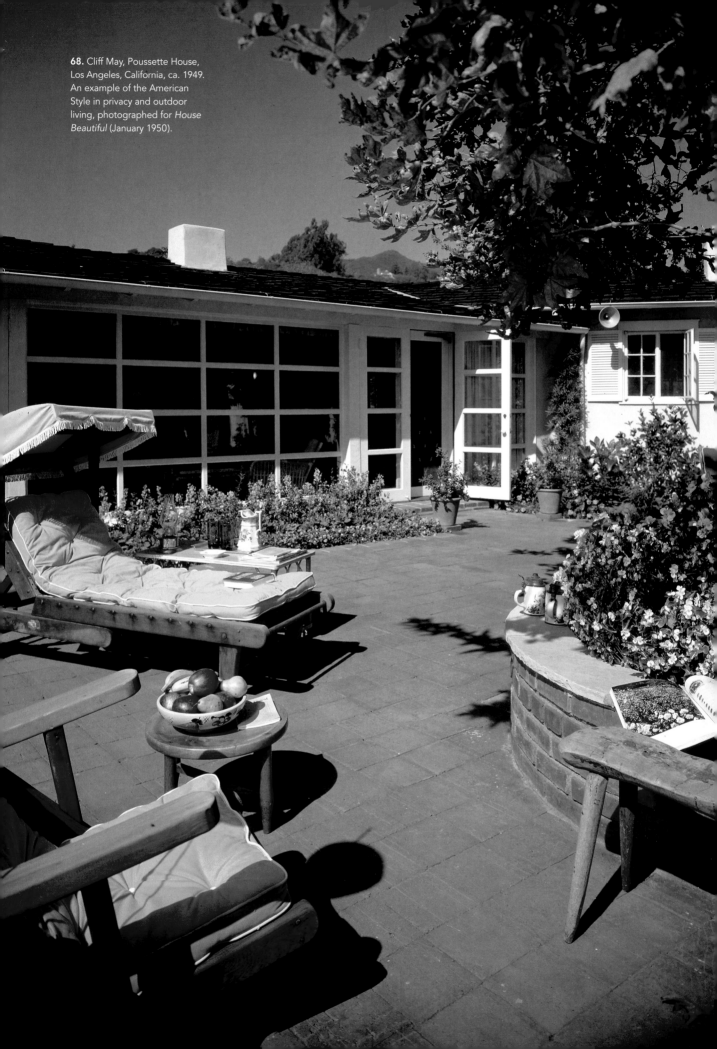

**68.** Cliff May, Poussette House, Los Angeles, California, ca. 1949. An example of the American Style in privacy and outdoor living, photographed for *House Beautiful* (January 1950).

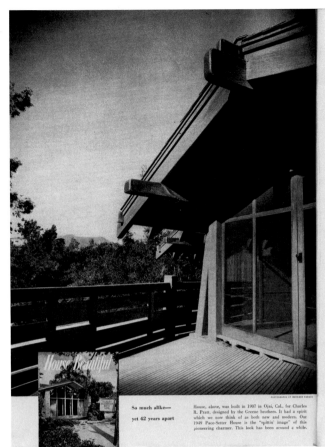

(123)

The New American Style
grew from
America's Way of Life

An American eagle butter stamp—
used by a dairy in the early Nine-
teenth Century to identify its product.
From the New York Historical Society.

by Elizabeth Gordon
Editor

Yes, America is finally developing its own Style. This is amazing news to most people. But what is more amazing is that it was not recognized and joyfully proclaimed 10 or 15 years ago. For the signs of it have been everywhere around us, varying in frequency and clarity from region to region, from social group to social group.

We have not been quick to recognize our new American Style because of its grass roots origin. Its very familiarity has made it hard to see, and made us take it for granted. Were it not for the unusual opportunity that we, as Editors, have to travel everywhere and see everything, we might not have gained the broad, social perspective necessary to realize that America has, at last, produced its own art forms.

For nearly ten years, HOUSE BEAUTIFUL has been gathering evidence, tracing origins of design, sifting truth from propaganda. At last we are ready to announce, for we are sure, that an American Style has been born, and is growing into maturity. In the next issues, HOUSE BEAUTIFUL will show you dozens of examples of how our American Style looks and works—in various regions and in many sides of life. Here are 38 pages to introduce you to your own new offspring.

For the new American Style has been created by us Americans and has grown from the traits of our American Character. All of us, including our ancestors, have made a contribution to it. All national styles have been the product of the society in which they grew. Because this country was founded so people could have a better life, it was inevitable that our social values would cause us to reshape our imported art forms, as well as eventually produce our own. Now, after 175 years of trial and error, the manifestations of a completely American Style are clearly appearing in the major arts of architecture and landscape, and in the minor arts of furniture, fabrics, china, silver, glass, and the like.

This new kind of beauty has evolved from our talent for manipulating the practical, the everyday, the ingenious, the technical. It has emerged because we have finally realized that our present environment matters more than our heredity.

As a result, a new spirit and look is appearing all over this country—in our houses, our habits, our behavior. It is significant because it shows that we want to live for ourselves and not for the effect on other people. (Fifty years ago, this was not true.) Now we want to live comfortably, cheerfully, easily, without fuss. We don't want to be slaves to our possessions, like some of our grandparents who were still under the influence of European attitudes and manners. We want our houses and their furnishings to serve us, to pamper us, to leave us free. It is not American to "put on side," so our manners have become less formal and less ostentatious. Consequently, our styles have limbered up, become less formal and less self-conscious, and freer to do what needs to be done, regardless of the rules.

All styles are social manifestations. So when we develop a style of our own, rather than copy others, it is a sure sign of greater social maturity.

The best guide to recognizing our new American Style is this: *See how it works.* Unless it offers some gain or improvement in performance over that of previous things, it rules itself out, even though it may look new, and look American. Only if it works better is it eligible.

We give you, on page 158, a set of criteria for recognizing this Style which is already everywhere around us. But, before you can use these criteria, you will need to understand how our Way of Life has produced a Style. When you see that this American Style is really an American *point of view*, then and only then are you ready to apply the standards by which you recognize it.

So much alike—
yet 42 years apart

House, above, was built in 1907 in Ojai, Cal., for Charles R. Pratt, designed by the Greene brothers. It had a spirit which we now think of as both new and modern. Our 1949 Pace-Setter House is the "spittin' image" of this pioneering charmer. This look has been around a while.

**69.** Greene and Greene, Pratt House, Ojai, California, 1907, and Schmidlin, 1949 Pace Setter. American Arts and Crafts are shown as the "roots" of the American Style, *House Beautiful* (May 1950).

Gordon's language was one of inclusiveness: she used the pronouns "we" and "ours" to engage her readers, and to demonstrate that *House Beautiful*'s editors were part of the American "melting pot" responsible for formulating a shared design tradition and a shared national identity.

In "What Makes Us Americans," Gordon's new art editor, John English, applied a consistent visual formula to a series of images that conveyed the gradual development of American Style objects (fig. 70). English laid the pages out in a grid, with three columns across four rows. The first column contained the caption for one of the eight American "traits"; the remaining spots were given to small black-and-white illustrations of houses or furnishings—for example, chairs, tables, and case goods. The first image (reading from left to right) generally showed a vernacular example of a common object, and the final image in the series depicted a contemporary up-market version of the same type of object. For example, when

*House Beautiful* wrote that "we have high standards of physical comfort," the first illustrative object was a Shaker rocker dating to 1858, and the final image in the series was an adjustable club chair from Dunbar, dated to 1950.[15] In this one sample article, *House Beautiful* established a lineage and historic precedents for the American Style. The "roots" spanned everything from Mission to Queen Anne. The successors, or so the magazine intimated through its images, comprised a list of contemporary designers and manufacturers that ranged from T. H. Robsjohn-Gibbings to Cliff May, from Widdicomb Furniture to Davidson, Ltd.

Though Gordon saw herself as a truth-seeking educator who stood apart from the vast propaganda machine that she criticized, articles such as "What Makes Us Americans?" revealed that she was equally biased—and, in fact, the author of a similar publicity campaign. What she accomplished was nonetheless significant: she

coined a new term for a "mature" design movement and converted that term into a recognizable national brand complete with a distinct graphic identity.

Gordon's years in advertising certainly trained her well, as she devised a sellable name and paired it with a trademarkable stamp, or logo. This editorial strategy was effective, if not new for *House Beautiful:* Gordon had used the same approach in 1946 when she launched the phrase and logo "Better Your Home, Better Your Living." Likely with the assistance of her art editor, Gordon designed the American Style logo to use alongside the magazine's editorials. *House Beautiful* ran three variants of the American Style logo, all adapted from a turned-wood butter mold that had been used by a nineteenth-century dairy (see figs. 69 and 70).[16] The first version featured an eagle with outstretched wings, flanked by stylized branches

(possibly sheaves of wheat or an olive branch), all captured within a banded circle. A second version of the logo, created at about the same time, contained the eagle surrounded by the phrase "This Is American Style" (fig. 71). *House Beautiful* developed a third variant, used for stamping Pace Setter Houses; this one depicted an eagle encircled by the words "Pace Setter" (fig. 72).

The content of the American Style logo, in all its variations, was a clear indicator of Gordon's agenda. The eagle was already an established American symbol. As the national bird and the official emblem of the United States, prominently displayed on the nation's Great Seal, the eagle stood for the "unique" nature of all things American (in that the bald eagle was believed to only inhabit North America). As a national icon, the eagle was tied to notions of boundless freedom and unrestricted

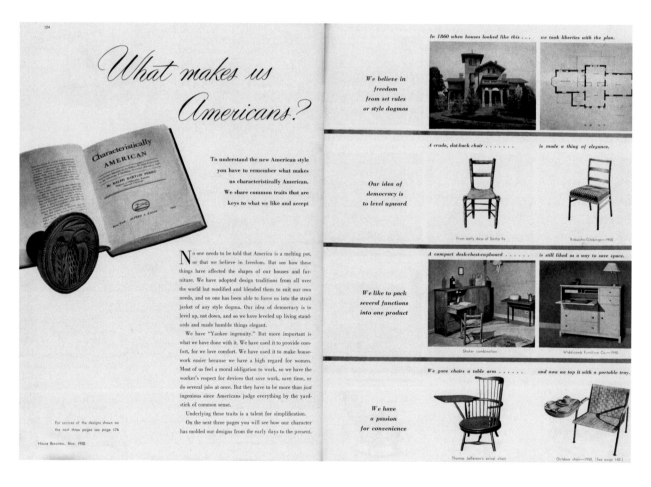

**70.** "What Makes Us Americans?" *House Beautiful* (May 1950).

**71.** "How to Recognize a Style Trend," with the American Style logo (lower left), *House Beautiful* (January 1951).

**72.** The American Style logo, integrated with the Pace Setter brand, *House Beautiful* (May 1951).

democracy. Gordon's appropriation of the eagle motif thus implied similar ideals. And because the American Style logo was derived from a nineteenth-century butter mold, it invoked simpler times and past traditions that underpinned Gordon's American Style.

Gordon used the American Style logo as a stamp of approval. In this, it was both a consumer service and marketing strategy, not unlike the "Better Your Home" stamp or *Good Housekeeping*'s "Seal of Approval." The American Style logo, like the *Good Housekeeping* seal, functioned as a visual endorsement from *House Beautiful*'s editorial staff (if not from the parent Hearst Corporation) and a universal indicator of Gordon's certified "good" modern design.

## The (Unofficial) American Style Manifesto

To provide a material counterpart and theoretical framework for the cultural values bound up in the American Style, Gordon outlined a specific set of design principles. Her May 1950 article "How to Recognize the American Style" was an unofficial manifesto, in the grandest of modernist traditions (fig. 73). The article paraphrased several key tenets drawn from modern architectural theory,

and many of these approximated Frank Lloyd Wright's principles of organic design. Among the nine points presented, *House Beautiful* placed a particular emphasis on purpose- and site-specific design, honest use of natural and common materials (reminiscent of both Wright and the Arts and Crafts movement), frank expression of structure, and the use of "integrated" rather than "superfluous" architectural ornament.[17]

Gordon's preference for a softer, humanistic (and "naturalistic") version of modern design was evident, yet technology still ranked high: it was third on her list. She argued here and elsewhere that advancing technologies made "things perform better, wear longer, require less upkeep."[18] In this context, though, consumer technologies outranked advancing construction techniques and to some degree industrialized materials and processes. This emphasis underscored a key difference between the American Style and its International Style competitors (most obviously, Le Corbusier). For Gordon, the American Style "harnessed" technology for the domestic interior, in the form of appliances, gadgetry, new maintenance-free materials, heating, ventilation, or solar shading. Significantly, the American Style—meant to be adopted in suburbs across the nation—adeptly

## *How to Recognize*
# The American Style

*Its design should be agreeably fitted to its purpose.* If it is a structure, it should fit its environment. If it is a garden, it should take advantage of its site, the needs of the family who will use it, and be so constituted that it is beautiful twelve months of the year. If it is furnishings, it should perform effectively and simply—without tortuous, stylistic tricks.

*Its materials should be honestly and appropriately used* with some indication that their nature and capacity have been understood, appreciated, and made the most of—not made to imitate something, or complicated beyond their true nature.

*It should take advantage of our numerous technologies* (if they pertain) which can be harnessed today to make things perform better, wear longer, require less upkeep.

*It should have no superfluous ornament* which is tacked on as an afterthought to the basic design. It may have ornament, but it must be integrated ornament. Our American talent for simplification is enormous, and some of our most beautiful things are the simplest.

*It may be reminiscent of our past,* but it will be a *modified, simplified, almost impressionistic version of the original.* If we do use the past, it is because of its usefulness, not because it is "an authentic copy." If it is "periody," it is most likely to be a derivation of some of our older, native American design idioms like Cape Cod, Shaker, Pennsylvania Dutch, Spanish, etc.

*It may be Modern,* but it will be an American version of Modern, not a straight European version. Again the adapting, modifying concept applies, for we change what we import.

*It should have the appeal of the familiar.* We Americans like the new, but in practice we want the radically new to have some familiar link to its previous prototypes.

*It should appeal to common sense.* Americans' reaction to the intellectual stunt or trick is "so what." We do not judge things intellectually, but by common sense.

*It should combine beauty and utility,* for in the best American design they are indivisible. Neither abstract beauty nor mechanistic utility is enough by itself. We Americans want both.

House Beautiful, May, 1950

**73.** "How to Recognize the American Style," *House Beautiful* (May 1950).

accommodated the most influential technology of the twentieth century: the automobile. This was, after all, the architectural analogue to what Gordon had described as the "station wagon way of life." American Style carports and push-button garages were, therefore, synchronized with the latest consumer enthusiasms.

Perhaps most importantly, the "how-to" guide presented an architectural language that was specifically "an American version of Modern," albeit an adaptation and simplification of both past American design traditions and the "European version" of modern design.[19] The past work of architects such as H. H. Richardson, Frank Lloyd Wright, and Greene and Greene were of particular importance, and *House Beautiful* praised these designers elsewhere in the magazine.[20] Gordon believed that this "native" brand of modern would appeal to an American sense of beauty, utility, and common sense more so than the "intellectual stunt[s] or trick[s]" that she believed were the trade of European modernists, particularly those associated with the International Style.[21]

Through short features such as "How to Recognize the American Style," Gordon codified a national style,

provided a forum for its popularization, and attempted to unite members of what had thus far been a fragmented architectural movement. Her approach publicized alternative models of modernism, disseminated these to the broader public, and, perhaps most significantly, signaled that the postwar consumer (the "we" in all of her stories) had been and continued to be a vital part of the American Style's evolution.

## Expert Endorsements

Gordon had employed professional experts as consultants or guest contributors since the beginning of her editorship. With the American Style campaign, she wanted to substantiate her claims with outside cultural expertise, and so she drew upon figures whose names would have been familiar to an educated public—for example, through recently published books. Gordon read widely and was constantly "self-educating," and she hoped to transfer her curiosity to her readership. More importantly, though, Gordon wanted to supplement her own voice of authority—as she had penned in a 1950 headline, "You Don't Need to Take Our Word for All This!"[22] She would act as a guide, but she wanted her readers to gather enough information and experience to think for themselves.

After Gordon's announcement of the American Style, she began to feature pedigreed experts more frequently. Among them was the American philosopher Ralph Barton Perry. Perry, a faculty member at Harvard and a leader in the New Realism philosophical movement, was a force in defining what it meant to be "American" at mid-century. In the May 1950 issue of *House Beautiful,* Gordon published the frontispiece from his 1949 book *Characteristically American* twice, on two different pages. These illustrations served as proof that respected scholars such as Perry, operating outside the venue of *House Beautiful,* had come to recognize a new set of values in postwar culture, and agreed (with Gordon) that these values shaped postwar domestic environments.

Perry and Gordon both used the term "characteristically American" to describe and defend a fledgling independent national culture. In the escalating Cold War, it was of the utmost importance to thinkers like Perry, and thus to cultural mediators like Gordon, to promote American achievements in politics, economics, and the arts. In *Characteristically American,* Perry argued that the very core of American character was a shared national investment in individuality. For Perry, America's emphasis on the individual did not necessarily lead to a nation of selfish, isolated citizens, but rather to a culture based on "collective individualism."[23] While "collective" could have been a dangerous term to use in the heated political climate of 1949, Perry was careful to define "collective" not as a group mentality resulting from corporate, institutional, or governmental control, but rather as the "manyness of distinct individuals" in social cooperation.[24] This was key for Gordon, who eagerly promoted the idea of "manyness" in modern American design. For her, the "American cast of mind" was unique, as Perry contended, and therefore had logically, inevitably birthed a distinctive national style of architecture.[25]

With individualism as a core component of the American Style in everything from architecture to landscape to fabrics and glassware, Gordon expanded the concept to include the notion of a "democratic" design for a democratic nation, or, simply put, "better things available to more people."[26] She set out to convince the *House Beautiful* audience—the beneficiaries of a democratized mass media—that democracy in design was essential to the postwar good life. Democracy in design enabled a certain freedom within the American Style, presented as the design equivalent to Franklin D. Roosevelt's 1941 "Four Freedoms" (freedom of speech, freedom of worship, freedom from want, and freedom from fear).[27] Though Roosevelt described the values and benefits of American democracy to reassure and mobilize a nation on the brink of war, Gordon appropriated his rhetoric to define the values and benefits of American design: the freedom from set design styles; the freedom from the past (or to choose without obligation to tradition); the freedom (and means) to buy for comfort and convenience; and—most importantly—the freedom to participate in the design process. Gordon's belief that an informed consumer could influence the future of domestic architecture, paired with Perry's concept of "leveling up" (the raising of living standards and design standards from the bottom upward), was essential to the future success of the American Style.[28]

Other critics might have eschewed the notion of democratic or mass design, but Gordon was adamant that mass availability (to a wide socioeconomic swath of American consumers) did not necessarily threaten quality. She argued that true democratic design would instead prosper under a reduced price tag, where expense was

decreased through a process of simplification. More specifically, designers and manufacturers could reduce costs by eliminating nonessential features and ornamentation. These ideas were of course not new and had been circulating for nearly a century through various reform movements, chief among them English and American Arts and Crafts (with which *House Beautiful* was closely linked during the late 1890s). What was new, and what Gordon traded on, was postwar excess. The sheer increase in consumer goods, buyers' desire for domestic products, and access to quality information was unprecedented. And this was, to put it simply, why Gordon was so compelled to position *House Beautiful* as the public, democratic voice for American design.

Though Gordon promoted what she understood as a distinctive American Style, she understood that "contemporary design" was far from consistent or monolithic or, for that matter, singularly "American." She recognized that American design benefitted from the fusion—or "melting pot"—of many traditions. But as *House Beautiful* accurately observed, by 1950, American designers had gained a certain amount of independence and "self-confidence."[29] In the wake of this revelation, *House Beautiful* again adapted Perry's arguments to emphasize the "unmistakable flavor" of American design:

> We select and reject, and the things we select we modify. We may borrow a line or a motif or even a whole design, but we discard the rest. We adapt our borrowings to our own purposes. We simplify them. We make them more comfortable, more convenient, and easier to care for. Some things we make more informal, others, more elegant. We judge their performance, not by intellectual theories, but according to common sense. The emerging American taste is for simplified things that work.[30]

*House Beautiful*'s emphasis on simplicity and utility was significant. Gordon and her staff wanted to encourage an understanding and desire for functionality as something that performs in an efficient manner, setting up a clear opposition to the machine-age functionalism of European modernism. Though Gordon often employed experts to bolster her social arguments, her particular interest in function and performance was presented without grounding in intellectual theory. This reflected a growing anti-intellectual sentiment common within the American architectural community in the 1950s. With *House Beautiful*, Gordon (like many of the postwar designers she published) sought to bring modern ideas and a contemporary aesthetic to the mainstream without "burdening" the public with "esoteric" theories. The contemporary preference was to build according to straightforward criteria and common sense.

By linking architecture to the broader cultural phenomenon of individualism and the political future of democracy, Gordon based her promotion of the American Style on the belief that "all styles are social manifestations." The emergence of a national style of architecture, then, had necessarily developed from a national "social maturity."[31] This was a vital argument and an important effort to boost national self-confidence. Gordon, in "You Don't Need to Take Our Word for All This!" referenced at least five experts (including cultural critics such as Perry, Lewis Mumford, and Arthur M. Schlesinger) who believed that the United States had approached this maturity (fig. 74). She argued that in the few short years that followed the Second World War, distinct American art forms such as the New York School's Abstract Expressionism had emerged. And new forms of architecture were following. This, she contended, could occur only when "a new nation stops being timid, apologetic, and imitative."[32]

As the United States grew in economic and political power, it faced competition on all fronts, and the assertion of cultural dominance (and cultural independence) became a national concern. Gordon and her *House Beautiful* staff participated in a sophisticated exploration of cultural developments, addressing larger issues than those typically covered by women's journals and home magazines. Without implying elitist intellectualism, Gordon critically positioned her editorial policy to achieve these goals. She not only commissioned essays by significant figures, but also recommended that *House Beautiful* readers study other important "social observers and thinkers" of the day, from Perry and Schlesinger (then a social critic and professor of history at Harvard) to Ralph Linton, Sigfried Giedion, and Lewis Mumford.[33]

The use of experts strengthened *House Beautiful*'s authority on both American culture and American architecture, but the point of view expressed within the magazine remained carefully curated. Gordon handpicked experts with whom she agreed. She published quotes that

perfectly illustrated her arguments. She recommended books of which she approved. And she selected illustrations—carefully framed photographs of carefully chosen houses—that fit into the model of American design that she wanted to promote. Though her language was that of freedom and democracy, her approach was in fact controlled and controlling. Her job was to select, to frame, and to edit. In doing these things, she formed a vision of American modernism that was at best incomplete and at worst myopic. Despite the problematic nature of her construct, Gordon's systematic approach to taste-making was both perceptive and powerful.

## The American Style Pace Setters

Gordon "sold" her newly defined American Style to her readers through a series of small houses published in 1950 and 1951. Four of these were double-branded as Pace Setters and, in fact, triple-branded as Climate Control Houses. Three of these were designed as model homes, intended as publicity for merchant builder David D. Bohannon's new tract development in San Mateo, California (fig. 75). Bohannon's approach to residential architecture, refined during his activities as a defense builder during the Second World War, was to provide the best design at the best price.[34] This certainly appealed to Gordon, whose *More House for Your Money* still guided *House Beautiful*'s editorial position. Bohannon had a "common sense" attitude toward building, and his tract houses were a perfect fit for Gordon's American Style campaign.

As had been the case with Fritz Burns's Postwar House (but not with Cliff May's 1948 Pace Setter), *House Beautiful* did not control the production or marketing of Bohannon's Pace Setters. This remained the purview

**74.** "You Don't Need to Take Our Word for All This!" *House Beautiful* (May 1950).

*Overleaf*
**75.** David D. Bohannon (builder), "3 Pace-Setter Houses," San Mateo, California, 1950. *House Beautiful* (June 1950).

STRONG PREVAILING WINDS

See how each house deflects wind and embraces morning and early afternoon sun.

# 3 Pace-Setter Houses
## and what they mean to you

*The best things in life CAN be enjoyed by most Americans. But they don't fall in your lap; they have to be reached for. By keeping abreast of the newest ideas, you'll know what to ask for. In each of these $25,000 Pace-Setter houses all three of the BIG ideas of 1950 are merged*

Take the Big Idea of Climate Control. These houses are in a region of fairly strong winds and moderate temperatures. The weather is definitely "marginal." Twelve months a year the wind blows from the west at an average speed of 6½ m.p.h. Only in July do afternoon temperatures run over 80° F.; for five months they'll be in the seventies; and for the rest of the year, they'll never climb above the mid-sixties. Although these houses are in San Mateo, in the San Francisco Bay area, the famous "California-type living" would not be possible without *wind control*. With it, these houses have a good private climate.

*So how do you control the wind? Turn the page to go back to the beginning* ...........................................

DRAWING BY VINCENT FURNO

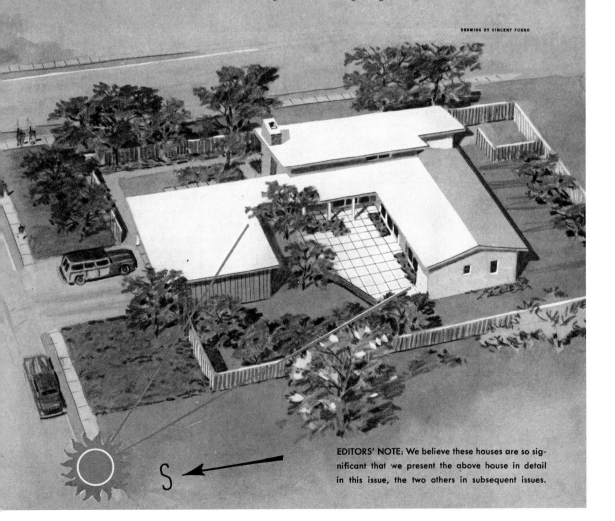

S ⟵

EDITORS' NOTE: We believe these houses are so significant that we present the above house in detail in this issue, the two others in subsequent issues.

of Bohannon and his supervising architect, Edwin Wadsworth (fig. 76). Regardless of *House Beautiful*'s secondary role, the magazine was able to use Bohannon's model homes to illustrate the "3 Big Ideas of 1950," including the American Style, Climate Control, and privacy (fig. 77).[35] On the whole, these three Pace Setter Houses were unremarkable. But what was notable was that Gordon proved to her readers that American Style "good living" was attainable at a "good value." The core components were straightforward: "moderate cost" (each house sold for $25,000), simple climate control mechanisms (good orientation with regard to sun and wind), siting that guaranteed "privacy" from neighbors, "common sense" materials, and interiors designed for "casual good looks and easy maintenance" (fig. 78).[36]

The fourth American Style Pace Setter was a bit more compelling: Julius Gregory's 1951 house in Dobbs Ferry, New York (fig. 79).[37] Gregory's project was again triple-branded as American Style, Pace Setter, and Climate Control. The house, just a few blocks from Elizabeth Gordon's own home, provided the perfect opportunity for *House Beautiful* to express the regional and, simultaneously, national viability of the American Style. If Bohannon's three 1950 Pace Setters reminded readers that the American Style was intimately tied to "California-type living," Gregory's 1951 Pace Setter extended that link eastward (in much the same way that the 1949 Pace Setter had).[38] The analogue between the California Pace Setters—including the 1950 houses and Cliff May's inaugural (and pre-American Style) 1948 Pace Setter—was reflected in Gregory's use of a low-profile roofline, U-shaped plan, fireplace core, and sheltered patio (fig. 80). The interior was not quite "modern"; despite the pitched ceiling with exposed rafters and window-walls opening onto the patio, the house remained confined, hemmed by a dominant blue-tile fireplace and warren of compartmentalized rooms (fig. 81).

The innovation in Gregory's 1951 Pace Setter—and the area where it most successfully represented the American Style—was its domestic technology. The most

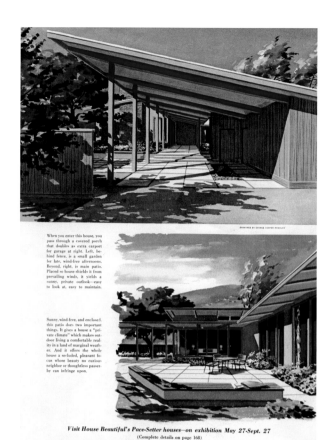

Visit House Beautiful's Pace-Setter houses—on exhibition May 27-Sept. 27
(Complete details on page 168)

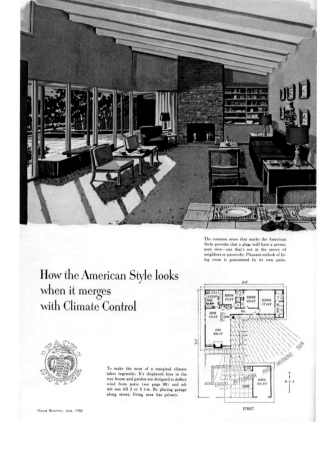

How the American Style looks
when it merges
with Climate Control

**76.** Edwin Wadsworth for David D. Bohannon, 1950 Pace Setter (#1), San Mateo, California, 1950. *House Beautiful* (June 1950).

**77.** Wadsworth for David D. Bohannon, 1950 Pace Setter (#1). Sketch, living room with view to the private patio, demonstrating the "merger" of American Style and Climate Control, *House Beautiful* (June 1950).

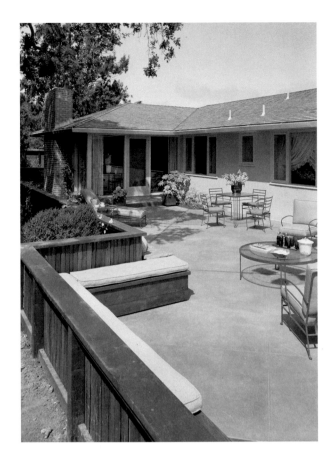

*House Beautiful*
MAY 1951

*Defining the*

# AMERICAN WAY OF LIFE

*executed in the*

# NEW AMERICAN STYLE

Once a year House Beautiful devotes a whole
issue to showing a home which is perfect and complete to the smallest detail, and which represents
the best current values. This one symbolizes what the average American now has,
or can reasonably expect to achieve by his own endeavors under the American democratic system

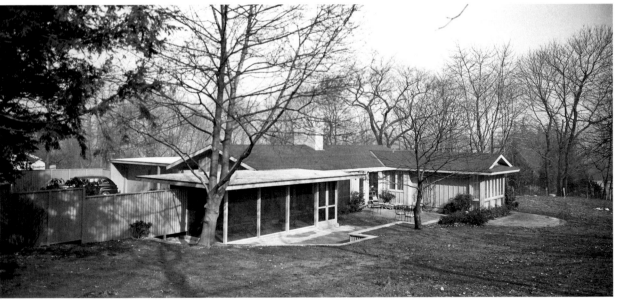

78. Wadsworth for David D.
Bohannon, 1950 Pace Setter
(#3). Patio, designed for privacy
and Climate Control, *House
Beautiful* (September 1950).

79. Julius Gregory, 1951 Pace
Setter House, Dobbs Ferry,
New York, 1951. "Defining the
American Way of Life Executed
in the New American Style,"
*House Beautiful* (May 1951).

80. Gregory, 1951 Pace Setter.
Exterior, rear elevation looking
toward patio and screened
porch.

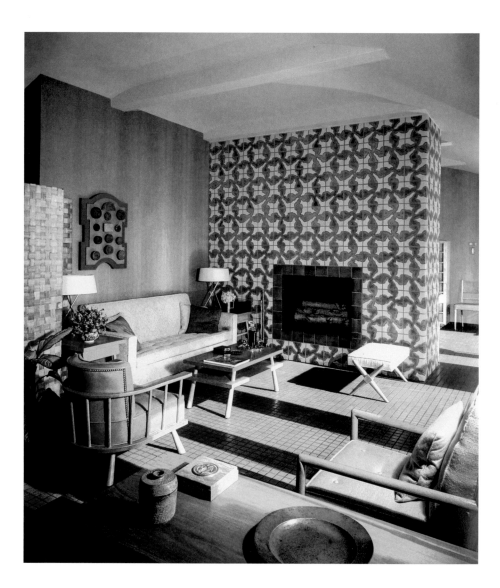

**81.** Gregory, 1951 Pace Setter. Living room with a decorative tile fireplace at center.

**82.** Gregory, 1951 Pace Setter. Climate Control technology and radiant heating diagram, *House Beautiful* (May 1951).

convincing component, and the one most closely linked to ideas of Climate Control, was the radiant heating system (fig. 82). The architect installed heating coils in the floors and ceilings, mechanisms that ensured stable temperatures year-round. The house, though spatially modest, "performed" well. The emphasis on emerging technologies underscored the subtheme of "American plenty" here, in terms of heating and cooling technology made affordable for the average consumer.

Gordon relied on an established editorial device to make an argument for the home's "Americanness": applied decoration. For the 1951 Pace Setter House, the dominant decorative motif became the American Style sheaf of wheat. *House Beautiful* staff likely applied this motif to the house, outside of the architect's design scheme and perhaps without his endorsement. The sheaf of wheat was not fully integrated into the home's

architecture, as the American Style manifesto had encouraged, though it was embroidered on tablecloths, printed on household stationery, painted on the family station wagon, and embedded in plastic lighting fixtures (figs. 83 and 84). The emblem nonetheless worked as a powerful graphic reminder, underscoring what Gordon described as a "completely American design idiom."[39]

The importance of Gordon's published houses lies not in the architects' adherence to all principles of the American Style, but in *House Beautiful*'s ability to establish a cohesive body of American Style examples, even if this was achieved by extracting (or applying) otherwise insignificant qualities. *House Beautiful*'s theming of the Pace Setters—the 1951 house in particular—was often a stretch; the effort nevertheless illustrates Gordon's insistence on finding physical representatives and relatable houses that could effectively sell her larger ideas.

The American Style Pace Setter Houses, while not stunning architectural masterworks, were crucial in understanding Gordon's presentation of the ideas that shaped the postwar house. With these four examples, she emphasized the American Style as "modern, but not extreme modern."[40] She used the Pace Setters to demonstrate modest designs that foregrounded technological performance, combined with the "beauty of appropriateness, the beauty that springs up inevitably when something does well what it is supposed to do."[41] Undoubtedly advanced in technical terms, these houses remained aesthetically conservative. The designers' hesitancy to explore innovative modern forms indicated that public taste, in the visual sense, remained conventional. Certainly, new and "modern" features were incorporated, but the traditional architectural elements remained. The fireplace, pitched roof, and projecting eaves still had a place in the American Style home.

Gordon presented each of these houses in defense of the new American Style, a modern style that ultimately "stress[ed] human values, which unfortunately, some styles of modern do not."[42] The dominant values that

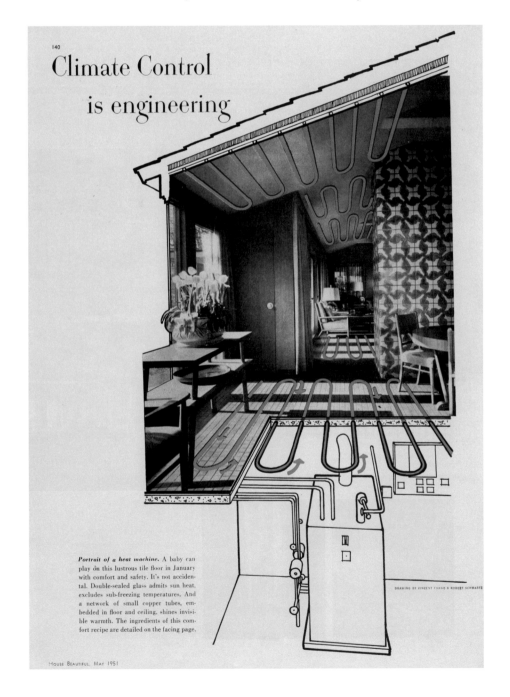

140

## Climate Control
## is engineering

*Portrait of a heat machine.* A baby can play on this lustrous tile floor in January with comfort and safety. It's not accidental. Double-sealed glass admits sun heat, excludes sub-freezing temperatures. And a network of small copper tubes, embedded in floor and ceiling, shines invisible warmth. The ingredients of this comfort recipe are detailed on the facing page.

DRAWING BY VINCENT FURNO & ROBERT SCHWARTZ

HOUSE BEAUTIFUL, MAY 1951

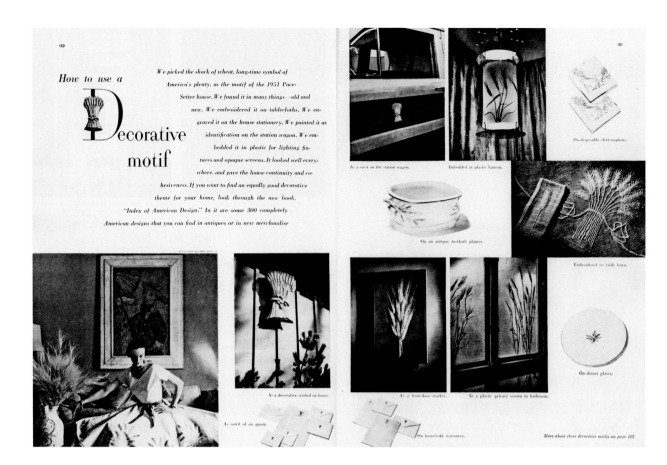

*How to use a*

# Decorative motif

We picked the shock of wheat, long-time symbol of America's plenty, as the motif of the 1951 Pace-Setter house. We found it in many things—old and new. We embroidered it on tablecloths. We engraved it on the house stationery. We painted it as identification on the station wagon. We embedded it in plastic for lighting fixtures and opaque screens. It looked well everywhere, and gave the house continuity and cohesiveness. If you want to find an equally good decorative theme for your home, look through the new book, "Index of American Design." In it are some 300 completely American designs that you can find in antiques or in new merchandise

As a decorative symbol on house.

As motif of an apron.

As a crest on the station wagon.   Imbedded in plastic lantern.

On an antique footbath planter.

As a front-door marker.   In a plastic privacy screen in bathroom.

On household stationery.

On disposable cloth napkins.

Embroidered on table linen.

On dinner plates.

More about these decorative motifs on page 188.

Gordon promoted in 1950 and 1951 were comfort and convenience, as experienced by a home's inhabitants. She framed the Pace Setters as American Style, though this was certainly *House Beautiful*'s editorialized representation; developers such as David Bohannon and architects such as Julius Gregory prioritized their own agendas over conforming to a "style." Their attitudes, including their willingness to take part in Gordon's campaign, had a profound impact on American domestic architecture, particularly in the middle-income market.

Shortly after Gordon published these American Style houses, *House Beautiful* signaled the conclusion of one phase in the evolution of the postwar house. These early Pace Setters represented the developer-built, technologically driven homes of the early 1950s, an early phase of Gordon's American Style; by the mid-1950s, a new set of concerns began to emerge.

**83.** "How to Use a Decorative Motif" (shock of wheat, at the 1951 Pace Setter), *House Beautiful* (May 1951).

**84.** Gregory, 1951 Pace Setter. A shock of wheat frieze, the home's dominant motif, hung (far right) near the front door, *House Beautiful* (May 1951).

# The Threat to the Next America

In April 1953, Elizabeth Gordon declared, "Something is rotten in the state of design." In "The Threat to the Next America," she lambasted the International Style, the line of modern architecture "spoiled" by the Miesian notion that "less is more" (fig. 85).[1] Gordon's goal with this controversial editorial was threefold: to illustrate the failings of "bad modern"; to promote what she defined as "good modern"; and to provide the American public with both the confidence and the skills to judge (and buy) good modern design for themselves.

These aims were not new. They had been part of her larger agenda for over a decade. What was new in 1953 was Gordon's activism. While she had previously promoted good design, she now demanded action. Her criticism became forceful (her detractors would say "hysterical") and loaded with a new sense of consequence. Her arguments conveyed a new awareness of what she would later term the "social significance" of design.[2] Gordon's editorial tactics were likewise revised to leverage contemporary pressure points, including individualism, consumerism, and nationalism. Her tone was colloquial. Her rhetoric was politically charged. And both played perfectly in McCarthy-era America.

Gordon's editorial—more so than her actual position on good design—sparked an instant and enduring controversy. Her views galvanized an opposition, yet her stand against the "self-chosen elite" won her new allies, including, most significantly, Frank Lloyd Wright.[3] The "Threat" essay, its fallout, and its subsequent alliances all significantly affected Gordon's agenda; its publication marked a watershed moment that both energized and politicized Gordon's efforts to shape American taste toward a specific kind of modern design.

## The "Next America" and the Politics of Home

> To reach the fullness of the next America we must sign another declaration of independence, another resolution of individualism. We must erect homes that shelter and enrich human life. We must build the architecture for the new age of humanism. We must expose the mechanistic forms, reject the authoritarian dogmas of the cult of stark, sterile modern.[4]
>
> —*House Beautiful* (April 1953)

In 1953, Gordon began to explicitly connect personal taste in design to the political and social well-being of America. As she had done in previous years, she called upon experts from a variety of professions to establish a broad context for her arguments. Their presence in *House Beautiful,* whether as quoted sources or byline

*Overleaf*
**85.** Elizabeth Gordon, "The Threat to the Next America," *House Beautiful* (April 1953).

# THE THREAT
## TO THE NEXT

**By Elizabeth Gordon,** *Editor*

I have decided to speak up.

In this issue, devoted to the wonderful possibilities for the better life in the Next America, I must also point out to you what I consider to be the threat to our achieving the *greater good* which is clearly possible for us, if we do not lose our sense of direction and independence.

What I want to tell you about has never been put into print by us or any other publication, to my knowledge. Your first reactions will be amazement, disbelief, and shock. You will say "It can't happen here!"

But hear me out. You may discover why you strongly dislike some of the so-called modern things you see. You may suddenly understand why you instinctively reject designs that are called "modernistic." For you are right. It's your common sense speaking. For these things are bad—bad in more ways than in their lack of beauty alone.

Here is the story, in its bluntest terms.

**There is a well-established movement, in modern architecture, decorating, and furnishings, which is promoting the mystical idea that "less is more."** Year after year, this idea has been hammered home by *some* museums, *some* professional magazines for architects and decorators, *some* architectural schools, and *some* designers.

They are all trying to sell the idea that "less is more," both as a criterion for design, and as a basis for judgment of the good life. **They are promoting unlivability, stripped-down emptiness, lack of storage space and therefore lack of possessions.**

They are praising designs that are unscientific, irrational and uneconomical—illogical things like whole walls of unshaded glass on the west, which cause you to fry in the summer, thus misusing one of our finest new materials. Or tricks like putting heavy buildings up on thin, delicate stilts—even though they cost more and instinctively worry the eye. Or cantilevering things that don't need to be cantilevered, making them cost more, too. A strong taint of anti-reason runs through all of their houses and furnishings.

No wonder you feel uneasy and repelled!

They are trying to convince you that you can appreciate beauty only if you suffer—because they say beauty and comfort are incompatible.

They are trying to get you to accept their idea of beauty and form as the measure of all things, *regardless* of whether they work, what they do to you, or what they cost.

They are a self-chosen elite who are trying to tell us what we should like and how we should live. And these arbiters have such a narrow, often ignorant, con

*Something is rotten in the state of design—and it is spoiling some of our best efforts in modern living. After watching it for several years, after meeting it with silence, House Beautiful has decided to speak out and appeal to your common sense, because it is common sense that is mostly under attack. Two ways of life stretch before us. One leads to the richness of variety, to comfort and beauty. The other, the one we want fully to expose to you, retreats to poverty and unlivability. Worst of all, it contains a threat of cultural dictatorship*

# AMERICA

ption of the good life that only non-human, low-performance things get their stamp of approval. **These biters make such a consistent attack on comfort, onvenience, and functional values that it becomes, in reality, an attack on reason itself.**

"Incredible!" you say. "Nobody could seriously sell ch nonsense."

My considered answer is this. Though it *is* incredle, some people *are* taking such nonsense seriously. hey take it seriously because this propaganda comes om highly placed individuals and highly respected stitutions. Therein lies the danger.

For if we can be sold on accepting dictators in matrs of taste and how our homes are to be ordered, our inds are certainly well prepared to accept dictators other departments of life. The undermining of ople's confidence is the beginning of the end.

Break people's confidence in reason and their wn common sense and they are on the way to attachg themselves to a leader, a mass movement, or any rt of authority beyond themselves. Nothing better xplains periods of mass hysteria or various forms of cial idiocy than the collapse of reason, the often eliberate result of an attack on people's self-conlence.

If people don't trust themselves and their own judg-

ment, then they turn helplessly to leaders, good or bad. And they can only recover the good, sensible life when they recover their senses and discover again that, by and large, the ultimate hope for mankind is the application of reason to the world around us. This *rediscovery* leads individuals to their own declaration of independence against the frauds, the over-publicized phonies, the bullying tactics of the self-chosen elite who would dictate not only taste but a whole way of life.

So, you see, this well-developed movement has social implications, because it affects the heart of our society —the home. Beyond the nonsense of trying to make us want to give up our technical aids and conveniences for what is *supposed* to be a better and more serene life, there is a social threat of regimentation and total control. **For if the mind of man can be manipulated in one great phase of life to be made willing to accept less, it would be possible to go on and get him to accept less in all phases of life.**

I can hear you say: "How can people collaborate for their own discomfort and frustration?"

Believe it or not, some people do, because their own self-confidence has been shaken. Not very many, fortunately, but enough so that I can clearly see the aberration growing.　　　　*(Please turn the page)*

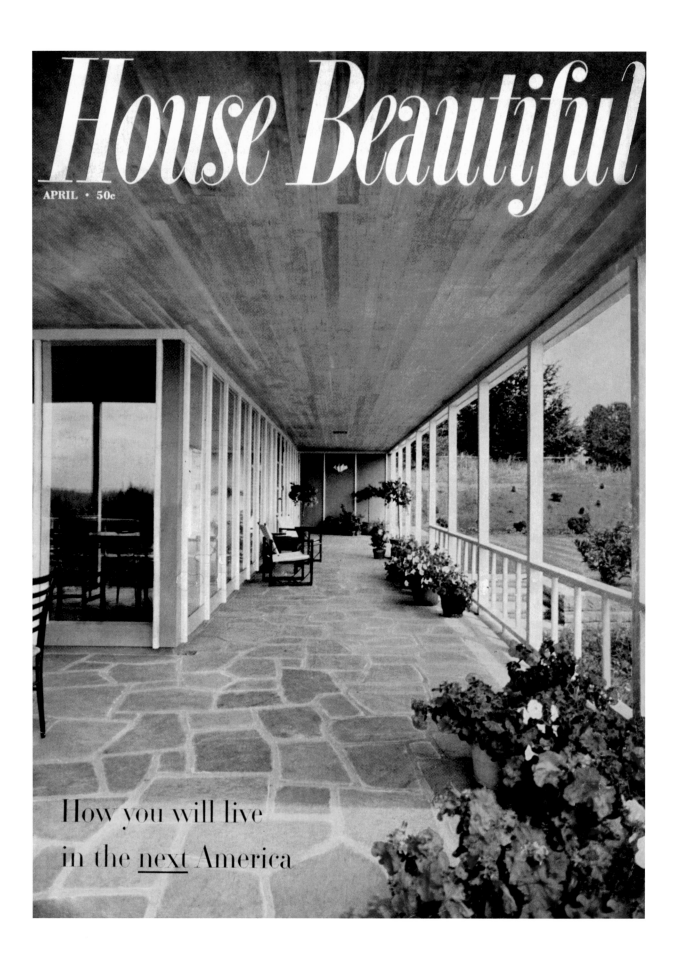

# House Beautiful

APRIL • 50c

How you will live
in the <u>next</u> America

authors, lent legitimacy to Gordon's cause. As she attempted to elevate *House Beautiful*'s quest for "better living" to a more meaningful social statement, Gordon offered her readership a view of the future, of "how you will live in the *next* America" (fig. 86).[5] For this, she borrowed concepts and terminology from cultural theorist Lyman Bryson, and recruited him to write for *House Beautiful*. Bryson, who also worked as an educator and public affairs consultant at Columbia Broadcasting System (CBS), was happy to contribute to *House Beautiful*. He was motivated to promote his work and to fulfill his own social mission: to educate American adults through public media, including radio, television, and magazines. *House Beautiful* was eager to utilize his expertise and his skill for delivering his message in "plain English."

Gordon used Bryson's 1952 book, *The Next America: Prophecy and Faith,* to launch the editorialized discussion within *House Beautiful* (fig. 87).[6] Using his work as a foundation, Gordon translated the "Next America" into a temporal location, a physical place, and a state of mind where magazine readers could find "richness" in their daily lives.[7] The American public would have a guide in *House Beautiful,* and each magazine issue would "chart" the way to this new future. If readers embraced the ideas put forth in the magazine, they could achieve their fullest "personal possibilities," greater personal expression, and an "enriched quality of . . . daily life."[8]

For the April 1953 issue of *House Beautiful,* Gordon used Bryson's book cover to illustrate her own editor's introduction (see fig. 87), which she directly followed with his commissioned essay on democracy and design entitled "The Next America Now Brings the Greatest Good—*and Goods*—for the Greatest Number."[9] Central to Bryson's theory of democratic culture for the Next America (as summarized for his *House Beautiful* article), and relevant for the magazine's readership, was the quest for equal access and unfettered liberty in the context of domestic design.[10] He linked freedom of "individual choice" (another term for access and liberty) to the success of capitalism, and more specifically to the great American industrialists who had used their resources to eliminate the basic "wants" of life and solve great social issues. Released from the worries of basic survival, average citizens of the

"Next America" would be free to "express whatever greatness and creative power is in them."[11]

It is unclear whether Gordon coached Bryson to apply his theories to the specific case of home design, but his article did clearly establish a foundation for "democracy in the arts of the home," "democratic living," and the democratic consumption of household goods.[12] Bryson argued that these "privilege[s]" depended upon an informed public. He must have believed that *House Beautiful* was well positioned to educate consumers, and was certainly aware of the magazine's long-standing agenda. In a statement that foreshadowed Gordon's later writings, Bryson declared: "Men cannot choose what they have never heard of; ignorance is the greatest obstacle to freedom. In politics, we call the danger totalitarianism. It is evil, not only because men in totalitarian countries have to live by tyrannous dictation, but also because they can never even make the acquaintance of the rich possibilities of other ways of life. In the arts, we call it rigidity of taste."[13] This very issue—rigidity of taste—was at the core of Gordon's concerns for the well-being of future citizens of the "Next America."

While Bryson provided a theoretical framework for a postwar "cultural revolution," Gordon sought to make the "Next America" tangible and consumable.[14] Gordon, like Bryson, envisioned the "Next America" as a nation of consumers. As such, Americans would play host to a strong market for design, where the best products would be affordable, "beautiful," and "practical."[15] To illustrate Bryson's theory, Gordon paired his text with images of consumer products that expressed, for example, "the social significance of a pretty dish towel."[16] The choice of specific household goods was certainly Gordon's. The range of products—all with prices listed—reflected both her parameters for good design "for everybody" and some of her preferred manufacturers: a set of forty glasses from Libbey Glass Company ($9), a dish towel from Martex (60 cents), and a Bakelite drawer unit from Warren Furniture Company ($2.50 for each drawer; $90 for the chest).[17]

Gordon used Bryson's theories to encourage flexible taste and free choice in the design marketplace, though the larger cultural revolution that he described was laden with political overtones and anxieties. In the foreground, she presented a guideline for good taste that could be had through a range of affordable goods. *House Beautiful* offered what Gordon believed was a broad menu

**86.** "How You Will Live in the Next America," cover caption, *House Beautiful* (April 1953).

of possibilities from which consumers might choose freely, though in truth, the magazine provided a carefully curated (and idiosyncratic) set of "acceptable" products. In the background, Bryson hinted that cultural production and consumption were tainted by conspiracy, anarchy, and suppression.[18] In this context, and for the readers of *House Beautiful,* he forecasted a coming battle against communism and "totalitarian oppression," in which free market capitalism and household consumerism would be wielded as powerful weapons. Political and nationalistic rhetoric was very much at play in Bryson's writing; Gordon co-opted this same strategy for her own effort to develop a market for American Style goods.

## Humanism in the "Next America"

As Gordon recruited outside expertise to comment on the state of design (and politics) in the "Next America," she began to strategically expand *House Beautiful*'s staff. Joseph A. Barry joined the magazine as the executive editor in September 1952. His contributions added new depth and critical rigor to Gordon's agenda. Barry, an American writer and protégé of Gertrude Stein, came to *House Beautiful* after his return from Paris in 1952.[19] A longtime contributor to the *New York Times, Reader's*

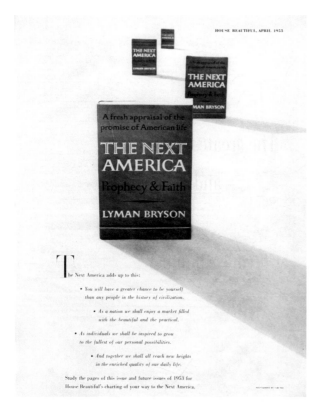

*Digest,* the *New Republic,* the *New York Herald Tribune,* and the Paris bureau of *Newsweek,* he was a commanding figure. More importantly, he held the authority of a critic who had met Matisse and Picasso (through Stein), who had interviewed Le Corbusier while the Unité d'Habitation was under construction in Marseilles, and who would later edit Bruno Zevi's *Architecture as Space* (1957).[20] Barry's 1951 book, *Left Bank, Right Bank,* was typical of his cultural criticism; in this work, he discussed (among other topics) the social implications of architectural choice and criticized modern architects who trained in Europe during the 1920s and 1930s.[21] With this viewpoint, he was well matched to Gordon and *House Beautiful.*

Writing for *House Beautiful* in April 1953, in an article titled "The Next America Will Be the Age of Great Architecture," Barry offered the architectural counterpart to Bryson's cultural theory.[22] His writings, like Bryson's, created a broad context for Gordon's larger agenda. He also provided a concrete example of what the magazine dubbed the Next American House. Barry's strategy was to create an architectural foil: he contrasted "good modern houses," or the "architecture of humanism," with the "poverty-stricken clichés of doctrinaire International Stylists with their machine forms and concrete cubes."[23] Like Gordon and Bryson, Barry adopted a politically charged tone, writing: "If we choose the barren glass cage of a Mies van der Rohe, we shall suffer the consequences of a loss of privacy and personality. If we crowd collectively in the colossal pigeonholes of a Le Corbusier, we shall set ourselves up for total and authoritarian control. But if we encourage the kinds of homes where the spirit of man can grow and flower, where each can develop in his own peculiar way, we shall ensure the new democracy of culture."[24]

Barry described the Next American House, exemplified by John Yeon's Shaw House (Portland, Oregon, 1950), as the antithesis of Le Corbusier's "colossal pigeonholes" (fig. 88). His critique was made all the more believable by his account of his personal visit to the Unité d'Habitation. Yeon's work, Barry claimed, was a far more

**87.** Lyman Bryson and "The Next America," book cover featured in *House Beautiful* (April 1953).

**88.** John Yeon, Shaw House, Portland, Oregon, 1950. Published as "The Next American House" for *House Beautiful* (April 1953).

livable example of modern architecture; it was "simultaneously regional and universal," and thus far more suited to its client, site, and nation than anything Le Corbusier (or his European modernist colleagues) had produced. Barry further praised Yeon's design for its dignity, comfort, warmth, and vitality—in short, its "union of function and form, delight and performance."[25]

Barry's authorial style was nearly as important as the architectural content he chose to illustrate the text. His perspective was erudite, conjuring images of the Parthenon, Mozart, and Thoreau. His tone was at times wandering and romantic, in contrast to Gordon's direct, biting criticism that appeared elsewhere in the issue. He used vivid architectural descriptions to walk the reader through his chosen examples of domestic architecture. His biography of Yeon was likewise strategic; here, he appealed to the American love for the "genius, lonely,

isolated . . . who has wrestled answers out of nature on his own and by so doing finds his place in the thin, front rank of Melville, Whitman, Thoreau, Wright, Faulkner, and other lonely men of achievement."[26]

Though he was a permanent member of the *House Beautiful* staff, Barry was a newcomer with an established reputation and functioned much like the outside experts whom Gordon recruited: he lent credibility. Given the breadth of his work in France, his critiques of European modern architecture were both relevant and persuasive. And he did not hide his bias, vilifying European modernism and openly endorsing what he viewed as its opposite, the "democratic" American architecture of humanism, which was synonymous to what Gordon called the American Style. Most importantly, Barry's essay—both in content and in physical placement in the magazine—set Gordon up to launch her own attack.

## "The Threat to the Next America": Modernism and the "Reign of Error"

*House Beautiful* finally speaks up to point plainly to the nonsense that goes on in the name of "good design." For, if you are aware of what is happening, we believe that you will be quite competent to handle the matter for yourself. We still operate on common sense and reason. We know that less is *not* more. It is simply less![27]

—Elizabeth Gordon, "The Threat to the Next America," *House Beautiful* (April 1953)

With her "The Threat to the Next America" editorial, Gordon took a hostile stance against the International Style. Her specific critique of Mies van der Rohe, Le Corbusier, Walter Gropius, and the entirety of the Bauhaus School was couched in terms of, as she wrote, "freedom of choice—and its consequences." As an editor, she felt compelled to "speak out" in the interest of her readers and the American public. Where other editors, critics, and designers hesitated, she was willing to "start a public fight with the cultists" who dominated architectural trade journals and museums. And "start a fight" is precisely what she did in April 1953.[28]

Gordon opened "The Threat to the Next America" with a provocative statement displayed with the visual power of a pull quote (see fig. 85):

Something is rotten in the state of design—and it is spoiling some of our best efforts in modern living. After watching it for several years, after meeting it with silence, *House Beautiful* has decided to speak out and appeal to your common sense, because it is common sense that is mostly under attack. Two ways of life stretch before us. One leads to the richness of variety, to comfort and beauty. The other, the one we want to fully expose to you, retreats to poverty and unliveability. Worst of all, it contains a threat of cultural dictatorship.[29]

Her declaration, and her visual presentation of this declaration, was effective. With a few short sentences set against a bold essay title, she grabbed the reader's attention, pinpointed an enemy, and set up a combative tactic. She positioned *House Beautiful* as the defender of, and advocate for, the public good.

In the guise of a "common sense" appraisal, Gordon prepared a lengthy and lucid (if slightly skewed) case against "bad" modern design. She attacked four components: designers, promoters, products, and consumers. Gordon took aim at what she characterized as "the Cult of Austerity." She argued that this cult, led by European modernists who embraced "less is more" or "existence minimum," demanded "suffering" as both a design quality and a way of life.[30] She argued that their domestic designs were "cold, barren" and storage-less; thus these "artistic dictators" ignored the basic human need for both warmth and possessions.[31] This, she claimed, led to "box-like and mechanistic" houses that subverted democratic individuality.[32] As evidence for her case, she published a full-page illustration of Mies's Tugendhat House and Le Corbusier's Villa Savoye (fig. 89). Using black-and-white photographs from the 1932 MoMA *Modern Architecture* exhibition, Gordon made her targets specific and her view clear: "The Cult of Austerity is the product of Mies van der Rohe's cold, barren design (above) and Le Corbusier's International Style (below)."[33]

She further lambasted modern architects for their "unscientific, irrational and uneconomic" practices, specifically their use of "thin, delicate stilts" and "unshaded glass" walls.[34] Other critics had praised the same architects' structural methods as achievements in efficiency, but Gordon complained that they were extravagant—for example, "cantilevering things that don't need to be cantilevered." The problem, for her, was that this "hair shirt school" seemed to value appearance over performance and comfort.[35] What Gordon refused to acknowledge, however, was that these same modernists had attempted to redefine both function and comfort in a very different cultural moment and under tight economic circumstances. In Gordon's critique, their limitations and achievements went unmentioned.

Her own motivations—why she worked so vigorously to discredit a small group of modernists—were complex. She certainly wanted to alert consumers to the dangers that she had perceived. And, because she was so inextricably tied to the consumption-centric business of American design, the International Style's minimalism, and its lack of storage for household goods, was actually a "threat" to her own industry and livelihood.

Gordon herself was an arbiter of taste, but she railed against arguably similar "publicists" who used "propaganda" to promote their own anointed version of modern

The Cult of Austerity *is the product of Mies van der Rohe's cold,*

*barren design (above) and Le Corbusier's International Style (below)*

**89.** Mies van der Rohe, Tugendhat House, Brno, Czech Republic, 1929–30; and Le Corbusier, Villa Savoye, Poissy, France, 1929. Illustrations for "The Cult of Austerity" in "The Threat to the Next America," *House Beautiful* (April 1953).

design.[36] These arbiters, she wrote, were in fact "self-chosen elite who are trying to tell us what we should like and how we should live."[37] The antagonists to whom she made thinly veiled references were stationed at "*some* museums" (read: Philip Johnson and MoMA), "*some* professional magazines for architects and decorators" (read: *Architectural Forum* and *Arts & Architecture*), and "*some* architectural schools" (read: Harvard and the Illinois Institute of Technology).[38] Gordon denounced both their power and their point of view, writing that they all promoted the "mystical idea that 'less is more,'" which, in her view, was "simply less."[39]

The "danger" for the American consumer, argued Gordon, was that these were "highly placed individuals and highly respected institutions."[40] She feared that cultural strongholds such as MoMA exerted undue pressure, and that consumers would dutifully adopt whatever line of design these institutions "thoughtlessly" endorsed. She viewed this as a totalitarian influence (she used the term "total control" here, and "totalitarian" elsewhere), detrimental to the formation of free taste and, specifically, to the American consumer's ability to separate good modern from bad.[41]

To give her argument a deeper legitimacy and cultural resonance, she used analogies that drew upon the contemporary rhetoric of political anxiety and paranoia—this was, after all, 1953, and the height of the McCarthy era. If modern architects and their promoters were "artistic dictators," she argued, then figures such as Mies or MoMA's Philip Johnson (inferred rather than mentioned by name) were cultural dictators on par with Hitler, Mussolini, Stalin, and Kim Il-Sung. She prompted the American public to end this "reign of error."[42] Gordon's concern was for the broader social implications of their influence: "If we can be sold on accepting dictators in matters of taste and how our homes are to be ordered, our minds are certainly well prepared to accept dictators in other departments of life."[43]

For Gordon, "bad" modern products, including everything from buildings to chairs, were an "attack on comfort, convenience, and functional values."[44] To her credit, she did not criticize "bad modern" without offering an alternative—she presented a road map to rediscovering what she considered "good modern" design. She provided time-honored (and vaguely Vitruvian) principles as a guide: "comfort *and* performance *and* beauty."[45] Borrowing heavily from Lewis Mumford's *Roots of Contemporary*

*Architecture* (1952), which had appeared in abridged form in *House Beautiful*'s October 1952 issue, Gordon argued that the early modern ideas of simplification had been necessary to counter the excess of the late nineteenth century. However, she continued, design went awry in the late 1920s, when "form became separated from function and purpose," and architects instead prioritized aesthetics. With this argument, she encouraged her readers to reexamine the International Style and all other forms of modern architecture and design, to apply "canons of common sense," and to ask three crucial questions: Does it work? Will it hold up? and Does it look good?[46] With the entire April 1953 issue of *House Beautiful* (and really, as longtime readers would have recognized, every issue since at least 1946), Gordon presented an alternative form of modern design that answered these questions in the affirmative.

## Fallout

"The Threat to the Next America" was intended to be a bombshell, but Gordon did not anticipate the fallout. She had hoped that her essay (and her subsequent related editorials) would inform and shift public opinion. Instead, she opened a vicious public debate. She had both shocked and galvanized the architectural community, and her essay garnered reactions from architects, builders, editors, educators, critics, and consumers alike. The dialogue reverberated for months in print, and for decades within her public career and private life.

If Gordon hoped to create a broad public forum for architectural discussions, or, as she wrote, merely "start a public fight," she was successful. *House Beautiful* had advertised and circulated "The Threat to the Next America" beyond its immediate subscribers (with, for example, a series of full-page advertisements in the *Journal of the American Institute of Architects*). This enabled and encouraged the wider architectural community to contribute commentary. The magazine's promotional effort had a negative consequence, though: Gordon's professionalism, judgment, and knowledge, as well as her audience's ability to evaluate her opinion, were widely called into question.

Within days of its release, the "Threat" article provoked a substantial response from the trades and in the professional architectural press. Gordon's stance was the subject of discussion (what she called "gossip") at the

furniture markets in both Grand Rapids, Michigan, and Chicago, where, as she acknowledged, "more speakers made negative remarks" than did not.[47]

*Architectural Forum* published a full-page rejoinder to the "wild controversy" in its May 1953 issue.[48] *Forum,* then edited by P. I. Prentice, never mentioned Gordon by name, but its "Criticism vs. Statesmanship in Architecture" was a clear critique of her editorial tactics (rather than of her advocacy for a more "human" form of modern architecture).[49] In a veiled reference to Gordon's text, *Forum* asked, "Who can really declare that his or her preferences represent 'free taste' but yours are part of a conspiracy to subvert the nation?"[50] Without naming names, *Forum* took aim at Gordon as the author of one of "today's hatchet campaigns," while pledging that its own editors would "do their best to avoid being captured by *any* of the new 'styles' and to be guided by Style: to belong to no group but to publish the best work regardless of origin and on the basis of its individual merit and its ideas."[51] *Forum* claimed it would remain a neutral "forum." Yet, paradoxically, *Forum*'s editorial chairman, Douglas Haskell, circulated a form letter requesting what Gordon described as "mail on their pages that tried to show that we [Gordon and *House Beautiful*] don't know what we are doing."[52] Publically, or at least in print, *Forum* intended to show evidence of its own objectivity and "statesmanship"; it ran its censure of Gordon in an issue that featured Frank Lloyd Wright's Price Tower on the cover. As a parting commentary on what the journal certainly believed was Gordon's professional lapse, *Forum* wrote: "Criticism of architecture is important, even partisan criticism; but more important than parties is statesmanship."[53]

*Progressive Architecture* likewise published an antagonistic rebuttal in its May 1953 issue. Unlike *Forum, Progressive Architecture* did not hesitate to name Gordon as the offending party. The journal then published a set of letters from its readers, who were struck by her dramatic and politicized rhetoric (again, more so than her actual opinion on modern architecture). *Progressive Architecture* certainly did not publish every response in full, but those that were excerpted were unanimously against Gordon. The respondents were all architects. They all shared a sense of bewilderment (if not outrage) at Gordon's "architectural McCarthyism."[54] Charles Granger, for example, took issue with what he described as *House Beautiful*'s "editorial hate campaign." Granger, adopting

Gordon's own rhetorical strategy, accused her of being the real "Dictator of Taste."[55] John Carden Campbell echoed the criticism of Gordon's "dictatorial approach," summarizing and simultaneously ridiculing the whole episode as "hysterical nonsense."[56]

Granger, in his letter to *Progressive Architecture,* questioned if Gordon would be "democratic and print the reaction" to her editorial. Whether in response to his call or not, Gordon did publish dozens of readers' letters to *House Beautiful* in the June, July, and October 1953 issues. The magazine had received, by Gordon's count, hundreds of letters. According to her self-reported—and therefore potentially suspect—statistics, eighty-five percent of these letters were in "hearty approval." The remaining fifteen percent were reportedly "divided between those who say we are flogging a dead horse and those who say we are attacking the greatest designers and architects alive."[57]

Opposition was indeed fierce. W. E. Ross from Jackson, Mississippi, wrote to *House Beautiful* (printed in capital letters, indicating a telegram): "Your Elizabeth Gordon is an uninformed masterpiece and her so called article on design is really nothing but [a] mass of self-contradiction, insinuations and vituperations. Why don't you have this bigoted female educated before you let her preach further."[58] Others were shocked that Gordon dared to attack Mies, Gropius, and Le Corbusier in such an "emotional" and "irrational" manner, and for the "obvious purpose of selling 'possessions.'"[59] Arthur Millier, art critic for the *Los Angeles Times,* wrote to inform Gordon that in Los Angeles, at least, the International Style "had been dead so long that to see a big magazine like yours pugnaciously saving us from it is like watching somebody exhume and hang a corpse."[60] However dated Millier believed Gordon's argument may have been, his obituary for the International Style was not entirely accurate, as illustrated by contemporary building in the Hollywood Hills publicized through *Arts & Architecture*'s Case Study House program.

Like *Progressive Architecture, House Beautiful* published scores of critical responses from architects. At least one designer was so offended that he canceled his subscription.[61] George Howe, a proclaimed modernist and the chairman of the Yale School of Architecture, offered a particularly salient argument. He outlined (aptly) the flaws and inconsistencies in Gordon's logic, lambasted her vicious attack, and proclaimed finally,

"Grandmother, what big teeth you have!"[62] Peter Blake, then an editor at *Architectural Forum,* branded Gordon—rather than the International Style—as the real "threat" to the "Next America." While he agreed that architectural criticism fell within her right as a journalist, he believed that portraying all modernists (of which he was one) as "interested in promoting total control, regimentation and dictatorship" was not. He accused her of merely trying to increase her magazine's circulation (which she did), and predicted (to some degree, rightly so) that she had penned her own epitaph: "Here lies *House Beautiful,* scared to death by a chromium chair."[63]

Given *House Beautiful*'s previous support of the Bay Region School, William Wurster's reaction was perhaps most surprising. In the first of two letters, he dismissed Gordon's article as having no "basis for serious architectural discussion."[64] His second letter, previously printed in *Progressive Architecture,* appeared with thirty signatures from prominent California designers including Wurster, John Carden Campbell (who had sent his own letter), Lawrence Halprin, Garrett Eckbo, Theodore C. Bernardi, and Donn Emmons.[65] *House Beautiful,* to its credit, printed these objections and signatures in full—as urged by the authors—though Wurster had already sent a copy of the letter to all the "leading architectural magazines and schools."[66] As a group, the Californian designers opposed Gordon's implication that modern architects were seditious (thus "preparing minds for totalitarianism") and harbored the intent to "undermine American freedom." They objected to the "political criteria" with which she assessed modern architecture, and moreover "regret[ted] deeply the attack on European art and architecture . . . [and] the implication that all 'good' art has its roots in America and all that is European is subversive, perverted or sick."[67]

Despite this unanticipated and overwhelming fallout, Gordon gathered a large body of supporters. Many architects were on her side and applauded her courage to speak out against the architectural mainstream. Among these was Henry H. Saylor, the editor of the *Journal of the American Institute of Architects.* His view was perhaps independent rather than representative of the AIA, as the institution would later shun her, quite profoundly.[68]

Allegiance also came from the expected quarters, as critics and avowed "humanist" designers rallied around *House Beautiful.* Lewis Mumford, a frequent contributor to the magazine, wrote that "the point you yourself make about the irrational nature of so much modern design,

and the authoritarian way in which it has been put over, might as well be emblazoned in gold."[69] J. Robert Swanson and Pipsan Saarinen Swanson took their "hats off," hoping the article would trigger a "general movement against 'the gang.'"[70] Bruce Goff expressed that he and the University of Oklahoma backed her "one hundred percent to expose this racket."[71] Karl Kamrath, an organic architect practicing in Texas, wrote that Gordon's "ability and courage to put into words what I am sure so many of us deeply feel provides a tremendous lift and inspiration." He repeated her "message" by using Gordon's text as part of his commencement address at the University of Texas School of Architecture (a school then led by Harwell Hamilton Harris, who was later recruited as a Gordon ally).[72] Furniture manufacturers and professionals from the building materials sector—including, notably, James M. Ashley of Libbey-Owens-Ford—also rallied around Gordon's "flag," expressing their wholehearted support for "when the enemy retaliates."[73]

Gordon received one telegram that had more impact than any other response—and she published it first among all of the readers' letters. It read: "Surprised and delighted. Did not know you had it in you. From now on at your service . . . —GODFATHER" (fig. 90).[74] She had no idea who "Godfather" was. Three short days later (perhaps long days for the anxious "goddaughter"), Frank Lloyd Wright sent her a letter. He revealed that he was indeed the author of the telegram and her new champion (fig. 91). He offered Gordon both support and pointed advice: she should be more forceful in her editorial policies—and he wanted to be at the center. "Why," he asked, "have you been describing the play of Hamlet with Hamlet left out?"[75] To this, Gordon replied that she was "more than willing to put Hamlet back into Hamlet."[76] Wright not

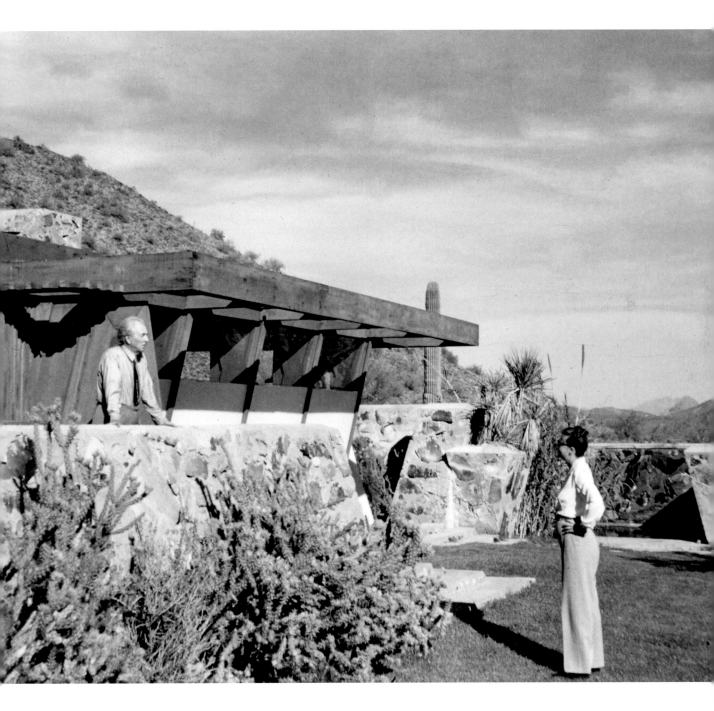

**90.** Telegram to Elizabeth Gordon from "Godfather" (Frank Lloyd Wright), March 1953.

**91.** Frank Lloyd Wright and Gordon at Taliesin West, ca. 1946.

only offered himself as a foil but urged her to renew her "attack" and expose the detrimental effects of the "Bauhaus invasion . . . upon the true basis of Architecture for Next America."[77]

## Appeal, Promise, and Warning

> Often I have wondered why people, who for the greater part are born, educated, work, live, and die within the framework of architecture, are so unaware of its great power to condition them for better or for worse. I also like the stimulating note of optimism that runs through the entire [April 1953] issue. The theme is like a cocktail—one jigger of exhortation to three of promise, with a dash of warning. But don't rest on your laurels; we can only expurgate false notions, and create new concepts of a great, new, sincere, and truly modern architecture for the next America by pounding away—louder and more often than the boys who are running the architectural flim-flam racket.[78]
>
> —Ralph E. Winslow to Elizabeth Gordon (July 1953)

Gordon, encouraged by Ralph E. Winslow's July 1953 reader letter, did not rest on her laurels. But she certainly did not anticipate the bitter controversy that would follow (something she admitted years later). And, as she wrote to Frank Lloyd Wright, the whole scene just made her "mad."[79]

She continued her polemic and defended her position in her June 1953 "The Responsibility of an Editor" speech at the American Furniture Mart in Chicago, and in a follow-on essay published in *House Beautiful* in October 1953.[80] In the latter, "Does Design Have Social Significance?" she insisted that "democratic architecture for a democratic society" was not "solely a matter of taste and esthetics" but "literally a matter of cultural—and social—life and death."[81] She firmly believed that in 1953, American design had reached a pivotal moment, a "fateful fork in the road." She saw only two possible alternatives: democratic individualism or totalitarian collectivism.[82] With these conflicting choices, she urged the American public to weigh the evidence (which she had so clearly laid out), and to choose a path for themselves.

With "The Threat to the Next America," Gordon became embroiled in "the politics of architecture."[83] Her essay was both perceptive and provocative, if hyperbolic and, to some degree, paradoxical. On the one hand, she opened professional polemics to a non-architectural audience. On the other hand, she invoked seemingly irrational rhetoric that threatened her own credibility. Gordon endured pronounced criticism and enjoyed great support—but more importantly, she reopened a significant architectural debate. She represented those who opposed, often in silence, the continuation of a "stagnant" modernist lineage, and she supported those who offered an alternative design trope. Her unrestrained public assault on the International Style forced her into a camp opposite to that of many prominent designers and institutions, including, not insignificantly, both MoMA and the AIA. Yet Gordon's newly articulated position gained her the alliance of the "other side," those who had been quietly, and not so quietly, marshaling forces around Frank Lloyd Wright or the Bay Region School. Invigorated by the events that followed the April 1953 editorial, Gordon began to transform *House Beautiful* into a powerful vehicle for the dissemination of alternative modernist ideas, with Wright at the center.

# A New Alliance

With Frank Lloyd Wright as an ally, Elizabeth Gordon's crusade for an alternative modern architecture for the "Next America" took a new turn. The controversy that followed "The Threat to the Next America" editorial provoked her, and she became even more determined to lead the American public toward good taste and better living, and away from the International Style. Her nascent friendship with Wright gave her cause a new impetus; with his partnership came an august reputation and a recognizable "organic" modern brand.

## Frank Lloyd Wright Speaks Up

Wright's ties to *House Beautiful* dated to the magazine's founding in 1896, but under Gordon's early editorship, she seldom published his work. This was due in part to an agreement between Wright and *Architectural Forum* (which he claimed to revoke in 1953, after he declared his support for Gordon's cause), and in part to Gordon's personal preference. If Wright's architecture did not appeal to Gordon—at least in the early 1940s—his theories did. Upon his death in 1959, she claimed that she had always "tried to edit by Wrightian precepts and principles."[1] This was true to some degree: his ideas, or their derivatives, were often the basis for Gordon's proclamations, but before 1953, she rarely referenced the architect or used the term "organic."

Wright's most notable rare appearance in *House Beautiful* during Gordon's first decade of editing was in June 1946. As part of her "People Who Influence Your Life" series, Gordon encouraged her readers to "Meet Frank Lloyd Wright." She hailed him as a "modern magician," the "greatest architect alive," and, ultimately, "the greatest architect who ever lived."[2] She repeated her praise of his "genius" in that same year, when she visited Wright's Taliesin West in preparation for her December 1946 feature, "One Man's House" (fig. 92). She gave it a positive review in print, but remarked privately that she was "not impressed."[3]

Wright did not appear in *House Beautiful* for four more years, until Gordon began to promote "Naturalism" and the American Style. Her editorials contained oblique references to Wright's theories, but she still avoided the term "organic." Wright was keenly aware of her commentary—or, rather, her omission. Offended, he wrote to complain that by leaving him out and by failing to credit him as the "father" of what Gordon termed "Naturalism" (and its extension in the American Style), she had "falsified" the origins and the "nature of organic architecture."[4] In uncharacteristic acquiescence, Gordon returned a long letter of apology: "That we should offend you in even the slightest degree is an overwhelming tragedy to me. And that we have caused you distress is a crime for which we can never forgive ourselves." She went on to affirm America's debt to him as the "spiritual leader" of *House Beautiful,* and reminded him (with carefully selected excerpts) of her 1946 "tribute" articles that declared him the "greatest architect alive."[5] Her repentant tone failed

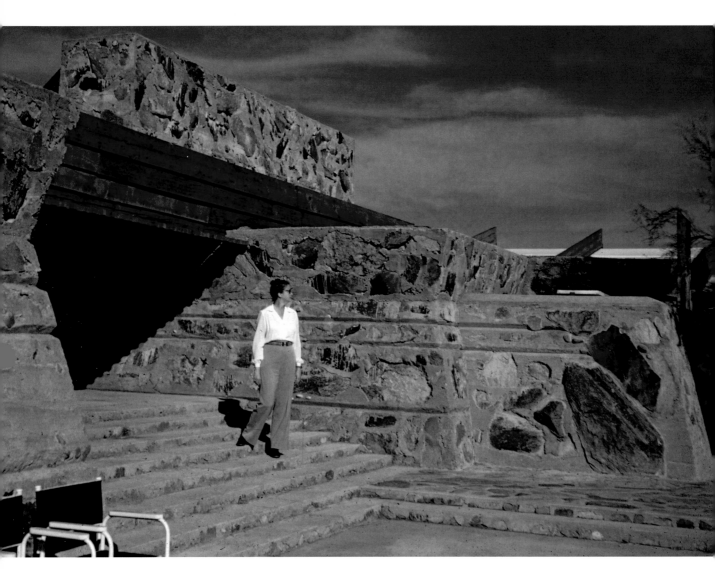

**92.** Gordon at Taliesin West, ca. 1946.

to heal the rift, and the two remained at odds until the spring of 1953.

"The Threat to the Next America" got his attention. After Wright declared his support—and positioned himself as Gordon's "godfather"—she became part of his "fold." And she began to revise her definition of good modern architecture for the "Next America": it now included direct references to Wright and the use of his term "organic."

Wright was certainly an opportunist, and he must have enjoyed this new publicity. But his interest in Gordon's crusade was not entirely selfish. All evidence suggests that he sincerely liked Gordon (whom he affectionately called "Beth") and earnestly championed her cause. He

was happy to join her battle against the International Style, to extend his own views and designs to a receptive popular audience, and to gain a new advocate. And Gordon was delighted to promote him and to gain a powerful (if polarizing) ally in return. The benefits were mutual. Wright encouraged Gordon privately in a string of letters and visits. Gordon went to Taliesin on several occasions, and when Wright was in New York, they often had dinner or drinks.[6]

Wright also furthered *House Beautiful*'s campaign publicly with two essays published in the July and October 1953 issues. In the first of these, "Frank Lloyd Wright Speaks Up," he echoed and defended Gordon's critical stance from "The Threat to the Next America."[7] His own

censure was clear: he condemned the "sterility" and "collectivism" of the International Style, that "poverty-stricken" glass-box architecture that cast a "communistic shadow . . . over our own [American] tradition."[8] He made an acerbic case against the style's "machine for living" and "less is more" slogans, and its "imported" architects (Le Corbusier and Mies, respectively), who "ran from political totalitarianism in Germany to . . . their own totalitarianism in art here in America."[9]

Wright's rhetoric was both nationalistic and self-serving. He railed against what he viewed as the externality and un-American character of the International Style, and offered his own work as the antithesis. He tied his arguments to what he perceived as America's core values, democracy and individuality, and argued that the International Style subverted both.[10] For Wright, and increasingly for Gordon, organic design was the only "truly American" modern architecture.[11] It was, wrote Wright, the only "rational hope for the future."[12]

Wright resumed this theme in *House Beautiful* for an October 1953 essay, "For a Democratic Architecture." Gordon, revealing her favoritism, subtitled the piece "A Statement by the Greatest Architect of Today."[13] Aiming squarely at Gordon's detractors, specifically the "30

architects and designers of the San Francisco Bay area" who had written in to protest her "Threat" essay, Wright again championed individualist, democratic architecture.[14] He condemned the International Style as building for "massology," which he likened to "anarchy, monarchy, fascism, or communism. All forms of totalitarianism."[15] He offered little in the way of concrete examples, but he did help Gordon to establish a social and political framework for her future editorials.

## Taliesin at *House Beautiful*

Wright's essays established his presence in the magazine and within a broader popular culture, but he and Gordon devised a second way to "get the word out": Wright sent his apprentices to work at *House Beautiful*. Following the 1953 "Threat" controversy, Gordon found her staff in flux. Architectural editor James Marston Fitch "resigned in protest" over the "decisive issue [of] . . . whether the Gropian/Miesian/Bauhaus version of modern architecture was 'communistic,' hence somehow un-American, while that of the San Francisco Bay region which the magazine editorially supported was safely 'American.'" Fitch wanted no part of what he later described as Gordon's "absurd posture" and "red-baiting frenzy."[16]

In need of a replacement, Gordon cabled Wright to ask his advice. He recommended his associate John deKoven Hill (fig. 93). Hill had gone to Taliesin in 1938 and, joining at only eighteen years of age, was the youngest apprentice. During his four years as a student, his access to Wright was limited. He learned from the older apprentices: Wes Peters, who taught him about engineering; John Howe, who taught him to draw; and Eugene Masselink, who taught him about texture and color. Hill displayed a talent for artistic composition, and Wright pushed him to develop his skill with interior design—openly discouraging him from becoming an architect and seeking licensure.[17] By 1941, Hill was still "learning by doing," as was the Wrightian pedagogical model, but had been promoted to senior apprentice; he went on to complete the design and construction of sixty-nine projects

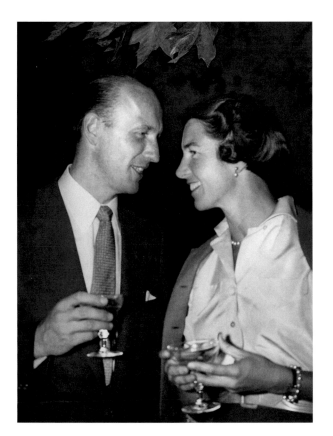

**93.** John deKoven Hill (left) with Marva Shearer, at the opening of the *Arts of Daily Living* exhibition, Los Angeles, California, 1954.

and at least twenty interiors under Wright.[18] Hill's sharp sense of style and easy manner made him a quick favorite in the drafting room, and he became one of Wright's most valued assistants.

For nearly a decade, the two men worked closely together, but in 1952, Hill got a big professional opportunity, and a break from Taliesin. Wright sent him, with Oscar Stonorov, to oversee the installation of *Sixty Years of Living Architecture: The Work of Frank Lloyd Wright* in Mexico City.[19] The exhibition, installed at the National Autonomous University, went well. In early 1953, Hill began to dismantle the show for its return to the United States and its installation in New York, at the future site of the Guggenheim Museum. At this very moment, Gordon telegrammed Wright about Fitch's resignation. The timing was perfect. Wright sensed that Hill was growing restless at Taliesin, and he thought a brief "sabbatical" in New York would provide Hill with a much-needed respite.[20]

Gordon knew Hill had no experience in journalism or publishing. But he was a good designer, and he had excelled in his exhibition work with *Sixty Years of Living Architecture*. She was impressed enough to give him a trial. Hill was unsure if he could "deliver the goods" to Gordon, who was notoriously demanding. He, like many of the magazine staff he met during his interview, was intimidated by Gordon, though he was not "frightened" of her, as others were. She remained guarded (Hill described her as "cagey"), but in truth, she was thrilled to have him join her team.[21] And Wright was pleased to have someone "on the inside" to further the cause of organic architecture—and bring him additional commissions.[22]

Hill thought he would stay at *House Beautiful* for one year; he was there for ten. He became an indispensable part of the magazine's staff and a close friend of Gordon's. As the architectural editor, and later as executive editor, Hill became increasingly responsible for design content, a task that had been solely Gordon's before he arrived. His experience with Wright, and his intimate understanding of organic design, proved invaluable for *House Beautiful*'s new direction.[23] Hill began to select publishable material, though still under Gordon's oversight: *House Beautiful*, as Hill knew, was very much *her* magazine. Gordon continued to generate most of the story ideas. She still chose the cover shots (though the Hearst corporate office had to approve her final selections). She also continued to rewrite or "fix" other writers' contributions, including Hill's. Eventually, she trusted him enough to do his own writing.

But she still set the magazine's editorial policy—what Hill described as her "stand."[24] Though she often credited Hill as the "brains," he insisted that she was always very much in charge. He believed his job was to "produce the evidence of what [Gordon] was trying to do and show."[25] His contributions, however, amounted to far more.

Soon after he joined the magazine, Hill began to help Gordon determine "what things were worthy of our running and what the point of view should be . . . what there was to learn." He relied on her "genius" (his term) and her ability to identify trends-in-the-making. But he was free to select what would be featured. Other staff members, including Laura Tanner and Frances Heard, made suggestions, but according to Hill, he and Gordon "couldn't depend on their [Tanner's and Heard's] judgment . . . because they didn't know for modern things."[26] He and Gordon made all of the final decisions.

Hill wanted *House Beautiful* to publish good modern content in a visually modern way. He wanted to "clean up" the magazine's appearance, and Gordon agreed. She relied on his understanding of design principles, and she trusted his training with Wright. As Hill began to exert more control over published content, he began to influence the graphic appearance of the magazine. His small changes appeared over time, including alterations to the magazine's standard page layout and typeface. Under Hill's direction, the magazine began to use more and larger photographs, though Gordon was already far ahead of her competition in this.

Hill also began to design sets for the magazine's photo shoots.[27] When Gordon discovered a product that she wanted to promote, she would convince the manufacturer (for example, U.S. Rubber) to donate merchandise, and to pay for Hill to design and build sets for publicity and advertisements (fig. 94). These were costly endeavors, but the magazine frequently reused both the sets and the photos in subsequent ads and feature stories. Hill's design work created a new look for *House Beautiful:* his advertising sets were of the highest quality, and his aesthetic was consistent with what Gordon promoted elsewhere in the body of the publication.

Their in-house work was not limited to advertisement sets, as Hill and Gordon increasingly began to design for the magazine's editorial projects. Together, they established a design studio (housed within the *House Beautiful* offices) and created decorative arts accessories, complete interiors, and exhibition installations to

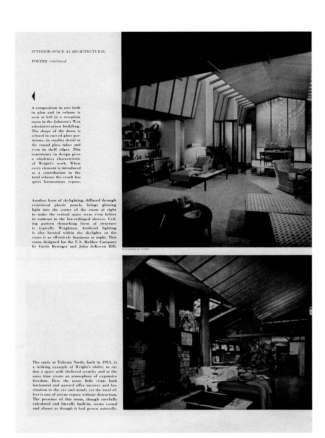

A composition in arcs both in plan and in volume is seen at left in a reception room in the Johnson's Wax administration building. The shape of the dome is echoed in curved glass partitions; in smaller detail in the round glass tubes and even in shelf edges. This consistency in design gives a wholeness characteristic of Wright's work. When every element is introduced as a contribution to the total scheme the result has quiet harmonious repose.

Another form of skylighting, diffused through reinforced plastic panels, brings glowing light into the center of the room at right to make the central space seem even loftier in contrast to the low-ceilinged alcoves. Ceiling pattern demarking form of structure is typically Wrightian. Artificial lighting is also located within the skylights so the room is as effectively luminous at night. This room designed for the U.S. Rubber Company by Curtis Besinger and John deKoven Hill.

The study at Taliesin North, built in 1911, is a striking example of Wright's ability to endow a space with sheltered security and at the same time create an atmosphere of expansive freedom. Here the many little vistas both horizontal and upward offer mystery and fascination to the eye and mind; yet the total effect is one of serene repose without distraction. The presence of this room, though carefully calculated and literally built-in, seems casual and almost as though it had grown naturally.

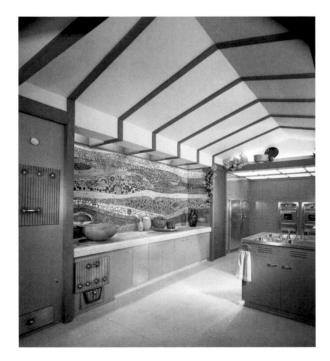

**94.** John deKoven Hill and Curtis Besinger, Sets for U.S. Rubber Company, made for *House Beautiful*, ca. 1954. Featured in *House Beautiful* (October 1959).

**95.** John deKoven Hill, Kitchen for the *Arts of Daily Living* exhibition, Los Angeles County Fair, 1954. On the cover of *House Beautiful* (January 1955).

showcase in the magazine. This became a big job, with a dedicated staff, all paid for by *House Beautiful.* Hill and Gordon hired Gair Sloan, who had trained under Taliesin apprentice Aaron Green in San Francisco, as a full-time draftsman. Hill recruited Kenn Lockhart, another Taliesin apprentice, to join his growing team. They also expanded the decorating department under Laura Tanner and engaged the firm Minic Display as craftsmen-on-call to build custom sets and furniture exclusively for the magazine. This opened up a new set of opportunities for *House Beautiful:* if the magazine was not publishing the work of another designer, it featured its own creative contributions (anonymously, of course). Hill was the primary force behind all of this, and was undoubtedly productive; he claimed to have designed and produced at least a quarter of the exhibitions, sets, and interiors that *House Beautiful* published between 1953 and his departure in 1963.[28]

Among Hill's more important contributions to the magazine was his work on the *Arts of Daily Living* exhibition, which opened at the Los Angeles County Fair in September 1954 (fig. 95). Organized by Millard Sheets (then-director of fine arts for the Los Angeles County Fair), the exhibit was jointly sponsored by *House Beautiful* to promote "modern American ways of living." Hill, alongside a few other architects, including Alfred Browning Parker and Hawaiian architect Albert Ely Ives, designed twenty-two model rooms to showcase contemporary American Style design, with an emphasis on the integral role of California artisans. Each room was a stage set, carefully constructed to demonstrate that art, whether painting, sculpture, textiles, tile mosaics, or furniture, could improve daily domestic life. The show not only promoted this philosophy, but it expressed a vitality in American modernism that was particularly critical in 1954—and especially important for Gordon in the aftermath of "The Threat to the Next America." As Gordon was still actively and contentiously engaged in countering the foreign "invasion" of the International Style, the *Arts of Daily Living* proved an especially convenient venue; the vibrant California design scene, aptly translated by Hill, proved a perfect counterpoint. This was also an enormous opportunity for Hill: he designed most of the exhibition, including the Wrightian living room featured on the October 1954 cover of *House Beautiful* (fig. 96). It was no coincidence that *House Beautiful* dedicated the exhibit to Frank Lloyd Wright.[29]

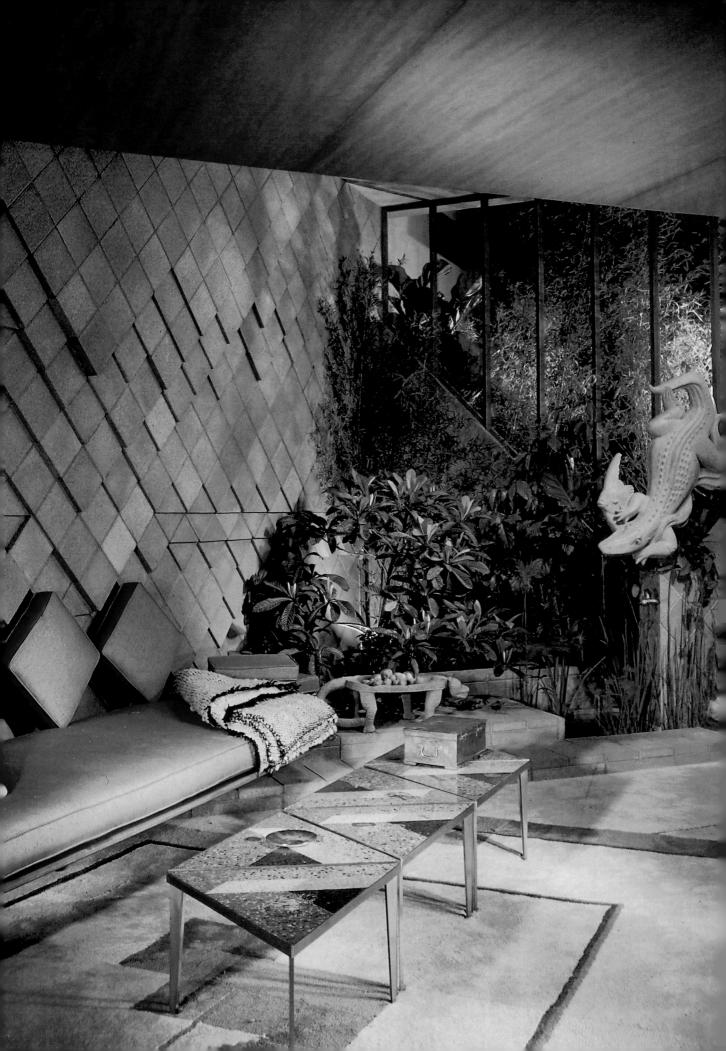

THE USONIAN HOUSE
THE WORK OF FRANK LLOYD WRIGHT

A FEATURE OF THE EXHIBITION: 60 YEARS OF LIVING ARCHITECTURE
AT THE SOLOMON R. GUGGENHEIM MUSEUM    NEW YORK    NOVEMBER 1953
SOUVENIR

**96.** John deKoven Hill, "A Room to Be Alone In," for the *Arts of Daily Living* exhibition, Los Angeles County Fair, 1954. On the cover of *House Beautiful* (October 1954).

**97.** Cover, *The Usonian House* (Guggenheim Museum souvenir booklet from *Sixty Years of Living Architecture*), 1953.

Wright's "Godfather" telegram helped Gordon at a crucial moment of public dissent and at a personal moment when she "felt mighty alone," but his loan of Hill (and other apprentices) to her staff proved to be much more powerful. Hill's design talent was especially crucial, and—to use Gordon's words—"allowed *House Beautiful* to ... design & build & show [its] alternative to the Bauhaus."[30] And that was precisely what Gordon did in the months and years that followed "The Threat to the Next America."

## The "Alternatives": Publicizing Organic

In the wake of their new alliance, Gordon became Wright's unofficial publicist. Correspondence between the two suggests that shortly after Hill joined the magazine, Wright agreed to publish exclusively with *House Beautiful*. He failed to honor this agreement (and it remains unclear whether the agreement was contractual or informal). Gordon was "bothered" by his lingering relationship with *Architectural Forum,* and wrote to him in July 1953 that "they are clearly using you as proof that they are broad-minded and not the organ of one school—which they really are."[31] Nevertheless, with Hill's help, Gordon began to vigorously—and uncritically—promote Wright to *House Beautiful*'s audience.

Wright's growing presence in popular media and his ambitious production of moderate-cost Usonian Houses intensified the public's, and *House Beautiful*'s, interest in his postwar designs. As he moved from "outside the ranks" to the head of the architectural mainstream, a position strengthened by his receipt of the AIA Gold Medal in 1949, he was eager and able to spread his "gospel" of organic to a broad national audience.[32]

His retrospective exhibition, *Sixty Years of Living Architecture: The Work of Frank Lloyd Wright,* was a particularly effective advertising opportunity (fig. 97). Arthur C. Kaufmann, a cousin of Wright's Fallingwater client, Edgar Kaufmann, Sr., and the chief executive of Gimbels department store in Philadelphia, was a key player.[33] With Kaufmann's support, Wright debuted the exhibition at Gimbels in January 1951. Oscar Stonorov (and, in some venues, Hill) supervised the installation, and opened it in at least six additional venues over the next three years, including the Palazzo Strozzi in Florence (June 1951), Paris, Zurich, Munich, Rotterdam, and Mexico City.[34] In the fall of 1953, Wright brokered a deal with Solomon Guggenheim to install the exhibit on the future site of the Guggenheim Museum. This was a brilliant public relations maneuver, orchestrated to "prepare people in New York" for Wright.[35]

Wright's concept for *Sixty Years of Living Architecture* on the Guggenheim site had two components: an exhibition pavilion and a full-scale Usonian Exhibition House. Wright designed both. Henken Builds, led by

David Henken (a former Wright apprentice working in New York), oversaw the construction, alongside a group of Taliesin apprentices who Wright sent to "assist." The team included John deKoven Hill, on loan from his new post at *House Beautiful*.[36]

Wright designed the exhibition pavilion specifically for the site and for the occasion. It encompassed nearly ten thousand square feet, with an open hall large enough to accommodate a reported eight hundred original drawings, large-scale photographs (some measuring eight feet square), and architectural models, including the 1932 Broadacre City project. The pavilion's tent-like form clearly recalled Wright's open-air studios at Taliesin West, repurposed for an urban setting. He used a flexible pipe structure (reportedly for the first time in New York) and clad the walls with Cemesto panels and "pottery red brickcrete" blocks.[37] For the roof, which vaulted to twenty feet at its ridge, he selected bands of Cemesto and sandblasted wire-glass (though some news sources reported the material was canvas) (fig. 98).

Wright also designed a full-scale model Usonian House specifically for the Guggenheim show. The Exhibition House was, as one news release established, the "piece de resistance" (fig. 99).[38] As with the adjacent pavilion (and with other Usonian Houses), Wright employed a restrained material palette: the model home's exterior was clad in brickcrete and Weldtex, a striated fir plywood

product provided by the U.S. Plywood Corporation; the interior finishes were limited to red brickcrete (both solid and perforated versions), square panels of red Rift Oak plywood, and the occasional accent of brass and copper. The 1,700-square-foot house included two bedrooms and one bath, laid out in a "simple in-line plan" that opened to a living terrace and (hypothetical) view.[39] Floor-to-ceiling glass doors, twelve feet in height, opened the interior to the terrace, allowing sunlight and natural ventilation and giving an illusion of "deep space."[40] Clerestory windows positioned along the opposite wall (facing the public street) admitted additional light and contributed to the sheltered, private experience of the model's interior.

General Electric provided all appliances for the "work space" (Wright's term for the kitchen) and the laundry. The "conveniences" were part of the architect's original scheme—or so GE's public relations office claimed—and included a refrigerator, under-counter dishwasher, garbage disposer, automatic washer, dryer, and ironer. GE also "collaborated" on lighting for both the house and the exhibit pavilion.[41]

Wright designed the Usonian Exhibition House, but Hill, working with *House Beautiful*, finished and furnished the interiors. Though Hill was busy in his new role at the magazine, Gordon had put him "completely at [Wright's] disposal" during the exhibition. He proved instrumental in the project's completion, a role that won him top

**98.** Exhibition Pavilion for *Sixty Years of Living Architecture*, Guggenheim Museum, New York, 1953.

**99.** Interior, The Usonian House, at *Sixty Years of Living Architecture*, Guggenheim Museum, New York, 1953.

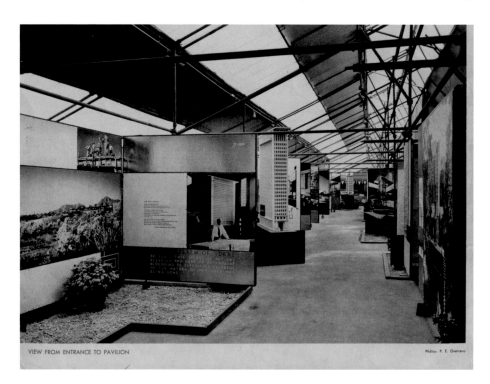

VIEW FROM ENTRANCE TO PAVILION

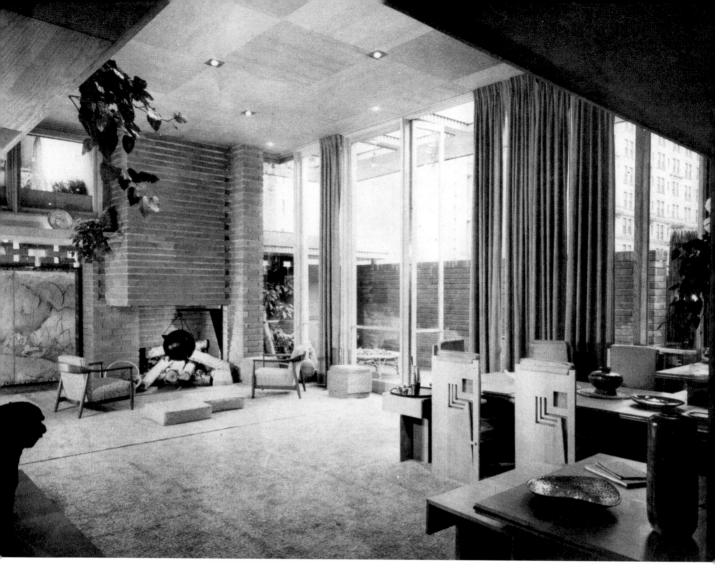

billing in Wright's list of acknowledgments.[42] Hill and other *House Beautiful* staff, including Laura Tanner and Frances Heard, selected and sourced all of the furnishings and accessories. They convinced individuals, manufacturers, and retailers to loan items, presumably with urging from Gordon herself. The list of purveyors, credited by Wright and in subsequent *House Beautiful* coverage, paralleled the magazine's list of regular suppliers. Among the common partners were Heritage-Henredon (which provided armchairs), U.S. Rubber (for cushions, pillows, and mattresses), and Dorothy Liebes (who lent handwoven fabrics and blankets).[43] Hill secured loans from other sources as well, including decorative accessories from Wright's daughter Frances, who ran America House, a retail shop in New York.[44] He also borrowed a few decorative pieces from Gordon's personal collection (possibly Japanese screens, textiles, and Chinese sculpture). Gordon was not credited, but it was customary for her to anonymously contribute personal objects to complete

magazine projects and photo shoots; it was likely that she did the same for Wright's exhibition.

The Guggenheim show was a great triumph, and print promotions and media coverage helped Wright's acclaim soar. The Guggenheim Museum and *House Beautiful* each played significant roles. Wright may have intended the exhibition primarily as a retrospective of his work and as a prelude to his designs for the new Guggenheim building (completed in 1959), but his secondary motivation was surely to generate publicity for his still-vital architecture practice. He made his intentions clear in two publications produced by the Guggenheim Museum: an exhibition catalogue, *Sixty Years of Living Architecture: The Work of Frank Lloyd Wright,* and a souvenir booklet, *The Usonian House.* The Guggenheim *Sixty Years* catalogue was analogous to the publications that had accompanied Wright's European installments of the *Sixty Years* exhibition: the catalogue featured a statement by Wright, key photographs, and an exhibition checklist. The souvenir booklet

had the same format, but focused on the Usonian House; this afforded Wright yet another opportunity to showcase and advance his postwar residential practice (see fig. 97).

In the booklet, Wright introduced the Usonian Exhibition House with a bold statement that linked him to the current debate in which he and Gordon were participating: his Usonian House type, in development since the early 1930s, was the "first truly democratic expression of Architecture." He had built numerous examples across the United States—including his first and most famous Usonian, the Jacobs House in Madison, Wisconsin (1936)—but Wright designed the Usonian Exhibition House in New York so that visitors could explore, at full scale and in person, the "real meaning of the term Organic Architecture."[45] For Wright, the Exhibition House proved that his design principles could be successfully applied to "democratic," cost-conscious housing—or what he thought was such: he estimated the price of the as-built Exhibition House at $35,000 in 1953.[46] The same house, he wrote, would have cost $15,000 in the 1930s. He noted, with apparent sincerity, that "times have changed."[47] He failed to acknowledge that both budgets were far above the contemporary average.

Wright used the Usonian Exhibition House to update his prewar domestic experiments, but he also wanted to prove his continued viability as a modern architect sensitive to the average "individual homester" who sought "a home ... in the spirit in which our Democracy was conceived."[48] He emphasized a familiar theme, one that echoed Gordon's: the American home should be designed for the "individual ... appropriate to his circumstances—a life beautiful as he can make it—with *her* of course."[49] The "her" in Wright's description was the "housewife," whom he described in his introduction as a "planned for" and "central figure" in his Usonian House.[50] This dream of the life beautiful, so he argued, was "within the reach of many."[51]

Wright was determined to have the "many" tour his Usonian Exhibition House, but recognized the limited reach of the Guggenheim's publicity and that of the local media; he knew that *House Beautiful* was circulated to a much larger national audience. Gordon was eager to promote Wright's latest message to her readers, and Hill's position at the magazine guaranteed them priority access to the architect and the show.[52] When the house was finished, Gordon sent her staff, with Ezra Stoller, to ready it for photography. She recruited James Marston Fitch, who had resigned in May 1953 but remained on good

terms with Gordon, to critique the design and record visitors' responses. The publication of his feature story, however, would be delayed by two years.[53]

Gordon's involvement with Wright and the Guggenheim show—and, more specifically, with the Usonian Exhibition House—sparked a grand idea: Gordon decided to devote a full issue of *House Beautiful* to Wright. The single-subject issue was not a new idea for her: she had previously dedicated monthly installments to one architect or one project—for example, with the Pace Setter Houses or the Climate Control Project. Yet she envisioned a Wright-themed issue as something with greater reach, a print homage that would function much like *Sixty Years of Living Architecture,* as both a look back and a look forward. This publicity would help Wright, and equally benefit Gordon, who was still reeling from the "Threat" debacle. In typical fashion, she began to lay the groundwork for the Wright tribute project years in advance. Before she published Wright, she wanted to grow her subscription numbers, increase her advertising pages, and expand the magazine's total page count. (The November 1953 issue, which featured the 1954 Pace Setter House, was the largest to date, but she wanted more.) Two years passed. Finally, in 1955, Gordon was ready for Wright.

In November 1955, Gordon published an extraordinary issue of *House Beautiful,* titled "Frank Lloyd Wright: His Contribution to the Beauty of American Life." Pictured on the cover was Wright's Taliesin living room (fig. 100). Gordon would use the entire magazine to tell Wright's "dramatic story."[54] The special Wright issue was expansive and expensive: to cover the cost of printing 385 pages, *House Beautiful* secured a historic 248 full pages of advertisements.[55] Of these advertisements, at least seven featured Wright or Wright-designed homes. (This thematic advertising strategy was similar to the one Gordon perfected for the Pace Setter Houses.) Wright typically refused to "recommend" products, but allowed the magazine to print his name alongside anything that he had specified for his projects. Hill obtained the product list directly from Taliesin and found images that could be run alongside the ads.[56] Though Hill did not directly

**100.** "Frank Lloyd Wright: His Contribution to the Beauty of American Life," cover, *House Beautiful* (November 1955).

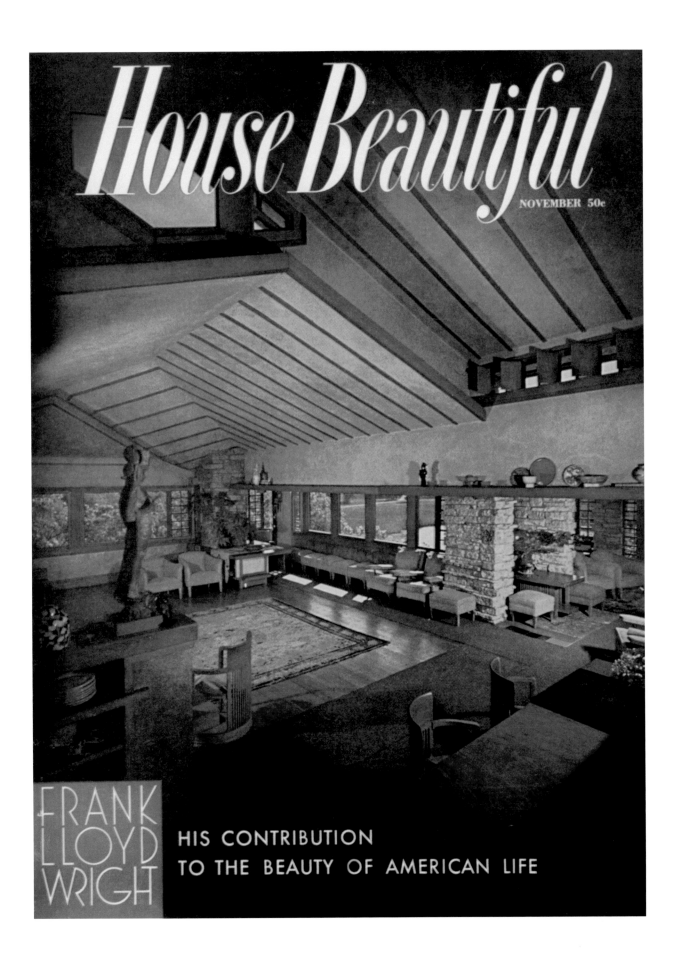

# House Beautiful

NOVEMBER 50c

FRANK LLOYD WRIGHT

HIS CONTRIBUTION
TO THE BEAUTY OF AMERICAN LIFE

solicit, he "lined up" this advertising business for *House Beautiful*'s sales team.[57]

The Hearst Corporation must have loved the idea of a Wright issue, and agreed to the large production budget. It imposed two conditions: the ad revenues had to be sizable, and the magazine had to be successful. And it was a success. The November 1955 Wright issue sold out in record time and in record numbers, and in many cases, for an amount far greater than the fifty-cent cover price.[58]

*House Beautiful*'s Wright issue was spectacular, if openly biased. At moments, it verged on hagiography. Gordon summed up her editorial point of view in the introductory pages: "[Wright] has achieved the immortality of influence and universal recognition, and continues to amaze even his admirers with the freshness of his latest work."[59] He was, so Gordon believed, the "World's Most Honored Architect."[60]

As Gordon intended, the 1955 issue served as a print retrospective of Wright's work. She gave her readers a glimpse of the man and his ideas, conceptually and visually framed by some of his best designs. The issue included twenty-two separate articles, including "Faith in Your Own Individuality," written by Wright himself. Joseph A. Barry's twelve-page story, "Frank Lloyd Wright: The Man Who Liberated Architecture," provided a biography and an introduction to organic theory, illustrated by a full-color portrait of Wright and five black-and-white snapshots (fig. 101). John deKoven Hill's essay, "The Poetry of Structure," covered Wright's construction methods and structural innovations, with a look at Fallingwater. The editors' short article, "The Character of the Site Is the Beginning of Architecture," introduced organic siting strategies, exemplified by Taliesin. San Diego architect and *House Beautiful* contributor Robert Mosher, not to be confused (as he is in some sources) with Wright's apprentice Robert Keel Mosher, recounted Wright's position on "the nature of materials" in "The Eloquence of Materials," an essay featuring illustrations of (among others) the Clinton Walker House in Carmel and the Ennis House in Los Angeles. Bruno Zevi wrote a brilliant essay on Wright and space; his "The Reality of a House Is the Space Within" showed both residential projects (the Neils House and Taliesin) and commercial projects (the Guggenheim Museum, the Johnson Wax Administration Building, and the V. C. Morris Gift Shop). Fitch's long-overdue coverage of the 1953 Guggenheim Usonian Exhibition House appeared in this same issue,

as "Frank Lloyd Wright's Contribution to Your Daily Life." Gordon used her own essay, "The Symphonic Poem of a Great House," to discuss Wright's masterful merging of "art and life" within one work of architecture (here, the 1908 Coonley House in Riverside, Illinois).[61]

Gordon's goal was to provide, in magazine format, a comprehensive overview of Wright's contributions to American design. She accomplished this with ease. But she did one other crucial thing with the November 1955 issue: she launched the Taliesin Ensemble, a new line of Wright-designed home furnishings.

## The Taliesin Ensemble

In late 1953, Gordon and Hill went to Chicago, a trip they often made together to visit the Merchandise Mart. Their travels coincided with a Taliesin Fellowship recital at the Art Institute of Chicago's Goodman Theater, where Wright's apprentices were performing a series of dances based on the Gurdjieff movement. The fellowship members were clad in "rich, flowing... colorful" costumes that, according to Hill, "didn't look anything like Mr. Wright." But Gordon was nevertheless captivated.[62] She collected a sampling and sent them to her friend René Carrillo, who was in charge of merchandising for the fabrics division at F. Schumacher and Company. She asked if he was interested in making a line of Wright-designed textiles. He was. This brief exchange was the catalyst for Frank Lloyd Wright's Taliesin Ensemble.

With Schumacher on board, Gordon expanded her initial concept to include a full line of domestic products for the mass market. She envisioned the line as an ensemble, a complete set of furnishings and accessories that would conform to Wright's definition of integrated design: "everything had to go together."[63] Wright was intrigued by Gordon's idea. Such an ensemble would allow him to spread his philosophy to a broad audience and, if licensed properly, could bring in a substantial (and always needed) income. He must have been conflicted, though. He had long promoted organic design and the custom work that it demanded. And he often ridiculed decorators hired to furnish and "finish" interiors; he believed these adjunct designers threatened the cohesive whole, and the architect's control, of organic architecture. Mass-produced home furnishings seemed counter to his long-held values, but his interest in democratizing modern design triumphed.[64]

Mr. Wright at home in Spring Green, Wisconsin, on his 86th birthday.

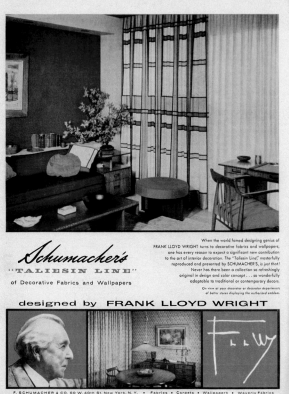

*Schumacher's*
"TALIESIN LINE"
of Decorative Fabrics and Wallpapers

designed by FRANK LLOYD WRIGHT

When the world famed designing genius of FRANK LLOYD WRIGHT turns to decorative fabrics and wallpapers, one has every reason to expect a significant new contribution to the art of interior decoration. The "Taliesin Line," masterfully reproduced and presented by SCHUMACHER'S, is just that! Never has there been a collection so refreshingly original in design and color concept . . . so wonderfully adaptable to traditional or contemporary decors.

On view at your decorator or decorator departments of better stores displaying the authorized emblem.

F. SCHUMACHER & CO. 60 W. 40th St. New York, N. Y. • Fabrics • Carpets • Wallpapers • Waverly Fabrics

Gordon convinced him (and, to some extent, the American public) that "to have Frank Lloyd Wright design furnishings for the general homemaker, rather than for special clients, seems a development that is logical and long overdue."[65] The new line, though mass-produced, would be based on Wright's custom work. She recruited a few longtime *House Beautiful* industry partners to manufacture and promote the pieces: Carrillo at Schumacher, Walter Guinan at Karastan rugs, William Stuart at Martin-Senour Paints, and T. Henry Wilson (with Ralph Edwards) at Heritage-Henredon.[66] She persuaded these four major manufacturers, along with Minic Display, to produce, respectively, Taliesin-designed fabrics and wallpapers, carpets, paints, furnishings, and accessories. Gordon advised them to keep their prices "reasonable," so that the ensemble would be "available for all to buy."[67]

The collaboration began with Schumacher. Gordon connected Carrillo and Wright, and Hill facilitated a meeting between the two at Taliesin West. The architect agreed to partner with the firm to design both fabrics and wallpapers. He did, however, warn Carrillo that "it's going to cost you a lot of money." Though the Schumacher executives balked at Wright's request for a $10,000 retainer fee and twenty-five cents per yard or roll sold, they pushed the deal through.[68]

In March 1954, Wright signed a contract with Schumacher, announcing to the Taliesin Fellowship that "we're now in the fabric industry."[69] He emphasized their financial incentive: they were working for a hefty retainer and future royalties. Wright submitted a set of conceptual designs in a matter of weeks.[70] The designs, according to Hill, were all Wright's, though Hill later contributed complementary patterns of his own under the Taliesin name.[71] Wright and his apprentices provided prototype sketches and worked in collaboration with staff at Schumacher—under a very tight deadline—to select the final designs. The manufacturer, as Carrillo proposed, would determine the final color schemes; his goal was, in large part, "saleability and practicality." Together, they produced the initial line of thirteen fabrics and three wallpapers (fig. 102).[72]

**101.** Frank Lloyd Wright, portrait (ca. 1953), *House Beautiful* (November 1955).

**102.** Frank Lloyd Wright, Schumacher and Company "Taliesin Line" fabrics for the Taliesin Ensemble. Advertisement in *House Beautiful* (November 1955).

THE FOUR SQUARE
HERITAGE HENREDON
FINE FURNITURE
FRANK LLOYD WRIGHT
ARCHITECT

Wright's working relationship with the furniture collaborative Heritage-Henredon was a similar sort of partnership, with equally tight production schedules.[73] T. Henry Wilson, then-president of Henredon and an "admirer of Wright," was instrumental in the project, as was Henredon cofounder Ralph Edwards.[74] Wright drew from his long experience designing geometric furniture and proposed three complete lines: the "Honeycomb," the "Burberry," and the "Four Square" (fig. 103). Each set contained armchairs, side chairs, sofas, dining tables, accessory tables, case goods, and "ornaments" (vases, lamps, or carpets). Heritage-Henredon combined the three proposed groups into a single sixty-six-piece collection, dubbing the new set the Taliesin Line (fig. 104).[75]

Wright's work for Martin-Senour Paints (again, coordinated by Gordon) was no less collaborative, though certainly less innovative. The paint company was proud of its association with "the most creative architect the United States has yet produced," and its promotional portfolio described their working process as one of selection.[76] Wright did not "invent" the paint colors;

rather, he and Mrs. Wright "personally" chose thirty-six hues that could be "custom [mixed]" by customers at participating Martin-Senour stores (fig. 105). Wright named each shade in what would become the "Taliesin Palette," including "Spring Green" (number 396) and "Cherokee Red" (number 68). The final line contained twenty-seven hues intended for wall coverage, and nine for accent (fig. 106). The paints were an integral part of the Taliesin Ensemble, establishing what *House Beautiful* described as the "harmony" between the other components of the line.[77]

To complete the ensemble, Wright produced several carpet designs for Karastan. Though Gordon's deal was with this company, the architect simultaneously submitted eight large-scale patterns to Schumacher; historian Virginia T. Boyd has suggested that these were possibly intended as floor coverings.[78] Despite Wright's efforts, when *House Beautiful* debuted the Taliesin Ensemble in November 1955, it was without the Karastan carpets. The magazine promised—in a quarter-page advertisement— that the rugs were "on the way."[79] The collection, *House*

# Frank Lloyd Wright

## Now applies to furniture a genius that is world-renowned

Frank Lloyd Wright, the prophet of new ideas in architecture, now for the first time applies his visionary ability to designing a group of dining room, bedroom and living room furniture.

The Frank Lloyd Wright concept of furniture will create a new form of family happiness in today's home, a new adventure in freedom and dignity, a new flexibility of function and design.

When you see this fresh, imaginative furniture, you'll feel its quality and integrity. In each piece you'll find the sensible, sensitive touch of the man who is the most creative designer of our time. Everywhere the beauty is integral with the nature of the materials.

The collection will be produced (exclusively) by Heritage-Henredon. Look for the signature of Frank Lloyd Wright on each piece. For the name of the dealer nearest you, see page 342 or write to Heritage-Henredon, Box HB11, High Point, North Carolina.

### Heritage Henredon *fine furniture*

CUSTOM QUALITY AT PRACTICAL PRICES.
Factories at High Point, Mocksville, and Morganton, N. C.

### Heritage Henredon *fine furniture*

He "belongs to the present . . . he is a link with the past. One feels a sense of never-ending richness, potential, heart and meaning." The New York Times.

And of his buildings, "as if they were to take their place in a happier world—one of light, of grace." So says The American Academy of Arts and Letters.

This is Frank Lloyd Wright, a man who designs for real people, respecting their roots, their hopes. Of all forms, furniture seems a natural expression of his genius.

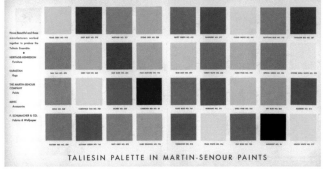

TALIESIN PALETTE IN MARTIN-SENOUR PAINTS

**103.** Frank Lloyd Wright, "The Four Square" furniture group for Heritage-Henredon, for the Taliesin Ensemble, 1955.

**104.** Frank Lloyd Wright, Heritage-Henredon furnishings for the Taliesin Ensemble. Advertisement in *House Beautiful* (November 1955).

**105.** Frank Lloyd Wright, Martin-Senour Paints' "Taliesin Palette," for the Taliesin Ensemble. Advertisement in *House Beautiful* (November 1955).

**106.** Frank Lloyd Wright, Martin-Senour Paints' "Taliesin Palette," sales brochure, 1955.

Mr. Wright has designed a line of accessories in exotic woods (with metal liners) to hold flowers, branches of foliage, fruit, shells, or whatever you might want to display. Some match the mahogany furniture; others are of walnut, ebony, rosewood and holly.

**Frank Lloyd Wright designs home furnishings** *continued*

See how Mr. Wright co-ordinated the design of the furniture with one of his fabric designs. Both the moldings and the doors are echoed in the printed Belgian linen. Note how both relate to the cube of the wooden container on the sideboard above and left.

*More photos of Taliesin Ensemble on page 336*

*Beautiful* wrote, was "still on the drawing boards," but was sure to be "beautiful and livable, as thoughtful and original as everything this great designer has done."[80] Though it confirmed the collection for spring 1956, Karastan never produced the line (fig. 107).[81]

Because Gordon and Hill had been working with Minic to fabricate temporary sets and exhibitions for the magazine, the company was an easy choice for the Taliesin Ensemble's accessory line. Wright provided Minic with a range of drawings for decorative pieces, including "holders" for "flowers, branches of foliage, fruit, shells, or whatever you might want to display."[82] He wanted some of the objects to coordinate with Heritage-Henredon's mahogany furniture, and others to be executed in walnut, ebony, rosewood, olive wood, and copper. Minic made several prototypes for the Taliesin Ensemble's launch, including the selection pictured in *House Beautiful,* but could not mass-produce any of the designs (fig. 108). Minic's accessories, much like Karastan's rugs, never went into full production.

The Taliesin Ensemble opened in New York in October 1955 (Wright previewed the collection a month earlier), to a small audience of decorators and potential clients gathered at the National Republican Club. The club provided an elegant setting for Wright's pieces, installed in a sequence of five small exhibition rooms. Schumacher paid for the show (the venue was adjacent to its offices) and hired Virginia Conner Dick to "decorate" the rooms.[83] Local media covered the launch, including the *New York Times.* Gordon sent Maynard Parker to photograph the event for *House Beautiful* (fig. 109).

Dick's involvement was surprising, given Hill's proximity to the project. Hill's Taliesin ties, experience in exhibition design, and recent success at *House Beautiful*'s 1954 *Arts of Daily Living* show would have made him a better choice for such a job. Carrillo and Schumacher must have had reasons for hiring their own decorator, but in Wright's estimation, they chose poorly. Dick's spaces were, as Betty Pepis of the *New York Times* wrote, "completely unrelated" to the ensemble furniture.[84] Wright was enraged. He demanded that Schumacher remove his name from the exhibit and complained to Carrillo that he had been "misused" by the interior decorator, a profession that Wright generally disparaged as "inferior desecrator."[85]

Maynard Parker's photographs revealed the substance of Wright's complaint: the furniture and fabrics were recognizably Wrightian, but the environment lacked the unity and sophistication that had been achieved, for example, at the Guggenheim Usonian Exhibition

**107.** Frank Lloyd Wright, Design for Karastan Carpets (not produced), for the Taliesin Ensemble, 1955.

**108.** Frank Lloyd Wright, Prototype accessories by Minic (top photograph) for the Taliesin Ensemble, 1955. *House Beautiful* (November 1955).

**109.** Frank Lloyd Wright, The Taliesin Ensemble, debut installation at the National Republican Club, New York, 1955.

House (see fig. 109). According to Carrillo, in his defense to Wright, Schumacher had not intended to display a full Wright interior, nor did it endorse the exhibit as such.[86] The company merely wanted to showcase its new product line.

With such a poor showing in New York, Gordon and Hill hoped to redeem the next launch for the ensemble. Hill designed the second exhibit, this time for the Chicago Merchandise Mart in October 1955 (fig. 110). The *Chicago Sunday Tribune* anticipated a "furor" of success and, although the writer saw "no revolutionary departure from accepted trends in modern furniture," praised the line for its "unmistakable Wright stamp" (referring to both the aesthetic and the burned-in maker's mark present on each piece).[87] Other viewers, including journalists and buyers, were more critical.[88] The *Chicago Daily News* was "confused," and the *New York Times* seemed disappointed that Wright's "enormous new venture" was

rather "conventional."[89] Though the set and the individual objects reportedly "looked nice," the collection fell flat.[90]

New York retailers began to sell the Taliesin Ensemble in November 1955, the same month *House Beautiful* published the line. The availability was, however, limited. Heritage-Henredon only offered the furnishings through its franchises, and most of the major stores that carried Wright's designs only stocked the products at their flagship locations: B. Altman and Company, Abraham and Straus (in Brooklyn), and Bloomingdale's were among these. A few department stores advertised the arrival of the ensemble in the *New York Times,* but publicity after mid-November ceased.[91]

Wright's line sold poorly. Retailers were mystified: the pieces were affordable and priced competitively. Yet the collection seemed to perplex both customers and retailers. As Hill lamented, "They [the stores] didn't know whether it was traditional or modern."[92] The biggest

problem, as Hill later speculated, was that the ensemble "wasn't shown together ... it never was shown the way [Wright and Gordon] intended it to be."[93] Bloomingdale's, for example, split the line between its fabric department on the fourth floor and its modern furnishings department on the fifth floor.[94] Other stores showed pieces alongside competing lines, placing Wright's beds and dining room tables among every other offering. And, as Hill complained, the accessories "never got anywhere near the furniture."[95]

Outside of *House Beautiful,* the line was neither viewed as nor used as an ensemble: this was its downfall. The lifespan of the project was, as a result, quite short. Karastan and Minic never carried through with their productions. Heritage-Henredon discontinued the furniture collection in 1956 (in part because the company was sold to Drexel). Martin-Senour continued to mix the "Taliesin Palette" until at least 1956. The Schumacher decorative fabrics and wallpapers were, however, an exception: the company kept Wright's designs as part of its portfolio until 1960, when the patterns were gradually "phased out."[96] Two decades later, though, the company reissued a new line of Wright fabrics and featured some of the 1955 "Taliesin Line" pieces.[97]

*House Beautiful*'s promotion of the Taliesin Ensemble was, predictably, the most enthusiastic of all the related press coverage for this project. Gordon was convinced that Wright's pieces could provide beauty in homes where there was otherwise a "lack of architectural distinction."[98] The key was in composition (fig. 111). "The richest effect," she wrote, was "not so much in individual pieces as in the grouping of them together."[99] The success of the line depended on the concept of ensemble, a concept that retailers, decorators, and consumers failed to embrace. Was the line successful? Hill himself summed up the endeavor: "It's hard to say. It didn't go on long enough to be a big success. It wasn't a failure."[100]

With *Sixty Years of Living Architecture, House Beautiful*'s 1955 Wright issue, and the Taliesin Ensemble, Wright found a new legitimacy within the mainstream of American taste. Gordon was instrumental in this process. Under her careful editorship, organic architecture was repackaged as an alternative expression of the "American Style." By the mid-1950s, Wright's version of modern design had reemerged from the annals of architectural history to which it had been relegated, as Wright put it, by the "Bauhaus invasion" of 1932.[101] Wright's emphasis on humanism resonated in a postwar culture that was becoming, as critics posited, increasingly standardized and mechanized. Negative reviews of this very process, and of functionalist architecture in general (written by figures such as Lewis Mumford), suggested that organic design presented a newly desirable model of modern building and modern living.

In these years, at the apex of Gordon and Wright's productive alliance, the ranks of organic designers (some self-identified, some not) began to swell. Wright's organic design principles, alongside his commentary on the social, cultural, and architectural issues that haunted postwar America, became a new rallying point not only for Gordon but for many young architects who would increasingly fill the pages of *House Beautiful.*

**110.** Frank Lloyd Wright, The Taliesin Ensemble living room set at the Chicago Merchandise Mart, with installation design by John deKoven Hill, 1955.

**111.** Frank Lloyd Wright, The Taliesin Ensemble, 1955. Dining room set (above) and patterned edging (below), *House Beautiful* (November 1955).

A New Alliance    147

# The Next American House

In the fall of 1953, Frank Lloyd Wright offered *House Beautiful* readers his "Prescription for a Modern House" (fig. 112).[1] He encouraged them to aim for, among other things, two important components: character and individuality. These were precisely the qualities that Elizabeth Gordon promoted as part of the American Style, and, with Wright's approval, she added the term "organic." With Wright's endorsement, she used his quintessential Americanness to legitimize an emerging line of modern architects who were increasingly individualists and often regionalists; these men put a sizable distance between the domestic architecture that Gordon hoped to publish in the mid-1950s and the merchant-builder homes that she had published in the previous decade. The future of the modern house for the Next America, so Gordon implied, lay with the young architects who followed Wright's prescription.

## Introducing Alfred Browning Parker

In 1946, Gordon introduced *House Beautiful*'s readers to Alfred Browning Parker, a young Florida architect on the rise. Parker's first house, completed that year for a mere $1,200, was the subject of the March "Home Planner's Study Course."[2] Parker, as the architect and builder (and a then-lieutenant in the Navy Reserves assigned to shore duty in Miami), offered readers a model of "initiative and ingenuity."[3] Gordon presented his house as a prototype worthy of study, primarily to answer the timely question: "Is there such a thing as a low cost house?"[4] Yet the home's architecture was not the focus. It was a sidebar, pictured in black and white. The leading image suggested as much: it captured the house from an obscured vantage point, showing only a bay of louvered windows hidden behind trees and vines that, as the magazine explained, "[ensured] privacy" and prevented "goldfish bowl conspicuousness."[5]

*House Beautiful* showed Parker's design, but focused less on his architectural skill and more on the man, with his "brain power and brawn power."[6] Parker was self-reliant, and thus the perfect role model for the angle Gordon had in mind: he had designed and built his own home despite high costs, spending limits (controls still in place from the Second World War allowed only $200 per year), scarce materials, and building restrictions (both local and federal). All of these factors had forced Parker to approach the project as a remodel of an existing building (an old filling station that stood on his property), and so his was a credible solution to the housing problems that many Americans faced at that moment.

Parker's debut in *House Beautiful* was well-timed marketing, but the magazine left his architectural backstory untold. That story, and Frank Lloyd Wright's role in it, was not part of Gordon's agenda in 1946. It would, however, become essential to her plan in 1953.

When Gordon published Parker's first house in 1946, he was virtually unknown. He had recently finished college at the University of Florida (and was one of only

228

"**P**rescription for a Modern House:

"**First, a good site.** Pick one at the most
difficult spot—pick a site no one wants—
but pick one that has features making for character:
trees, individuality, a fault of some kind in the realtor mind.

"That now means getting out of the city.

"Then, standing on that site, look about you so that
you see what has charm. What is the reason you want
to build there? Find out. Then build your house so that
you may still look from where you stood upon all
that charmed you and lose nothing of what you saw
before the house was built, but see more.
Architectural association accentuates the character of
the landscape, if the architecture is right."

FRANK LLOYD WRIGHT
*in a lecture, 1938*

*For the story of how the Pace Setter took advantage
of the faults of its site, turn to page 354.*

House Beautiful, November 1953

**112.** Frank Lloyd Wright, "Prescription for a Modern House," with the site plan for the 1954 Pace Setter House (below), *House Beautiful* (November 1953).

three students to graduate in 1939). His college mentor, Rudolph Weaver—a Beaux-Arts–trained architect who had recently broken from that pedagogical tradition—had insisted that he consider architecture not as a "piecemeal" practice but as a complex, integrative process.[7] Parker used this, and Weaver's implicit rejection of the popular Beaux-Arts method of training, to inform his early designs. When he was not working, he studied and traveled. He read history and Transcendentalist philosophy (Emerson, Thoreau, and Whitman were his lifelong favorites), and, when abroad, devoured the climatically responsive architecture of Cuba, the expressive designs of Scandinavia, and the ancient monuments of Mexico.[8]

In a transformative moment, sometime in 1938, Parker discovered Frank Lloyd Wright. He encountered Wright first through magazines, just as *Architectural Forum, Time,* and *Life* declared him the "greatest architect of the 20th century."[9] Parker, like the rest of America, was captivated by Fallingwater.[10] He was moved, and wrote to thank Wright, expressing that "truly your life and work—your life-work—has been an inspiration."[11]

In 1944, Parker received an invitation from Wright to join the Taliesin Fellowship. He accepted, but later declined, explaining that he "thought maybe it was best to worship a great man from afar, rather than get too close and be consumed by the flame."[12] He chose instead to stay

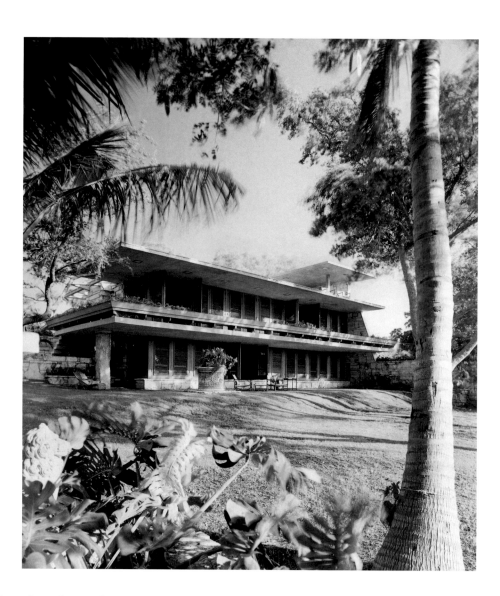

**113.** Alfred Browning Parker, 1954 Pace Setter House, Biscayne Bay (Miami), Florida, 1953. View from the bay to the house. Copyright © Ezra Stoller/ESTO.

**114.** Parker, 1954 Pace Setter. View from the road to the house (southwest elevation). Copyright © Ezra Stoller/ESTO.

in Florida and, after his release from the Naval Reserves, opened his own architectural practice. His started his first day of business on 1 January 1946, working out of the studio in his newly completed home, the very house Gordon would publish a few months later.[13] His professional success was quick. He kept his firm small, but by 1950, he had designed seven custom homes and a number of speculative units.[14] His executed projects were valued in the millions of dollars. With a thriving practice, and now four children and a Great Dane, he had long outgrown his "$1,200 house."[15]

Ready to build his next home, Parker purchased land on Royal Road in Miami. Priced at $7,000, the "cheap" lot had a magnificent view of Biscayne Bay, but came with significant challenges. The site was long and narrow and sloped toward the water's edge. It was bounded on three sides—by the bay, a public road, and an adjacent school (see

fig. 112). Parker had certainly taken Wright's "Prescription for a Modern House" to heart: he selected a building site that no one else wanted, one that was difficult, but one that had "features making for character: trees, individuality, a fault of some kind in the realtor mind."[16]

Guided by the "faults" of his new lot, Parker started to design. His primary motivations were personal, practical, and, to some degree, professional. He hoped to build a house that fit his family's size, habits, values, pocketbook, and dreams—but that could also attract prospective clients. He had developed a design process, but he had "no formula."[17]

Parker had another practical constraint: the challenges of the Florida climate. His approach was "ecologically oriented," in both architectural concept and materials selection.[18] He carefully studied the site's topography and microclimate to help him determine the home's function

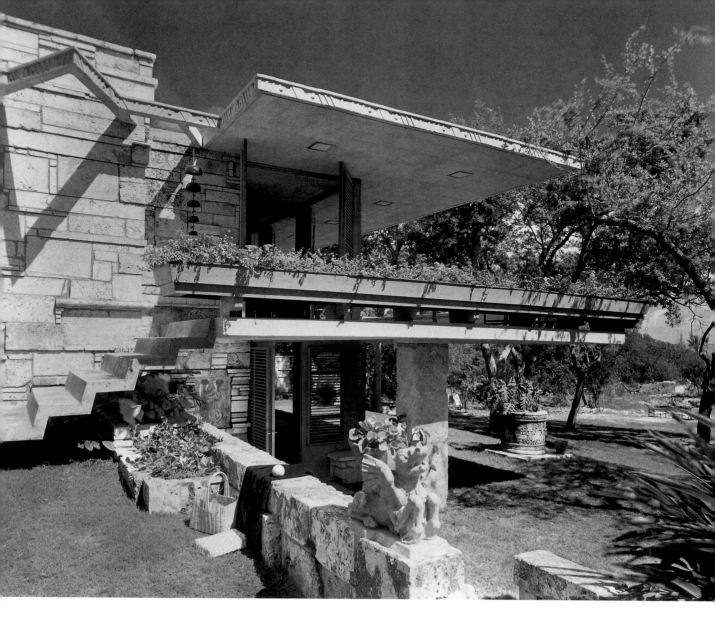

and form.[19] He wanted a house that worked well in its locale, a design embedded in nature that "strengthens, exploits, and extends" the landscape.[20] To achieve this, he made two significant choices: to build the house as a series of cantilevered platforms, and to use only concrete and stone.

He chose the cantilever because, as he later wrote, it worked simply. It was also economical. It was, for Parker, a happy marriage of aesthetics and utility.[21] He composed the house as three horizontal concrete slabs, anchored at each end by a monolithic limestone wall (fig. 113). The slabs, sandwiched between slender steel support members, left the interiors open and free, so that neither space nor view were interrupted. This was a perfect solution for Parker's narrow bayside lot. The cantilever system also responded well to the Miami climate: it provided deep overhangs for shade, it offered shelter during heavy tropical rains, and it formed wide balconies and a flat rooftop that nearly doubled the home's usable living space. And, as Parker later remarked, he thought the cantilever just looked good (fig. 114).[22]

He chose certain materials, particularly the Florida quarry keystone (a fossilized coral limestone) that made up the perimeter walls and hearth, as a philosophical statement.[23] Native materials, as he had learned from Wright, physically and aesthetically connected the building to its locale. In Miami's harsh tropical climate, native materials also ensured both performance and longevity. The stone, in particular, had another potential: it provided both a visual complexity and an ornamental scheme for the building (fig. 115). The composition of the masonry walls in particular, revealing the influence of Yucatan stonework (which had impressed him during his travels in the early 1940s), inspired an ornamental

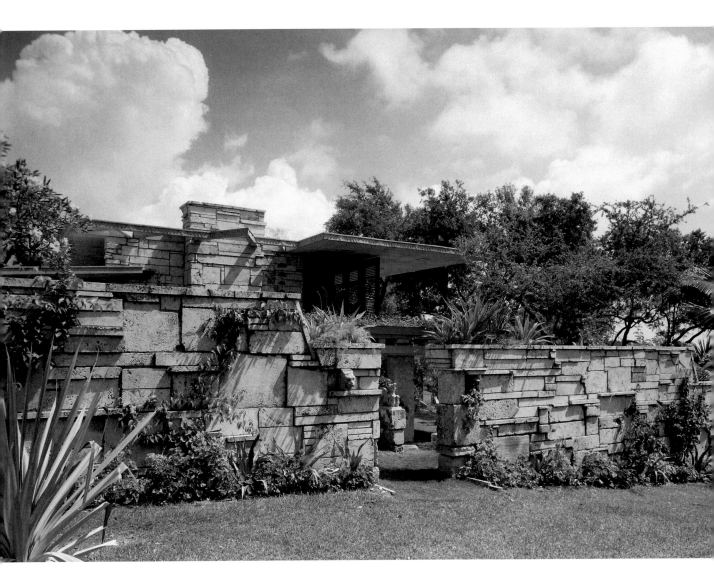

*leitmotif* found in most of the home's decorative elements.[24] Later, after *House Beautiful* became involved with finishing the house, Parker expanded his materials' palette. With Gordon's mediation, building suppliers provided—either gratis or at wholesale—Cuban mahogany, Honduran mahogany, and tidewater cypress, all of which were used for custom doors, windows, trim, wall paneling, and hand-built furnishings.[25]

As with his 1946 residence, Parker built this new house himself. He did the work in part because his budget was tight, and in part because he believed that his labor gave "spirit" to the design. With little assistance, he poured the concrete cantilever slabs and laid the masonry blocks. He cut and planed all of the interior wood surfaces and crafted all of the built-in furniture. He controlled every element of the creation, so that he maintained a spontaneity and flexibility that would otherwise have been impossible.

In 1950, Gordon visited Miami and stopped over to see Parker. The house was still under construction, but she was impressed by his work. When she returned to New York, she immediately wrote to him that the house was a "masterpiece" that would make him "a designer of stature."[26] And she wanted to help, by publishing the house as a Pace Setter. The timing of her visit was perfect, as Gordon was, at the moment, engaged in the first wave of promoting the American Style—of which she believed Parker's house was a perfect example. By the time Parker finished the house in 1953, Gordon would leverage Parker's allegiance to Wright to make the house an even more powerful statement in her battle against the International Style.

In the summer of 1953, Gordon dispatched her interior decoration staff, led by Laura Tanner, to complete the project. Together with Parker, they worked on finishes,

interior decoration, and staging for *House Beautiful*'s imminent photo shoot. As *House Beautiful* decorator Frances Heard explained, Gordon's staff began by selecting a "hub" around which they could make decorating decisions. This strategy was practical for the decorating team, and could later be relayed to readers as advice they could implement in their own homes: "Pick something significant and worthy as a take-off point. *What* you pick is not so important as that you *do* pick something—and that it be a *good* thing with meaning for you."[27] At Parker's Pace Setter, that "something" was coral stone.

Tanner and her team helped Parker select and install subtle finishes that would not "compete for attention" with the stonework.[28] They specified paint and textile colors that "brought out" the beige and brown within the coral. They bought, cut, and fitted matching cotton carpet, laid in the master bathroom. They tacked up coordinating cork ceiling tiles, a process that photographer Ezra Stoller unwittingly documented and *House Beautiful* printed in small photos within the November 1953 feature story. In a rare cameo appearance, Gordon herself was pictured helping Parker ready the house (fig. 116).

*House Beautiful* staff also carefully selected all of the movable furnishings in the house. Because they took guidance from Parker's cantilevered structure and masonry patterns, they reasoned that their furnishings "had better *not* be geometric, but had better be softly rounded or curved with the everchanging [*sic*] curves of the human body."[29] The focal point of each interior space, at least as it was photographed, was often a chair—what Gordon called the "flower of modern design."[30] The house's furnishings eventually included "curving" mass-market pieces from Heritage-Henredon (a regular *House Beautiful* advertiser), a sculpted chair by Wharton Esherick, and a selection from Hans Wegner's line for Hansen and Son.[31] The Wegner chairs would eventually become the focal point for the Pace Setter cover shot (and would reappear often in other *House Beautiful* spreads) (fig. 117).

Gordon insisted that her staff finish the house as an "integrated" whole; to this end, they designed and made a series of textiles. She used familiar pieces here: custom

carpets, hand-embroidered bed linens, monogramed hand towels, and, in the dining room, her own Swedish tapestry by Barbro Nilsson (which was used repeatedly in *House Beautiful* photos; see fig. 117). All of these accessories unified Parker's design and created a learning opportunity for Gordon's audience, as the magazine printed detailed instructions on how readers could craft this "perfection" themselves.[32]

Most important, though, was the work of the noted Hungarian textile artist Mariska Karasz.[33] Gordon had hired Karasz as the magazine's guest needlework editor from 1952 to 1953, and to create custom pieces for the Pace Setter House series. For Parker's Pace Setter, Karasz made an ensemble of textiles that included carpets, wall hangings, bedspreads, and linens. Karasz, like Parker and Frank Lloyd Wright, looked to nature as a source of inspiration for form, content, and color. She looked, too, at the architect's design. With Parker's Pace Setter, her two sources of inspirations were the stonework patterns and the structural cantilever.

Among the many pieces Karasz designed for the 1954 Pace Setter, her rug for the living room was perhaps the most significant (fig. 118). Parker wanted the piece to work around his built-in coffee table and to complement the nearby fireplace. After careful study of both, Karasz chose an embroidery stitch that resembled the "brain-like convulsions of the coral."[34] The texture of the yarn itself recalled the stone's coarse variety and porosity, and the colors echoed the soft cream tones of the masonry and the warm browns of the oiled mahogany used throughout the house.

**115.** Parker, 1954 Pace Setter. View from the road to the southwest garden wall, with the house beyond. Copyright © Ezra Stoller/ESTO.

**116.** Parker, 1954 Pace Setter. Parker and *House Beautiful* staff ready the house for a photo shoot (Gordon is pictured in the foreground). Copyright © Ezra Stoller/ESTO.

**117.** Parker, 1954 Pace Setter. Dining room, photographed for the cover of *House Beautiful* (November 1955). Copyright © Ezra Stoller/ESTO.

**118.** Parker, 1954 Pace Setter. Living room with a view out of opened *persianas,* and a Karasz rug pictured at far right. Copyright © Ezra Stoller/ESTO.

**119.** Parker, 1954 Pace Setter. Coverlets, sheets, and bedskirt for the master bedroom, featuring the embroidered coral motif. Copyright © Ezra Stoller/ESTO.

**120.** Parker, 1954 Pace Setter. Bath towels for the master bathroom, featuring the embroidered coral motif. Copyright © Ezra Stoller/ESTO.

Parker's stonework likewise inspired textiles for the master bedroom, where Gordon had coverlets made to mirror a segment of the garden wall that Parker's wife, Martha, found particularly delightful. Using Karasz's embroidery techniques (which she may have learned through the magazine's instructional segments), Mrs. Parker appliquéd and hand-stitched her husband's pattern onto handwoven Indian silk tweed.[35] The representation was perfect, from the play in depth to the placement of the wandering coral segments. Mrs. Parker, so the magazine claimed, likewise machine-embroidered the bed linens (fig. 119). The pattern was again Parker's creation: he derived the "square and squiggle" from a combination of the rectangular form of

the cantilever, the rectangular blocks of stone, and the undulating waves embedded within the coral itself. Mrs. Parker repeated variations of this pattern in the master bath, where she embroidered the bath towels with chenille yarn.[36] Her stitchery provided texture, and the texture of the chosen yarn in turn became part of the composition (fig. 120).

The cantilever motif found its way into the home's decorative accessories, particularly in the rooftop retreat (fig. 121). This room served as a guest room and Parker's home office, so the dominant motif remained geometric and masculine. The decorative scheme here was "cool," a quality that neatly corresponded to the room's business function. Here, the abstracted cantilever form inspired

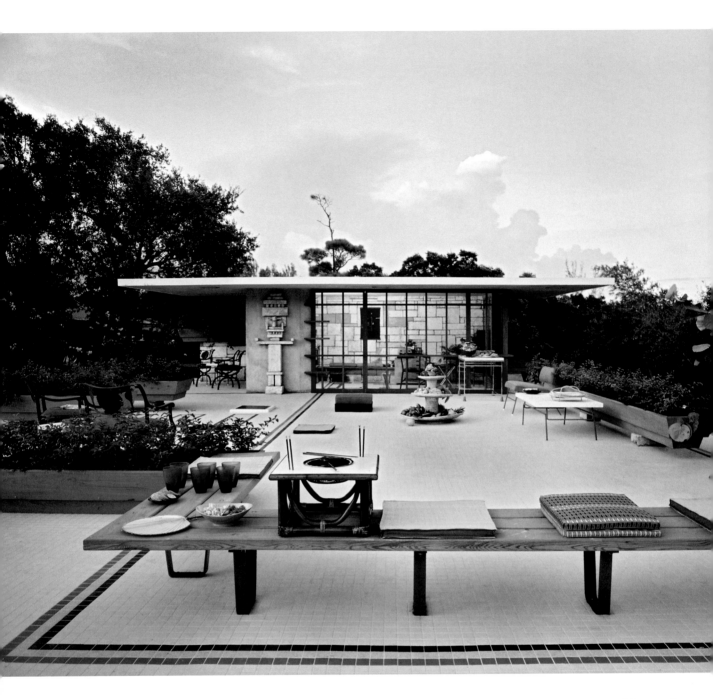

no less than five types of stationery used by the Parker family, as well as patterns for fabrics.[37] Parker developed the pattern for these from a section through the house as seen in perspective (fig. 122). Mrs. Parker lent a hand and stitched the patterns on percale sheets.

The centerpiece in the rooftop retreat, as in the living room, was a hand-hooked rug (fig. 123). True to Karasz's teachings (though she did not design or make this piece), it was displayed prominently as a piece of fine art. Parker designed the pattern, which was an adaptation of the floor plan of the retreat, set in its rooftop garden.

He referenced geometric elements of the architectural scheme: the skylights, plant boxes, and floor tiles were all recognizable in the rug's weave.[38]

The importance of the Pace Setter textiles and motifs, outside of their design and manufacture, was their function on the printed page. Through these abstractions, Gordon was able to create and print one marketable image, a *leitmotif* that offered a lasting individual identity for this house. Importantly for Gordon and her battle against "sterile" modern design, these patterned textiles also lent the appearance of warmth and texture,

121. Parker, 1954 Pace Setter. Rooftop retreat. Copyright © Ezra Stoller/ESTO.

122. Parker, 1954 Pace Setter. Axonometric drawing of the rooftop retreat.

123. Parker, 1954 Pace Setter. Writing desk in the rooftop retreat, with a custom rug visible beneath a Wegner chair. Copyright © Ezra Stoller/ESTO.

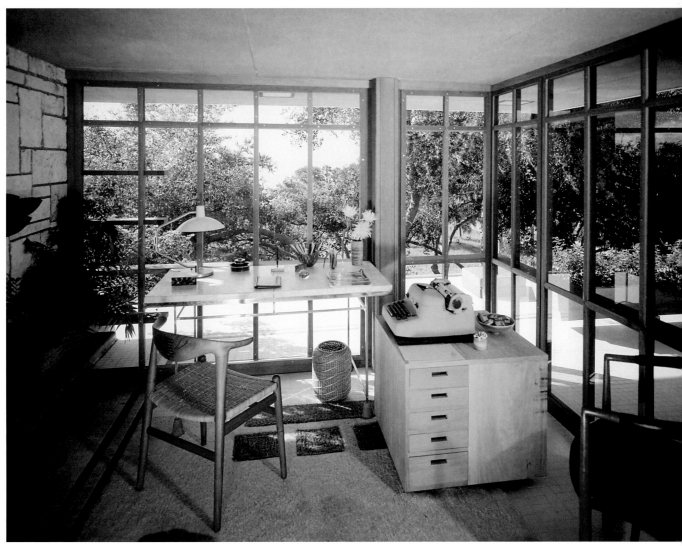

and contrasted with the geometric coolness of concrete and stone. They added bursts of color and dynamism. And they tied the design scheme to the home's natural surroundings. These were for Gordon an important (and quite successful) example of organic design. For Parker, his motifs were a condensed metaphor, an abstract encapsulation of his design philosophy, and the fusion of that philosophy with architectural form. This was a form of communication—the abstract representation of an architectural problem and visual proof of its solution. Parker's 1954 Pace Setter was, as he would later describe it, a "total, unified concept."[39]

## The Pace Setter in Print: "This is The House Beautiful"

With *House Beautiful*'s help, Parker's house was readied for publication. In November 1953, Gordon published it as the 1954 Pace Setter. Her announcement was celebratory. The house, she wrote, was neither ordinary nor even typical for a Pace Setter. This was, she declared, *the* house beautiful: "I have seen many good houses. I have seen some great houses. And we have been showing them regularly. But this is the first time I have wanted to say to you, 'This is it! This is The House Beautiful.'" Her opinion was admittedly "personal," but she believed "that a good house is a personal house, and a great house is the most personal of all."[40]

She encouraged her readers to study Parker's house for its personal and individual character, but above all for its "concern for human beings." These were essential qualities, especially the "human" component. Though personal character (and, by extension, personal taste) continued to be a central theme, she presented Parker's Pace Setter as an example of the "architecture of humanism." For "however different their lives and tastes," Gordon reasoned, "all people have their humanity in common."[41]

Gordon recruited Frank Lloyd Wright to reinforce this argument. She opened the Pace Setter magazine feature with a full-color image of the house, captioned by Wright (fig. 124). He declared—in bold print embellished with Taliesin red—that the house was a setting where an "enlightened mind can flower," and "where people can develop their fullest potentials." It (and its designer) had attained the "highest goal to which architecture may aspire: organic architecture."[42] With this phrase, Wright had paid Parker a rare compliment. His appraisal

and Gordon's interpretative framework upheld the Pace Setter as humanistic and American Style, but also, more importantly, organic. Gordon's editorial, with Wright's endorsement, was more powerful than she could have hoped: it launched Parker's career and opened a new path for organic architecture—a path that could eventually extend beyond Wright.

Gordon and Wright dominated the first five pages of *House Beautiful*'s coverage; Parker was not even mentioned. Gordon's interpretive method was shrewd. She used Ezra Stoller's stunning color photographs, Wright's pithy quotes, and her personalized editorial to unite the components of her agenda: the Pace Setter brand, organic architecture, Frank Lloyd Wright, humanism, individuality (or the "personal"), good taste, and the good life. She offered Parker's work as proof that all of these could coexist in one house (fig. 125). This Pace Setter, she posited, was an exemplar of the good life that she pushed for in her April 1953 "Threat" editorial. Parker had built her ideal house for the "Next America." After all, she argued, "it takes the house beautiful for the life beautiful."[43] She understood this and assured her readers that after careful study, they would, too: she would "spell it out in detail," "show it in pictures," and "break it down into all its parts

House Beautiful's 1954
PACE SETTER HOUSE

"This Florida house aims at the highest goal to which architecture
may aspire: organic architecture.
Along this new but ancient way a home where the enlightened mind can flower,
where people can develop their fullest potentials, is still a possibility."

FRANK LLOYD WRIGHT

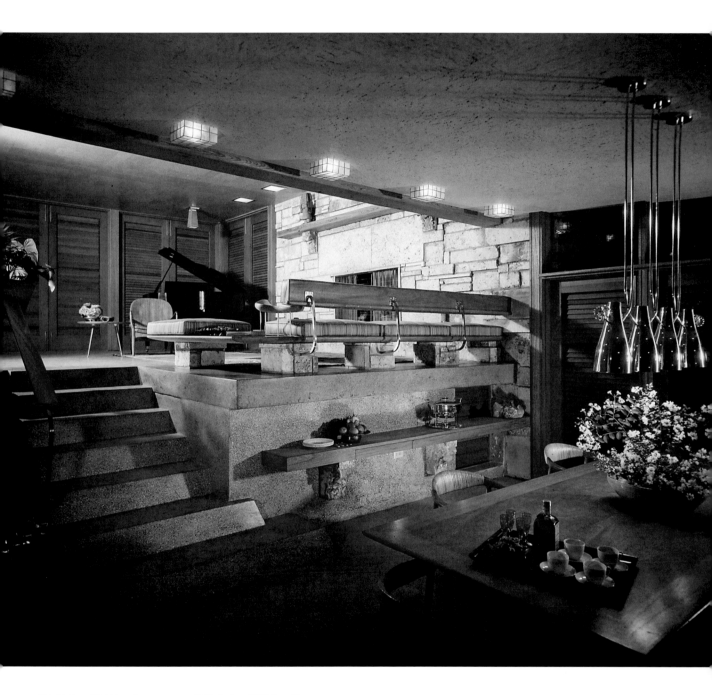

**124.** Parker, 1954 Pace Setter.
View to a carport and arrival
court, featured in the editor's
introduction to the 1954 Pace
Setter, with a Frank Lloyd Wright
quotation, *House Beautiful*
(November 1953).

**125.** Parker, 1954 Pace Setter.
Dining room (foreground) and
living room. Copyright © Ezra
Stoller/ESTO.

**126.** Alfred Browning Parker and family (ca. 1953), photographed on the stairs to the balcony at the 1954 Pace Setter. Copyright © Ezra Stoller/ESTO.

so people [could] fit the parts into their own efforts."[44] This is precisely what she did in the November 1953 issue of *House Beautiful*.

She presented Parker's house to her readers, ostensibly, for their "guidance and encouragement."[45] She believed that the house was worthy of study, and that it, like every Pace Setter, "set new standards of beauty and comfort." She organized the magazine stories so that specific lessons were evident and extractable. The home's characteristics, all selling points, were aimed to appeal to individual readers; Gordon showed them

"What This Pace Setter Can Mean to You."[46] By 1953, the potential meaningfulness included affordability, unified and custom-tailored aesthetics, zoned planning (especially separate spheres for parents and children), automobile accommodation, climate control, perfected details and integrated design, and an organic site plan (one that yielded a "private, personal and thoroughly glamorous estate").[47] Gordon developed a series of practical and didactic stories around each of these, but the greatest number of pages and illustration were given over to themes of humanism, cost, plan and structure

(the "anatomy" of the house), climate control, and integrated design.

The refrains of humanism and the American Style remained a subtext; Joseph A. Barry was tasked with framing the house, and framing Parker as an architect, in terms of both themes. Barry's contribution was essential, as he alone defined "humanism" and "organic architecture" for the magazine's readers. He had written about these themes before, in part to bolster Gordon's "Threat to the Next America" argument.[48] In the context of Parker's Pace Setter, he revisited a familiar theme: "building for individual man."[49] His essay "The Architecture of Humanism" became the philosophical counterpoint to Gordon's more practical articles that followed.

Barry's essay was also an intensely personal study of Parker: the architect, builder, poet, and family man. He opened with an excerpt from their conversations: "'There is a great glow in everyone,' he [Parker] had said. As simple as that." The first line was cryptic, and Barry considered it "pure poetry." This set the tone for what followed. Barry wrote with a romantic flourish, and he used it to introduce the whole Parker family (fig. 126): Alfred, an "architect with a ten-fingered grasp on reality"; Robin, who had to sit on his hands because they were "too lively for photography"; Derek, whose "glow is turning inward—the pride of adolescence"; Bebe, the "only girl"; Bobo, "the little boy with a more formal name"; and Sans Souci, the "noble" Great Dane nicknamed Suzy who starred in no fewer than four of the subsequent photographs.[50] Barry had no equivalent description for Mrs. Parker (to the right in the family photo); he referred to her in passing and then, a hundred pages later, as only "the wife and mother who must take care" of the house.[51] However incomplete, Barry's narrative was intimate. And the accompanying snapshots of Parker at work and with his family were endearing. Barry delivered, as any good writer might, a developed set of characters. He portrayed Parker (not inaccurately) as a lively figure among American architects, one who could design, build, and quote Whitman or Thoreau. His version of Parker was an architect for the individual, for "real people," not "abstract people."[52]

If readers were not charmed or convinced by Barry's portrait of Parker, they were surely intrigued by the magazine's frequent references to Wright. Within this article (by Gordon's design), and other stories that preceded and followed it, Barry and his fellow editors reminded their readers of Wright's endorsement. They sprinkled hints of the architect's backing throughout the issue, with the best quotes pulled out and emphasized with bold, Taliesin-red print. They let Wright's words do the work, describing, by extrapolation, Parker's living room as "the most desirable work of art in modern times." With Suzy the dog sprawled out next to Karasz's custom rug, this was certainly a "beautiful" and comfortable "room to live in" (fig. 127).[53] Barry in particular positioned and defined Parker, then still virtually unknown, in relation to Wright, that famous "father" figure of American architecture. This surely helped *House Beautiful*'s readers understand the younger designer's viewpoint, his adherence to an organic architectural tradition, and his allegiance to Gordon's American Style. And Wright's praise helped boost Parker's reputation and popularity.

For Barry, Wright was also a rhetorical entry point: mention of the architect gave him license to define organic architecture in Wright's terms, Parker's, and his own. Barry's central goal—a discussion of the architecture of humanism—depended upon a clear statement of Wright's theories of organic design. He admitted that Wright's ideas were elusive, but used the architect's writings—for example, *When Democracy Builds* (1945)—to clarify the connection between organic design and humanistic design, noting Wright's assessment that "all architectural values are human values, or not valuable."[54]

Barry also used Wright, and by extension Parker, to launch an architectural critique. He and Gordon continued to assault the International Style, and organic architecture—like Parker's Pace Setter—was a perfect foil. Barry praised the "genius (there is no other word) of America which is in our mechanics and our inventors," hailing the architects who "build like men who know the earth, who know the nature of wood and stone and people. They work from a fullness and richness of experience."[55] Barry openly censured the opposite, the "dry-as-dust esthetics that [have] been refined to nothingness." These modern designs, Barry reminded his readers, were produced under the "well-known slogan of Mies van der Rohe, *beinahe nichts* or 'almost nothing.'" With this assessment, Barry continued Gordon's argument from six months before, condemning the "intellectual purist" architects who failed to embrace the "common sense" design that Americans should value.[56]

Gordon was certainly pleased with Barry, as he aptly brought Wright into the story and furthered *House*

"The most desirable work of art
in modern times
is a beautiful living room
or, let's say, a beautiful
room to live in."

FRANK LLOYD WRIGHT
from *An Autobiography*

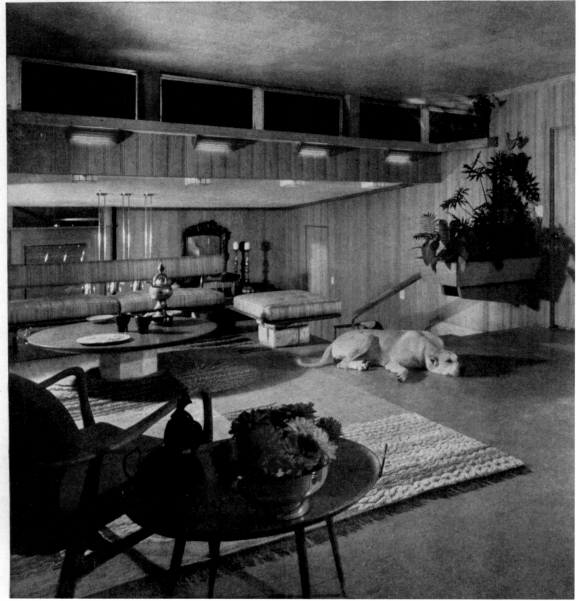

*Beautiful*'s campaign against the International Style. His writing freed other staff writers, and Gordon, to present Pace Setter "lessons" in a more practical (though no less moralistic) frame. The didactic tone of the Pace Setter articles continued with "How to Build the House You Can't Afford," in which Gordon offered the "moral" of Parker's financial story. Her advice was bold and, given the broader financial constraints of the 1953 recession, optimistic: "Don't wait until all the conditions are perfect before you set about building the house you want and need."[57] Her rationale was pointed. There was never a perfect time to buy or build ("Who would get married if everything had to be perfect? Or have a child? Or start a new business?").[58] So why not get started *now*? This was, she contended, how pioneers built America: "They did what they had to do" without "excuses and procrastination."[59]

This must have resonated with the magazine's readers, who Gordon believed still struggled to house themselves well. She wanted to encourage action, advising her readers to look for and buy a lot, gather ideas, stockpile materials, supervise everything and do some of the work, build in stages, and build big. They should hire an architect and become good (and educated) clients. She advised them to "learn by looking and studying [lots, houses, and magazines], looking and asking questions, looking and more looking." The latter, the reader might have noted, was profitable advice from a shelter magazine whose business was built upon providing something to look *at*. The final lesson was that Parker had managed to house himself (for a second time, no less), and he had done it exceedingly well. But so could anyone else, and, as Gordon lured, "Who knows? [Your house] might be the Pace Setter of 1956."[60]

Gordon wanted to give her readers a model for building their own pace-setting house, and she included a detailed study of the "anatomy" of Parker's example. She presented his design choices as progressive, yet "practical" and broadly applicable. His split-level plan, for example, was "sound": he chose it because it responded to the slope of his lot. The floor plan allowed other benefits, enumerated in the magazine, such as ventilation, visual linkages, and functional separations ("adult" or family life separated from the children's life).[61]

**127.** Parker, 1954 Pace Setter. Living room, described with a quotation by Frank Lloyd Wright, *House Beautiful* (November 1953).

She must have been concerned that readers would balk at the form of the house, particularly its defining cantilever. She recognized that some might connect Parker's chosen structural system—with its unmistakable visual modernity—to similar designs by the International Stylists (particularly Mies, Le Corbusier, and Gropius). She tasked her new architectural editor, John deKoven Hill, with explaining the simplicity and the "romance and livability" of the concrete slabs.

Hill wrote (but admitted later that Gordon rewrote) an elegant defense of the cantilever.[62] He used *House Beautiful*'s familiar figurative argument: a good house framed a good life. In this case, he referred quite literally to the Pace Setter's frame and slab structure. He opened with a series of simple statements that revealed his own commitment to Wright's organic principles and his allegiance to Gordon's campaign: "When you look at the Pace Setter, you instinctively feel the honesty and health of its structure. Construction is solid. Materials are naturally and honestly used. Forms are simple. Space is not contained but extended. There are no fetishes or stylistic fads."[63] He, like Barry, offered a veiled critique of competing architects, taking aim, yet again, at Mies: "There are some modern architects who think *their* job is to dream up something, say a glass box, and the engineer's to make it livable. So they design not for living, but for publicity, and are more dilettante than architect in the houses they are responsible for."[64] Hill argued that Parker, on the other hand, employed the cantilever as an element of livability, as a simple structure that (under the right circumstance) met the "human need for comfort and delight."[65] Hill's article played another critical role: it offered explanations of key architectural concepts and vocabulary. He defined, in plain language, the term "cantilever" and its function, "which means here that they [the concrete slabs] project from eight to ten feet beyond their supports, as a tray extends beyond the balancing hand of the waiter who carries it."[66]

He concluded with a final statement that carried both a Wrightian message and yet another hint of criticism: "Perhaps the finest lesson the Pace Setter has for us is in its *honest* use of natural materials, of wood as wood, stone as stone, concrete as concrete—each in its separate and private glory. Here there is no pretense, no hypocrisy."[67] The house was, Hill concluded, "absolutely honest."[68] Hill explained to *House Beautiful* readers what this meant: Parker selected materials, beyond the

**128.** Parker, 1954 Pace Setter. View from the yard to the dining room doors (used as "front" doors, at left) and steps to the upper balcony. Copyright © Ezra Stoller/ESTO.

concrete and steel, because they solved problems. He surfaced the concrete slabs with terrazzo, which was easy to maintain in a humid climate; he sheathed interior walls in cypress, which repelled insects, resisted dry rot, and rejected water stains; he used mahogany to clad the steel columns and to frame door and window openings, because of its "dimensional stability" (it would not swell or shrink).[69]

In his final paragraphs, Hill linked all of Parker's design and construction choices to the Florida climate, and staff writer James Marston Fitch continued the discussion. His article, "The Pace Setter Laughs at the 3 Furies: Sun, Wind, and Water," detailed the specific challenges of designing in a tropical climate.[70] Parker's solutions, such as the hurricane-strength structural system, natural ventilation (the "blow-through" floor plan), reflective roofs, wide overhangs, and spot air conditioning, were illustrated here and elsewhere in the magazine. Fitch revisited these specifically to link the Pace Setter to the magazine's ongoing Climate Control research program (which was advertised at the end of the article).[71]

Fitch praised Parker's climate-wise innovations and placed his achievements in context for the magazine's readers. He boldly stated that "with this house, domestic Florida architecture now comes of age." This work, he argued, placed Parker alongside pioneers who had done the same in California (a region that was, he wrote, the "same age architecturally"): the Greene brothers, Harwell Hamilton Harris, and William Wurster. These heroes of the prewar period, with Wright among them, had brought the West out of its "tailspin" and created an "indigenous architecture, suited to the climate and the people." Fitch's statement implied a divergence of modern architecture between the "imported" versus the "native"; a regional response was, for him, a rational

response. Gordon's broader agenda, and the reminder that Parker's Pace Setter belonged within the lineage of modern American architecture, had again surfaced.[72]

The 1954 Pace Setter was a compelling piece of architecture, perhaps the finest to emerge out of the series. For Gordon, Parker's house was also a persuasive piece of propaganda (fig. 128). As an exemplar of organic architecture, the house, and, to no small degree, its architect, helped her solidify and publicize *House Beautiful*'s partnership with Wright. As feature content, it was powerful evidence for Gordon's case against the International Style: Parker's Pace Setter was her best argument yet. In the drama that surrounded Gordon and *House Beautiful* in 1953, the publication of this house was the crescendo, if not the final act. Gordon's investment in the 1954 Pace Setter, in Parker's version of the "Next American House," and in Parker himself would pay off in yet another way: it opened a new door for subsequent "organic" and increasingly "regional" projects.

# Chapter 11

# A New Regionalism

After the success of the Wright-approved 1954 Pace Setter, Elizabeth Gordon continued to use *House Beautiful* features and exhibitions to contest the International Style. Her fervor, however, cooled—at least in print. In February 1955, she issued a "quiet, comforting" statement of triumph: "The revolutions are over and you [the *House Beautiful* audience] are the victors. Now consolidate your victories."[1] The consolidation came in the form of the 1955 Pace Setter (fig. 129). Designed by architect Harwell Hamilton Harris, the house offered a middle ground: it was contemporary but not modern, traditional but not period, prototypical yet individual. And Gordon, in her promotion of the house, remained critical but not polemical, and didactic but not (overly) moralistic. As the voice of "victory," she brokered a compromise and offered the terms of a peace treaty.

## Regionalism and the End of Revolution

If Gordon started, or escalated, a style revolution in the early 1950s, by 1955 she meant to end it. The struggle between modern and traditional, and the controversy surrounding the International Style, did not disappear. The "hard" modernists, or those who supported functionalism and the International Style, and the "soft" modernists, or those who supported alternatives such as the Bay Region Style or Wrightian organic, were still at odds. But even hard modernists, among them Walter Gropius and Le Corbusier, were softening. It seemed the

battle was waning, and the troops were tired—or simply bored. In Gordon's case, it is entirely possible that the Hearst Corporation demanded that she stand down. This remains unclear. But she was certainly ready to move forward. By 1955, her textual and visual arguments, along with the houses she published, began to show a new "maturity and wisdom and stability."[2] Though she did not give up her effort to promote good modern design, she "ceased struggling" to define contemporary architecture in certain terms.[3]

Compromise was in the air. Gordon's interest in mid-century regionalism, as an architectural theory and building practice, was born in this spirit of negotiation. Outside of the Climate Control program, she rarely used the terms "regional" or "regionalist" to describe design (or her own preferences), but she had long argued that the key ingredient in modern American design—its unique character—was its regional diversity. For her, local and regional solutions to building problems, taken together, composed a national architecture, or what she had termed the American Style. This was a *national* architecture, but it was regionally diverse, and necessarily rooted in specificity and in place.

Gordon was not the only shelter magazine editor to explore the vitality of regional design in the mid-1950s. Increasingly, after the national debut of the 1949 Climate Control Project, others joined in the discourse surrounding "comfort" and regionally responsive design. For example, *Sunset* (arguably a regional publication),

**129.** Harwell Hamilton Harris, 1955 Pace Setter House, Dallas, Texas, 1954. View to the motor court.

edited by Walter Doty, had long been a proponent, whether its writers used the specific term "regional" or not; Doty's support of Cliff May, the quintessential California designer, was perfect proof. On the other hand, *Better Homes and Gardens,* with its lucrative stock-plan business and national Five Star Homes project, seemed to trail behind.

As architects, historians, critics, and other magazine editors joined Gordon to question the future of "placeless" modern architecture and to examine the limits of the International Style, many looked toward what architect Harwell Hamilton Harris had called a more "liberative" form of expression.[4] These men (and a few women) gave name and professional legitimacy to a new

movement in postwar architecture: regionalism. The eventual proponents of regionalism included, significantly, several orthodox modernists whose views had evolved: Sigfried Giedion, Walter Gropius, Le Corbusier, Pietro Belluschi, Richard Neutra, and Harwell Hamilton Harris, among others.

There were, it seemed, as many theories of regionalism as there were practicing "regionalist" architects.[5] For some mid-century designers, regionalism was no more than a romantic or scenographic gesture. It provided a source language and an image catalogue, but little substance and even less basis in history. Regionalism in this vein was referential and often limited to the superficial addition of "local flavor" (for example, an "Alamo"

parapet in central Texas). For others, regionalism was a historicist overlay, one that invoked architectural traditions that were locally popular (for example, Greek Revival in the American South). Most of these regional inflections tended toward traditional design and ideological conservatism.

For others still, regionalism was what Gordon would have called "common sense design." This version explored architectural solutions and design strategies drawn from existing examples that were proved to function well in a given locale. This practice grew in popularity during the 1930s, in the work of architects such as David R. Williams (hailed as the "father" of Texas regional modernism) and his onetime assistant O'Neil Ford; both looked toward the "pioneer" buildings and towns of Texas as sources for new design.[6] John Gaw Meem, a contemporary of Williams who worked in New Mexico, also argued for the relevancy of old forms to current practice, though he allowed the use of new materials such as concrete, steel, and glass.[7]

Other architects found validity in what they termed regional modernism, or modern regionalism. Richard Neutra was foremost among them. In his 1939 essay "Regionalism in Architecture," he connected modern and regional design. He argued that regional variations proved that modernism was "far from being international," and that this kind of modern design was neither placeless nor uniform.[8] For Neutra, regional solutions were simply a reality of building, the result of local variations in labor costs, fuel, materials, construction traditions, and craft skills. Regionalism of this sort was less about form, process, and aesthetics, and more about local economics.[9]

Hugh S. Morrison, a leading scholar of modern American architecture, added an important question and a stylistic dimension to the discourse with his 1940 essay "After the International Style—What?" He predicted that the future of modernism in American architecture would yield a "mingling" of the International Style with "existing architectural traditions," the result of which would be the "evolution of American regional modernisms."[10] He argued, for example, that in the American South, new regionalist architecture would combine the International Style with Spanish or French traditions, and in New England, colonial and modern would likewise merge. Morrison observed this trend—as had Elizabeth Gordon—in California "modern" architecture, where Spanish Colonial, Mexican, and Native American traditions mixed with the ranch house and the International Style.[11]

The renowned architectural theorist, critic, and historian Lewis Mumford joined Morrison in his appreciation of the simultaneous modern and regional aspects of California design. In his "The Sky Line" series for the New Yorker, Mumford championed the Bay Region Style as the future of American regional modernism. For Mumford, the architects who embraced the Bay Region Style had "absorbed the universal lessons of science and the machine... [and] reconciled them with human wants and desires, with full regard for the setting of nature, the climate and topography and vegetation." Mumford's key point here was that regional modern design "belonged to the region and transcended the region."[12]

Though Sigfried Giedion had been an early supporter of the 1920s International Style, by the 1950s, he had developed ideas similar to those that Mumford espoused. In Giedion's 1954 essay "The New Regionalism," he argued that in a "new regionalist" approach, modern architects moved beyond the "tyranny of the right angle" to carefully study "the way of life (the climate of living) of the place and the people for whom he is going to build. This new regionalism has as its motivating force a respect for individuality and a desire to satisfy the emotional and material needs of each area."[13] Giedion was particularly attuned to work in developing countries, where a new regionalist approach was being adopted by Le Corbusier in Chandigarh, by Georges Candilis and Shadrach Woods in Morocco, and, a decade later, by Louis Kahn in Dhaka. Giedion understood that modernism had evolved, and—much as he had done for the International Style—he offered a legitimate theory to guide practicing architects.

It was in the context of this national debate that Harwell Hamilton Harris developed his own thoughts on regionalism, modernism, and nationalism. He broached the subject in 1954, during a speech in Eugene, Oregon, at the Northwest Regional Council of the AIA. There, and in subsequent essays, he argued that "architectural specificity," or particular design solutions generated by a response to individual and regional concerns, was the new generative power in modern architecture.[14] Harris denied Neutra's suggestion that regional architecture arose *only* out of the forces of "climate, geography, [or] the presence or absence of certain materials." He argued instead that "regionalism is a state of mind." The regional mindset, argued Harris, could impose limits. For example,

**130.** Harwell Hamilton Harris, Havens House, Berkeley, California, 1941.

transportation networks could limit building materials, or "iron-clad traditions" could impose "living patterns rooted in a vanished past."[15] But this regional state of mind could also liberate. He wrote: "This is the manifestation of a region that is especially in tune with the emerging thought of the time. We call such a manifestation 'regional' only because it has not yet emerged elsewhere. It is the genius of this region to be more than ordinarily aware and more than ordinarily free. Its virtue is that its manifestation has significance for the world outside itself."[16]

In this, Harris was clearly referring to his home state of California, a region in which architects had been free to move ahead of their eastern counterparts, who were still wedded to orthodox modernism; his early designs, including the Weston Havens House in Berkeley (1940),

underscored this liberated spirit (fig. 130). The vitality of regional design, for him, hinged upon the region's "free minds, its imagination, its stake in the future, its energy and, last of all, its climate, its topography, and the particular kind of sticks and stones it has to build with."[17] Harris knew that the postwar construction boom had encouraged architectural progress *and* regional expression; he hoped this large-scale development would "provide a friendly climate long enough for a new school of design to develop."[18]

## A Regional House for Texas

Harris left his native California in 1951, looking for a "friendly climate" in which to explore his own new design

direction. He found it in Texas. Appointed as the director (later dean) of the newly formed School of Architecture at the University of Texas at Austin, he moved his practice and his ideas eastward. He quickly began to translate his version of regional modernism to his new locale.

One of Harris's most important experiments of the mid-1950s was a house designed from his studio in Austin to be built in Dallas; this would, in 1954, become *House Beautiful*'s 1955 Pace Setter. The commission did not, however, originate with Gordon. It began as a more modest request made by General Electric (GE) and Dallas Power & Light (DP&L) to design a Texas State Fair kitchen exhibit that could showcase the latest in electric domestic technology. New to Texas, and with a new architecture program to develop, Harris could hardly refuse the invitation. He embraced the project as a growth opportunity—and GE, DP&L, and the state fair organizers benefitted from his talent and his reputation, which the *Dallas Morning News* described as "second only to the

fabled and leonine Frank Lloyd Wright."[19] Harris found the all-electric kitchen job compelling on three fronts: promotional, technological, and pedagogical. The project offered an unprecedented public spotlight for his work, and at little monetary cost to him. With GE as a sponsor, he would have an opportunity to work with electric products that had yet to hit the market. And, finally, he could use the project to provide real-world experience for his Texas architecture students.

Harris delayed the original timeline for the state fair project and offered it as a class project to his architecture studio in 1954 (fig. 131). His goal was to teach his students the "entire" architecture process, from conception to construction. He selected five students as "junior" partners: David Barrow, Jr., William Hoff, Neil T. Lacey, Patrick Chumney, and Haldor Nielsen. (Don Legge would join the team later.)[20] The students worked individually to conduct research and provide prototype designs; the group collaborated on conceptual drawings (fig. 132). Harris provided daily critiques and managed the project as a senior partner in an architecture firm might.[21]

Harris's team was midway through its design when Elizabeth Gordon approached him to design *House Beautiful*'s Pace Setter for 1955. He and Gordon must have agreed to use the State Fair House, so that it would now serve a double or triple purpose: fair exhibit, student project, and Pace Setter. Harris and his team would complete their design as planned, but as with other Pace Setter Houses, *House Beautiful* would become the principle patron, interior decorator, photographer, and primary publicist (fig. 133). GE and DP&L would still contribute all of the electric appliances and retain billing (though, even in the local papers, not top billing) as the state fair sponsor (fig. 134). For his part, Harris needed only to provide the architectural framework.

Though this was a cooperative and pedagogical effort, the completed 1955 Pace Setter was clearly Harris's design and influenced heavily by his theory of regionalism, which he taught freely. His design method revealed a crucial theme: the house had to be practical, in local and regional terms. For him, this meant the design had

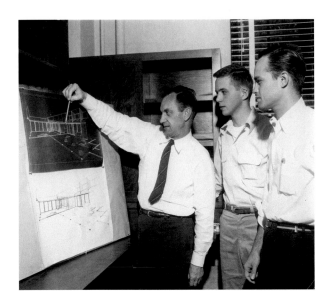

**131.** Harris with University of Texas at Austin students, working on the 1955 Pace Setter, ca. 1954.

**132.** Harris, 1955 Pace Setter. Conceptual diagrams sketched by University of Texas at Austin students, 1954.

to respond to (among other things) market demands, individual client needs, local building traditions, and the local climate. This nicely paralleled *House Beautiful*'s interest in "common sense" design. The architectural problem, then, was what Harris called a "pragmatic" one.

Harris, though new to Texas, believed he understood the regional housing market. He was convinced—rightly so—that everyone wanted a "California house."[22] By this, he meant the California ranch house as developed, for example, in Los Angeles by Cliff May and others. Harris had argued that in architecture, California had become a "pace-setter" for America, and like Gordon, he believed that the California ranch house was viable nationwide (fig. 135).[23] The California ranch house became Harris's starting point for the Texas project—though he did offer minor modifications. The State Fair House would retain the characteristics of its California prototype—very

much what Gordon promoted as the national Pace Setter idea—but it was "individualized" and regionalized. Though he did little to incorporate entrenched aesthetic traditions found elsewhere in Texas architecture (as did regional architects such as David Williams and O'Neil Ford), Harris did respond to the local climate, use local labor, and incorporate certain cultural aspects of postwar Dallas. These adjustments, however, were arguably similar to what might have been done for houses built in other sprawling American cities, from Houston to Phoenix to San Jose.

For the Texas project, Harris and his students designed a large and sprawling ranch house, with an L-shaped plan closed at one end to form a rectangle (fig. 136). The Pace Setter turned its back to the public (for both privacy and shade) and embraced a generous courtyard. An innovative feature, well suited to suburban Dallas, was

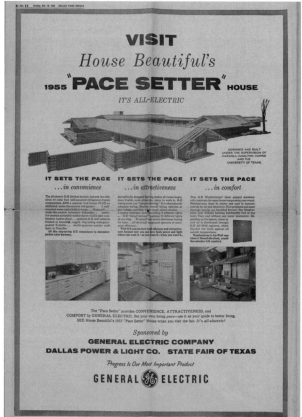

**133.** State Fair of Texas brochure for the 1955 Pace Setter House (October 1954).

**134.** Advertisement for the 1955 Pace Setter, sponsored by GE and Dallas Power & Light, *Dallas Times Herald* (October 1954).

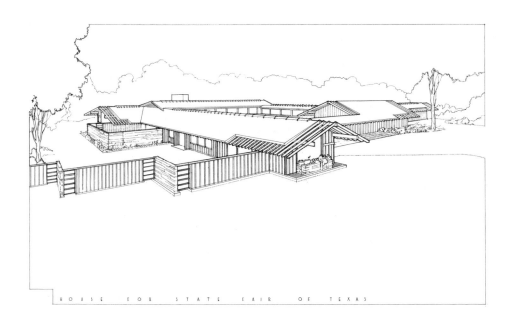

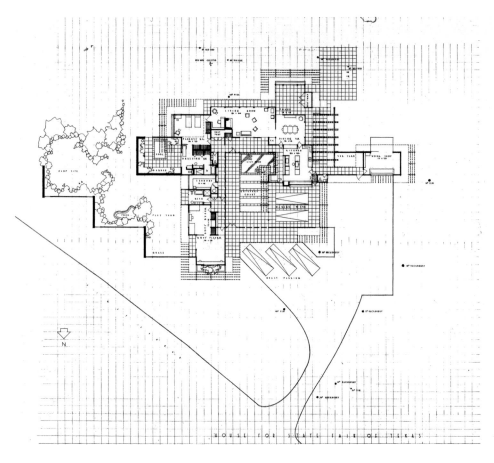

**135.** Harris, 1955 Pace Setter.
Perspective drawing, originally
dated March 1954.

**136.** Harris, 1955 Pace Setter.
Plan, originally dated April 1954.

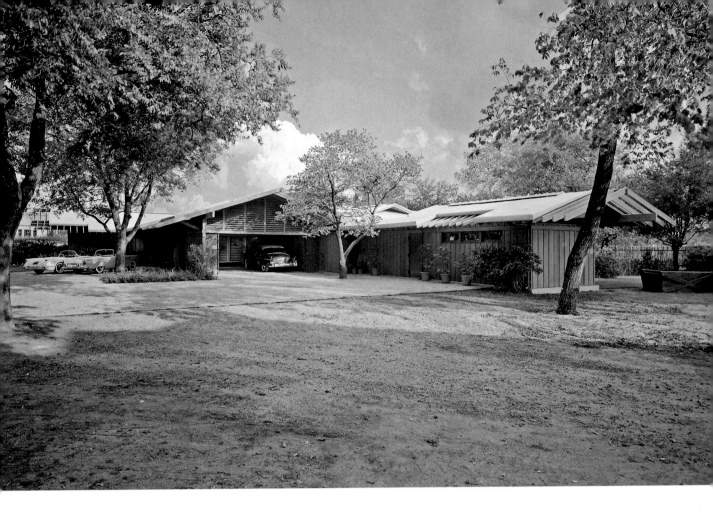

the automobile court, which transformed the Pace Setter into what *House Beautiful* would call a "drive-in" house (fig. 137). Harris provided a transition area that accommodated both cars and a series of "reception" activities.[24] Though conventionally framed in wood and clad in redwood, a segment of the exterior was clad in stone, recalling a Texas tradition of masonry construction (fig. 138). The exterior walls were shaded by deep overhanging eaves, yet Harris instilled a feeling of lightness with his introduction of clerestory windows.[25] The interior plan was open, yet displayed interlocking spaces. He placed few barriers between indoors and outdoors, and extended space upward with high ceilings that followed the pitch of the roof (fig. 139).

The site (the grounds of the state fair) was atypical for residential construction in Dallas, but the topography and microclimate of the fairgrounds were not. Because local climatic considerations were crucial to Harris's and Gordon's concept of regionalism, environmental considerations remained a high priority. In the hot and humid climate of north Texas, "natural" responses were crucial. Using *House Beautiful*'s Climate Control data—a fact that Gordon would later emphasize in the magazine—Harris and his team

conducted specific research on regional microclimates.[26] They wanted a design that could seamlessly function in its specific locale, and could efficiently and passively reduce the load on the home's mechanical systems.

Harris made a significant adjustment for local weather, designing what he called a "house with a man-made climate." Much to the delight of GE, technology and, specifically, electric power played a crucial role. The

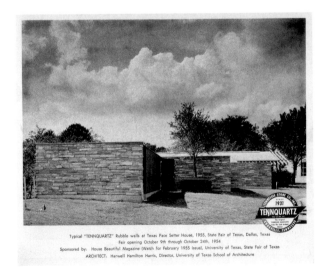

Typical "TENNQUARTZ" Rubble walls at Texas Pace Setter House, 1955, State Fair of Texas, Dallas, Texas
Fair opening October 9th through October 24th, 1954
Sponsored by: House Beautiful Magazine (Watch for February 1955 issue), University of Texas, State Fair of Texas
ARCHITECT: Harwell Hamilton Harris, Director, University of Texas School of Architecture

house included one other innovation, which was likely installed at Gordon's insistence rather than Harris's (and rather resembled techniques used by Cliff May a decade earlier): a movable canvas wall shade (or "sunshade") that screened the interiors from fierce sunlight and reduced the need for conditioned air.[27]

Harris and his team completed their initial designs for the Pace Setter just before construction was to begin at the fairgrounds in Dallas. In June 1954, only five months before the state fair opened, Harris and two of his University of Texas students, Don Legge and David Barrow, Jr., arrived on-site in Dallas to complete detail drawings and oversee the construction of the house. They set up a temporary office across from the building site.

As the project moved from design to build, other partners joined the collaborative. The construction trades, GE, and *House Beautiful*'s decorators began to take a more active role. The Dallas Home Builders Association, under the leadership of Joe F. Maberry, agreed to serve as the general contractor at no profit. For Maberry and his crews (including at least twenty-one subcontractors), the Pace Setter was a "race against time."[28] Maberry was given the near-impossible task of completing the house in four

months, whereas a project of that size would have normally taken nine.

Harris was instrumental to the completion of the Pace Setter, as were Maberry and the local construction crews, but industry sponsors and collaborators played an even larger role. Recruited through various personal and professional channels, many of which belonged to Gordon and *House Beautiful,* resource suppliers donated their materials and products in exchange for advertising at the fair, in local media, and in *House Beautiful* (fig. 140). GE, as the headline sponsor, made perhaps the biggest contribution—and had the greatest influence on the final design. The company donated at least $10,000 in cash to partially fund the project and provided (according to the *Dallas Morning News*) "1001 exciting ideas you can use from this all-electric dream house."[29] The local newspapers and the state fair press advertised GE's products aggressively, and the emphasis on "you" was crucial: the entire production was orchestrated to win over viewers and convert them into new GE customers (fig. 141).

With GE's donations, the Pace Setter truly did become the "all-electric" house of the future. The house

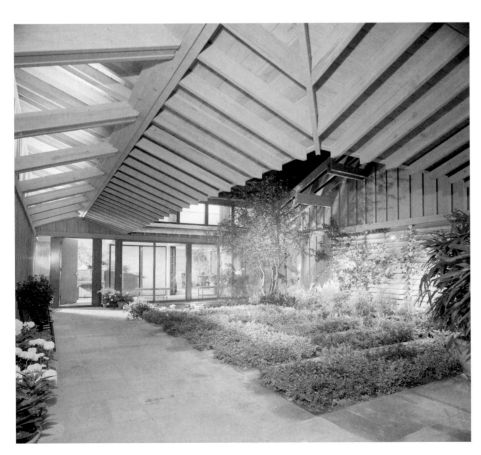

137. Harris, 1955 Pace Setter. Motor court for the Pace Setter as a "drive-in" house.

138. Tennquartz advertisement featuring the 1955 Pace Setter.

139. Harris, 1955 Pace Setter. Entrance court with expanded circulation space and a lily pond.

demonstrated the latest ideas in heating, cooling, lighting, and domestic gadgetry. It is likely that GE—rather than Harris, his students, the hypothetical client, Gordon, or other *House Beautiful* staff—selected the products it wanted to install. In this, the Pace Setter design was ultimately subordinate to the "free" products donated by GE. This was particularly true in the Pace Setter kitchen (fig. 142). Harris and his students were responsible for the initial spatial concept and the floor plan, but the details were later redesigned (some during construction) to accommodate GE's products. GE staff even provided technical advice for the use and installation of appliances. The innovative and "new" domestic gadgetry included a built-in dishwasher, a fifteen-cubic-foot upright freezer, a cabinet-style refrigerator, and a custom built-in range with the widest opening on the market. The laundry featured the "futuristic GE combination automatic washer and dryer" and an electric nylon-drying cabinet "not yet on the market."[30] GE, along with *House Beautiful* and Harris, wanted to prove that these gadgets—everything from the home's three televisions to the hi-fi stereo, the rotating vacuum, the

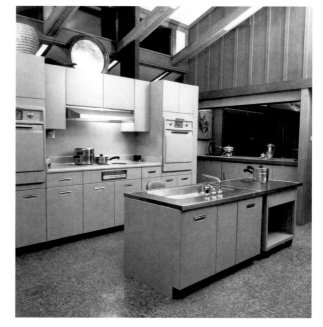

**140.** Advertisement for Martin-Senour Paints "selected" for the 1955 Pace Setter, *House Beautiful* (February 1955).

**141.** Advertisement for General Electric "appliances of the future," featuring the 1955 Pace Setter all-electric kitchen, *Dallas Times Herald* (October 1954).

**142.** Harris, 1955 Pace Setter. Kitchen.

air conditioning, and the push-button garage—would enhance the life of the American consumer (fig. 143). This was the "best" in modern living.

While GE influenced the content and, to some degree, the planning of the Pace Setter, *House Beautiful*'s decorating staff—in what had become their standard practice—controlled the house's interior design. Two key staff members contributed: Frances Heard and John deKoven Hill. With input from Dallas interior designer William P. McFadden, they prescribed interior color palettes, finishes, motifs, textiles, custom tile-work, and furnishings (fig. 144).

*House Beautiful*'s involvement as the decorator of the project shifted the home's final appearance away from what Harris might have conceived alone. The magazine's participation, as student architect David Barrow, Jr., later attested, affected what might otherwise have been a "simple" project.[31] Hill, in particular, made a series of decisions that expanded Harris's original concept, including the house's dominant decorative motifs, patterns, and color schemes (fig. 145). Hill's greatest contribution—or violation, as Harris and Barrow saw it—was the front door. This Wright-inspired entry, featured prominently in *House Beautiful*'s photographs and in advertising for Southern Pine (an important sponsor), was not a Harris design: it was, as Barrow claimed derisively, "Wrighted" by Hill (fig. 146).[32]

The *House Beautiful* decorators pulled the house together, creating what they would promote as an integrated whole, primarily to emphasize, via Hill's input, a lasting connection with Frank Lloyd Wright. They believed they were giving average consumers, represented by the state fair and the magazine audience, what they wanted in terms of fit and finish. The creation of identifiable motifs and images, such as the Pace Setter front door, added a layer of individual identity and personalization to what was, in its final summation, a prototypical California ranch house transplanted to Texas. Thus, *House Beautiful*'s collaboration (which some viewed as interference) was part of Gordon's strategy of interpretation. It allowed the magazine to emphasize the

**143.** Harris, 1955 Pace Setter. Multipurpose sitting room, with a General Electric television set.

**144.** William Manker and John deKoven Hill, Decorations and color styling in the 1955 Pace Setter living room, *House Beautiful* (February 1955).

larger issue of individualizing and regionalizing design in an increasingly generalized mass market.

## "The Pace Setter Is Yours, Please Come In . . . "

In February 1955, the same month *House Beautiful* published the Pace Setter and the same month the house reopened for tours (because of popular demand, it in fact reopened twice), the Texas State Fair put the Pace Setter up for auction.[33] The house was sold, deconstructed, moved, sold again, and, in 1995, finally demolished to make way for a condominium complex.[34]

The legacy of the Pace Setter remained, however, in the pages of *House Beautiful*. The magazine published the Pace Setter in two separate issues, in February and March 1955 (fig. 147). With text and carefully framed images, Gordon and her staff shaped a double meaning for the house: it was a haven for the individual, and a representative of the regional, even national, possibilities of modern design. Jean Murray Bangs, Harris's wife and a *House Beautiful* staff writer, eloquently described the house as a dramatization of "America the abundant," and as the product of "modern technology" and "the force of American industry," all "put at the service of the private citizen, to provide him with higher and higher standards of beauty, comfort and utility." Always promoting her husband's role (and underscoring *House Beautiful*'s interest in encouraging relationships between the consumer and design professionals), Bangs continued that the Pace Setter "shows the architect as the man who brings together the technologies used in building and makes them work together in the service of man—to glorify the values of family life—to magnify the importance of the individual. It is the most revealing structure in our society—the result of a thousand forces meeting at the level of the individual man."[35]

*House Beautiful* wanted the experience of this house to be clearly understood as personal (fig. 148). The editors

The Magic of Southern Pine

**145.** John deKoven Hill (and others), Motifs and custom accessories for the 1955 Pace Setter.

**146.** John deKoven Hill, Front door for the 1955 Pace Setter (upper left). Southern Pine promotional pamphlet, ca. 1954.

**147.** Harris, 1955 Pace Setter. On the cover of *House Beautiful* (February 1955).

You have parked your car in the ample space outside. You walk under the wide protecting eaves to the front door. You push it open and the Pace Setter for 1955 unfolds before you. Perhaps it bursts upon you, for the interior court has unexpected grandeur and beauty—truly a wonderland of wood. Your eye follows the rhythm of the rafters, and lingers, charmed by their warm rich color and its pleasant blending with the cool contained greenness of the enclosed garden. The rafters and beams are Southern Pine, lending strength to the structure and beauty to the scene.

Note how successfully the architect has created the impression of open, flowing spaces, of the indoors reaching out to include the air and breadth of the outdoors. To achieve this effect, he has fully exploited the most distinctive and valuable characteristics of Southern Pine. The dimensions of the rafters and beams, their size and shape, and the wide clear span, indicate his awareness of the physical strength of the wood, its nailholding power. And by exposing the structure, by applying just a slightly weathered stain, he has brought out Southern Pine's fine texture.

# House Beautiful

FEBRUARY 50c

House Beautiful's
## PACE SETTER HOUSE FOR 1955

**148.** Harris, 1955 Pace Setter. *House Beautiful* invites "you" in to sit down at "your" built-in writing table, *House Beautiful* (February 1955).

extended a direct invitation to the reader from the opening story forward, with a welcoming "The Pace Setter Is Yours, Please Come In."[36] The magazine's headlines spoke directly to "you," and each feature persuaded "you" to walk through the house and live the life pictured. The house may have been built of standardized parts, or reminiscent of other ranch houses, but Gordon presented it as individualized. She wanted to teach each reader—convince each reader—that the pace-setting life was customizable, for any budget and in any climate. As with previous Pace Setters, Gordon promoted the 1955 house as a dream that could become real, as a standard against which readers might measure their own domestic reality and aspirations.[37]

The secondary meaning embedded within *House Beautiful*'s representation of the 1955 Pace Setter was a nuanced argument for both regionalism and nationalism in contemporary American design. In Gordon's ongoing battle of styles—a battle between two competing visions of modern architecture—the Pace Setter continued to represent the American Style. This was a modern architecture that prioritized client-centered individualism, physical and psychological comfort, and technological convenience. The battle, specifically against the ascendancy of the International Style, had been long and ferocious. Within this context, *House Beautiful* positioned the Pace Setter as a victory.

With the 1955 Pace Setter, Gordon and her staff conveyed the salient themes of mid-century regionalism. They argued, as had Giedion, Mumford, and Harris, that the concept of "region" was scalable, from microclimates to macroclimates, from block to neighborhood, from town to city, from state and nation. The goal of regional modernism was not just to build regionally but to use regional methods to transcend the region. Gordon, by sponsoring and promoting Harris's Pace Setter, an

adaptation of a quintessential California ranch house to Texas, did just this.

Understood in this way, the label "regional" became a way to assert architecture that had specific, individualized features (some of them climatically responsive), but belonged largely to what Gordon understood as an American tradition of modern design. In the pages of *House Beautiful*, the "regional" label, even when used indirectly, was a marketing tool, a brand that set this line of modern design against its competitors, specifically the International Style. In this assessment, "regional," as a term, functioned largely as propaganda. And specifically in the mid-1950s, it was yet another weapon in Gordon's arsenal, where regional modern architecture was linked to democracy, the individual, and American cultural identity.

# Chapter 12

# Which Way, America?

Frank Lloyd Wright died in April 1959. His death halted the forward movement of architecture, at least momentarily.[1] Thoughtful critics began to question how far American design had come. And still others asked, as Lyman Bryson had in those tense moments of 1939, which way now, America?[2] As Elizabeth Gordon looked for her own answers, published possibilities, and sought the reaction of her *House Beautiful* readers, she returned to one consistent concept: the path forward, in design, was inseparable from the path behind.

## The *House Beautiful* Look and the *Next* "Next American House"

Wright's death would mark a significant moment of pause, but Gordon's contemplation of the past and future of American design remained unrelenting. In the 1950s, she had used well-established editorial programs to test new and old ideas; the Pace Setter program and Climate Control remained the most frequent of these. She did not launch any sweeping new projects between 1955 and 1960 (though she had research in the works), but she did use her editorial pages to hint at big things to come. Two of these installments were prophetic.

In January 1958, Gordon published an essay that summed up her seventeen years of editing: "What Is the *House Beautiful* Look?" Over twenty-one pages (fourteen dedicated to color schemes), Gordon and her staff outlined the characteristics of the "*House Beautiful* Look."

The list recalled their announcement of the New Look in 1948 and the American Style in 1950, with Gordon's original call for an "American" design language replaced by the magazine's new proprietary claim. Gordon, it seemed, was hoping to consolidate fragments of a splintered and perhaps fading philosophy, now under *House Beautiful*'s own name.

She presented the *House Beautiful* Look, like the American Style, as a design language that derived from "a certain way of life" and a "moving, living set of values." Gordon insisted, again, on specific qualities: common sense design; a whole greater than the sum of its parts; warmth and humanness; expansive space ("real or illusory"); harmonious natural materials; control and discipline without austerity; organized abundance; adaptability; richness without costliness; performance and function beyond functionalism; playfulness; and simple beauty.[3]

In perhaps the most predicative of all declarations, Gordon wrote: "The look of 1958 is the Post-Modern Look."[4] In the context of *House Beautiful*'s article, which circulated years before the architectural discourse on Postmodernism had begun, she most certainly indicated design *after* modernism. Gordon was finished with "modern," and had seemingly abandoned her own definition that she had forged in the early 1940s. With the *House Beautiful* Look, she endorsed design characterized by "elements sorely missed in modern design—elements that warm the emotions, stir man's restless spirit, and enchant his imagination." In calling for design to "delight

*all* the senses," she predicted the yet-to-be-formed Post-modern movement, pioneered by such figures as the complex and contradictory Robert Venturi and the playful Charles Moore.[5]

Though the *House Beautiful* Look as a design brand did not endure much past 1958, its announcement suggested that Gordon was still motivated to find the "contemporary look of here and now."[6] A year later, she found that contemporary look, though she apparently abandoned her *House Beautiful* label of the previous January in favor of an even older tagline: the Next America. In February 1959, Gordon again used her editorial pages to test a new concept—this time, a prototype for the *next* "Next American House."[7] This experiment was significant: it was Gordon's attempt to define the ideal American house of the 1960s, just as she had defined the 1950s with John Yeon's Shaw House and Alfred Browning Parker's 1954 Pace Setter.

It had long been her practice to forecast future design trends, whether in color, fabrics, wallpapers, or architecture. In past years, Gordon had relied on research surveys, sales data, her wide travels, and her own vast network of informants; these sources again proved instructive. Yet at the end of the decade, she seemed to publish more of her favored architects and fewer emerging figures. This implied that, at least from Gordon's viewpoint, the future was in the hands of a now-mature set of American designers.

Gordon returned to Alfred Browning Parker, a fixture in the magazine, to provide yet another model house. She ran Parker's design for Graham Miller in Coconut Grove, Florida, as *the* house for the "next decade," the next "Next American House," and—almost as an aside—the 1959 Pace Setter (fig. 149). With her editor's introduction, Gordon asked her readers a key question: How might the house of the 1960s be different from those that came before? Parker's house, she argued, demonstrated that the "hundreds of ideas that were considered experimental and extreme" before the Second World War were now, two decades later, "standard practice."[8] Gordon's proclamations conflicted, however. On the one hand, she noted that Parker's house was "unremarkable" in many respects; on the other hand, she argued that it contained themes that were "new." The latter claim was especially suspect. Longtime readers of *House Beautiful* would have noted that, despite her assertion of novelty, Gordon's perspective had not really changed with the new decade. She

had, in fact, been advertising the same ideas since the late 1940s, and had just refreshed them in 1958 as the *House Beautiful* Look. What was new, however, was her belief that "practice has nearly caught up with theory—a very rare social phenomenon."[9] For Gordon, Parker's 1959 house exemplified not just design for a new decade but the fulfillment of fifteen years of postwar promise.

More importantly, though, she posited Parker's house as a "remarkable" solution to "problems common to all of us at this point in history."[10] Though her crusading voice had faded, Gordon did pinpoint a distinct challenge for late-postwar Americans: finding affordable, "desirable" land on which to build. While real estate developers, builders, and prospective home buyers had boundless prospects for good sites in the mid- to late 1940s, America had become crowded. She did not censure developers for overpricing land, nor did she criticize builders for overbuilding. She did suggest, faintly, that the postwar housing crisis had come to an end, only to yield to a new obstacle for better living: sprawl. Though she did not use this term, she did hint at the consequences of rising land costs and shrinking lot sizes. She failed, however, to acknowledge the role of expanding square footages (Parker's 1959 Pace Setter, for example, was a sizable 4,700 square feet, including screened-in living areas).[11]

If Gordon's predictions were true, and if her editing would have any influence, the ideal house for the 1960s would swell to the limits of its (relatively) small lot, "inward-turning, instead of outward-turning" (fig. 150).[12] Parker's 1959 house pointed to an architectural and social trend, one that would continue for at least four decades: the expansive, "livable" backyard and patio of the immediate postwar years gave way to spacious, climate-controlled (air-conditioned) interiors.

Parker offered an unusually compelling proposition for a life lived indoors: he designed the 1959 Pace Setter around a dynamic central court and enclosed swimming pool, an element that ostensibly replaced the traditional hearth as the heart of the 1960s American house.[13] Significantly, Parker screened the pool court with an interlacing triangular structure, a dynamic shape suggestive of motion and reminiscent of Buckminster Fuller's

**149.** Alfred Browning Parker, 1959 Pace Setter House, Coconut Grove, Florida, 1959. On the cover of *House Beautiful* (February 1959).

House Beautiful

FEBRUARY 50c

House Beautiful's 1959
Pace Setter

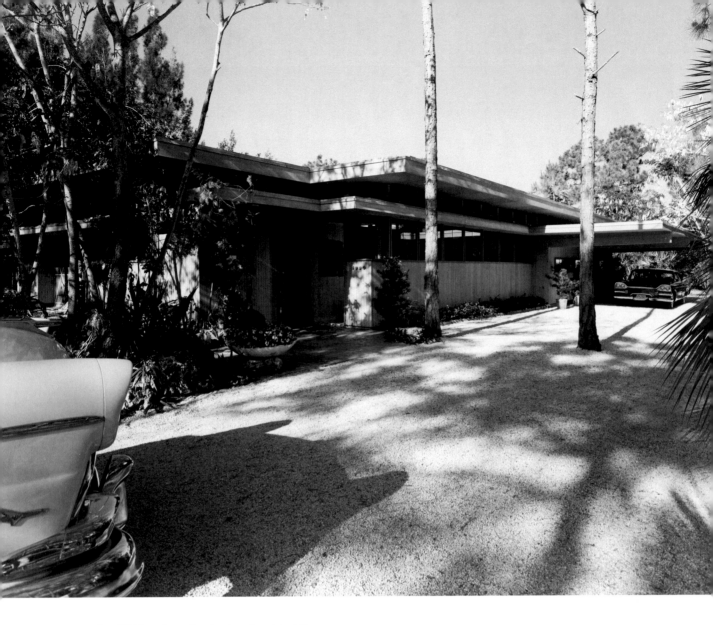

**150.** Parker, 1959 Pace Setter. Exterior view. Copyright © Ezra Stoller/ESTO.

geodesic domes (fig. 151). Curtis Besinger, in his introduction to Parker's project, underscored the timeliness of the architect's spatial explorations: "Our newspapers tell us daily of exciting exploits directed toward the frontiers of outer-space. But they say nothing of what can happen and is happening right here where we all live, in *inner-space*. This Pace Setter house shows you something of the significance and the quiet excitement that can be achieved by a venture into the frontiers of *inner-space*. How appropriate it is now."[14] Architects, alongside NASA astronauts, could chart new territory.

If Parker's interior-space design pointed the way forward for the 1960s, his interior design and decoration strategies—implemented by Gordon's staff—were firmly rooted in the 1950s (fig. 152). In critical retrospect, Parker's design conventions, so indebted to Frank Lloyd Wright, undermined any claim that his house was visually innovative beyond the device of the central atrium space with its screened roof. His use of a limited natural material palette was but one example of his continued use of Wrightian traditions; here, he finished the 1959 house with mahogany and terrazzo, the same materials used at the 1954 Pace Setter (fig. 153). Though Parker used these materials with remarkable ease and sophistication, he and Gordon both acknowledged the potential risk of avoiding "newer" products, including innovative plastics: in a contemporary design for the 1960s Space Age, wood could seem "rustic." Still, as Gordon later argued, Parker's

application of "the Wrightian way [was] the opposite of rustic. It means living in a cultivated and cultured way—not camping."[15] Living in this otherwise elegant house was certainly beyond camping, but its decoration was rooted in decades-old traditions.

Gordon's attempt to brand the *House Beautiful* Look and her forecast for the "next" house of the 1960s were in fact two pivotal moments, and both indicated that in setting the forward pace, she would increasingly return to successes of the past. This strategy would be amplified in the aftermath of Frank Lloyd Wright's death in April 1959.

## Eulogy to Frank Lloyd Wright

> The death of a great genius causes those who are left behind to stop short and try to assess what has been lost, as well as what has been left behind as the man's heritage to us and to posterity.[16]

—Elizabeth Gordon, *House Beautiful* (October 1959)

Gordon was deeply affected by Wright's death. John de-Koven Hill was devastated.[17] To come to terms with their grief, and America's loss, they dedicated the October 1959 issue of *House Beautiful* to Wright (fig. 154). Their goal was to measure Wright's influence, both as an architect and a "crusading social thinker."[18] Gordon wrote the lead article. In "The Essence of Frank Lloyd Wright's Contribution," she recalled the breadth of his interests and the depth of his thinking. "The flowering of mankind was his goal," she wrote, "and architecture was his tool." She found him difficult to "classify," and his life impossible to summarize in a few short pages. But, as any good eulogist might, she recounted his many accomplishments in buildings, books, and awards. She suggested that his greatest legacy was his teaching, specifically his influence on designers whom he had trained at Taliesin. She celebrated him as "the Lone Ranger in American architecture," a figure who bucked trends and defied his detractors. Her final words of tribute (which could have described Gordon herself) revealed, more than anything, their shared crusade for

**151.** Parker, 1959 Pace Setter. Plan, featuring the atrium and swimming pool, *House Beautiful* (February 1959).

**152.** Parker, 1959 Pace Setter. Decorative motifs for the master bedroom, *House Beautiful* (February 1959).

### The inward-turning plan makes a small lot seem big

● As the premium put upon land in our residential areas increases, the chance that many of us can afford a large site on which to build diminishes. The problem immediately confronting us then is how to have spaciousness on a small-size lot.

We feel that this house supplies some of the answers. It does provide a desirable and necessary openness and yet it respects the privacy of those living in it. (An "open plan" does not necessarily mean that you will live exposed to the street or with all activities in the same room.) It is spacious in a truly modern sense. Goldfish bowls are not necessarily spacious. A sense of spaciousness within depends upon how that space is shaped and enclosed—not upon the amount of glass used, although glass is a material very helpful in achieving spaciousness in exterior relationships.

This is not a large house. It has the average number of rooms, of average size, found in the average house. Yet it seems large. The central patio plays a major role in achieving this effect. It provides an area independent of outside environment, into which all rooms have an outlook without loss of privacy and to which they may be related architecturally for greater spaciousness.

This house seems far bigger than the average house, without having any more floor area. It does this through several devices: a flexibility of use which makes it possible to open or close rooms when desired; a flow of continuity both within the house and to the out-of-doors; and the inclusion within the interior of many lengthy vistas, both oblique and rectangular. Most of these vistas are directed through several adjoining rooms so you receive an accumulative impression of extensiveness, something that you would expect to find only in a palatial house. This is a plan which would work very well on an even smaller lot.

Its entrance is planned for approach by auto. One drives near the entrance and enters directly into the house. But because of the high window sill and the placement of the entrance door, cars are not visible from inside. The owner's cars, parked under the shelter of the porte-cochere, do not block the main entrance for visitors.

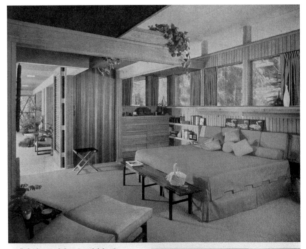

By day the master bedroom is a secluded continuation of the central patio to which it opens through the doors at left. A closet, built into one of the piers and concealed by a folding door, and the built-in chest at its right provide storage space for the husband's clothing. The wife's closet is at opposite side of room.

Sheets and pillow cases are embroidered with an abstraction of the plan of the central patio and its surrounding piers. See the story on the motifs used throughout the house on page 116.

With the draperies at the windows drawn and the doors to the patio closed, at night the bedroom becomes sequestered and snug, a change from its daytime openness (top photo).

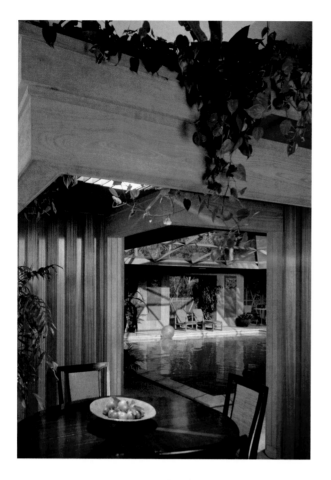

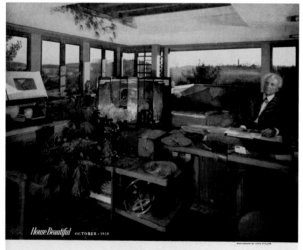

better living: "He was a fierce critic of what he considered dangerous, and, unlike many critics, he always had a solution for what he was criticizing."[19] Gordon's tone here was somber and reflective, but she arranged the remainder of the issue around more uplifting and forward-focused themes. She firmly believed, as she told her readers, that Wright's influence would outlast his lifetime; she was determined to safeguard his legacy.

She had already started to champion his heirs: *House Beautiful*'s 1955 Wright-themed issue marked her inaugural effort. Then, after Wright died in 1959, Gordon was doubly committed to uniting architects who were devoted to his principles. She filled the October 1959 issue with references to these men and images of their work. She featured the Taliesin Associated Architects prominently, including William Wesley Peters, John Howe, Allen Davison, Kenneth Lockhart, Eugene Masselink, Aaron Green, Charles Montooth, and Stephen Oyakawa. Their presence was certainly no surprise, given Gordon's admiration and Hill's enduring Taliesin connection. She also showcased former Taliesin Fellows such as Alden Dow and Fay Jones, and gave equal space to designers such as Karl Kamrath and Alfred Browning Parker, men who had absorbed Wright's lessons indirectly from outside of Taliesin.

Her list was incomplete: missing were scores of architects who were tangentially associated with organic architecture. This seemed odd, especially because most were friendly with Gordon and were *House Beautiful* regulars (such as Harwell Hamilton Harris, John Yeon, Bob Anshen and Steve Allen, Edla Muir, and Joseph Esherick). Hill later defended their omissions, claiming the staff had worked in haste and with the material "on hand."[20] Their "recommended" list may have been too short, but even this partial account was proof, at least for Gordon, of Wright's posthumous vitality and the future of American architecture.

In February 1960, ten months after *House Beautiful*'s Wright tribute hit the stands, Gordon published a final homage to the master: John deKoven Hill's 1960 Pace Setter (fig. 155). The project was part of her ongoing crusade to promote good design and good taste, and a powerful

**153.** Parker, 1959 Pace Setter. Interior view from the dining room to the central atrium and swimming pool. Copyright © Ezra Stoller/ESTO.

**154.** Frank Lloyd Wright, portrait from *House Beautiful* tribute issue, "Your Heritage from Frank Lloyd Wright," *House Beautiful* (October 1959).

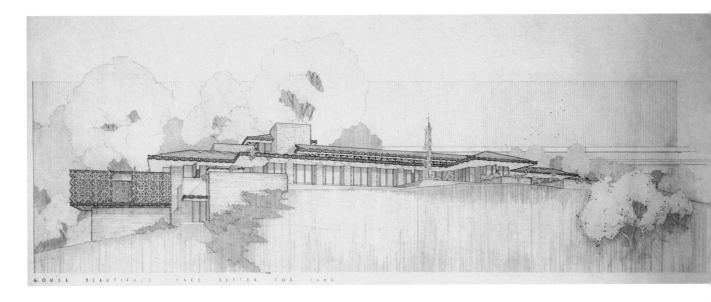

**155.** John deKoven Hill, 1960 Pace Setter House (Corbett House), Cincinnati, Ohio, 1960. Rendering attributed to Gair Sloan.

statement that she and Hill controlled fully from start to finish. Yet this Pace Setter, more so than any previous house that Gordon had published, had the double task of testing the future for organic design in Wright's absence.

The February 1960 issue of *House Beautiful* was relatively thin, at 180 pages (fig. 156). Hill's Pace Setter House was the center of twenty stories. Wright was noticeably absent from all of them; Gordon did not mention his name, though remnants of his theories were there, and Hill's connection to Taliesin remained invisible. Wright was again in the background, much as he had been before April 1953. Wright's currency was no longer his name, either dropped in stories as pull quotes or used directly in an article's text, as had been Gordon's method before his death. It was rather in the foundational quality of his ideas and, to some degree, in the continuation of his recognizable aesthetic.

For most of the 1960 Pace Setter stories, Gordon chose an architectural tack. This was a marked shift from the lively "personal" angle that she had used before—for example, with Alfred Browning Parker's 1954 Pace Setter. She did not compose personal vignettes about the architect, nor did she insert images of him engaged in the design or building process. Likewise, she did not credit the Pace Setter clients. All references to them were vague, and the reader was not privy to their individual narrative. She did discuss the clients' programmatic requirements as a central design challenge, but these were revealed

only to demonstrate that Hill, a shadowy figure (named only once in the magazine's "credits" section), succeeded in meeting their needs. Though the custom characteristics of their Pace Setter were public, the designer's and clients' identities were not.[21]

Gordon's change in method was clear and might have surprised her longtime readers. Perhaps the absence of intimate personal portraits was the clients' wish. Perhaps Hill wanted to downplay his role as both *House Beautiful* staff member and the architect of the project. (Well-conditioned by Wright, he was modest and did not often seek credit for what he did.) Curtis Besinger or other staff architectural writers may have persuaded Gordon to present the house through a more rigorous design perspective, though this is unlikely, as the magazine was still fully subject to Gordon's iron rule. Whatever the motivation, she focused her editorial attention elsewhere, specifically on the architectural themes of space and ornament. Gordon promoted the house around these two themes, but her perspective was far more than an editor's device. Hill had in fact conceived the project, from the start, around these core concepts.

In September 1957, J. Ralph Corbett, the owner of NuTone, had approached Gordon and Hill about designing his next house.[22] He wanted the magazine to sponsor it as a Pace Setter. It was unusual for a potential client, rather than an architect or builder, to seek a Pace Setter designation; these suggestions usually came directly from

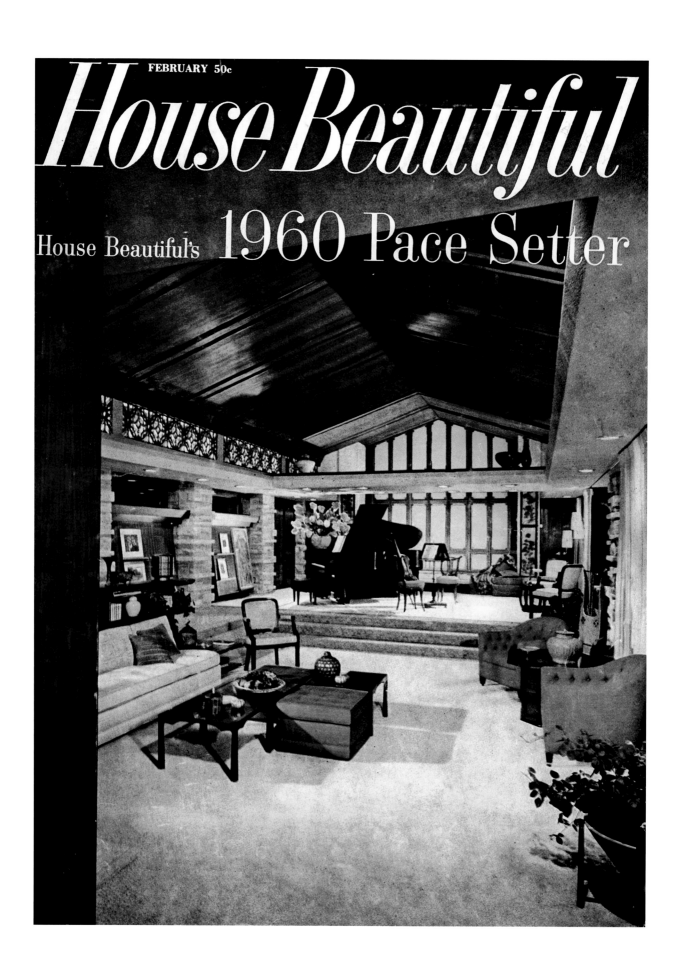

**FEBRUARY 50c**

# House Beautiful

## House Beautiful's 1960 Pace Setter

Ralph and Patricia Corbett
at their new home —
overlooking the Ohio River

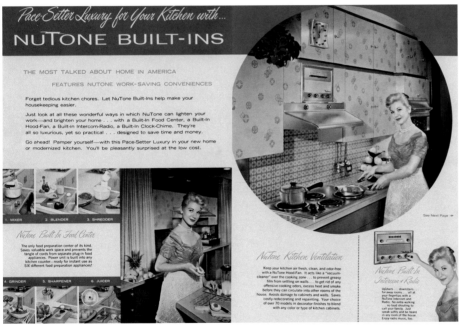

156. Hill, 1960 Pace Setter. Living room and performance space, on the cover of *House Beautiful* (February 1960).

157. Holiday card, Patricia Corbett (left) and J. Ralph Corbett (right) at the 1960 Pace Setter.

158. Advertisements for NuTone, featuring the 1960 Pace Setter kitchen (with custom Formica patterns visible in the background), *House Beautiful* (February 1960).

Gordon, one of her "talent" scouts, or her favored designers. But Corbett had unusually close ties to the magazine: he had been a major advertiser for nearly two decades, and he was a personal friend of staffer Julie Polshek. He knew that Hill designed interiors and exhibition spaces for the magazine. And through NuTone, Corbett had already partially underwritten several Pace Setter Houses.[23]

Corbett and his wife, Patricia, wanted a home that was tasteful, yet unconventional (fig. 157). They had moved to Cincinnati in 1936 to found NuTone, but in the closed society of the city, they were newcomers. They were outsiders, yet not outcasts.[24] They asked Hill to design a contemporary yet "timeless" house, and they wanted something elegant, but more dramatic than Cincinnati's typical revivalist mansions. They wanted a showpiece, a place to integrate and exhibit NuTone's innovative products and, no doubt, demonstrate the company's financial success (fig. 158). They wanted a dynamic public space

in which to entertain intimate groups and large parties. And they needed expansive private space to accommodate separate bedrooms (a his-and-hers master suite) and studios, an indoor swimming pool, and guest space for their two grown children (fig. 159). Patricia was a professional musician, so they also needed rehearsal and performance areas. Their final request was for storage: they had amassed a large collection of fine art and needed to accommodate pieces not on display. All things considered, they left Hill with a complex programmatic challenge.[25]

Hill knew from the start that the house would be a Pace Setter, and that his job would be a difficult one. He had to balance the Corbetts' specific needs with those of the magazine. He was tasked with designing a home for show (both for the magazine and for the Corbetts' benefit), one that would perform *and* photograph well. And he would have to accommodate the many advertisers and industry partners that donated building materials and decorative accessories gratis—all in exchange for product placement and generous advertising.

Hill put together a large design team to help him. He had the regular *House Beautiful* staff to help with interior decoration, but added other assistants to oversee the

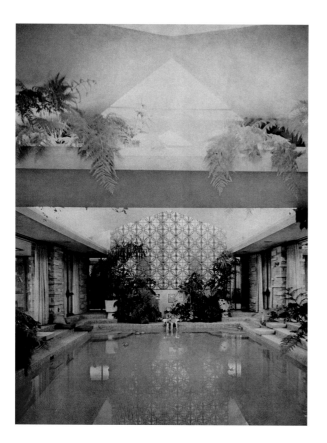

on-site architectural and construction work. He hired John W. Geiger (a former Taliesin apprentice who had worked with Hill on the Guggenheim Exhibition House) and Paul L. Soderburg as associate architects. Gair Sloan was the head draftsman and superintendent. Because Hill often worked from *House Beautiful*'s New York office, he hired Cincinnati architect Thomas Landise, Jr., to oversee the project. Landise was a crucial member of the team: he signed the final drawings, shepherded the plans through the city's approval process, and supervised construction.[26]

Hill began his designs with an appraisal of the site. Corbett had purchased a large tract of land in a well-established and prestigious neighborhood on the outskirts of Cincinnati. The lot had varied topography and stunning views of the Ohio River Valley. Hill used the hillside as more than just a "piece of real estate"; it became the "one fixed and dominant element in the design," and provided Hill with inspiration for the "form and character" of the house.[27] The land and the building were part of one unified (and organic) design concept. Wright had taught him well: Hill sited the house at the brow of, rather than atop, the knoll, as the original house on the site had been. His plan extended lengthwise across the lot and paralleled the course of the river below (fig. 160).

Once he had determined the best siting, Hill began his designs for the house. His concept was a simple, open pavilion (though this would grow to be quite complex over the course of the project). He selected steel and reinforced concrete piers clad in limestone for the framing material; these supported a broad roof of standing-seam aluminum, donated by Alcoa (fig. 161).[28] The walls alternated between textured limestone and clear glazing. By choosing these specific exterior forms and materials, Hill conveyed a sense of physical gravity.

He also infused the project, just as Wright might have, with psychological intangibles (what he would later describe as "emotion"): shelter, security, privacy—and, once inside, release. Gordon described the house as a place of "enhanced living," where the interior experience was one of liberation. It was "a disclosure of prospects and possibilities of which one was not aware."[29] Hill was indeed a master of liberated space, and of what the magazine aptly described as "delightful revelations."[30] His vision was one of dramatic exuberance. And with it, the house functioned just as his clients had hoped.

Hill designed a floor plan that, despite its generous

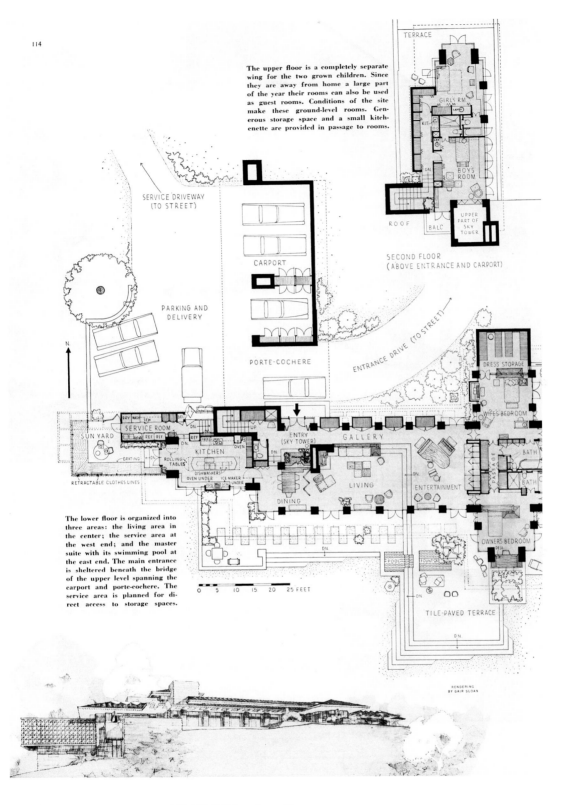

The upper floor is a completely separate wing for the two grown children. Since they are away from home a large part of the year their rooms can also be used as guest rooms. Conditions of the site make these ground-level rooms. Generous storage space and a small kitchenette are provided in passage to rooms.

SECOND FLOOR (ABOVE ENTRANCE AND CARPORT)

The lower floor is organized into three areas: the living area in the center; the service area at the west end; and the master suite with its swimming pool at the east end. The main entrance is sheltered beneath the bridge of the upper level spanning the carport and porte-cochere. The service area is planned for direct access to storage spaces.

RENDERING BY GAIR SLOAN

**159.** Hill, 1960 Pace Setter. Swimming pool pavilion, *House Beautiful* (March 1960). Photo by Ezra Stoller.

**160.** Hill, 1960 Pace Setter. Plan and rendering, *House Beautiful* (February 1960).

Which Way, America? **189**

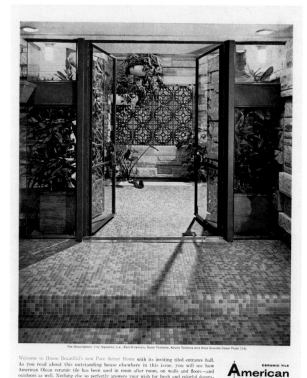
square footage, was compact. The overall form was linear, with appendages that extended outward. He centered the house, both physically and metaphorically, on the entrance hall. This was his pivot point: the plan and circulation patterns unfolded from the entrance core, what he called "The Center."[31] He attached the public spaces (living room, dining room, kitchen) on one side, and private spaces (the master suite and guest rooms) on the other.

The entry space was dramatic: the glazed front door, hidden beneath a porte-cochere, opened onto a double-height "tower of light."[32] Paved in tile (provided by American Olean), clad in limestone, and capped with a clear plastic "sky-dome," the tower was a "promise of what is to come, once you are inside" (fig. 162). Hill conceived the light tower as a grand entrance, one that functioned as a traditional grand staircase might have. It became the focal point of movement and pageantry. It was an impressive, if illusory, space. It appeared much grander in photographs than it was in person (it was only eighteen feet high). Gordon, or Besinger writing for her, boasted that "it reminds you of the Pantheon in Rome: soaring exaltation, with the sky the only dimension above you that might stop you."[33] This was an extravagant comparison, but the light tower was, as Hill intended, "dramatic." It was his "mood-setter."[34]

In the pages of *House Beautiful*, Gordon (or perhaps Hill himself) invited her readers to explore the Pace Setter and its "mood," to find the "qualities calculated to delight us, to give us more than physical pleasure." She wanted viewers to understand the house as more than a dwelling: for her, it was "rhythmic" poetry and "a work of art."[35] In her typical role as guide, Gordon carefully explained what she meant by artful or "poetic concepts of living," and how to view the house in these terms. Even after twelve years of pace-setting advice, she still believed her readers needed this kind of help.

Hill's pace-setting concept, she argued, was more "inclusive" than a typical definition of art, which might have excluded architecture or interior design. She complained that Americans' "concept of art has become limited, isolated, and piecemeal." The problem, for her, was that "we tend to think of art as something detached from everyday life," something to "hang on a wall or to place on a shelf." Her argument wasn't new, nor was Hill's association with it: this was identical to the discourse that surrounded his work for *House Beautiful's* 1954 *Arts of*

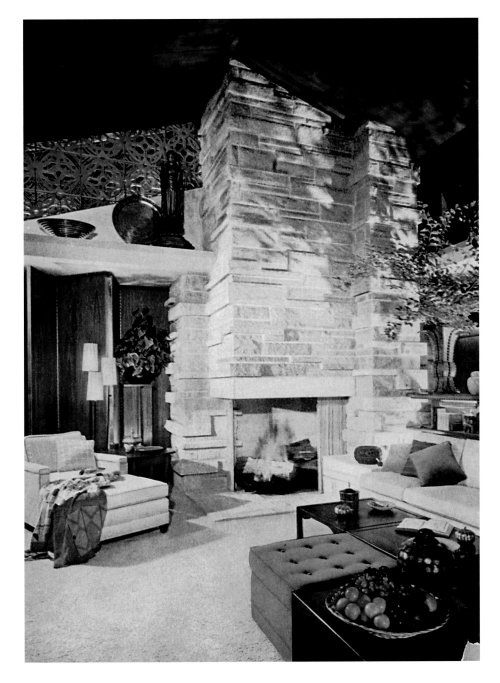

161. Advertisement for Alcoa aluminum roof, featuring the 1960 Pace Setter, *House Beautiful* (February 1960).

162. Advertisement for American Olean tile, featuring the 1960 Pace Setter entry and "tower of light" (background), *House Beautiful* (February 1960).

163. Hill, 1960 Pace Setter. Living room, *House Beautiful* (February 1960).

*Daily Living* exhibition. Gordon must have worried that her readers had forgotten, and so she used Hill's Pace Setter as a chance to remind them of such essential ideas. Her final assessment, clearly stated for the benefit of her readers, was that Hill had transformed an entire house, including the site, interiors, furnishings, accessories, fine art, and "the way of life within," into art.[36]

Hill best expressed the artistry of his design in the Pace Setter's ornamental scheme—a significant achievement for which he did not receive direct credit within *House Beautiful* (fig. 163). He established a rhythm for the

house with a module: an eighteen-inch square served as the basic unit. From this module, he created an ornamental pattern in which the rectangle dominated. He applied it to rectilinear building materials (cut Indiana limestone laid in a random pattern and protruding segments), to the concrete floor surfaced with ceramic tile, and to the paneled wall surfaces. Hill's decorative cast-aluminum grillwork was perhaps the most striking application of these patterns—significant not just as an ornamental element but as an architectural element (fig. 164). He designed the Sullivanesque pattern to be nondirectional; the individual

This
basic
PACE SETTER
design
motif

...inspired these and other
magnificent decorative fabrics
from *Schumacher's*

Schumachers' is proud to have been selected as
the source for all of the specially designed
decorative fabrics for this "house of the year." Here
you see just a few of the patterns from our Pace
Setter collection. The entire group is available to you, to
enhance the beauty of your home with draperies,
slipcovers and upholstery of unique distinction.

All are modestly priced through your decorator
and decorating departments of fine stores.

"Quality is a Schumacher tradition"
F. SCHUMACHER & CO., 60 W. 40th ST., N.Y. 18, N.Y.
FABRICS · CARPETS · WALLPAPERS · WAVERLY FABRICS

TOPS AND CABINETS WITH A SPECIAL CUSTOM DESIGNED FORMICA PATTERN IN HOUSE BEAUTIFUL 1960 "PACESETTER" HOUSE

A Formica® Wishing Kitchen...

**for pacesetters with "high hopes"**

When expense is no object and new ideas for "Pacesetter" kitchens abound—nobody, but
nobody can think of a more luxurious colorful carefree surfacing than Formica laminated plastic.
When the kitchen is small and the budget is even smaller—nobody, but nobody can
think of a more practical and economical surfacing than Formica laminated plastic.
Look in the Yellow Pages under "plastics" for a Formica fabricator-dealer near you.

new patterns new colors **new ideas** Jane Hampton, Formica home
fashion director can send you paper color swatches of the complete
Formica line including the new soft CandleGlo colors just introduced—send 50¢.
A big 9" x 12" Decorating Idea Book with 43 full color room
settings completely keyed to Formica colors, includes floor plans for
imaginative kitchens and bathrooms—send $1.00. Use coupon today.

Miss Hampton
Formica Corporation
4703 Spring Grove Avenue, Cincinnati 32, Ohio

*Please send me the Formica materials as indicated:*
☐ *Full set of Formica paper color swatches—50¢*
☐ *Decorating Idea Book—$1.00*  ☐ *Free color folders*

*The wash-off trade mark is your assurance of
the world's finest quality laminated plastic.*

name _____
address _____
city _____ zone ___ state ___

units were infinitely configurable. He applied the same
motif to interior finishes and materials, most notably
in his custom wallpaper and fabric collections made for
Schumacher; the Pace Setter Collection included eighty-
four fabrics and five wallpapers (figs. 165 and 166). He
used the same pattern language on durable surfaces,
including the kitchen countertops and cabinetry clad in
his custom-designed and locally made Formica (fig. 167).
His custom furniture for the home, manufactured by
Henredon and sold as the "Pan Asian" line, repeated the
now-familiar Pace Setter motif and simultaneously indi-
cated an "oriental" inspiration (fig. 168).[37]

What made this Pace Setter exceptional, as Gordon
told her readers, was that it was so *complete*. It was a

**164.** Hill, 1960 Pace Setter.
Dining room with a decorative
grill in the background, *House
Beautiful* (February 1960).

**165.** John deKoven Hill,
Fabrics for Schumacher for the
1960 Pace Setter collection.
Advertisement, *House Beautiful*
(March 1960).

**166.** Hill, Fabrics for
Schumacher for the 1960
Pace Setter collection. *House
Beautiful* (March 1960).

**167.** Advertisement for Formica,
featuring custom laminates in
the 1960 Pace Setter kitchen,
*House Beautiful* (February 1960).

Bottom right: "Which Way, America? 193"

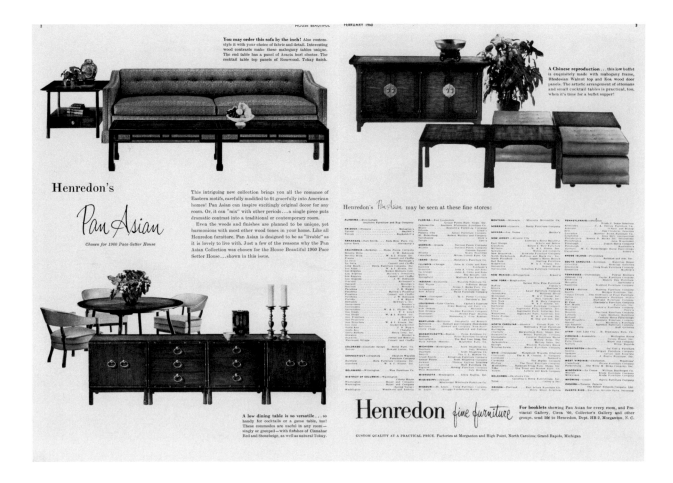

**168.** John deKoven Hill, Pan Asian furniture line for Henredon, designed for the 1960 Pace Setter. Advertisement in *House Beautiful* (February 1960).

livable, three-dimensional *Gesamtkunstwerk*. It was a "synthesis of the practical and the aesthetic with no sacrifice of either."[38] As Gordon acknowledged, Hill had designed a perfect blend of function, technology, and emotion. He had "lifted" the house beyond mere building to what Wright might have called the "realm of architecture."[39] In a subtle reminder of past controversies, Gordon invoked—and reversed—the words of Sigfried Giedion, the historian and sometime-champion of the International Style: she proclaimed that at the 1960 Pace Setter, "mechanization has *not* taken command, but is kept in a proper supporting role."[40]

Hill's sophisticated schemes went far beyond Gordon's expectations, and beyond what most Pace Setter architects had ever produced. She used the house to test her ideas for the "best" house of the year—as was the goal of all Pace Setters in the *House Beautiful* series—and to confirm her belief that organic design had a place in 1960s America. In both of these endeavors, Hill's Pace Setter was an enormous success, thanks in part to the product advertisements that accompanied the publication.

As she put the Pace Setter issues to print in the early spring of 1960, Gordon was keenly aware of the aesthetic and artistic quality of Hill's 1960 Pace Setter. She believed that she had discovered the same "elegance" in only one other source: "Japanese life and architecture."[41] With this final compliment to Hill, buried in the final pages of the February 1960 issue, Gordon foreshadowed her next big project and a new direction for American design.

# American *Shibui*

By the late 1950s, Elizabeth Gordon feared that American "design [was] in a vacuum—on a dead center."[1] Frank Lloyd Wright was dead. Modernism was dying. And good design had yielded to what Reyner Banham characterized, in 1955, as a "throw-away aesthetic."[2] The current predicament, so Gordon believed, had paradoxically been born out of the very same circumstance that had launched good design in the late 1940s: postwar prosperity. Although she had spent two decades trading on America's good fortune, she was increasingly convinced that affluence had distorted design to the point of "visual indigestion."[3] Her critique (true to form) was both social commentary and design catalyst: she urged Americans to sharpen their senses, now "badly atrophied from disuse or warped by phony values."[4] She counseled her readers to "exercise new muscles of awareness" and to "proceed rationally and thoughtfully to a new, higher plane."[5] The path forward (or perhaps backward) began in Japan, with the Japanese aesthetic concept of *shibui* (fig. 169).

## The Pursuit of Beauty

In November 1960, Gordon addressed the Retail Paint and Wallpaper Distributors of America at their annual trade show in Atlantic City. "The thing you and I have in common—and the reason I am here today," she told her colleagues, "is that we are both in the business of selling beauty. But before we can sell it we have to know what it is and how to create it."[6] Americans, she argued, crave and

indeed "deserve" beauty (generally in life, and specifically in architecture and home furnishings). But they had been sold the "bottom of the value scale." They were growing dissatisfied with "the cute and the trivial" and the mere "pretty." What Americans wanted, and what Gordon hoped to give them with the help of the paint and wallpaper retailers, was the "top" kind of beauty: the "lasting, timeless kind of beauty . . . that soothes and fulfills and calms, while it inspires and nourishes the soul." The problem, however, was that "western civilization" had yet to define beauty.[7]

Gordon's sweeping proclamation—and accusation—was based in frustration. She had to fill "1,000 editorial pages a year with words and pictures" about beauty in the American home, yet she had no "specifications" on which to rely. She found it difficult, at best, to edit under such "chaotic" conditions.[8] Her progress had been thwarted, and she was sure that her industry counterparts were equally stuck.

Gordon's pursuit of beauty was not a new quest: she had in fact spent years trying to establish a concise definition, design standards, and production methods, all related to the vague concept of "beauty" (a term she and her fellow editors had used frequently since the 1940s, though with imprecision). She tested these in *House Beautiful,* most directly in her 1958 essay "What Is Beauty? Can You Afford Any of It?"[9] This was a start, but she was still unsatisfied. She studied aesthetic theory and philosophy, but even the most vaunted works of Bernard

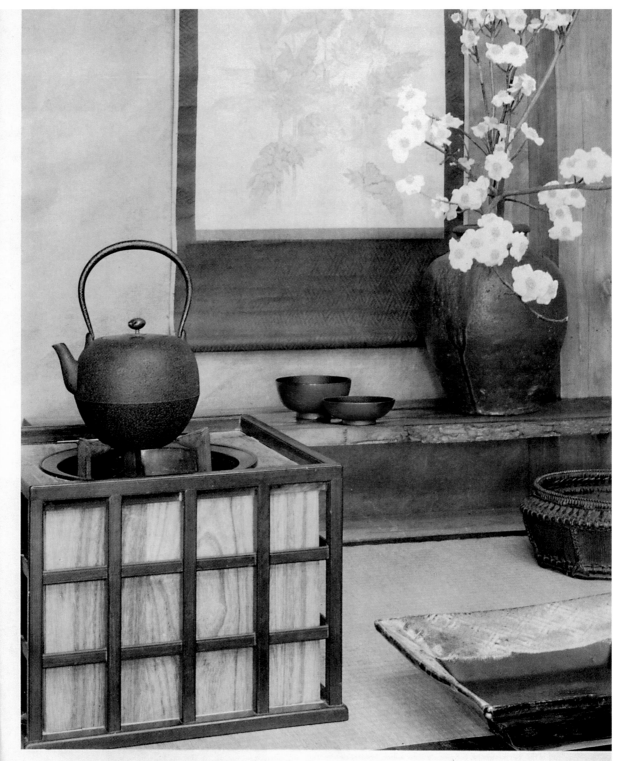

*Clarity of form, unpretentious artistry, texture that is expressive of both
material and method of crafting, give all these objects shibui character.
Their appeal is not through falsification or applied decoration but a beauty
from within, brought forth by the greatest skill and insight into the material.*

Berenson and George Santayana yielded no conclusion. "Western" concepts of beauty, so she argued, were too vague, ephemeral, and enigmatic. So she cast a wider net.

In the mid-1950s, she began to look eastward, toward "the oriental civilizations, which had long been highly thought of as producers of beauty."[10] She went in search of beautifully designed homes and domestic objects, but she also hoped to find "a system for *thinking* about, *talking* about, and *creating* beauty." In a word, she sought order: something desperately needed to rescue American design from its current crisis of "materialistic clutter."[11]

Two major factors motivated Gordon to look to Japan: taste and politics. American taste, she argued, had fallen victim (despite her best efforts) to the substandard, if novel and affordable, enticements of the postwar market. Americans had lost "awareness," or their ability to "see" beauty and bring beauty into their designed environments. The Japanese, on the other hand, had spent centuries cultivating what Gordon described as a "sensitivity to things," or a "subtlety of discrimination." While Americans continued to undervalue or shun the ordinary (again, despite her best efforts), the "Japanese did not make the same mistake that we westerns did . . . of separating the useful and practical from the beautiful" so that even "their most commonplace objects are worth paying serious attention to as aesthetic achievements."[12] The fundamental American problem, Gordon implied, was one of taste.

Japanese culture, and especially the practice of shibui design, reflected a refined and arguably ancient version of good taste, an "understanding of great lasting beauty" that surpassed all Western efforts, including, declared Gordon, the time-tested "elegance and sophistication" of France.[13] Her nod toward (or perhaps against) French design was predictive, and set *House Beautiful* in sharp contrast to other home magazines, including, for example, *Better Homes and Gardens* and *House & Garden,* which at this same moment filled their pages with "tasteful" French provincial interiors, reproduction or antique furniture, "period" color schemes, and French cuisine. (A few short years later—corresponding roughly with the famed Julia Child's 1963 television debut of *The French Chef—House Beautiful,* too, would be swept away in this cultural current, though under the leadership of

**169.** Shibui arrangement of Japanese objects, *House Beautiful* (August 1960).

Gordon's successor.) With her burgeoning interest in Japanese culture, Gordon led her readers in a different but consistent direction, toward an undiscovered "gold mine . . . judged by all the standards" that she had promoted for the preceding two decades.[14]

If the taste problem, under the guise of "beauty," was squarely in the foreground of Gordon's agenda, politics lurked in the background. Though her personal views remain ambiguous, her editorials reveal that she was, throughout her career, aware of and responsive to national concerns, especially if these concerns could influence buyers' opinions and sell good design. In 1953, for example, she had leveraged the popular rhetoric of nationalism, and to some degree of McCarthyism, to encourage an American Style. In 1960, as she began to promote the "foreign culture" of Japan, readers and critics who followed her during that inward-looking period, and certainly those who knew her only for "The Threat to the Next America" essay, might have considered her apparent editorial shift odd. But it was not. In fact, it was no shift at all. Despite her 1950s tirade against the "invasion" of the International Style, she had consistently encouraged cultural exchange: most notably, through an ongoing endorsement of Scandinavian design, which she had published and exhibited widely since at least 1954.[15]

After the hard lessons of 1953, Gordon employed politically charged rhetoric with reserve, but by 1958, her editorials began to carry the subtle hint of a new Cold War weapon: cultural diplomacy. Like many politicians and diplomats, including, most famously, President Dwight D. Eisenhower, Gordon believed design had the power to communicate values and unite divergent cultures.[16] She wrote cautiously (but spoke more forcefully at public events) about her own desire to open a dialogue of appreciation between East and West. She believed that art and design were powerful diplomatic tools that, when properly leveraged, could "bridge the gap of ignorance which has so long separated our unlike cultures."[17] Though she was less concerned than Eisenhower with containing the Soviet Union or positioning Japan as an ally or barrier in the fight against communism, she did suggest, forebodingly (and quoted Bernard Leach), that "the very future of the world may depend on this kind of understanding."[18]

Gordon's interest in and access to Japan was certainly accelerated by the U.S. government's involvement in East Asia. Since the close of the Second World War and Japan's surrender in 1945, General Douglas A. MacArthur had

led Allied Powers in the monumental task of rebuilding the country, initiating widespread political and economic reforms that all but guaranteed Japan's turn toward Western democracy and capitalism. The Dulles Peace Mission in 1951 and the subsequent treaty negotiations held in San Francisco brought the period of Allied occupation and restoration to a close, and opened a new era of vigorous cultural exchange. Cultural diplomacy would become, in short order, a desirable mode of "soft power" wielded to repair diplomatic relations between the two countries (particularly as the West courted Japan as an ally, and as Japan struggled to rebuild its national image).[19]

John Foster Dulles, a foreign affairs adviser for President Harry S. Truman and secretary of state under President Eisenhower, played a large role in negotiating this cultural exchange. His primary job was to broker a peace treaty with Japan, but as historian Takeshi Matsuda has argued, "he was fully aware of the importance of long-term cultural relations."[20] In a farsighted move, Dulles (a trustee and chairman of the board of the Rockefeller Foundation) invited philanthropist John D. Rockefeller III to join the mission as a "consultant on cultural affairs."[21] Rockefeller accepted readily, on the premise that "politics, economics, and culture were the three major components of American foreign relations."[22]

Rockefeller proved to be a perfect addition to the team: he held a degree in economics from Princeton, he had experience with international politics through his activities with the Institute of Pacific Relations (the IPR was a Rockefeller-funded organization founded in 1925), and he was an enthusiastic fan of Japanese culture, invigorated by a 1929 conference trip to Kyoto, which he attended as an IPR delegate. Rockefeller's personal links to the world of art and culture certainly influenced his policy-making, especially his ties to MoMA (founded by his mother, led by his brother Nelson, and financed in part by his own Rockefeller Brothers Fund). Perhaps with American cultural institutions in mind, he proposed a "two-way street" on which culture could be shared freely and equally between the United States and Japan. While historians, including Matsuda, have suggested that Rockefeller's scheme was intended to circumvent appearances of cultural imperialism, with its "one-way imposition of culture by a powerful country on a weaker nation," his subsequent activities suggest that he was genuinely invested in bringing Japanese culture to the West.[23]

Two of Rockefeller's most significant endeavors stemming from his role in the Dulles Peace Mission were tied directly to Gordon's Japan campaign: the reopening of the Japan Society of New York in 1952, and the launch of MoMA's 1953 Japanese Exhibition House and subsequent 1955 book, *The Architecture of Japan.*

## Discovering Japan

Gordon, like many Americans, encountered Japan initially through late nineteenth-century sources. Though she was born thirteen years after the debut of the Japanese pavilion at the 1893 World's Columbian Exposition in Chicago, she would meet American designers who had experienced it firsthand. Some of these architects, most notably Frank Lloyd Wright, had traveled to Japan; after 1916, Wright had spent a significant amount of time in the country designing Tokyo's Imperial Hotel and amassing his Japanese print collection.[24] Following her predecessors at *House Beautiful* (and many other editors at shelter magazines and architectural journals), Gordon featured architects who referenced, directly or indirectly, Japanese art and architecture. Under Gordon's leadership, especially after 1950, Wright and Greene and Greene got the most press.[25] For Gordon, the connection between modern American architecture and Japanese design was ambiguously present, but often dominated by other, more pressing themes (for example, "naturalism").

After 1952, in the wake of the Dulles Peace Mission and the Treaty of San Francisco, Gordon began to notice what historian Penny Sparke has described as the "two-way traffic of designers and design objects between Japan and the West."[26] Through Gordon's own networks, she had discovered several designers who were either part of or influenced by this cultural flow. One such designer was Albert Ely Ives of Honolulu, whose "Hawaiian Lanai" vignette for *House Beautiful*'s 1954 *Arts of Daily Living* exhibit was described as "influenced" by Japan, but "Americanized for comfort."[27] Another was George Nakashima, the Japanese-American architect and furniture designer whose handcrafted designs made regular *House Beautiful* appearances. Gordon was also supportive of Vladimir Ossipoff, whose houses in Hawaii (chiefly his 1956 Liljestrand House, which Gordon published as *House Beautiful*'s 1958 Pace Setter) reflected his early childhood in Japan and his reliance on Japanese craftsmanship.

More broadly, Gordon observed an unmistakable "oriental" influence at furniture markets and showrooms,

and in private homes, all of which she toured regularly. She would have also noted her competitors' fleeting interest in Japan. As one example, in April 1952, *House & Garden* announced "Pacifica: A New Trend in Living." The editors showcased the Hawaiian houses of Ives and Ossipoff, noting the Japanese and "oriental" influences on each. In a summary history titled "Biography of an Idea," *House & Garden* acknowledged the many precedents for its new Pacifica look: Frank Lloyd Wright (specifically his 1916 Imperial Hotel in Tokyo); Harwell Hamilton Harris; Antonin Raymond; Isamu Noguchi; John Yeon; Thomas D. Church; interior decorator Frances Elkins; Paul Frankl; T. H. Robsjohn-Gibbings; Dorothy Liebes; and MoMA (specifically, the oceanic art exhibition of 1945, arranged in collaboration with Ralph Linton).[28] This "biography" was not news to Gordon; she had already published all of the designers whom *House & Garden* referenced. But the point was clear: a design aesthetic was in the making. This made her "curious," and she began to investigate.[29] Why, she wondered, were Americans increasingly fascinated with everything Japanese?

It was, in part, a question of access, as travel and trade played a large role in this burgeoning design trend. Tourism boomed with the growth of international air travel between the United States and Japan, facilitated by three key factors: after 1949, the use of Hawaii, still a U.S. territory, as a midpoint; the emergence of trans-Pacific airline routes on Pan American, Northwest Orient, and, after 1954, Japan Air Lines; and the official birth of the Jet Age in 1952. The increase in "flow of people" was matched and surpassed by the movement of goods; trade between the United States and Japan rose nearly thirty percent (for both imports and exports) in this same period.[30] It was not surprising, then, that Gordon observed a new current in American design culture.

The lively exchange that Gordon witnessed in the mid-1950s was sponsored in part by the Japan Society of New York, which had since its founding in 1907 published books, mounted exhibitions, offered film screenings, hosted public lectures, and encouraged educational curricula in American schools.[31] Though rising political tensions forced the society to close during the Second World War, it experienced a renaissance after 1952, aided significantly by its new president, John D. Rockefeller III, and its new chairman of the board, John Foster Dulles.[32] With such august leadership, the society expanded its cultural and educational programming to include, most

notably, the Intellectual Interchange Program, art and textile exhibitions (for example, at the Metropolitan Museum of Art and, later, MoMA), film screenings, theater and opera performances (including *Madame Butterfly*), music concerts (at Carnegie Hall, the Philharmonic Hall, and other venues), television programing, scholarly books, and a widely circulated bibliography titled *What Shall I Read on Japan?*[33]

Gordon's own investigation, begun around 1954, paralleled the Japan Society's reading list. After 1959, she was directly influenced by her interview with Douglas Overton, director of the Japan Society.[34] She read widely, devouring published books on Japanese history, culture, art, and architecture. She learned about Japanese lifestyle, music, film, and food. She studied pioneering scholarship that had emerged since the 1930s, including the work of George Sansom, a noted diplomat, historian, and professor of Japanese Studies at Columbia University. Her personal reference library came to include, among many titles, Sansom's *Japan, A Short Cultural History* (1931, revised in 1943) and *The Western World and Japan* (1950); Harvard historian, Japan Society board member, and, later, U.S. Ambassador to Japan Edwin O. Reischauer's *Japan Past and Present* (1946, revised 1952); Herschel Webb's *An Introduction to Japan* (published in 1955 and revised in 1957, under the auspices of the Japan Society); and Frank Lloyd Wright's *The Japanese Print* (1912).[35] She was thoroughly convinced of the value of these works and, in 1960, suggested at least thirty of her sources to *House Beautiful* readers as part of the magazine's "Recommended Reading on Japan."[36] MoMA's 1955 publication *The Architecture of Japan,* penned by Arthur Drexler, was notably absent from her list.

Gordon was certainly aware of Drexler's activities at MoMA. The two had moved in similar professional circles, particularly from 1948 to 1950, when Drexler served as the architectural editor for *Interiors* magazine. Drexler became the curator (and, later, director) of MoMA's Department of Architecture and Design in 1951, just as Dulles and Rockefeller opened the floodgates for cultural exchange with Japan. In April of that year, the museum mounted its first postwar exhibition on Japanese design, titled simply *Japanese Household Objects.*[37] Whether Gordon attended or not is unclear (though she kept abreast of the competition or, in this case, the "enemy"), but she would have been intrigued by the array of domestic goods on display. These were precisely the kinds of

objects she preferred. As MoMA reported, these were not "export" pieces, but "beautiful objects" made by hand and "designed for everyday use." She would have been doubly interested in the collection's source: the display was courtesy of architect Antonin Raymond, who had worked with Wright at the Imperial Hotel in Tokyo (and continued to live in Japan).[38]

Three years later, with significant backing from Rockefeller, Drexler unveiled MoMA's Japanese Exhibition House. Conceived and constructed in 1953 as the third in the museum's "House in the Garden" series, the Japanese House opened to the public in June 1954, with a second exhibition in the summer of 1955. The project was sponsored in part by the America-Japan Society of Tokyo, "private citizens" (including Rockefeller), and MoMA.[39] The museum commissioned Japanese architect Junzo Yoshimura to design and build a traditional structure "based on 16th and 17th century prototypes," at full-scale. The process was complex, as Yoshimura first assembled the building in Japan, disassembled it, shipped it to New York, and reassembled it in the museum's garden, all with the assistance of his team of Japanese craftsmen.[40] The house was intended to demonstrate, as Drexler wrote, the "relevance" of Japanese design to "modern Western architecture."[41] He specifically noted four key transferable "characteristics": "post and lintel skeleton frame construction; flexibility of plan; close relation of indoor and outdoor areas; and the decorative use of structural elements."[42]

The Exhibition House was widely publicized and must have piqued Gordon's interest. It was around this time that she also began to test the very question that Drexler had asked: Was Japanese design relevant to postwar American architecture?

## Discovering Shibui

In the spring of 1959, Gordon made her first trip to Japan. Though she initially planned to make only one trip, her research eventually spanned four years and seven visits (two in 1959, two in 1960, and three between 1961 and 1962).[43] She traveled in style, and she rarely traveled alone. She had "VIP" status in most of the major cities she visited, and when in Tokyo, she always stayed at Frank Lloyd Wright's Imperial Hotel. She brought members of her *House Beautiful* staff, including John deKoven Hill, Marion Gough, and Frances Heard, to assist with

research and to "train their eye and mind" to recognize the beauty that Gordon saw.[44] She also brought photographers: Ezra Stoller accompanied her on at least one occasion in 1959 to shoot most of *House Beautiful*'s published images. Other design colleagues tagged along, most notably Roger Rasbach, the architect of the 1961 Pace Setter. *House Beautiful* paid for everything.[45]

Gordon's research in Japan was exhaustive. Her methods were painstaking and thorough, no different from any major project she had launched before (including, for example, Climate Control). She visited major cities, including Tokyo, Osaka, and Kyoto. She toured the requisite "tourist" destinations, such as the Katsura Imperial Villa, but she was more interested in Japanese cultural institutions, specifically Tokyo's Japan Folk Crafts Museum, the Japanese Crafts Center, and the Tokyo Art Club. And most importantly for her *House Beautiful* research, to develop the angle she wanted for her editorials, she prioritized "everyday" locations ranging from teahouses to bookstores, markets, and department stores (where she purchased textiles and household goods to publish in the magazine). She relied on her own observations and her growing understanding of Japanese design, shaped in large part by local experts and the "leads" from Douglas Overton at the Japan Society.[46] This helped her to develop a sophisticated understanding of Japanese "elements of beauty," and the intertwined value system that Gordon translated as "good taste."[47]

The watershed moment for Gordon came during her first trip. In April 1959, while visiting Kyoto, she met Eiko Yuasa, a city worker who served as a visitor's guide.[48] Yuasa accompanied Gordon during her first visit. Gordon was so impressed with the young woman that she returned eight months later to "get better educated" under Yuasa's tutelage.[49] This decision would shape Gordon's approach to the planned magazine issue on Japan and, to a large degree, the rest of her editing career: it was Yuasa who introduced her to the term "shibui."[50]

Gordon absorbed Yuasa's lessons on the street, careful to discriminate between "straight Japanese" and the growing influence of "western style," which Gordon thought got them "off the track completely."[51] The two women browsed domestic goods in local department stores, observed the clothing of passersby, studied food presentation, and ate local cuisine. At each stop, they assigned each product or experience the "correct" Japanese aesthetic term, of which "shibui" was only one (they

also tested the terms *"hade," "iki,"* and *"jimi"*).[52] These trips cemented Gordon's admiration of Japanese designers and consumers. They shared a philosophy that she had long espoused, refusing to separate "the useful and practical from the beautiful."[53] The Japanese had found a way to inject beauty into otherwise ordinary and mundane objects and activities, and had a precise language with which to describe this process.

On Gordon's second trip to Japan, in December 1959, she arranged a series of interviews with experts who would expand her knowledge of shibui, now the focus of her investigation. Of these, she would rely most on her meetings with the British potter Bernard Leach, the artist Frances Blakemore, the leading aesthetician Soetsu Yanagi, and architect Junzo Yoshimura.

Frances Blakemore had a particularly useful perspective. She had been in Tokyo since 1935 (though she spent the war years in Honolulu) and was a noted artist, designer, and curator in her own right; she had also married Thomas Blakemore, a respected attorney who had earned his stripes as a member of MacArthur's legal team during the Allied Occupation.[54] Though she studied modern Western art at university, where she was influenced by Cézanne and Diego Rivera, she was an enthusiastic student of Japanese folk craft, inspired by her friend Soetsu Yanagi. It was this knowledge that she shared with Gordon. Perhaps the biggest, and most difficult, lesson that Gordon took from Blakemore was that "Japanese language is, semantically, almost impossible to translate to western concepts."[55] The inability to translate Japanese terms would plague Gordon as she compiled her shibui research and, in the end, would undermine her goal of creating a "concise" definition.

Nevertheless, Blakemore offered two more useful suggestions, both of which resonated with Gordon's long agenda. First, she said that objects required a full "context" and a well-developed setting to be "truly shibui." Second, she advised that the character of shibui design would be best captured in photographs that were "simple, moody" and "Zen-style."[56] Gordon took Blakemore's advice on both counts. She directed John deKoven Hill to frame objects within a coordinated setting, encouraged photographer Ezra Stoller to shoot the magazine spreads without "camera-angle tricks," and pressed Warren Stokes, her art editor in charge of the magazine's design, to "evoke a strong mood around the shibui pages."[57]

Gordon's most productive interview was with Dr.

Soetsu Yanagi, founder of the folk craft (*mingei*) movement and head of the Japan Folk Crafts Museum. Yanagi, who was a key influence on both Leach and Blakemore, provided the substance on which Gordon would base her own interpretation of shibui. In what must have been a semi-prepared lecture (he had "notes" for Gordon), he outlined six key points or "elements of beauty" central to *shibusa* (the noun form of the more commonplace adjective "shibui"): simplicity, or plainness; integral quality ("beauty *of* a thing—not *on* a thing"); modesty or humility; tranquility; naturalness; and *yugen,* roughly translated as "the look of freedom . . . that comes when a craftsman has mastered his technique."[58]

Most of Yanagi's points resonated with Gordon and echoed arguments that she had already made in support of good design. She quickly saw the relationship of shibui's "naturalness" to what she had promoted in 1950 as naturalism, or what Frank Lloyd Wright had termed organic. Yanagi's discussion of integral quality likewise paralleled Gordon's (and Wright's) interest in integrated design. She struggled, however, with what Yanagi described as "plainness almost to the stage of austerity." She disliked the term "austere," clearly still invested in her battle against the International Style, but reconciled its meaning in this context. Shibui, she reasoned, was restrained, but this was "not Bauhaus austerity. . . . This kind of shibui plainness does not mean nothingness or emptiness. . . . It is not the empty box (or volume) concept of Mies."[59]

Gordon's meeting with architect Junzo Yoshimura, who had designed MoMA's Japanese Exhibition House, underscored this new and more palatable meaning of "austere." She must have felt particularly validated in her fight against functionalism when he offered his opinion that "the mechanically perfect thing could not be shibui." Yoshimura convinced her that while shibui design was rational, it was not "modern." Modern design, he explained, "is not yet deep enough to have reached the stage of shibui."[60] It would take another year for Gordon to develop her own position on the relationship between shibui and modern design, but she eventually agreed with Yoshimura. Writing in *House Beautiful* in 1960, she concluded:

Very few modern things can be said to be shibui. Modern design is too new a point of view to have developed the depths necessary for *shibusa.* Anyway, the modern movement has put too high a value on

the machine-made look. *Shibusa* is humanistic and naturalistic, and the opposite of mechanistic. For this reason, it has nothing whatever to do with the "less is more" thinking of Bauhaus and "The International Style." *Shibusa* is organic simplicity producing richness. It is not denial and austerity, for it is developed to the hilt.[61]

After two years of research, Gordon was ready to define "shibui" for her readers. She believed that the principles, or "specifications," that she had uncovered had "never existed before—in our western civilization." She knew she was on to something big. She had concluded that "shibui matters." Her goal was to show the American public that shibui was not just one of many Japanese words for beauty: it reflected a larger system of values and principles that could raise "beauty to the nth power, into the realm of lasting greatness." She sensed people were "hungry" for this kind of beauty in their homes, and that they would embrace these new ideas. Most importantly, Gordon was convinced that if presented and adopted properly, shibui would be no fleeting fashion, fad, or whimsy. Shibui design was without temporal or national bounds.[62]

## Shibui in Print

In early 1960, after nearly six years of research, Gordon asked her *House Beautiful* staff this pivotal question: "How are we going to sell Shibui to the American people, and most importantly, to the stores we feel are appropriate for this program?"[63] With a simple and direct "Here's How ... ," she laid out a two-part editing plan. They would publish two full issues, in August and September. The first would summarize Japanese shibui and showcase Japanese domestic objects; the second—to the relief of her advertisers—would demonstrate "how to be shibui with American things."[64] The timing was perfect, as 1960 marked the centennial anniversary of open trade between Japan and the United States, and the start of a renewed alliance between the two.[65]

In August 1960, in a tone that echoed John F. Kennedy's recent "new frontier" rhetoric, Gordon invited her readers to "enter a new dimension: shibui" (fig. 170).[66] This would be a journey of discovery, a "journey to a different viewpoint."[67] Gordon set the tone of the August issue with a lengthy excerpt written in 1904 by the noted

American "interpreter" of Japanese culture, Lafcadio Hearn.[68] Hearn's description of Japanese people and lifestyle provided the first glimpse of Gordon's underlying premise: Japan was "unchanging," yet its culture remained "applicable" to contemporary times.[69] Gordon quoted Hearn unapologetically, without qualification of the author's broad (and, by twenty-first-century standards, offensive) generalizations, particularly about Japanese women. She also failed to mention Hearn's fluctuating popularity among critics and historians, especially respected figures such as Edwin O. Reischauer, who had discounted Hearn's observations as naïve, misleading, exoticized, and overly romantic.[70] But it was precisely this atmosphere of romance that Gordon wanted.

Shibui was the centerpiece of the August issue, but Gordon delayed introducing the concept. In what could be interpreted as a savvy, even shibui, approach to magazine design, she let her argument unfold. In the first few pages of the magazine, and eighty-eight pages before Gordon defined "shibui," Americans learned about the traditional Japanese tea ceremony, music (complete with a "suggested listening list"), travel to Japan (a pragmatic piece that doubled as an advertisement for Japan Air Lines), and travel in Japan. As a complement to the latter essays, Marion Gough aimed her "journey to a different viewpoint" at the *House Beautiful* reader looking to "improve your quality of living at home." This comprehensive overview covered a full range of activities, from sightseeing to museum-going, "eating, sleeping, [and] living Japanese."[71] Gough's recommendations (though she did not confirm as much in the article) were based on the itinerary that she, her fellow staffers, and Gordon had personally followed.[72]

Gordon's challenge with the Japan issue was to convince her readers that Japanese design, and the involved pursuit of beauty, held "meaning" for them. She laid out her reasoning like a frontline defense, opening with "Why an Issue on Japan?" She followed this with articles in which she presented philosophical and physical evidence of "what Japan can contribute to your way of life," printing large, full-color images of "flexible" and climatically responsive Japanese houses, sparse yet practical interiors, "uncluttered" storage rooms (key in maintaining

**170.** "Discover Shibui," on the cover of *House Beautiful* (August 1960).

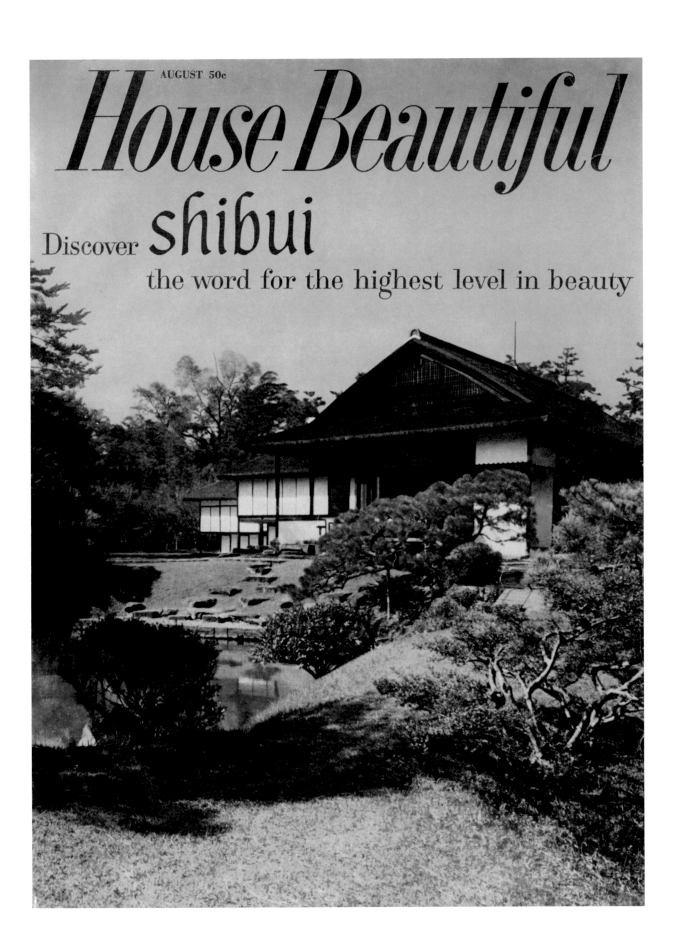

AUGUST 50c

# House Beautiful

Discover **shibui**

the word for the highest level in beauty

the "spare" Japanese look), poetic gardens, gastronomic delights, and haiku (the "poetry of awareness").[73]

Contributing author Anthony West, presumably the same West who was a critic, novelist, and columnist for the *New Yorker,* offered yet more evidence of "what Japan has that we may profitably borrow."[74] After a sweeping exposition on color, painting, interior design, structures, religion, rituals, gardening, and music, West concluded that the Japanese had mastered at least two valuable skills that Americans had not: the disciplined art of "selection and elimination," and an acceptance of "imperfection."[75]

West set the stage for Gordon's two central essays: "The Profits of a Long Experience with Beauty" and "We Invite You to Enter a New Dimension: Shibui" (fig. 171). Though Gordon found no direct English translation of "shibui," and ultimately failed (despite her promise) to offer a concise definition, she framed it perfectly for her American audience. She suggested that shibui offered a perspective and a guideline for how to live well or, perhaps more specifically, how to create an environment that would encourage good living. It was, ultimately, the expression of good taste.

In the first of these two essays, Gordon made her express point: the "most valuable lesson to be learned from Japan," she wrote, was the system of "values and value-words" used to "analyze" and "grade" beauty.[76] Rather than relying on her own interpretation, as she would later, she reprinted the words of the "master," Soetsu Yanagi. This lengthy excerpt recounted the content from his seminal essay, "On Shibusa" (1960), which he had summarized for Gordon during their interview one year before.[77] The translation used slightly different terminology, citing the noun "shibusa" more frequently, and in consistent grammatical accuracy. Yanagi repeated the basic elements of shibusa that Gordon had introduced, adding one to the count, for a total of seven (odd numbers were perhaps more shibui): simplicity, implicitness, modesty or humility, silence or tranquility, naturalness or inevitability (or spontaneity), uneventfulness or normalcy, and coarseness.[78] These characteristics painted a poetic vision of shibui, expressive yet imprecise. Yanagi provided a

*Quiet richness and depth result from controlled unevenness in the tarnished silver lacquer in the bowl lining, the come-and-go of wall color, the slightly undulating rim of the dish, the interplay of patterns in the brocade. All skillfully avoid the uninteresting finality of perfection.*

**171.** Elizabeth Gordon invites readers to "Enter a New Dimension: Shibui," *House Beautiful* (August 1960).

**172.** Shibui arrangement of Japanese objects, *House Beautiful* (August 1960).

second list, which was perhaps more instructive for *House Beautiful* readers. Here, he appealed to "human common sense," a line that Gordon must have loved, and presented the "opposites" to clarify what shibusa was not: showiness or gaudiness; loudness (in contrast to tranquility); sumptuousness; and vulgarity or commonplaceness (meaning superficiality in contrast to depth).[79]

In the second essay, the product of Gordon's travel notes, interviews, and staff memos, she repeated and expanded Yanagi's descriptive lists, but added one significant element: explanatory pictures and captions (fig. 172). This five-page portfolio conveyed "beauty" more powerfully than any other part of Gordon's twenty-page feature series. This surely was the section that sold shibui. The contents of the portfolio, all household objects, were souvenirs from Gordon's travels to Japan. The majority of these, so Gordon believed, were not made for the export market; she had purchased goods that she believed Japanese people—of all economic classes—bought and used in their daily lives. Gordon's selection of objects would have stood in stark contrast to the "Made in Japan" products that were available in the West, what historian David Raizman has described as "cheap toys and knock-off electronic products."[80] While Japan's aggressive post-Occupation economic policies would eventually improve the design of export goods (for instance, cameras and motor scooters), Gordon was largely interested in "unWesternized" artifacts solidly rooted in Japan's folk craft tradition. These artifacts, as she called them, exemplified the "unpretentious artistry" that she espoused: traditional tea sets, bowls, plates, cups, ceramic vases, woven baskets, fabrics, scrolls, shoji, a gentleman's coat, kimonos, lacquered cases, living flower buds, and a single *koi* (see fig. 172). These objects were central to Gordon's shibui story, but the method of display (or composition) and techniques of photography were far more significant and instructive.

The displays, composed by John deKoven Hill, were just as Frances Blakemore suggested: they were "everyday" Japanese objects in full context, yet cropped in the shibui manner of an "unfinished statement."[81] Hill was an expert at this compositional technique, and for the shibui issue, he contributed a lengthy article on the "virtue" of designing the "fragmentary glimpse."[82] True to Japanese method and what Hill called the "Japanese Look," he and Gordon insisted that *House Beautiful*'s images of shibui drop the "hint which you are supposed to complete with your own imagination."[83] The portfolio was fully captioned, and the text below each image drew attention to the shibui character of each displayed object. These captions were clearly intended to instruct the readers, to guide their eyes to the shibui qualities embedded in each vignette: complementary (rather than contrasting), natural color schemes, complex yet unmatched patterns, rough textures, quality hand-craftsmanship rife with imperfections, and "mellowed" patinas. Ezra Stoller captured each composition, again as Blakemore suggested, in a moody, "Zen-like" manner. His photos were elegant and persuasive. The photos were doubly enhanced by the paper stock. The portfolio was printed on thick matte paper, using a technique Gordon preferred to capture color and texture more effectively than she could with the magazine's standard-issue thin, glossy pages. The finishing touch was in the portfolio's title: on Marion Gough's suggestion, the word "shibui" was penned in calligraphy, albeit decidedly Western.[84]

In a concluding statement, Gordon again quoted Yanagi: "But when his taste grows more refined, he will necessarily arrive at a beauty which is shibui. Many a term serves to denote the secret of beauty, but this is the final word."[85] This was a prophetic finish to the feature, and one that foreshadowed Gordon's own retirement: shibui was indeed her final word.

## Shibui Americanized

Gordon knew that the August shibui issue was pioneering: she had introduced a new aesthetic concept, a new beauty vocabulary, and perhaps even a "new look" to the Western world. But she was equally aware of the issue's shortcomings. The project was, to use the shibui term, unfinished. She admitted that, even after a full magazine dedicated to showing shibui design, "we haven't hammered out a set of specifications for how to arrive at it, nor can we be very precise about gradations between good, better, and best." The bottom line was that "we can't describe exactly what it is," but she reassured her readers that "we are for it."[86]

But what exactly was Gordon "for"? She had sensed an undercurrent in American design culture: her readers, including housewives and connoisseurs, were aging (and she along with them), their tastes were shifting, and they were no longer invested in "modernization." They were, in many respects, *post*-modern. For Gordon, this was not

SEPTEMBER 50c

# House Beautiful

## How to be shibui with American things

an architectural term (Robert Venturi and Charles Jencks were still in the distant future), but rather a temporal condition and a turn in the American design continuum. The fundamental question, the one that motivated Gordon, was: What happens next, *after* modern? And what could she do to influence this new path? She may not have described shibui precisely, but she understood its value in America in the early 1960s: "The reason I think shibui is important right now," she wrote to her staff, "is that it is synonymous with satisfying richness of the sort liked by people . . . who like traditional things."[87] With this statement, she predicted and encouraged a return to roots. Traditional Japanese design, specifically the *mingei* line (she conveniently ignored contemporary trends in Japanese architecture), was relevant in this regard. She successfully captured this in the August shibui issue; her next task was to apply the lessons to American design and American living.

She declared her ambitions with the second shibui issue, published in September 1960: she had defined shibui (loosely), and now she wanted to assimilate and Americanize shibui (fig. 173). Or, at the very least, she wanted to instruct her readers "how to be shibui with American things."[88] She introduced the issue with what even she recognized as an "old" and unresolved narrative: "At least three waves of Japanese influence have washed over America in the last hundred years. But all of them have passed."[89] This time, she implied, would be different. Her readers had the power to judge shibui, to consider its potential (in their own lives), to adopt its principles, and to adapt the aesthetic. This was no mere copying of Japanese shibui: she wanted her readers to "make [it] our own, *in our American way*."[90] Her argument was hauntingly familiar, a refrain of her American Style campaign of a decade before.

Gordon had, early in her research, predicted a potential problem with being "shibui with American things": she could teach Americans how to compose a shibui environment (aided by John deKoven Hill's superior examples), but most American products currently on the Western market were not up to the beauty standards that

she championed.[91] To make Americanized shibui a design movement with permanence, she would need to build it herself. And this is precisely what she did. Using her 1955 experiment with Wright's Taliesin Ensemble as a model, she recruited four industry partners to create a "new American taste trend."[92] Each partner participated in "collective product development and sales," but Gordon coordinated the entire project. This included, importantly, marketing and selling the Shibui Line through *House Beautiful*'s "channels of distribution."[93]

Gordon's collaborators were charged with "interpreting and instilling a rich Asian philosophy of beauty."[94] Together, they would design and produce a "pioneering" collection of shibui domestic goods specifically for the American home furnishings market (fig. 174). The products, to be sold both individually and as a set, included everything needed to make an Americanized shibui domestic interior. Baker Furniture Company, and later Ficks Reed, developed a complete line of furniture.[95] Wunda Weve Carpets designed and produced a rich array of carpets. Schumacher (presumably with help from Hill) designed draperies and upholstery. And Martin-Senour Paints developed a line of shibui paints and finishes

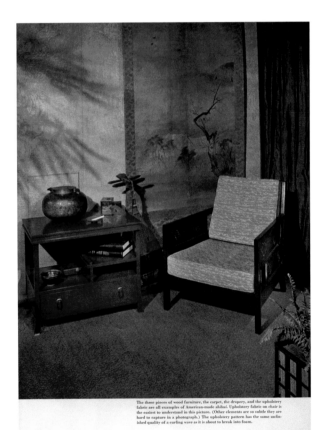

**173.** "How to Be Shibui with American Things," on the cover of *House Beautiful* (September 1960).

**174.** *House Beautiful*'s Shibui line, featuring furniture by Baker Furniture (foreground), upholstery, carpets, and draperies (far right). *House Beautiful* (September 1960).

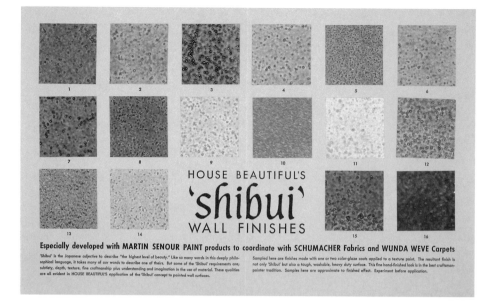

HOUSE BEAUTIFUL'S
'shibui'
WALL FINISHES

Especially developed with MARTIN SENOUR PAINT products to coordinate with SCHUMACHER Fabrics and WUNDA WEVE Carpets

'Shibui' is the Japanese adjective to describe "the highest level of beauty." Like so many words in this deeply philo-
sophical language, it takes many of our words to describe one of theirs. But some of the 'Shibui' requirements are;
subtlety, depth, texture, fine craftmanship plus understanding and imagination in the use of material. These qualities
are all evident in HOUSE BEAUTIFUL'S application of the 'Shibui' concept to painted wall surfaces.

Sampled here are finishes made with one or two color-glaze coats applied to a texture paint. The resultant finish is
not only 'Shibui' but also a tough, washable, heavy duty surface. This fine hand-finished look is in the best craftsman-
painter tradition. Samples here are approximate to finished effect. Experiment before application.

**175.** Shibui palette for Martin-Senour Paints, ca. 1960.

**176.** Advertisement for shibui fabrics by F. Schumacher and Company, *House Beautiful* (August 1960).

(fig. 175).[96] Gordon and her staff were instrumental in assuring the consistency of the line: they developed six "families of color schemes," so that rugs, fabrics, and paint would all complement each other (fig. 176).[97]

Each piece or component was "endowed" with shibui characteristics, using the same vocabulary that Gordon introduced in the August shibui issue. The line was useful and beautiful, yet understated; it featured "intrinsic good quality" in workmanship and materials and, most importantly, it embodied a modest simplicity. Gordon pushed the "timeless look" of the pieces, boasting that they were "casual-appearing and without any contrived, attention-demanding design effects."[98]

Gordon worked hard to sell the American public on the shibui idea, and on the subsequent Shibui Line. And her efforts paid off. Her fans and critics alike agreed that her shibui work was groundbreaking. Her accomplishments were confirmed by impressive magazine sales, both at home and abroad. Both the August and September issues sold out immediately. *House Beautiful*'s circulation at that time was well over 750,000—and outside of the usual run, Gordon reprinted tens of thousands of special issues. The Japanese Foreign Office in Tokyo (through the Consulate General in New York) even requested between ten thousand and one hundred thousand copies.[99]

The public response was tremendous. And unlike Gordon's 1953 media blitz, the reaction to shibui was overwhelmingly positive.[100] Though she did not publish the letters in *House Beautiful* (as she had during the "Threat to the Next America" controversy), she saved boxes of mail that had come from "fans," subscribers, colleagues, and others in the design profession.[101] Shibui had reached a broad audience, and, as Bruno Zevi attested in his letter to Gordon, her production was arguably "one of the very best issues of an architectural magazine."[102] Her success was confirmed not only by her readers' responses but by professional accolades. In 1961, the University of Chicago named her "Communicator of the Year," followed in quick succession by the "Trail Blazer" award from the National Home Fashions League.[103] As she received her award, Gordon declared she was proud of the shibui project. It gave her—and the American public—"a specific language with which to talk about, think about and create beauty."[104]

## Shibui on Display

Gordon continued to sell shibui to the American public, even outside of the magazine. To accompany the print issues, she hosted a small show of shibui objects at Bonnier's in New York.[105] In late 1961, she opened the first large-scale shibui exhibition in Philadelphia (fig. 177). *House Beautiful* was the headline sponsor, and costs were underwritten by Japan Air Lines. Over the course of three years, the exhibit traveled to venues across the United States, from Dallas to San Francisco to Newark to Honolulu. Ezra Stoller's photographs of the Dallas Museum of Fine Arts installation, shot in 1962, served as a visual guide for all of the subsequent shows.

*House Beautiful* staff, led by Gordon and John de-Koven Hill, curated and designed the installation (fig.

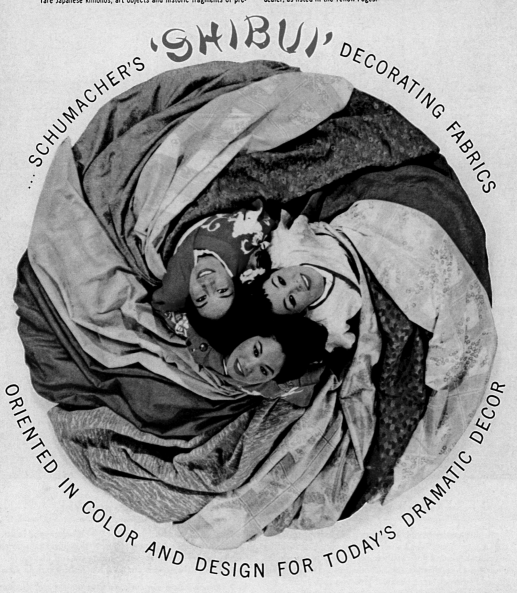

*Schumacher's* ...is proud to introduce this elegant collection of fabrics. It's most timely too, because the oriental influence is making a more-important-than-ever contribution to the decoration of today's distinctive homes. Each design is an adaptation from an authentic motif found on rare Japanese kimonos, art objects and historic fragments of precious materials. All are available through decorators and decorating departments of fine stores.

**martin senour,** famed maker of distinctive paints, has masterfully reproduced the subtle "SHIBUI" colors to provide complete harmony. "SHIBUI" paints are available from your Martin Senour dealer, as listed in the Yellow Pages.

...SCHUMACHER'S 'SHIBUI' DECORATING FABRICS

ORIENTED IN COLOR AND DESIGN FOR TODAY'S DRAMATIC DECOR

...and co-ordinated with martin senour 'SHIBUI' Paint Colors

178). Gordon's primary goal was to "reveal the nature of the most treasured portion of Japan's aesthetics," and to "show that quality of beauty most admired in Japan, yet rarely exported to other countries."[106] Most of the objects on display, ninety-seven in total, were Japanese items "for daily use" that Gordon had collected during her research trips, including kimonos, fabrics, pottery, and tatami mats (fig. 179). Most of these had already appeared in *House Beautiful*'s August 1960 shibui issue. Hill again composed a series of artful—and highly photogenic—vignettes. And, like his magazine spread, the displays were both elegant and didactic.[107]

Gordon opened each exhibition personally with a gala event and keynote lecture, paired with no fewer than fifty-six color lantern slides, many of these featuring photographs by Stoller.[108] The show and all of Gordon's gallery talks closed with rave reviews.

With her research on shibui, Gordon forged a new path forward for American design aesthetics. She did this by reintroducing (or, as she claimed, *introducing*) Japanese aesthetic principles to a broader public. She used *House Beautiful* to present shibui as an intellectual and emotional concept that transcended "superficial beauty" and "individual taste and preference."[109] This was a significant shift for Gordon, who had long been embroiled in a battle of taste; with shibui, she believed she had truly found something that would appeal to everyone, a universal design language with a soul.

Gordon's shibui project suggested two things about American design culture in the early 1960s. First, the "confusion," boredom, and "fatigue" that Sigfried Giedion would observe in 1963 had begun much earlier, and tastemakers like Gordon were among the first to respond. And second, by 1960, Gordon had significantly and permanently altered what she had described, in 1949, as the "River of Taste." Her 1949 version had only one tiny rivulet for magazines, but with pioneering cross-media projects such as shibui, she made her own tributary stream, and changed the downstream course of that river.

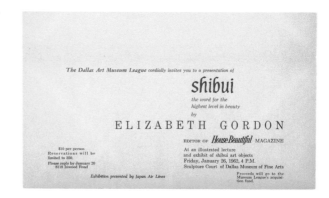

**177.** Invitation to the *House Beautiful* shibui exhibition and Elizabeth Gordon lecture at the Dallas Museum of Fine Arts, 1962.

**178 and 179.** *House Beautiful* shibui exhibition, Dallas, Texas, 1962. Copyright © Ezra Stoller/ESTO.

# Catalyst

In April 1964, Elizabeth Gordon had what she described as a "particularly fine vantage point from which to view what people want and are buying." She likened her job to "sitting on a mountain top watching weather approach, come to pass around you, then moving on out of sight. Sometimes weather veers off and never reaches you. Sometimes it simply evaporates, never culminating in anything—like fads and vogues. Taste trends are like that, taking many years from their appearance as a tiny hint on the horizon to their disappearance in history."[1] She wrote this text during her final eight months at *House Beautiful,* at a moment when she was clearly reflecting on all the "weather" she had watched come and go over twenty-three years. And in 1964, the weather was certainly shifting.

By the mid-1960s, design was increasingly defined, or rather undefined, by its ambiguity. What *was* modern, and what would come *after* modern? What themes would dominate the discourse for the home-owning public, for their architects, and for their editors? What would be the new taste trend? Just as the future had been uncertain during the war years, the view of the new *post*-postwar decade was obscured.

Gordon had her own set of questions and doubts. Shibui was, in a sense, her final word and final direction, significant in part because it was her last large-scale editorial project. But in her last four years as editor of *House Beautiful,* she had still forecasted trends and shaped important

themes in American domestic design. She experimented with multiple interests, most notably a series on Japanese cuisine written with her former shibui assistant and new *House Beautiful* writer, Eiko Yuasa (fig. 180).[2] Gordon also tested, for the first time, the serialization of essays. Between 1962 and 1963, she printed excerpts from Alfred Browning Parker's forthcoming book, *You and Architecture: A Practical Guide to the Best in Building;* these essays essentially stood in for her own editorials.[3]

But mostly, Gordon returned to familiar themes: improving one's taste, architectural space, climate control (with a new critique about current environmental threats), regionalism, individualism, and, in June 1964, "more house for your money."[4] In that same year, she launched a five-part series that recalled 1945's "People Who Influence Your Life," under the new title "Creators Who Influence Your Life." The list of creators included textile designer Boris Kroll (November 1964), with Gordon's own article introducing his work for the forthcoming 1965 Pace Setter (fig. 181). This was the last thing she wrote as editor of *House Beautiful.*[5]

In 1964, Gordon was hard at work preparing for this last Pace Setter House; she did so for the first time in a decade without John deKoven Hill, who had left the magazine in late 1963 to return to Taliesin. But she worked alongside a trusted partner: Alfred Browning Parker. This was his fourth Pace Setter (among the many other houses he had published with Gordon). Parker's 1965

Pace Setter, however, marked a transition for both the Pace Setter program and Gordon's editorship. Whether she intended it as a coda or not, the house was the perfect finale (fig. 182).

Parker's house, designed for his still-growing family, spoke of his own spectacular rise. And Gordon, with photographer Ezra Stoller's help, had published most of the important moments of this rise: from his first modest home in 1946 to the organic statement house that doubled as the 1954 Pace Setter to the Next American House (the 1959 Pace Setter) to the final Pace Setter, a stunning masterpiece in Coral Gables, Florida. The last house was a lavish and mature work of architecture, and it mirrored Gordon's own developed sensibilities. Parker remained attentive to all of *House Beautiful*'s values: integrated design, building performance, climatic responsiveness, good siting, and natural (native) materials (fig. 183). He still tapped the deep roots of what Gordon would have called the "American" tradition, but he, too, had moved far beyond the Wrightian precedents that dominated his early years. Yet there was no sense of testing new boundaries here—merely a final review, a statement of promise fulfilled (fig. 184). Parker, it seemed, had grown up, and *House Beautiful* along with him.

Gordon retired in December 1964, and her departure was announced in January 1965 (fig. 185). Her successor, Sarah Tomerlin Lee, marked the occasion with a "salute." Lee reviewed Gordon's career (as best one can in approximately two hundred words), highlighting her "ranging interests" and "zealous researcher's fascination."[6] Her tribute confirmed that Gordon was respected, if not feared. This had been established by Eleanor Page of the *Chicago Sunday Tribune,* who in 1960 penned the best description of Gordon in print anywhere: "Despite her awesome reputation as a boss with whom no employee dares differ, as an editor so powerful that those in home-making industries are said to quake lest they not live up to the Gordon standard in goods and services, and as a competitor so fierce that others say she's 'driving a couple of other home magazines into the ground,' Miss Gordon has womanly strength in her calm assurance that she knows where she's going." Gordon replied with: "I'm not the dragon that you say people make me out to be. I'm direct. Is that bad?"[7] Dragon or not, her colleagues knew that she had orchestrated a multi-decade, multi-media extravaganza in a way that most could not have managed. Even Richard Deems, the president of Hearst,

acknowledged that she had "educated literally millions, for the influence of *House Beautiful* goes so far beyond its one million circulation."[8]

Deems's statement points to the difficulty in "saluting" Gordon: influence is difficult to measure. And Gordon's case is more challenging than most. She earned accolades from her colleagues, and she was recognized with professional awards, including an Honorary AIA Membership, the Trail Blazer Award, and the Communicator of the Year Award; most of these (aside from the AIA award) paled in comparison to her knighthood, bestowed

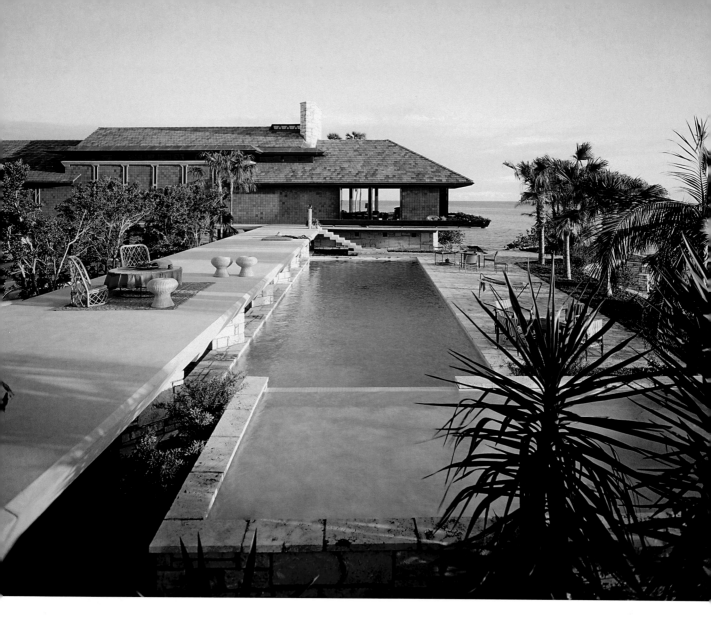

**180.** Shibui with food, *House Beautiful* (July 1962). Photo by Ezra Stoller.

**181.** Boris Kroll textiles for the 1965 Pace Setter (pictured center). *House Beautiful* (May 1965).

**182.** Alfred Browning Parker, 1965 Pace Setter, Coral Gables, Florida, 1964. Copyright © Ezra Stoller/ESTO.

**183.** Parker, 1965 Pace Setter. Night view of the arrival court with a view to the house and Biscayne Bay beyond. Copyright © Ezra Stoller/ESTO.

by the Finnish government for her reporting on Scandinavian design.[9] But other customary modes of tracking career significance remain problematic. Because she was an editor, and the convention in her field was to write anonymously, her work often went without reference. Because *House Beautiful* was a shelter magazine rather than a professional journal, it was rarely cited by architects or historians, though Gordon published substantial architectural content on par with, for example, *Architectural Forum*.

A few things in Gordon's long career are, however, quantifiable. Under her editorship, the circulation of *House Beautiful* grew from 226,304 in 1940 to just under one million in 1964.[10] Her competitors, particularly *House & Garden,* kept a close watch on her methods—acknowledging that she set the industry standard for content, layout, and illustration. The Climate Control Project, in partnership with the AIA, reached tens of thousands of

professionals nationwide. With this project, she became an early proponent of what we might now call sustainable design. Her Frank Lloyd Wright tribute issues (1955 and 1959) sold out immediately, and, as auction markets demonstrate, are still prized by collectors. The Taliesin Ensemble, while not entirely successful, did generate Schumacher's Frank Lloyd Wright line, still available today. The two shibui issues, from August and September 1960, sold in record numbers; because of the overwhelmingly positive (and international) response, these were reissued by Hearst as bound collector's volumes.[11] The follow-on shibui exhibitions were equally successful and

**184.** Parker, 1965 Pace Setter. Master bedroom with a platform bed and a view to Biscayne Bay. Copyright © Ezra Stoller/ ESTO.

**185.** "Elizabeth Gordon," retirement dedication by Sarah Tomerlin Lee, *House Beautiful* (January 1965).

# Elizabeth Gordon

has pushed her chair away from this editorial
desk after two hundred and seventy-six issues.
We could not begin this, our first, without
a salute to her—as clairvoyant, catalyst,
pace setter, teacher, enthusiast, editor
extraordinaire. Her ranging interests presented
Scandinavian design to America, heralded
climate control, launched a historic handcraft
program, continuously singled out coming
architectural talent, triggered for Frank Lloyd
Wright a second wave of homage, and brought
the strange beauty and subtlety of *shibui*
before our eyes. She has thrown a bridge of
understanding across from private citizen
to architect. Her concern for houses has always
been a zealous researcher's fascination—
probing their plan, construction, site, cost,
safety, workability, comfort, and material.
Elizabeth Gordon, as president of her own firm,
will continue advising the industries she
has served so brilliantly; as Editor Emeritus of
House Beautiful, she will write volumes
on those subjects on which she is the undoubted
authority. With her publisher and editors,
we wish her joy and the deepest satisfaction.
For this marvelous heritage
and for her greatness—we salute her.

**House Beautiful** JANUARY • 1965

*Sarah Tomerlin Lee*

traveled nationwide to reach an even broader audience. Gordon recognized the importance of shibui and, in 1988, donated her research collection to the Freer Gallery of Art and Arthur M. Sackler Gallery Archives at the Smithsonian; among her papers were nearly one hundred reader letters commending her for the shibui project.[12]

The Pace Setter program also generates a compelling data set: *House Beautiful* and the Pace Setter architects (and, in some cases, the Pace Setter homeowners) received hundreds, if not thousands, of reader letters as proof of its appeal. Gordon's readers wanted to buy the floor plans, shop for the furnishings, or hire the architect for their own custom job. Cliff May, for example, built at least eight derivatives of his inaugural model. Alfred Browning Parker likewise designed "mini" Pace Setters. Both of these men stated, in no uncertain terms, that Gordon launched their careers. But more importantly, *House Beautiful* readers confirmed what Gordon intended: she taught them to see the "good" design qualities in these featured Pace Setter Houses, and they in turn demanded "better" from their own architects.

This list of accomplishments is but a small start, one that measures an outcome. But the list misses the essence of Gordon's contribution. Her editorial process, and her vantage point, was in many ways far more important. This, more so than raw data, helps us understand what American design was, how it evolved, and who shaped it. But most importantly, it helps us understand what consumers who bought American design knew, what they wanted, what they liked, and how they were persuaded to like it. As Curtis Besinger later wrote, Gordon's biggest contribution was her editorial voice: she had "prescience," "courage," and "daring" where others did not.[13] As he suggested, Gordon was a crusader far ahead of her time.

The larger implications of Gordon's pursuit—what became her quest for good taste and good design—borrows a question often posed by historians and critics, and suggested in the writings of Gordon's former staffer James Marston Fitch: "What is American about American design?"[14] Gordon's bold and broad publishing, unhampered by architectural pretensions, provides a glimpse of the social concerns, cultural values, and aesthetic characteristics that informed this very question.

Through the lens of *House Beautiful,* as focused by Elizabeth Gordon, the forces that shaped postwar design—and American public opinion about design—become remarkably clear. She used a popular magazine and popular houses to educate, elevate, and disseminate these significant and sometimes revolutionary ideas. She was not just an average editor at an average magazine. Gordon was, as her successor Sarah Tomerlin Lee declared upon her retirement, a "pace setter" and a "catalyst."[15]

# Epilogue

It was a Monday afternoon, 22 June 1987, in a ballroom at the Convention Center in Orlando, Florida. Elizabeth Gordon was elegantly dressed in a black and silver pants ensemble, crafted from Japanese kimono fabric; her graying hair was pulled back in her trademark knot—the only thing missing was her classic 1950s Robert Dudley hat. She was among friends: architects whom she had collected long ago under *House Beautiful,* from Alfred Browning Parker to Vladimir Ossipoff, Aaron Green, and Robert Bell, and a few of the magazine staff with whom she had worked, including—to her great delight—John deKoven Hill, Guy Henle, and her former secretary, Irene Hoehl. Gordon sat proud and tall, "bubbling" even at age eighty. She was waiting for a long-delayed recognition: an honorary membership in the American Institute of Architects. This, as her husband, Carl, later reported, was one of the "high points of her career."[1]

Her membership was not without controversy. This was, in fact, the fourth time she had been nominated. In February 1964, just months before her departure from *House Beautiful,* Alfred Browning Parker and Miles Colean had nominated her for an honorary membership. The application was rejected, on the grounds that it was "late." Parker applied on Gordon's behalf two more times, in June 1964 and February 1965.[2] Both applications were rejected. In 1986, for Gordon's eightieth birthday, Parker and Curtis Besinger again submitted her name for consideration.[3] This bid, coming nearly two decades after her retirement, was successful.

In 1986, the AIA nominating committee received scores of letters endorsing Gordon. Her supporters commended her "unwavering dedication to aesthetic quality" and her "indefatigable pursuit of good domestic architecture [that] helped shape America's taste."[4] They reminded the AIA of Gordon's many contributions to the field of architecture, including the Pace Setter program, the Climate Control Project, the Wright tribute issues (1955 and 1959), and shibui.

Still, Gordon worried that she would again be denied: her relationship with the architectural profession had been divided since the 1950s. She had her supporters—the many designers whom she championed and published, and the many whose careers she had "made." But she had her enemies. Though she had been the darling of the profession until 1953 (with her 1949 Climate Control partnership with the AIA as evidence), many architects never forgave "The Threat to the Next America," her 1953 tirade against Mies, Gropius, Le Corbusier, and the International Style. And this conflict followed her into her retirement.

Charles H. Kahn, a professor of architecture at the University of Kansas, best summed up Gordon's controversial career in a letter to his colleagues:

> I believe it is time to put behind us the pique we felt in the '50's at some of Ms. Gordon's more controversial statements and recognize her for some of the very real contributions she made to the profession. . . . The issue which has seemed to stand in the way of Ms.

Gordon's full acceptance by the architectural fraternity is her April 1953 article in *House Beautiful* attacking the International Style ["The Threat to the Next America"]. It is now 35 years since that famous, and admittedly for the time, somewhat intemperate attack on the anointed standard bearer of modern architecture. What is for me most interesting is to reread that article in the light of the present polemic in our profession which identifies the same failings in so-called modern architecture that she articulated.[5]

Kahn recognized that "the strength of her remarks in 1953 were in response to her perception of an established position in the contemporary press which brooked scant tolerance for those who did not toe the commonly-accepted line." He believed that it was the "strong language in her 1953 article" rather than the substance of her criticism that had caused the polarizing public debate.[6]

His letter paralleled other recommendations: among her backers were Henry Eggers, Aaron Green, Harwell Hamilton Harris, John Lautner, Ezra Stoller, Edgar Tafel, Vladimir Ossipoff, and Bruno Zevi. Together, they convinced the committee that Gordon's achievements were indeed substantial—and that under her leadership, *House Beautiful* "became a serious architectural influence."[7] Kahn did admit that, as a professional body, the AIA (and presumably many practicing architects) "might not have totally agreed with her and might have sneered condescendingly at *House Beautiful* as a legitimate organ of architectural comment and criticism," but they could not deny that the viewpoint "for which she was excoriated by the then avant garde elite in the profession has come to be the accepted base on which our currently widely-published main stream is founded." Kahn pressed his fellow AIA members to accept Gordon's application, saying, "Surely, it is time to accept Ms. Gordon into the fold, to rescue her from that beyond-the-pale exile to which she has been condemned."[8]

# Abbreviations

The following abbreviations appear in the notes.

## Published Materials

| | |
|---|---|
| *A&A* | *Arts & Architecture* |
| *AF* | *Architectural Forum* |
| *AH* | *American Home* |
| *AR* | *Architectural Record* |
| *BHG* | *Better Homes and Gardens* |
| *HB* | *House Beautiful* |
| *HG* | *House & Garden* |
| *LAT* | *Los Angeles Times* |
| *LHJ* | *Ladies' Home Journal* |
| *NYT* | *New York Times* |

## Archives

ABParker Papers: Alfred Browning Parker Papers, Special and Area Studies Collections, George A. Smathers Libraries, University of Florida, Gainesville, Florida.

AIA Archives: American Institute of Architects, Library and Archives, Washington, D.C., vertical files.

Besinger Collection: Curtis Besinger Collection, Kansas Collection, RH MS 335, Kenneth Spencer Research Library, University of Kansas Libraries.

Church Papers: Thomas D. Church Papers, Environmental Design Archives, University of California, Berkeley.

FLWF: The Frank Lloyd Wright Foundation Archives, the Museum of Modern Art/Avery Architectural and Fine Arts Library, Columbia University, New York.

FSA: Elizabeth Gordon Papers, 1958–87, Freer Gallery of Art and Arthur M. Sackler Gallery Archives, Smithsonian Institution, Washington, D.C.

GA: Solomon R. Guggenheim Museum Archives, New York.

Henning Collection: Personal collection of Randolph C. Henning, Lewisville, North Carolina.

HHH Papers: Harwell Hamilton Harris Papers, the Alexander Architectural Archive, the General Libraries, the University of Texas at Austin.

Hill Papers: John deKoven Hill Papers, the Frank Lloyd Wright Foundation Archives, the Museum of Modern Art/Avery Architectural and Fine Arts Library, Columbia University, New York.

May Collection: Cliff May Collection, Architecture and Design Collection, Art, Design and Architecture Museum, University of California, Santa Barbara.

MLP Collection: Maynard L. Parker Collection, The Huntington Library, San Marino, California.

# Notes

## Preface

**1.** Elizabeth Gordon continually asked her readers "why . . . you like what you like" and questioned "the motivating factors that cause you to buy one thing and not another"; see, for example, "How to Recognize a Style Trend," *HB* (January 1951): 47.
**2.** The Editors [Elizabeth Gordon], "On Reaching Fifty," *HB* (December 1946): 149.
**3.** George Nelson in "What Is Happening to Modern Architecture?" (summary text from a symposium at the Museum of Modern Art, New York, 11 February 1948), *Museum of Modern Art Bulletin* 15, no. 3 (Spring 1948): 12–13.
**4.** For a discussion of "What *is* design history and what *should* it be?" see Grace Lees-Maffei, "General Introduction," in *The Design History Reader,* ed. Grace Lees-Maffei and Rebecca Houze (Oxford: Berg, 2010), 1–5.
**5.** Kathleen Corbett, "Tilting Modern: Elizabeth Gordon's 'The Threat to the Next America'" (PhD diss., University of California, Berkeley, 2010); Jennifer A. Watts, ed., *Maynard L. Parker: Modern Photography and the American Dream* (New Haven, Conn.: Yale University Press, 2012). Watts's volume includes contributions

by Edward R. Bosley, Daniel P. Gregory, Christopher Hawthorne, Elaine Tyler May, Monica Penick, Charles Phoenix, D. J. Waldie, and Sam Watters.
**6.** Russell Lynes, *The Taste-makers* (1949; repr., New York: Dover, 1980), 5.
**7.** For a recent categorization of architecture and design critics, including a description of "activist" critics who advocated, often preemptively, for reform (including, for example, Jane Jacobs and Allan Temko), see Alexandra Lange, *Writing about Architecture: Mastering the Language of Buildings and Cities* (New York: Princeton Architectural Press, 2012). For the origin of the term "activist critic," in relation to Allan Temko, see Blair Kamin, "Battling for Better Architecture: The Argument for Activist Criticism," *AR* (December 2006): 25.
**8.** Elizabeth Gordon, "What Is Quality?" draft chap. in *What Constitutes Good Taste: A Noted Editor's Lifetime Observations* (unpublished manuscript, ca. 1988), 1–2. Besinger Collection.
**9.** Marion Gough, "The One Thing You Can't Change Is Change," *HB* (February 1949): 52.
**10.** Robert C. Twombly, *Frank Lloyd Wright: His Life and His Architecture* (New York: Wiley, 1979), 319.

**11.** Bruno Zevi, "Introduction," in *Harwell Hamilton Harris,* by Lisa Germany (Austin: University of Texas Press, 1991), xiii.

## Prologue

**1.** Elizabeth Gordon, "The Responsibility of an Editor" (speech to the Press Club Luncheon of the American Furniture Mart, Chicago, 22 June 1953). Church Papers. Gordon revised and published this speech as "Does Design Have Social Significance?" *HB* (October 1953): 230, 313–15, 318.
**2.** Gordon, "Responsibility," 7.
**3.** Elizabeth Gordon, "The Threat to the Next America," *HB* (April 1953): 126, 129, 127, 250. For Gordon's specific use of the terms "totalitarian" and "democratic" to characterize bad and good modern architecture (terms that she implied in "Threat"), see Gordon, "Responsibility," 14, 10; and Gordon, "Does Design Have Social Significance?" 313–14.
**4.** Gordon, "Responsibility," 8; Gordon, "Does Design Have Social Significance?" 230.
**5.** Marilyn Bender, "*House Beautiful* Appoints New Editor," *NYT* (4 August 1964).
**6.** Gordon, "Responsibility," 30, 9, 10, 2, 27.
**7.** Ibid., 1, 14, 6.

## Chapter 1. Beginnings

**1.** Elizabeth Gordon, *What Constitutes Good Taste? A Noted Editor's Lifetime Observations* (unpublished manuscript, ca. 1988); Elizabeth Gordon, *How Did I Get to Be Me? On Becoming an Editor* (unpublished manuscript). Both in the Besinger Collection.
**2.** Marion Gough to Elizabeth Gordon, 8 August 1971, in "Collection of Letters for 65th Birthday," gathered by Carl Norcross. Author's collection.
**3.** "Cass County, Indiana, WPA Birth Record Index for 1882–1920," Book CH-2:18, "Gordon, Elizabeth," http://incass-inmiami.org. For a history of Logansport and its railroads, see Cass County Historical Society, "Railroad History," http://www.casshistory.com/railroad.html.
**4.** Elizabeth Gordon to Indira Berndtson, 17 September 1996, 3. Hill Papers. For Gordon's family history, see Indiana Census 1900, 1910, and 1930. Cass County Vital Records indicate that Gordon may have been the family's second child, preceded by a brother who lived only six months (and was deceased by 1905); see "Byron Gordon," in "Cass County, Indiana, WPA

Death Records," http://incass-inmiami.org/cass/vitals/death/gia-gou.html.

**5.** The Gordon family lived at 1530 Broadway, Logansport, Indiana. Sanborn Fire Insurance Maps indicate a construction date between 1890 and 1898 for the house. Moses and Emma Gordon owned the house by 1900; their son Byron owned the house by 1910. For neighbors and their occupations, see Indiana Census 1900, 1910, and 1930.

**6.** Gordon to Berndtson, 17 September 1996, 4.

**7.** For Gordon's education, see "Profile for AIA Nomination," Besinger Collection; Elizabeth Gordon, "Resumé of Elizabeth Gordon," FSA; and Gordon to Berndtson, 17 September 1996. For dancing, see, for example, the public notice published in the *Spokesman-Review* (Spokane, Washington) (12 September 1895): 3.

**8.** For Gordon's account, see Gordon to Berndtson, 17 September 1996, 3.

**9.** For an official history of the university, see University of Chicago News, "A Brief History of the University of Chicago," http://www-news.uchicago.edu/resources/brief-history.html. For the University of Chicago, Progressivism, the American university movement, and women's access to higher education, see Frederick Rudolph, *The American College and University: A History* (1962; repr., Athens: University of Georgia Press, 1990), 349–54 (quotes from 349, 351).

**10.** For Gordon's activities, see the University of Chicago yearbook, *Cap and Gown* (1927), 61.

**11.** Gordon, "Resumé," 1.

**12.** Elizabeth Gordon, *Why Have I Lived to Age 90 and Been So Healthy?* (unpublished autobiography, March 1996), 1. Hill Papers.

**13.** The *Digest of Educational Statistics*, in 1973, reported that in 1920, 48,622 bachelor's degrees were conferred, 16,642 of these to women (in a total population of 105.7 million Americans); in 1930, the number of bachelor's degrees increased to 122,485, with 49,969 of these earned by women (in a total population of 122.8 million). W.

Vance Grand and C. George Lind, *Digest of Educational Statistics*, 1973 ed. (Washington, D.C.: Department of Health, Education and Welfare/U.S. GPO, 1974), 84. For women and college, see Barbara Sicherman, "College and Careers: Historical Perspectives on the Lives and Work Patterns of Women College Graduates," in *Women and Higher Education: Essays from the Mount Holyoke College Sesquicentennial Symposia*, ed. John Mack Faragher and Florence Howe (New York: Norton, 1988), 134–35; and Rosalind Rosenberg, "The Limits of Access: The History of Coeducation in America," in ibid., 127. Statistics were reported in "Working Women in the 1930s," in *American Decades*, ed. Judith S. Baughman et al., vol. 4, *1930–39* (Detroit: Gale, 2001) (see Gale: U.S. History in Context, "Working Women in the 1930s," http://ic.galegroup.com).

**14.** For Gordon's teaching, see Gordon, "Resumé"; and Gordon, *Why Have I Lived*.

**15.** Gordon could have been referring to Ferber's novel *Dawn O'Hara* (1911), the story of a newspaperwoman in Milwaukee. For a reference to Ferber and the "learning route," see Gordon, *Why Have I Lived*, 2.

**16.** Gordon and Carl Hafey Norcross were married on 24 December 1928, and were still married at his death in 1988; a brief note in the *Chicago Tribune* hints that they might have divorced around 1960, but by 1964, they were reunited. See Sarah Booth Conroy, "The Old Battlers for Design, Retired to Their Country Keep," *Washington Post* (6 January 1974); for mention of a divorce, see Eleanor Page, "To Succeed, Must We Be Tough?" *Chicago Sunday Tribune*: pt. 7, 6. For more on Norcross, see "Carl Norcross Obituary," 1988. Besinger Collection.

**17.** For Gordon's descriptions of her early career, see Gordon, "Resumé"; Gordon to Berndtson, 17 September 1996; and Gordon, *Why Have I Lived*. For "making a living," see Diana J. Sims, "Beyond *House Beautiful*," unknown newspaper [Hagerstown, Maryland]

(3 September 1987). Besinger Collection.

**18.** Gordon, "Resumé," 1. For Gordon's employment at the Blaker Agency, see H. Humphrey to Condé Nast, 21 October 1941, box 17, folder 22, Condé Nast Archives, New York. I thank Jennifer Watts for alerting me to this correspondence.

**19.** For "education," see Christine McGaffey Frederick, *Selling Mrs. Consumer* (New York: Business Bourse, 1929), 339.

**20.** For a summary of Bernays and his contributions to American marketing, see Miguel Conner, "The Father of Market Research," American Marketing Association, https://www.ama.org/resources/Best-Practices/Pages/Father-of-Research.aspx; and Larry Tye, *The Father of Spin: Edward L. Bernays and the Birth of Public Relations* (New York: Crown, 1998).

**21.** While Gordon's name did not appear regularly on the *Good Housekeeping* masthead, her resumé asserts that she served on the magazine's editorial staff for eight years; she may have taken the job in about 1932 (while working freelance for other publications or ad agencies). Gordon, "Resumé," 1; "Elizabeth Gordon," in *Who's Who in America* (Chicago: Marquis, 1963).

**22.** Gordon does not mention the "fired" woman by name, but the director between 1936 and 1941 was Helen Koues; Dorothy Draper succeeded Koues (see masthead, *Good Housekeeping*). For the chronology and claims, see Gordon, *Why Have I Lived*, 3.

**23.** Gordon, *On Becoming an Editor*, 1–5.

**24.** Elizabeth Gordon and Dorothy Ducas, *More House for Your Money* (New York: Morrow, 1937), x.

**25.** Ibid., xii–xiii.

**26.** Ibid., ix.

## Chapter 2.
## Good Taste and Better Living

**1.** "Will Edit *House Beautiful*," *NYT* (17 October 1941): 18.

**2.** For a brief history of *HB*, see Frank L. Mott, *A History of American Magazines*, vol. 5,

*1905–30* (Cambridge, Mass.: Harvard University Press, 1968), 154–65.

**3.** For "spreading the gospel" and the crusading spirit of the magazine's first editors, see "What Inspired *House Beautiful*?" *HB* (December 1946): 151; for "reforming," see "How We Did It in the Old Days," *HB* (December 1946): 248.

**4.** "What Inspired," 151; for "American Authority," see *HB* (December 1900): 1.

**5.** "How We Did It," 153, 243. For the magazine's first slogan, see *HB* (December 1896). For the title, see Robert Louis Stevenson, "The House Beautiful," in *Underwoods* (London: Chatto and Windus, 1887), 9–11. An illustrated version appeared in *HB* in 1903. For the sermon, see William Channing Gannett, *The House Beautiful . . . in a Setting Designed by Frank Lloyd Wright and Printed by Hand by William Herman Winslow and Frank Lloyd Wright* (River Forest, Ill.: Auvergne, 1896–97).

**6.** Gannett, *House Beautiful,* n.p.

**7.** Elsie de Wolfe, "Suitability, Simplicity and Proportion," chap. 2 in *The House in Good Taste* (New York: Century, 1913).

**8.** For audience and market "vacancy," see *HB* (December 1896): 26; and "How We Did It," 250.

**9.** For average income data after 1929, see *Historical Statistics of the United States, Colonial Times to 1970* (Washington, D.C.: U.S. Department of Commerce and Bureau of the Census, 1975).

**10.** "Prize Competition," *HB* (August 1898): 74–79. For the national average per unit for home construction, see "New Housing Units Started, by Ownership, Type of Structure, Location, and Construction Cost: 1889–1970," ser. N 156–69, in *Historical Statistics*.

**11.** "The Poor Taste of the Rich: A Series of Articles Which Show That Wealth Is Not Essential to the Decoration of Houses," *HB* (1904–5).

**12.** "How We Did It," 245, 153.

**13.** Virginia Huntington Robie was a writer, editor, and artist (educated at the School of Decorative Design and Applied Ornament at the Art Institute of

Chicago); she was not related to Frank Lloyd Wright's client Frederick C. Robie.

14. "The International Exhibition," *HB* (April 1913): 147.

15. Mott, *History of American Magazines,* 162.

16. Kenneth K. Stowell, *Modernizing Buildings for Profit* (New York: Prentice Hall, 1935).

17. For a summary of this competition, and Stowell's role in it, see Gabrielle Esperdy, *Modernizing Main Street: Architecture and Consumer Culture in the New Deal* (Chicago: University of Chicago Press, 2008).

18. *Magazine and Circulation Analysis, 1937–1948* (New York: Association of National Advertisers, 1949); *Magazine and Circulation Analysis, 1940–1957* (New York: Association of National Advertisers, 1958); *Magazine Circulation and Rate Trends, 1946–1976* (New York: Association of National Advertisers, 1978).

19. The Editors, "On Reaching Fifty," *HB* (December 1946): 149.

20. "*House Beautiful* Presents a Basic New Decorating and Architectural Trend: Twentieth Century Colonial," *HB* (January 1942): 17. For Gordon's first editorial coverage of the "Small Homes" competition, see "Three Winners: *House Beautiful*'s 1941 Competition," *HB* (January 1942): 20–25, 81, 84.

21. The Editors, "Our Time Is Now," *HB* (April 1942): 17; for "time and taste," see the Editors, "On Reaching Fifty," 149.

22. U.S. Office of Price Administration, "Application for Certificate to Rent Class B Typewriters," form OPA-R-401, rev. 12-28-42.

23. For a comprehensive account of Gordon's and Maynard Parker's partnership, see Jennifer A. Watts, ed., *Maynard L. Parker: Modern Photography and the American Dream* (New Haven, Conn.: Yale University Press, 2012). For Gordon's rations, see her application to the Office of Price Administration for supplemental gasoline rations made on behalf of Parker, for a photo shoot in Chicago (for which he came east by train and hired a car). Elizabeth Gordon to Maynard L. Parker, 3 June 1943. MLP Collection.

24. For more on the Magazine Bureau, see Mary Ellen Zimmerman, *A History of Popular Women's Magazines in the United States, 1792–1995* (Westport, Conn.: Greenwood, 1998), 193.

25. Maureen Honey, *Creating Rosie the Riveter: Class, Gender, and Propaganda during World War II* (Amherst: University of Massachusetts Press, 1984; Google Play e-book), 11, 19, 16. For the discussion of "helpful," see ibid., 22–24.

26. For magazine topics, see *Readers' Guide to Periodical Literature* (Minneapolis: H. W. Wilson), annual volumes from 1939 to 1946. Because not all publications reported their titles to the guide, the list is certainly limited. For an early discussion of the difference between "victory" and "postwar" versions of consumer goods and houses, and the improvements anticipated for "postwar" versions, see Elizabeth Gordon, "Chart Your Future with *House Beautiful*'s Bond Bank," *HB* (January 1943): 39.

27. Gordon, "Chart Your Future," 39.

28. "Three Dead Americans," *Life* (20 September 1943): 34–35.

29. Elizabeth Gordon to Maynard L. Parker, telegram, 26 March 1943. MLP Collection.

30. Ibid.

31. For more on the War Advertising Council and its "propaganda" campaign, see Honey, *Creating Rosie the Riveter,* 13–18.

32. For a general discussion of the War Advertising Council, see Inger L. Stole, "The Initial Year of the Advertising Council," chap. 3 in *Advertising at War: Business, Consumers, and Government in the 1940s* (Urbana: University of Illinois Press, 2012), 56–70. "Powerful tool of democracy" from War Advertising Council, "A Plan for Business to Use One of Its Principal Tools to Help Win the War," n.d., National Archives, Records of the Office of War Information (OWI), Record Group 208, and quoted in Stole, *Advertising at War,* 63.

33. Stole, *Advertising at War,* 61.

34. Gordon, "Chart Your Future," 39.

35. Ibid; the Editors, "On Reaching Fifty," 149.

36. Advertisement, "House Beautiful . . . but Practical," *HB* (February 1942): 60.

37. Ibid.

38. Ibid.

39. Gordon made this statement many times over two decades; see, for example, Eleanor Page, "To Succeed, Must We Be Tough?" *Chicago Sunday Tribune* (14 February 1960): pt. 7, 5.

40. "Meet a Decorator-Designer Who Doesn't Believe in Period [Gilbert Mason]," *HB* (February 1942): 16; "Meet a Decorator Who Doesn't Believe in Rules [Tom Douglas]," *HB* (March 1942): 26.

41. Introduction, "People Who Influence Your Life" series, *HB* (March 1945): 73.

42. "Meet Edward Wormley," *HB* (March 1945): 75.

43. "Meet Frank Lloyd Wright," *HB* (June 1946): 163.

44. "Meet Edward Wormley," 75.

45. Introduction, "People Who Influence Your Life," 73.

46. For Gordon's endorsement of Robsjohn-Gibbings, and her characterization (which matched the designer's own) of his work as "American," see, for example, "Meet Robsjohn-Gibbings," *HB* (April 1946): 108–9. For a recent scholarly assessment of his "American modernism," see Daniella Ohad Smith, "T. H. Robsjohn-Gibbings: Crafting a Modern Home for Postwar America," *Journal of Interior Design* 34, no. 1 (2008): 39–55.

47. See, for example, Gordon, "What People Say They Want," *HB* (July 1944): 21; "What the GI Wants in His Postwar House," *HB* (August 1944): 31; and "*House Beautiful* Announces a Series of Research Contests to Determine How America *Wants* to Live," *HB* (June 1945): 50.

48. "*House Beautiful* Announces," 50.

49. Sarah E. Igo, *The Averaged American: Surveys, Citizens, and the Making of a Mass Public* (Cambridge, Mass.: Harvard University Press, 2007; Kindle edition), 154.

50. Gordon, "What People Say They Want," 21; "What the GI Wants," 31.

51. Surveys were summarized in *A Survey of Housing Research in the United States* (Washington, D.C.: Housing and Home Finance Agency, 1952); and Edward T. Paxton, *What People Want When They Buy a House: A Guide for Architects and Builders* (Washington, D.C.: U.S. Department of Commerce, 1955).

52. "What the GI Wants," 31; "The Veterans of World War II Say They Will Want . . . ," *HB* (August 1944): 33.

53. Elizabeth Gordon, "What Do You Want in a Dining Room . . . and Why?" *HB* (June 1945): 51.

54. "*HB* Announces," 50; Gordon, "What Do You Want?" 51; for the questionnaire form and contest eligibility, see "How to Win the Furniture and Fabrics in This Room," *HB* (June 1945): 55.

55. "How to Win the Furniture and Fabrics in This Room," *HB* (February 1946): 67.

56. "Easy to Make—Hard to Break: Resolutions for Better Living in 1942," *HB* (January 1942): 63.

57. Janet Hutchinson, "The Cure for Domestic Neglect: Better Homes in America, 1922–1935," *Perspectives in Vernacular Architecture* 2 (1986): 168–78 (quote from 169).

58. For "needs," see "Better Homes in America," *NYT* (6 November 1934): 24. For other press coverage, see, for example, "America's Little House," *AF* (February 1935): 173–76; and Helen Sprackling, "Homekeeping in America's Little House," *Parents* (February 1935): 28, 36, 83.

59. Andrew M. Shanken, "Better Living: Toward a Cultural History of a Business Slogan," *Enterprise & Society* 7, no. 3 (September 2006): 485–519.

60. Ibid., 486, 487.

61. For Dorothy Ducas and the first "Better Tomorrows" installment, see "What Do You Want Most in All the World?" *HB* (September 1944): 54–55, 90–93.

62. Elizabeth Gordon, "If You Better Your Home You'll Better Your Living," *HB* (January 1946): 41.

63. For a history of the *Good Housekeeping* seal and its accompanying guarantee,

see "The History of the *Good Housekeeping* Seal," Good Housekeeping, http://www .goodhousekeeping.com /institute/about-the-institute /a16509/good-housekeeping -seal-history/.

## Chapter 3.
## The Postwar House

1. "*House Beautiful*'s Creed for Americans in 1943," *HB* (January 1943): 63.
2. Between 1929 and 1933, annual housing starts fell by 81 percent (and, by 1933, starts were down 90 percent from the prewar peak in 1925). *Housing Construction Statistics: 1889–1964* (Washington, D.C.: U.S. Department of Commerce Bureau of the Census, USGPO, 1966), 18.
3. Franklin D. Roosevelt, "Fireside Chat" (29 December 1940).
4. Following the Lanham Act of 1940, Congress approved $440 million for the construction of one million units of war housing; Joseph Mason, *History of Housing in the U.S., 1930–1980* (Houston: Gulf, 1982), 34–36.
5. Miles Colean, "Housing a Nation at War," from *Banking,* collated in *The Impact of the War on Housing* (New York: American Bankers Association, 1942), n.p.
6. Ginny McPartland, "Henry J. Kaiser's Assembly-Line Building Fills Need for Postwar Homes," Kaiser Permanente, http: //kaiserpermanentehistory.org /latest/henry-j-kaisers-assembly -line-building-fills-need-for -postwar-homes/.
7. For a survey of architects involved with defense housing, see Peter S. Reed, "Enlisting Modernism," in *World War II and the American Dream: How Wartime Building Changed a Nation,* ed. Donald Albrecht (Cambridge, Mass.: MIT Press, 1995): 2–41.
8. Robert Moses, "Postwar Blueprint," *Saturday Evening Post* (13 March 1943): 27, 64, 66, 69.
9. A Returned Veteran, "Will You Be Ready—When Johnny Comes Marching Home?" *HB* (January 1945): 27.
10. "What Houses Will Be Like after the War," *HB* (July–August 1942): 30–31.

11. See, for example, W. Adams and J. Normile, "Your Next House, What Is It Like?" *BHG* (June 1943): 20–21, 72–77; "What Will Our Dream House Look Like?" *AH* (March 1943): 53–58; Henry H. Saylor, "In What Will We Live Tomorrow?" *Parents* (November 1942): 45, 102–4; Kenneth Stowell, "There's No Place Like Home! Just What It Will Be Like in the Postwar Period," *AR* (December 1943): 41; "Practical Plans for the Postwar House," *LHJ* (May 1944): 159; "Blueprints for Tomorrow," *HG* (June 1944): 70–71; and "Dreams That Will Come True!" *AH* (January 1945): 15–17.
12. For the terms "editor-expert" and "converting need," see "House Omnibus," *AF* (April 1945): 89.
13. The *Oxford English Dictionary* lists 1967 as the first date of usage for the term "white flight" (in a *New Republic* article of 22 July); the concept was discussed at length by the National Advisory Commission on Civil Disorders (known as the Kerner Commission), appointed that same year by President Lyndon B. Johnson in response to race riots. For a discussion of the American postwar family, including gender, class, and race, see Elaine Tyler May, *Homeward Bound: American Families in the Cold War Era* (New York: Basic, 1988). May's data has informed the demographic trends described here; see, for example, her "Introduction" in ibid., ix–xxvi.
14. Stanley Schuler, "You Don't Have to Resign Yourself to Poor Living Conditions During the Emergency," *HB* (January 1942): 42.
15. May, *Homeward Bound,* xxiv.
16. For "till," see "House Omnibus," 90; for "influence," see ibid., 91.
17. "Your Home and the War and the Future," *HB* (April 1943): 56–57.
18. "Can I Improve My House During Wartime?" *HB* (September 1942): 34.
19. "Your Home and the War," 56.
20. Gordon, "*House Beautiful* Presents—A Symbol of What We're Fighting For—A Fine

Home and a Beautiful Garden," *HB* (January 1944): 29. For the culture of planning, see, for example, "Planning the Postwar House," *AF* (January 1944): 75–79. For more on the shift in professional focus away from the production of singular architectural objects toward broad urban planning, see Andrew Michael Shanken, "From Total War to Total Living: American Architecture and the Culture of Planning, 1933–194X" (PhD diss., Princeton University, 1999); and Andrew M. Shanken, *194X: Architecture, Planning, and Consumer Culture on the American Home Front* (Minneapolis: University of Minnesota Press, 2009).
21. "*House Beautiful*'s Home Planner's Study Course," *HB* (August 1943): 41.
22. Gordon used the line "more house for your money" in the August 1943 "Home Planner's Study Course"; the same phrase occurred frequently in the magazine for years afterward. For becoming a "student," see the Editor, "There Is No Substitute for Time and Study in Home Ownership," *HB* (August 1943): 42–43.
23. Ibid., 42.
24. Ibid., 43.
25. Ibid.
26. Ibid.
27. "Details Worth Remembering for Your Own House," *HB* (August 1943): 52–53.
28. For a list of articles, see "Houses: Portable; Packable; Demountable; Prefabricated," in *Readers' Guide to Periodical Literature* (Minneapolis: H. W. Wilson), all editions between 1941 and 1951.
29. Colean's books included *Can America Build Houses?* (New York: Public Affairs Committee, 1938); *Housing for Defense* (New York: Twentieth Century Fund, 1940); *The Impact of the War on Housing* (New York: American Bankers Association, 1942); *American Housing: Problems and Prospects* (New York: Twentieth Century Fund, 1944); *Stabilizing the Construction Industry* (Washington, D.C.: National Planning Association, 1945); *Renewing Our Cities* (New York: Twentieth Century Fund, 1953); (with Leon T.

Kendall), *Who Buys the Houses: A Report on the Characteristics of Single Family Homebuyers* (Chicago: United States Savings and Loan League, 1959); and *Mortgage Companies: Their Place in the Financial Structure* (Englewood Cliffs, N.J.: Prentice-Hall, 1962). For Colean's biography and history, see the oral history *Miles Colean* (New York: Columbia University Oral History Research Office, 1975).
30. Elizabeth Gordon, "Good Houses Don't Just Happen," *HB* (November 1943): 71.
31. "Exercise No. 2 for Developing Architectural Taste: Scale," *HB* (February 1945): 70–75.
32. Elizabeth Gordon, "Modern? Traditional? Compromise? Which Do You Vote For?" *HB* (October 1943): 67; Gordon, "Your House Is a Statement of Your Life," *HB* (October 1943): 68; ibid., 68–69; "Modern? Traditional? Compromise?" 67; Gordon, "Here's a Modern Nobody Can Object To," *HB* (November 1943): 43.
33. Gordon, "Your House Is a Statement," 68–69; Tyler Stewart Rogers, "Let Your Needs Create the . . . Style of Your House," *HB* (April 1944): 66.
34. For a discussion of the term "194X," and the culture of wartime and postwar planning, see Shanken, *194X.* For all Teague quotes, see Walter Dorwin Teague, "A Sane Prediction about the House You'll Live in after the War," *HB* (August 1943): 49.
35. Gordon, "What People Want in Postwar Houses," *HB* (February 1944): 60–61.
36. For a discussion of developers and model houses, see Barbara Miller Lane, *Houses for a New World: Builders and Buyers in American Suburbs, 1945–1965* (Princeton, N.J.: Princeton University Press, 2015).
37. "The First Postwar House," *HB* (May 1946): 82–123, 194–95; the Postwar House, constructed at 4940 Wilshire Boulevard, remained extant upon the author's last visit (June 2011), but the original 1946 interiors (and the 1951 remodeled versions) are no longer intact.
38. Beatrice Lamb, "Reveling: The Post War Wonder House

in Los Angeles," *LAT* (31 March 1946): E8. Coverage appeared in the *New York Post* (11 March 1946): 4; *AF* (March 1946): 98–104; *AR* (April 1946): 90–99; and *Life* (6 May 1946): 83–86. For coverage of the remodeling as the Post-Postwar House (in addition to *HB*'s coverage), see "The Home of Tomorrow," *AD* (January 1951): 105–12.

**39.** Burns developed several large-scale housing tracts in Los Angeles in the early 1940s, including Westside Village, Toluca Wood, and Windsor Hills. See James Thomas Keene, *Fritz B. Burns and the Development of Los Angeles: The Biography of a Community Developer and Philanthropist* (Los Angeles: Thomas and Dorothy Leavey Center for the Study of Los Angeles, Loyola Marymount University, and the Historical Society of Southern California, 2001); see also Dana Cuff, *The Provisional City: Los Angeles Stories of Architecture and Urbanism* (Cambridge, Mass.: MIT Press, 2000).

**40.** For Burns's motivations, see "'Post War House' to Display Use of New-Era Innovations," *LAT* (3 March 1946): 13.

**41.** Burns donated part of this income to Los Angeles charities. Keene, *Fritz B. Burns,* 107. See also "$75,000 Showcase," *AF* (March 1946); for tour pricing and an account of "merchandising" at the Postwar House, see "Greatest Housebuilding Show on Earth," *AF* (March 1947): 105–13.

**42.** Fritz B. Burns, *Livable Homes for Those Who Love Living* (New York: Revere Copper and Brass, 1943), 12.

**43.** Joseph Hudnut, "The Post-Modern House," *AR* (May 1945): 70–75.

**44.** "Modern Design," in *Technical Bulletin* (U.S. Federal Housing Administration), no. 2 (15 March 1936): 8–9, 1.

**45.** Gwendolyn Wright, *Building the Dream* (Cambridge, Mass.: MIT Press, 1981), 251.

**46.** Burns, *Livable Homes,* 14.

**47.** Ibid.

**48.** "*House Beautiful* Accepts the Challenge of the Times" (advertisement series, "House Beautiful but Practical"), *HB* (May 1942): 41.

**49.** "First Postwar House," 82–83.

**50.** *Popular Science* advertised the cost of Burns's model house at $250,000. This estimate must have included the land value; *Popular Science* (June 1946): 84. *Popular Mechanics* estimated the cost of the house and its equipment at $75,000; *Popular Mechanics* (July 1946): 103.

**51.** "First Postwar House," 82.

**52.** "The Best Barbecue We Have Ever Seen," *HB* (July 1946): 52; "Dream House," *Life* (6 May 1946): 83.

**53.** Lamb, "Reveling," E8.

**54.** The net circulation of *HB* in 1946, including subscriptions and newsstand sales, totaled 365,275. As a comparative, by 1951, the magazine's circulation had increased to 593,359. Association of National Advertisers, *Magazine and Circulation Analysis, 1937–1948* (New York: Association of National Advertisers, 1949); Association of National Advertisers, *Magazine and Circulation Analysis, 1940–1957* (New York: Association of National Advertisers, 1958). For "need to demand," see "House Omnibus," *AF* (April 1945): 89.

## Chapter 4.
## The Pace Setter House

**1.** "The First Postwar House," *HB* (May 1946): 82; Elizabeth Gordon, "You Should Dream Better Dreams," *HB* (May 1946): 81. Gordon launched the "Pace-Setter" House program in 1948; the hyphen was dropped by 1953. For clarity, I have chosen to use the term "Pace Setter" (two words and no hyphen) throughout this book. For a full discussion of the Pace Setter program, including a complete list of its architects and houses, see Monica Penick, "The Pace Setter Houses: Livable Modernism in Postwar America" (PhD diss., University of Texas at Austin, 2007).

**2.** For a brief history of model rooms and model houses, see Martin Filler, "Rooms without People: Notes on the Development of the Model Room," *Design Quarterly,* no. 109 (1979): 4–15; for exhibition houses designed for various media and in various venues,

see Beatriz Colomina, "The Media House," *Assemblage,* no. 27 (August 1995): 55–66. For exhibition and prefabricated houses, see Barry Bergdoll and Peter Christensen, eds., *Home Delivery: Fabricating the Modern Dwelling* (New York: Museum of Modern Art, 2008).

**3.** See, for example, "*Life* Presents Eight Houses for Modern Living Especially Designed by Famous American Architects," *Life* (26 September 1938): 45–67; "*Life* Houses Open for Inspection," *Life* (12 December 1938): 35, 37; and Ruth Carson, "*Collier's* House of Ideas," *Collier's* (15 June 1940): 16–17, 84. Stone also designed another *Collier's*-sponsored home in March 1936, and a *Collier's* "weekend" house, published in 1938.

**4.** "House of Tomorrow," *New Yorker* (22 May 1937): 13; see also Kenneth T. Jackson, *Crabgrass Frontier: The Suburbanization of the United States* (New York: Oxford University Press, 1985), 232.

**5.** John Normile, "Home for All America," *BHG* (September 1954): 57–75; "The Idea Home of the Year," *BHG* (September 1955): 51–69, 78–79.

**6.** "Idea Home," 51, 54.

**7.** "Introducing Our House of Ideas," *HG* (July 1951): 31.

**8.** "The Summing Up," *HG* (July 1951): 59.

**9.** "How to Use This Pace Setter House," *HB* (May 1951): 112.

**10.** "Introducing Our House," 31.

**11.** "Our House of Ideas Shows You How To . . . ," *HG* (July 1951): 33.

**12.** "Introducing Our House," 31.

**13.** ADP, "Comments and Comparison of Editorial Contents: February, March, April Issues: House & Garden [and] House Beautiful," box 17, folder 9, Condé Nast Archives, New York.

**14.** John Entenza, "Announcement: The Case Study House Program," *A&A* (January 1945): 37–39. For an overview of the Case Study House program, see Esther McCoy, *Case Study Houses,* 2nd ed. (Santa Monica: Hennessey and Ingalls, 1977); Elizabeth A. T. Smith, ed., *Blueprints for Modern Living: History and Legacy of the Case Study Houses* (Cambridge, Mass.: MIT

Press, 1989); and Elizabeth A. T. Smith, *Case Study Houses: The Complete CSH Program, 1945–1966* (Cologne: Taschen, 2009).

**15.** Smith, *Case Study Houses,* 8.

**16.** Esther McCoy, "Remembering John Entenza," in *Arts & Architecture: The Entenza Years,* ed. Barbara Goldstein (Santa Monica: Hennessey and Ingalls, 1998), 13.

**17.** Entenza, "Announcement," 38.

**18.** Entenza sold *Arts & Architecture* to David Travers in 1962, and the program continued under Travers for a few short years. The last single-family Case Study House was completed in 1966, and the magazine folded in 1967. McCoy, *Case Study Houses,* 5.

**19.** McCoy, "Arts & Architecture Case Study Houses," in Smith, *Blueprints for Modern Living,* 15.

**20.** For May's biography, see Cliff May and Marlene Laskey, *The California Ranch House: Oral History Transcript* (Los Angeles: Oral History Program, University of California, 1984); for his early career building furniture and houses on speculation, see ibid., 81–85. For recent scholarly accounts of his career, see Jocelyn Gibbs and Nicholas Olsberg, eds., *Carefree California: Cliff May and the Romance of the Ranch House* (Santa Barbara: Art, Design and Architecture Museum, University of California; New York: Rizzoli, 2012); Daniel P. Gregory, "Promoting Ranch Living: Cliff May and Maynard L. Parker," in *Maynard L. Parker: Modern Photography and the American Dream,* ed. Jennifer A. Watts (New Haven, Conn.: Yale University Press, 2012); and Daniel P. Gregory, *Cliff May and the Modern Ranch House* (New York: Rizzoli, 2008).

**21.** For early publicity, see *Sunset* (March 1936): 21. For the Riviera Ranch houses, see, for example, *California Arts and Architecture* (August 1939): cover; *AF* (October 1939): 296; *AR* (July 1940): 82; and *AH* (May 1942): 17.

**22.** Elizabeth Gordon, "The 12 Best Houses of the Last 12 Years," *HB* (September 1947): 108.

23. Cliff May, *Sunset Western Ranch Houses* (San Francisco: Lane, 1946); for sales numbers, see May and Laskey, *California Ranch House*, 209; and Gregory, *Cliff May*, 22.

24. May, *Sunset Western Ranch Houses*, ix.

25. May and Laskey, *California Ranch House*, 30.

26. May published the house as the "Ranch House Classic" in *Western Ranch Houses*, 2nd ed. (San Francisco: Lane, 1958). He also referred to his own homes by number; this was Cliff May #3. For the numbering, see May and Laskey, *California Ranch House*.

27. For May's full list of publications in which the ranch house appeared, see "Magazines Featuring Ranch Houses Designed by Cliff May," 10–24. May Collection.

28. *HB* (June 1944): table of contents.

29. The "amphibious" furniture was made by the John B. Salterini Company; ibid.

30. Helen Weigel Brown, "Meet a Family That Really Knows How to Live," *HB* (April 1946): 75.

31. Patricia Guinan, "Nice People Come from Nice Homes," *HB* (April 1946): 73.

32. Brown, "Meet a Family," 75.

33. Ibid.

34. Ibid.

35. Ibid.

36. "It's Only One Acre but It's a Whole Kingdom," *HB* (April 1946): 76–77.

37. Ibid. For a discussion of landscape architect Aurele Vermeulen's contributions, see *AF* (December 1944): 13; and May, *Western Ranch Houses*, 24. Doug Baylis worked on the landscape as part of the 1949 remodel.

38. "We Don't Like Pretentious Architecture," *HB* (April 1946): 94.

39. Ibid.

40. Ibid.

41. "Our House Is Always Full of Children," *HB* (April 1946): 99; "Our Living Room Is No Parlor," *HB* (April 1946): 86.

42. "Here's How We Get along without Servants," *HB* (April 1946): 84–85. For a discussion of the freezer, see Cliff May, "A Freezer Revolutionized Our Marketing and Eating," *HB* (April 1946): 88–89, 166–68.

43. "Here's How We Get Along," 85.

44. "We Make Science Do Our Work," *HB* (April 1946): 97.

45. The plans date between 1945 and 1947, drawn by J. Roth. See "Drawings for the Pace Setter 1948." May Collection.

46. May and Laskey, *California Ranch House*, 212.

47. "A House to Set the Pace . . . in All Climates . . . for All Budgets," *HB* (February 1948): 61.

48. Gordon wrote to Maynard L. Parker about competing with *BHG* over publishing a specific house, arguing that *HB* should easily get the work, because "as you know, they don't give credit to decorators, and we do." Elizabeth Gordon to Maynard L. Parker, 27 November 1942. MLP Collection.

49. ADP, "Comments and Comparison," G.

50. Elizabeth Gordon, "The Responsibility of an Editor" (speech to the Press Club Luncheon of the American Furniture Mart, Chicago, 22 June 1953), 2. Church Papers. Emphasis in the original.

51. Elizabeth Gordon to Cliff May, 10 August 1948. May Collection.

52. "The Facts about This Modern Ranch House," *HB* (February 1948): 67. For median incomes, see *Current Population Reports, Consumer Income*, ser. P-60, no. 9, 25 (Washington, D.C.: Bureau of Census, March 1952).

53. May, *Sunset Western Ranch Houses*, 150.

54. "Facts," 68.

55. For May's discussion of his collaborators, including Paul Frankl's contribution, see May and Laskey, *California Ranch House*, 213.

56. The plans contain handwritten notes between May and *HB* staff regarding plants, color, and materials to give "livability to a room which is used three times a day, 7 days a week"; see "Drawings for the Pace Setter 1948," May Collection.

57. "House to Set the Pace," 61.

58. Ibid.

59. Ibid.

60. "Facts," 67.

61. "Why This House Is a Pace-Setter," *HB* (February 1948): 70–71.

62. Ibid.

63. "The Advantages of Turning Your Back on the World," *HB* (February 1948): 89.

64. "A New Concept," *HB* (February 1948): 62.

65. Ibid.

66. "Advantages," 88.

67. Ibid.

68. "Facts," 68.

69. All quotes are from "Advantages," 89.

70. "The Garden Room—Answer to Many Problems," *HB* (February 1948): 65.

71. "New Concept," 62.

72. "Why This House Is a Pace-Setter," 71.

73. "Garden Room," 65.

74. For a description of the "revolutionary" wind shutters and sky shade, see "Outdoor Climate Control," *HB* (February 1948): 72–73. For "extending," see "Why This House Is a Pace-Setter," 71.

75. "Could You Build the Pace-Setter House in a Cold Climate?" *HB* (February 1948): 84–85.

76. Ibid.

77. "Why This House Is a Pace-Setter," 71.

78. "How a House Develops a Theme Song," *HB* (February 1948): 103.

79. "The Most Important House Ever Built . . . Color Wise," *HB* (February 1948): 74.

80. Ibid.

81. Ibid.; "Fabrics Set the Color Pace," *HB* (February 1948): 83.

82. "Fabrics," 83. Celanese is credited along with other suppliers; see *HB* (February 1948): 142.

83. "Most Important House Ever," 74.

84. Cliff May to Elizabeth Gordon, 15 May 1948. May Collection.

85. "A Four Way Kitchen," *HB* (February 1948): 106–11.

86. Ibid., 111.

87. May to Gordon, 15 May 1948.

88. For circulation data, see *Magazine and Circulation Analysis, 1937–1948* (New York: Association of National Advertisers, 1949). For tour information, see "Facts," 67; see also "Pace Setter Guest Book," May Collection.

89. Elizabeth Gordon to John A. Smith, phone transcript, c. 1947. May Collection.

90. The Pace Setter guest book was used to record visitors for the launch parties on 7, 8, and 9 October, and subsequent public tours. The last entry was recorded on 1 December 1947. The book includes 126 pages of entries. The total guest count is difficult to confirm, as some entries are singular signatures, while others account for couples ("Mr. and Mrs." entries represent more than half of the signatures) and groups of individuals. The individual entries as recorded in the book were at minimum three thousand, but the total number (when counting couples and groups) is likely closer to five thousand. See "Pace Setter Guest Book," May Collection.

91. For confirmation of the guest list and dates, see ibid. May commented on the party held for Los Angeles "socialites" in May and Laskey, *California Ranch House*, 214.

92. The house was "open for the benefit of charity," as confirmed by public signage; however, the charity was not identified by *HB* or by the Los Angeles newspapers, nor did May recall who benefited. May and Laskey, *California Ranch House*, 214–15.

93. For the launch of the Ready-to-Build stock-plan program, see "Introducing a New *House Beautiful* Service for Home Builders: House Plans with Miniature Models," *HB* (January 1948): 77–85.

94. May and Laskey, *California Ranch House*, 218.

95. These included the K. S. "Boots" Adams House in Bartlesville, Oklahoma; the Austin Peterson House in Los Angeles (in Riviera Ranch); the Charles Montgomery House in Borrego Springs, California; the George Whitacre House in McFarland, California; the Irvin Bray House in King City, California; and the David Rubinoff House in Encino, California. Cliff May to Elizabeth Gordon, 10 August 1948. May Collection.

96. For May's work on the derivative Pace Setters, see May and Laskey, *California Ranch House*, 217. For May's Pricesetter, see *LAT* (29 January 1950): E2.

97. "Why This House Is a Pace-Setter," 71.

## Chapter 5.
## Climate Control

**1.** "A House to Set the Pace . . . in All Climates . . . for All Budgets," *HB* (February 1948): 61.
**2.** "Introducing *House Beautiful*'s Newest Effort, Climate Control," *HB* (October 1949): 129.
**3.** Elizabeth Gordon, "What Climate Does to You and What You Can Do to Climate," *HB* (October 1949): 131.
**4.** Elizabeth Gordon, "Keeping Weather in Its Place," *Pictorial Review* 38 (May 1937): 84–85. For "weather-control," see Gordon and Dorothy Ducas, *More House for Your Money* (New York: Morrow, 1937), 193–208.
**5.** For a recent history of the solar house in America, see Anthony Denzer, *The Solar House: Pioneering Sustainable Design* (New York: Rizzoli, 2013). Denzer includes two chapters on Keck's work. See also Daniel A. Barber, "Tomorrow's House: Solar Housing in 1940s America," *Technology and Culture* 55, no. 1 (January 2014): 1–39; and "The Modern Solar House: Architecture, Energy, and the Emergence of Environmentalism, 1938–1959" (PhD diss., Columbia University, 2010).
**6.** For an account of the "accidental" discovery and the House of Tomorrow, see Denzer, *Solar House*, 14, 36–39; for Keck's Sloan House, see ibid., 14–24.
**7.** For Keck's experiments with "Sun Control," including shading techniques, see ibid., 39–44. For Gordon's early coverage of solar experiments, see, for example, Elizabeth Gordon, "Demonstrating the Wonderful Principle of 'Windbreaks' and 'Sunpockets,'" *HB* (August 1943): 50–51, 81.
**8.** "Sunlight Is Heat—If You Can Capture It," *HB* (September 1943): 60–61. For other "solar" articles, see "What a Big Difference a Little Re-Orienting Makes," *HB* (September 1943): 64–65; and "How Solar Windows Look from the Inside," *HB* (September 1943): 66–67.
**9.** For media interest in the solar house, see, for example, Richard Pratt, "Water on the Roof," *LHJ* (July 1944): 110, 125; and

Ralph Wallace, "Proven Merit of a Solar Home," *Reader's Digest* (January 1944): 101–4. For a comprehensive listing, see *Readers' Guide to Periodical Literature* (Minneapolis: H. W. Wilson), annual volumes from 1943 to 1948: "houses; architecture-domestic." For a discussion of "the promotional effort," see Denzer, *Solar House*, chap. 4, 73–93.
**10.** "Can an Old House Be Remodeled for Solar Heating?" *HB* (June 1945): 75.
**11.** For more on the "energy shortages" in the 1940s, see Denzer, *Solar House*, 74; and Barber, "Modern Solar House," 130–40.
**12.** Elizabeth Gordon, "The First of the Postwar Prefabricated Houses," *HB* (November 1945): 127–37.
**13.** Elizabeth Gordon, "A Solar House Designed to the Compass," *HB* (November 1945): 128. See also "A Solar House Can Be Planned for Any Side of the Street," *HB* (November 1945): 131.
**14.** Maron J. Simon, *Your Solar House* (New York: Simon and Schuster, 1947), 12, 13. For a recent history of *Your Solar House* (and precedent programs sponsored by Libbey-Owens-Ford), including the project's commencement in 1944, see Barber, "Modern Solar House," 92–99.
**15.** For the complete list, see Simon, *Your Solar House*, 13.
**16.** For a detailed account of Keck's Duncan House, performance testing, and the IIT observation project, see "Products and Practice: Solar Heating," *AF* 76 (August 1943): 6–7, 114; and Denzer, *Solar House*, 24–27.
**17.** Simon, *Your Solar House*, 19, 7.
**18.** Denzer, *Solar House*, 80.
**19.** For a discussion of "the first oil crisis," and the shortages of 1947 and 1948, see Barber, "Modern Solar House," 130–40.
**20.** Gordon cited and recommended Markham's and Mills's books, along with others, in "It May Be News to You—But . . . ," *HB* (October 1949): 142.
**21.** Gordon, "What Climate Does to You," 131.
**22.** Ibid.; for "major obstacle,"

see Wolfgang Langewiesche, "So You Think You're Comfortable?" *HB* (October 1949): 132.
**23.** All quotes from Gordon, "What Climate Does to You," 131.
**24.** Ibid.
**25.** Paul Siple, "Climatic Criteria for Building Construction," in *Weather and the Building Industry: A Research Correlation Conference on Climatological Research and Its Impact on Building Design, Construction, Materials and Equipment,* Building Research Advisory Board Research Conference Report No. 1 (Washington, D.C.: Building Research Advisory Board, 1950), 7. Siple's comments were given as part of his conference speech at the National Academy of Sciences, 11 and 12 January 1950.
**26.** James Marston Fitch, "The Scientists behind Climate Control," *HB* (October 1949): 144.
**27.** Fitch Foundation, "About: James Marston Fitch," http://fitchfoundation.org/about/honorees_fitch/.
**28.** James Marston Fitch, *American Building: The Forces That Shape It* (Boston: Houghton Mifflin; Cambridge, Mass.: Riverside, 1947).
**29.** Ibid., ix.
**30.** Ibid., 348, 289, 290, 297.
**31.** James Marston Fitch, "Scientists behind Climate Control," 144.
**32.** Miles Colean, "Climate Control Can Save You Money," *HB* (October 1949): 145, 249.
**33.** Siple, "Climatic Criteria," 7–14.
**34.** James Marston Fitch, "How You Can Use *House Beautiful*'s Climate Control Project," *HB* (October 1949): 143.
**35.** Siple, "Climatic Criteria," 8.
**36.** Ibid.
**37.** Ibid., 9.
**38.** See "Regional Climate Analyses and Design Data: The *House Beautiful* Climate Control Project," *Bulletin of the American Institute of Architects* (September 1949): 15–36. The AIA published each regional report (fifteen total); the first appeared in September 1949, and the final installment ran in January 1952 (2–16); a summary abstract was published in the November–December 1952 issue (15).

**39.** Siple, "Climatic Criteria," 9.
**40.** See, for example, Gordon, "What Climate Does to You," 131; Langewiesche, "So You Think You're Comfortable!" 132–34, 230–34, 239–40; and "Can I Really Control Climate?" *HB* (October 1949): 138–41.
**41.** Fitch, "How You Can Use," 143.
**42.** Colean, "Climate Control," 145, 249, 145.
**43.** Wolfgang Langewiesche, "How to Fix Your Private Climate," *HB* (October 1949): 150–55, 192–97, 204–5; for Keck, see, for example, Richard Pratt, "Water on the Roof," *LHJ* (July 1944): 110, 125.
**44.** "A Lesson in Climate Control," *HB* (October 1949): 164–71; "Good Site Planning Can Double Your Outdoor Living," *HB* (October 1949): 172–75.
**45.** William H. Scheick, foreword to *Weather and the Building Industry*, iii. *HB*'s role in funding the published proceedings is established by the "Acknowledgment," in *Weather and the Building Industry*, n.p.
**46.** Chairman C. F. Rassweiler, "Conclusion of the Conference," in *Weather and the Building Industry*, 147.
**47.** Buford Pickens, "Statements by Members of the Round Table," in *Weather and the Building Industry*, 110.
**48.** Advertisement, *HB* (October 1949): 145.
**49.** See, for example, "How to Harness the Breeze in Hot, Humid Weather," *HB* (July 1952): 51–55; and Robert H. Reed, *Natural Ventilation of Houses: Research Reports* (College Station: Texas Engineering Experiment Station, 1953).
**50.** See all the features for 1951's House of Ideas, including "4 Ideas to Make Your House More Comfortable the Year Round," in *HG* (July 1951): 62–63.
**51.** "Presenting *House Beautiful*'s Pace-Setter House for 1949," *HB* (November 1949): 195.
**52.** "The Living Room," *HB* (November 1949): 197; "How to Look at a Pace-Setter House," *HB* (November 1949): 199.
**53.** "The Great Room," *HB* (November 1949): 206.

**54.** Ibid.

**55.** "The Outdoor Living Room," *HB* (November 1949): 211.

**56.** For more on Rasbach's ideas, see Roger Rasbach, *The Provident Home* (Houston: Provident, 1993).

**57.** Frances Heard, "*House Beautiful*'s Good-Living House in San Antonio," *HB* (March 1952): 84–91, 174, 182. Gordon praised Rasbach's climate control strategies in a similar article a year later, in "What Is Perfect Climate Control?" *HB* (July 1953): 82–93. *Resources for Freedom, A Report to the President by the President's Materials Policy Commission, 1952,* 5 vols. (Washington, D.C.: U.S. Government Printing Office, 1952).

**58.** "What Is Perfect Climate Control?" 82–93.

**59.** For an anthology and timeline of the American environmental movement, see Bill McKibben, ed., *American Earth: Environmental Writing since Thoreau* (New York: Penguin Putnam, 2008).

**60.** Curtis Besinger, "Why This House Is a Pace Setter," *HB* (September 1961): 109, 108.

**61.** Besinger, "Why This House Is a Pace Setter," 109; "A Floor Plan Worth Serious Study— by Dreamers and Builders," *HB* (September 1961): 106–7.

## Chapter 6.
## A New Look

**1.** Dior debuted his "New Look" in Paris in April 1947, as part of his spring collection. Lesley Jackson has argued that this triggered a shift in design aesthetics; see Lesley Jackson, *The New Look: Design in the Fifties* (New York: Thames and Hudson, 1991). For *HB* and the announcement of the "New Look" in architecture and home furnishings, see Elizabeth Gordon, "The New Look," *HB* (May 1948): 105.

**2.** For "unmistakable style," see "How to Recognize the American Style," *HB* (May 1950): 158; Gordon, "New Look," 105. For "Declaration of Independence," see James Marston Fitch, "The New American Architecture Started 70 Years Ago," *HB* (May 1950): 134.

**3.** Gordon, "New Look," 105.

**4.** For a discussion of "period" and "modern," see Laura Tanner, "What's All This Feuding Between 'Period' and 'Modern'!" *HB* (November 1948): 212–19; on "modern" as a state of mind, see ibid., 218.

**5.** Gordon and her staff used the rhetoric of "traditional" and "modern," and of "pocketbooks" (or cost brackets) and "free" personal taste, consistently throughout her editorship; see, for example, Tanner, "What's All This Feuding"; and "A House to Set the Pace . . . in All Climates . . . for All Budgets," *HB* (February 1948): 61.

**6.** Gordon, "New Look," 105.

**7.** Ibid.

**8.** For a history of the New Look (and its characteristics) in interior design, furnishing, and household accessories, see Jackson, *New Look.*

**9.** "Why This House Is a Pace-Setter," *HB* (February 1948): 71.

**10.** "The Advantages of Turning Your Back on the World," *HB* (February 1948): 88–89.

**11.** See, for example, the low-cost solar house with a "well-engineered" kitchen, in Helen Markel Herrmann, "Brand New Version of a Rose-Covered Cottage," *HB* (March 1948): 86–89, 134–35, 157. For the "modern" kitchen of 1948, see W. W. Ward, "125 Miles from Town but Only 50 Minutes Away," *HB* (March 1948): 94–97, 118–19, 121. For ample use of "window walls," see the coverage of architect Burton Schutt's home in Bel Air in Jedd S. Reisner, "Modern but Not Too Modern," *HB* (April 1948): 120–25.

**12.** For nineteenth-century roots, see Elizabeth Gordon, "Is Modern Architecture Mature?" *HB* (February 1947): 59. She encouraged this argument well after 1948; see, for example, James Marston Fitch, "The New American Architecture Started 70 Years Ago," *HB* (May 1950): 134–37, 258; and, for the specific influence of the Greene brothers, Jean Murray Bangs, "Prophet without Honor," *HB* (May 1950): 138–39, 178–79.

**13.** Elizabeth Gordon, "The 12 Best Houses of the Last 12 Years," *HB* (September 1947): 79. For the four criteria and scoring, see "How These 12 Houses Were Picked," *HB* (September 1947): 82–83. For "influences," see "Why These 12 Houses Are Revolutionary," *HB* (September 1947): 81.

**14.** Gordon, "12 Best Houses," 79.

**15.** For a discussion of restrictions, see Miles Colean, "Can I Build Now?" *HB* (September 1947): 83.

**16.** Gordon, "12 Best Houses," 79.

**17.** Elizabeth Gordon, "Are You Afraid to Be Different?" *HB* (August 1947): 29.

**18.** Elizabeth Gordon, "Personality Is as Personality Does, or the Dangers of Copying Your Friends," *HB* (November 1947): 161.

**19.** Elizabeth Gordon, "The Awful Truth," *HB* (May 1947): 100.

**20.** Will Mehlhorn, "More a Way of Living Than a Style of Architecture," *HB* (January 1947): 66–67; Gordon, "Is Modern Architecture Mature?" 59.

**21.** Gordon, "Is Modern Architecture Mature?" 59.

**22.** Elizabeth Gordon, "The New Trend to Usefulness," *HB* (June 1947): 89.

**23.** See, for example, "We'll Take Traditional," *BHG* (October 1947): 50–51, 160; and "Kohners Prove You Can Mix Periods," *BHG* (March 1948): 148–49.

**24.** Tanner, "What's All This Feuding," 218.

**25.** "What Is Happening to Modern Architecture?" (symposium at the Museum of Modern Art, New York, 11 February 1948), *Museum of Modern Art Bulletin* 15, no. 3 (Spring 1948).

**26.** Alfred H. Barr, Jr., introduction to symposium, in "What Is Happening to Modern Architecture?" 4. See also Lewis Mumford, "The Sky Line," *New Yorker* (11 October 1947), repr. in "What Is Happening to Modern Architecture?" 2.

**27.** For the successes and failures of the event, see Barr, introduction to symposium, in "What Is Happening to Modern Architecture?" 4. For Gropius's and Breuer's views, see "What Is Happening to Modern Architecture?" 11 (Walter Gropius), 15 (Marcel Breuer).

**28.** Ibid., 19 (Lewis Mumford).

**29.** Ibid., 21 (Mumford), 10 (Henry-Russell Hitchcock), 8 (Alfred Barr, Jr.).

**30.** For a comprehensive list, see Robert Wojtowisc, ed., "Lewis Mumford: A Bibliography," December 2000. Lewis Mumford Papers, Kislak Center for Special Collections, Rare Books and Manuscripts, University of Pennsylvania, Philadelphia.

**31.** Mumford, "Sky Line," 2.

**32.** Reisner, "Modern but Not Too Modern," 120.

**33.** See, for example, Elizabeth Gordon, "The Threat to the Next America," *HB* (April 1953): 126–30, 250.

**34.** "What Is Happening to Modern Architecture?" 12 (George Nelson).

**35.** Ibid.

**36.** For Gordon's "obsolete" upbringing, see Elizabeth Gordon to Indira Berndtson, 17 September 1996, 3. Hill Papers. For "familiar" designs, see, for example, Gordon, "Are You Afraid?" 29.

**37.** Marion Gough, "The One Thing You Can't Change Is Change," *HB* (February 1949): 52.

**38.** "Your Taste Is a Changing River," *HB* (February 1949): 49; and ibid., with the graphic "River of Taste," 50–51, 115, 131–32.

**39.** For taste as "likes and dislikes," see "Your Taste Is a Changing River," 51. Gordon, through Gough's article, suggested that readers would need an "entire course in psychoanalysis" to understand all of the influences on taste; Gough, "One Thing You Can't Change," 52.

**40.** Ibid.

**41.** Barry Schwartz, *The Paradox of Choice: Why More Is Less* (New York: ECCO, 2004).

**42.** Gough, "One Thing You Can't Change Is Change," 52–53.

**43.** Ibid. The follow-on articles are Charlotte Eaton Conway, "Is It True What They're Saying about Mechanical Sinks?" *HB* (February 1949): 78–81; "What You Need to Know about Dishwashers," *HB* (February 1949): 82–83, 121; and "What You Need to Know about Garbage Disposals," *HB* (February 1949): 84–85, 140.

**44.** Gough, "One Thing You Can't Change," 115.
**45.** Ibid., 52–53.
**46.** Ibid, 115.
**47.** Elizabeth Gordon, "The New American Look," *HB* (March 1949): 118.
**48.** Ibid.
**49.** Ibid., 122.
**50.** Ibid., 121.

## Chapter 7.
## The American Style

**1.** "What Makes Us Americans?" *HB* (May 1950): 124. Gordon used the phrase "characteristically American," drawn from Ralph Barton Perry, *Characteristically American* (New York: Knopf, 1949).
**2.** Wanda Corn, *The Great American Thing* (Berkeley: University of California Press, 1999), xv.
**3.** For "roots" and the role of the regionalists, see ibid. Corn's line of art historical inquiry followed what she described as the "mid-twentieth century question 'What is American in American Art?'" that paralleled what Gordon pursued for design; ibid., xiv.
**4.** Christopher Long, *Paul T. Frankl and Modern American Design* (New Haven, Conn.: Yale University Press, 2007). Frankl's work appeared with some frequency in *HB*, and Gordon used his work to illustrate the American Style in the May 1950 issue; see Frances Heard, "American Taste Has an Unmistakable Flavor," *HB* (May 1950): 140–43.
**5.** "The Emerging American Style," *HB* (May 1950): 122; Elizabeth Gordon, "The New American Style Grew from America's Way of Life," *HB* (May 1950): 123.
**6.** Ibid.; for "traits," see "What Makes Us Americans?" 124–27.
**7.** Gordon, "New American Style," 123.
**8.** Ibid.
**9.** "The Station Wagon Way of Life," *HB* (June 1950): 103; Frances Heard, "What Is the Station Wagon Way of Life?" *HB* (June 1950): 104–9.
**10.** Gordon, "New American Style," 123; see also Mary Roche, "The American Ideal of Leveling Up," *HB* (May 1950): 128.

**11.** James Marston Fitch, "The New American Architecture Started 70 Years Ago," *HB* (May 1950): 136–37; Jean Murray Bangs, "Prophet without Honor," *HB* (May 1950): 138.
**12.** Fitch, "New American Architecture," 134; Bangs also used "declaration" in "Prophet without Honor," 138.
**13.** "What Makes Us Americans?" 124–27.
**14.** Ibid.
**15.** Ibid., 126.
**16.** The turned wood (treenware) butter mold, dated ca. 1825–75, was part of sculptor Elie Nadelman's folk art collection. Object Number 1937.1732, Folk Art Collection, New York Historical Society, Henry Luce III Center for the Study of American Culture.
**17.** "How to Recognize the American Style," *HB* (May 1950): 158.
**18.** Ibid.
**19.** Ibid.
**20.** See Bangs, "Prophet without Honor."
**21.** "How to Recognize the American Style," 158.
**22.** "You Don't Need to Take Our Word for All This!" *HB* (May 1950): 144.
**23.** Perry, *Characteristically American*, 9.
**24.** Ibid.
**25.** Gordon, "New American Style," 123–24; for "American cast of mind," see Perry, *Characteristically American*, 3–33.
**26.** Roche, "American Ideal of Leveling Up," 128.
**27.** Franklin D. Roosevelt, "Four Freedoms" (state of the union, 6 January 1941).
**28.** Gordon and her staff used the rhetoric of "freedom" frequently; see, for example, "free of rules," in Fitch, "New American Architecture," 137; "freed . . . from borrowed forms," in Bangs, "Prophet without Honor," 138; and Roche, "American Ideal of Leveling Up," 128–33, 199–201.
**29.** Frances Heard, "American Taste Has an Unmistakable Flavor," *HB* (May 1950): 143.
**30.** Ibid.
**31.** Gordon, "New American Style," 123.
**32.** "You Don't Need to Take Our Word," 144.
**33.** Ibid., 144–45, 214.

**34.** For more on Bohannon's role in defense housing, see Joseph B. Mason, *History of Housing in the U.S., 1930–1980* (Houston: Gulf, 1982), 31–41.
**35.** "The 3 Big Ideas of 1950," *HB* (June 1950): 85.
**36.** "A $25,000 Pace-Setter House," *HB* (September 1950): 48, 51.
**37.** For Gregory's brief biography, see Jules Gregory, "Julius Gregory," Baldwin Memorial Archive of American Architects, AIA Archives; and "Julius Gregory," file, AIA Archives.
**38.** For "California-type living" in the 1950 Pace Setters, see "3 Pace-Setter Houses and What They Mean to You," *HB* (June 1950): 87; for the 1951 Pace Setter, see "Defining the American Way of Life Executed in the American Style," *HB* (May 1951): 107.
**39.** "Pace-Setter Fabrics in the American Style," *HB* (May 1951): 153.
**40.** "The New American Style Puts People First," *HB* (May 1951): 114.
**41.** Ibid., 115.
**42.** Ibid.

## Chapter 8.
## The Threat to the Next America

**1.** Elizabeth Gordon, "The Threat to the Next America," *HB* (April 1953): 127, 126. For mention of Gordon and the "Threat" in recent scholarship, see, for example, Mathew A. Postal, "'Toward a Democratic Esthetic?' The Modern House in America, 1932–1955" (PhD diss., City University of New York, 1998): 222–44; Monica Penick, "The Pace Setter Houses: Livable Modernism in Postwar America" (PhD diss., University of Texas at Austin, 2007); Kathleen Corbett, "Tilting Modern: Elizabeth Gordon's 'The Threat to the Next America'" (PhD diss., University of California, Berkeley, 2010); Greg Castillo, *Cold War on the Home Front: The Soft Power of Midcentury Design* (Minneapolis: University of Minnesota Press, 2010), 112–15; Edward R. Bosley, "Looking Both Ways: Modernizing the Past to Shape the Future," in *Maynard L.*

*Parker: Modern Photography and the American Dream*, ed. Jennifer A. Watts (New Haven, Conn.: Yale University Press, 2012), 114; Monica Penick, "Framing Modern: Maynard L. Parker, Elizabeth Gordon, and *House Beautiful*'s Pace Setter Program," in ibid., 181–82; and Monica Penick, "Modern but Not Too Modern: *House Beautiful* and the American Style," in *Sanctioning Modernism: Architecture and the Making of Postwar Identities*, ed. Vladimir Kulić, Timothy Parker, and Monica Penick (Austin: University of Texas Press, 2014), 219–43.
**2.** Elizabeth Gordon, "Does Design Have Social Significance?" *HB* (October 1953): 230.
**3.** Gordon, "Threat," 126.
**4.** Editor's introduction to Lyman Bryson, "The Next America Now Brings the Greatest Good—and Goods—for the Greatest Number," *HB* (April 1953): 112.
**5.** "How Will You Live in the *Next* America?" (caption), *HB* (April 1953): cover.
**6.** Lyman Bryson, *The Next America: Prophecy and Faith* (New York: Harper, 1952).
**7.** Introduction to Bryson, "Next America Now Brings," 112.
**8.** "The Next America Adds Up to This," *HB* (April 1953): 111.
**9.** Bryson, "Next America Now Brings," 112–15, 172–73.
**10.** Ibid., 172.
**11.** Ibid., 172, 113.
**12.** Ibid., 113.
**13.** Ibid.
**14.** Ibid., 112.
**15.** "Next America Adds Up," 111.
**16.** Bryson, "Next America Now Brings," 115.
**17.** Ibid., 114–15.
**18.** Ibid., 112–15, 172.
**19.** For Barry's biography, see Joseph A. Barry, "Postscript" and "About This Book," in *The House Beautiful Treasury of Contemporary American Homes* (New York: Hawthorn, 1958), 141–42, 144.
**20.** For Barry's interview with Le Corbusier, see Joseph A. Barry, *Left Bank, Right Bank: Paris and Parisians* (New York: Norton, 1951), 162–75.
**21.** Ibid.
**22.** Joseph A. Barry, "The Next America Will Be the Age of Great Architecture," *HB* (April 1953): 116–25, 168–71, 194–96.

**23.** Ibid., 118, 196. Barry used the term "architecture of humanism," citing Geoffrey Scott, *The Architecture of Humanism: A Study in the History of Taste* (London: Constable and Company, 1914).
**24.** Ibid., 117.
**25.** Ibid., 194, 117.
**26.** Ibid., 194–95.
**27.** Gordon, "Threat," 129.
**28.** Ibid., 251, 127. For "fight," see ibid., 129.
**29.** Ibid., 127.
**30.** Ibid., 127, 129, 126.
**31.** Ibid., 128, 126, 129.
**32.** Ibid., 129.
**33.** Ibid., 128.
**34.** Ibid., 129.
**35.** Ibid., 126, 251.
**36.** Ibid., 251, 127.
**37.** Ibid., 126.
**38.** Ibid. The emphasis on "some" was Gordon's. Gordon did specifically point to Gropius's role at Harvard and Mies's at the Illinois Institute of Technology; see ibid., 130.
**39.** Ibid., 126, 129. For Gordon's opinion that "the MOMA & P. J. [Philip Johnson] were leading the press around by the nose," see Elizabeth Gordon to Curtis Besinger, 26 November 1986. Besinger Collection.
**40.** Gordon, "Threat," 127.
**41.** Ibid. For Gordon's use of "totalitarian," see Elizabeth Gordon, "Does Design Have Social Significance?" *HB* (October 1953): 313.
**42.** Gordon, "Threat," 251.
**43.** Ibid., 127.
**44.** Ibid., 127.
**45.** Ibid., 129.
**46.** Ibid., 130. For Gordon's questions, see ibid., 250–51.
**47.** Elizabeth Gordon to Frank Lloyd Wright, 9 July 1953. FLWF.
**48.** Editor [P. I. Prentice], *AF* (May 1953): table of contents.
**49.** "Criticism vs. Statesmanship," *AF* (May 1953): 97.
**50.** Ibid.
**51.** Ibid.
**52.** Ibid. For a discussion of Haskell's form letter, see Gordon to Wright, 9 July 1953. FLWF.
**53.** *AF* (May 1953): cover; "Criticism vs. Statesmanship," 97.
**54.** A. L. Aydelott, letter to *Progressive Architecture* (September 1953): 12.
**55.** Charles Grainger, letter to *Progressive Architecture* (September 1953): 12, 20.

**56.** John Carden Campbell, letter to *Progressive Architecture* (September 1953): 20.
**57.** "Public Opinion on 'The Threat to the Next America,'" *HB* (June 1953): 28.
**58.** Ibid., 29.
**59.** For the accusation of irrationality, see W. C. English, Jr.'s letter in ibid., 91. For "selling possessions," see Henry Hill of San Francisco in ibid., 28.
**60.** Ibid., 91.
**61.** For cancellations of subscriptions, see "Public Opinion," 92. For other respondents who questioned Gordon's judgment, see "More Readers' Mail on: The Threat to the Next America," *HB* (July 1953): 6–8, 92–94.
**62.** "More Readers' Mail," 93.
**63.** Ibid., 92.
**64.** Ibid., 94.
**65.** "Letter to the Editor," *HB* (October 1953): 312. The complete list of signatures included: John Carden Campbell; David R. Mayes; Worley K. Wong, AIA; John W. Kruse, AIA; John W. Staley, Jr., ASLA; Asa Hanamoto; Theodore Osmundson, Jr., ASLA; Rex W. Allen, AIA; Robert Royston, ASLA; Lawrence Halprin; Edward A. Williams; William Corlett, AIA; Roger Sturtevant; Garrett Eckbo; Felix M. Warburg; Albert Aronson, AIA; Terry Tong; Theodore C. Bernardi, AIA; Eva Low; William Wilson Wurster, AIA; R. Burton Litton, Jr., ASLA; Donn Emmons, AIA; Kathryn Stedman; Roger G. Lee, AIA; George T. Rockrise; H.L. Vaughan, ASLA; Margaret Rockrise; Henry Hill, AIA; Esther Born; and Albert Sigal.
**66.** Photocopy of original "Letter to the Editor," [1953] MS 132. Frank Lloyd Wright Collection, Special Collections, Kenneth Spencer Research Library, University of Kansas Libraries, Lawrence.
**67.** "Letter to the Editor," 312.
**68.** "Public Opinion," 29.
**69.** Ibid., 28.
**70.** Ibid.
**71.** Ibid., 92.
**72.** "More Readers' Mail," 6.
**73.** "Public Opinion" (James A. Ashley), 94.
**74.** For the original draft telegram, with the misspelling of "surprized," see Frank Lloyd Wright to Elizabeth Gordon, telegram, 24 March 1953, FLWF;

for the recipient's copy, see Wright to Gordon, telegram sent from Phoenix, 24 March 1953, Hill Papers; for the corrected *HB* reprint, see "Public Opinion," 28.
**75.** Frank Lloyd Wright to Elizabeth Gordon, 27 March 1953, 1. Hill Papers.
**76.** Elizabeth Gordon to Frank Lloyd Wright, telegram, 8 April 1953. FLWF.
**77.** Wright to Gordon, 27 March 1953, 2.
**78.** "More Readers' Mail," 94. Winslow was head of the Department of Architecture, Rensselaer Polytechnic Institute.
**79.** Elizabeth Gordon to Frank Lloyd Wright, 9 July 1953. FLWF.
**80.** Elizabeth Gordon, "The Responsibility of an Editor" (speech to the Press Club Luncheon of the American Furniture Mart, Chicago, 22 June 1953), Church Papers; Gordon, "Does Design Have Social Significance?" *HB* (October 1953): 230, 313–15, 318.
**81.** Gordon, "Does Design Have Social Significance?" 230, 313.
**82.** Ibid., 313.
**83.** "Obituary, Elizabeth Gordon," *Economist* (30 September 2000): 101. Hill Papers.

## Chapter 9.
## A New Alliance

**1.** Diane Maddex, *Frank Lloyd Wright's House Beautiful* (New York: Hearst, 2000), 38–39.
**2.** "Meet Frank Lloyd Wright," *HB* (June 1946): 77, 163.
**3.** "The Most Influential Design Source of the Last 50 Years," *HB* (December 1946): 185; Elizabeth Gordon, "One Man's House," *HB* (December 1946): 186–96, 235. For "impressed," see Elizabeth Gordon to Indira Berndtson, 17 September 1996, 4, Hill Papers.
**4.** Frank Lloyd Wright to Elizabeth Gordon, 24 October 1950; Gordon to Wright, 5 December 1950; Wright to Gordon, 24 April 1950; Gordon to Wright, 8 May 1950, all in FLWF. Their correspondence came to a halt after 1950, but started anew after Gordon's "Threat to the Next America" came out in 1953.
**5.** Gordon to Wright, 5 December 1950. FLWF.

**6.** For a sample of these invitations, see Eugene Masselink to Elizabeth Gordon, 15 April 1953; Elizabeth Gordon to Frank Lloyd Wright, 2 June 1953; and Gordon to Wright, 11 October 1955. All in FLWF.
**7.** Frank Lloyd Wright, "Frank Lloyd Wright Speaks Up," *HB* (July 1953): 86–88, 90.
**8.** Ibid., 87.
**9.** Ibid.
**10.** Ibid., 88–89.
**11.** Ibid., 89.
**12.** Ibid., 90.
**13.** Frank Lloyd Wright, "For a Democratic Architecture," *HB* (October 1953): 316–17.
**14.** *HB* pull quote from Wright, "For a Democratic Architecture," 317.
**15.** Wright, "For a Democratic Architecture," 316–17.
**16.** "James Marston Fitch" in Fitch Foundation, "Brief Biography of James Marston Fitch," http://fitchfoundation.org. For Fitch's "protest," see also Mathew A. Postal, "'Toward a Democratic Esthetic?' The Modern House in America, 1932–1955" (PhD diss., City University of New York, 1998), 230. Postal's dissertation includes a brief chapter on Gordon and the "Threat," for which he interviewed Fitch and Gordon; see ibid., 200–244.
**17.** For Hill's biography, see John deKoven Hill and Maggie Valentine, *John deKoven Hill* (Los Angeles: Oral History Program, University of California, 1997); for his tutors, see ibid., 71, 142–45. For a discussion of Wright's encouragement of Hill's interior design talent, see Jane Margolies, "Johnny Hill," Frank Lloyd Wright Archives Oral History Program, interview, 26 March 1992 (interview by Jane Margolies for *HB,* 26 March 1992, at Taliesin West Sun Cottage Guest Cottages; transcribed by Indira Berndtson, 27 January 1993), 9–10.
**18.** "John deKoven Hill: Resumé." Hill Papers.
**19.** Hill and Valentine, *John deKoven Hill,* 98.
**20.** Elizabeth Gordon to Frank Lloyd Wright, 21 May 1953. FLWF. For Hill's "restless" feeling and his "sabbatical" with Gordon, see Hill and Valentine, *John deKoven Hill,* 101–2.

**21.** John deKoven Hill to "Mother and Dad," 1 June 1953; 18 June 1953; 4 July 1953. Hill Papers.

**22.** Hill and Valentine, *John deKoven Hill,* 306.

**23.** Elizabeth Gordon to Frank Lloyd Wright, 9 July 1953. FLWF.

**24.** For Hill's descriptions, including *HB* as Gordon's magazine, see Hill and Valentine, *John deKoven Hill,* 307, 314, 278–82, 307.

**25.** Margolies, "Johnny Hill," 26.

**26.** Hill and Valentine, *John deKoven Hill,* 275, 283.

**27.** Ibid., 315, 321.

**28.** For Hill's design work, and the *HB* studio, see Margolies, "Johnny Hill," 6; and Hill and Valentine, *John deKoven Hill,* 326, 374–76, 388–90.

**29.** "The Arts of Daily Living Exhibition" (special issue, eighteen articles), *HB* (October 1954): 167–219, 222, 224, 229–30, 232, 234–36, 238, 241–48, 252–66, 269–70, 280–81, 306–8; "*House Beautiful* Dedicates This Exhibition to Frank Lloyd Wright," *HB* (October 1954): 176–77; *HB* (January 1955): cover; Hill and Valentine, *John deKoven Hill,* 320–33, 388–90. For "ways of living," see "The Arts of Daily Living," *HB* (October 1954): 167; and Ed Ainsworth, "County Fair Plays up 'American Way,'" *LAT* (12 September 1954): A9.

**30.** Elizabeth Gordon to Curtis Besinger, 26 November 1986. Besinger Collection.

**31.** Gordon to Wright, 9 July 1953, 2. FLWF.

**32.** Frank Lloyd Wright, "AIA Acceptance Address for the Gold Medal," in *Frank Lloyd Wright Collected Writings,* ed. Bruce Brooks Pfeiffer, vol. 4, *1939–1949* (New York: Rizzoli, 1994), 324–30.

**33.** For more on the installations, see Wright's correspondence in "60 Years of Living Architecture," in *Letters to Architects: Frank Lloyd Wright,* ed. Bruce Brooks Pfeiffer (Fresno: California State University Press, 1984), 174–203.

**34.** Frank Lloyd Wright, "Sixty Years of Living Architecture," in *Sixty Years of Living Architecture: The Work of Frank Lloyd Wright* (New York: Guggenheim, 1953) (exhibition catalogue for

the Guggenheim installation, September 1953), n.p. GA.

**35.** Hill and Valentine, *John deKoven Hill,* 305.

**36.** For Hill's recollection of the *Sixty Years* Guggenheim exhibit, and *HB*'s role, see Hill and Valentine, *John deKoven Hill,* 303–6.

**37.** Press release by the Solomon R. Guggenheim Foundation, 20 October 1953. GA.

**38.** Press release, "News from United States Plywood Corporation," n.d. GA.

**39.** Frank Lloyd Wright, *The Usonian House: The Work of Frank Lloyd Wright, a Feature of the Exhibition: 60 Years of Living Architecture at the Solomon R. Guggenheim Museum* (New York: Guggenheim Museum, 1953), n.p. [5] (souvenir exhibition catalogue of the Guggenheim exhibition, November 1953).

**40.** Ibid., 4.

**41.** Press release by Walter Bennett (public relations officer for General Electric Company), "For Immediate Release" (publicity statement for the Wright exhibition), 20 October 1953. GA.

**42.** Hill and Valentine, *John deKoven Hill,* 304; Wright, *Usonian House* (souvenir catalogue), n.p. [back cover].

**43.** Frank Lloyd Wright, "Usonian House" (unpublished exhibition credits), n.d. [October 1953]. GA.

**44.** Ibid.

**45.** Frank Lloyd Wright, "Note," in *Sixty Years of Living Architecture,* n.p. [final page].

**46.** Wright, *Usonian House,* n.p. [6].

**47.** Ibid., n.p. [back cover].

**48.** Wright, introduction in *Usonian House,* n.p. [1].

**49.** Ibid.

**50.** Ibid.

**51.** Wright, *Usonian House,* n.p. [5].

**52.** The Guggenheim exhibition catalogue credits the Taliesin team of apprentices, but there is no mention of *HB,* though Hill represented both Taliesin and the magazine and verified the participation of other *HB* decorators. He also attested that the project was designed around the idea of public relations, not specifically to be published in *HB.* See Hill and Valentine, *John*

*deKoven Hill,* 306.

**53.** James Marston Fitch, "This Exhibition House Symbolizes Frank Lloyd Wright's Contribution to Your Daily Life," *HB* (November 1955): 264–69, 367–72.

**54.** For "dramatic story," see Table of Contents, *HB* (November 1955): 4.

**55.** Other authors have briefly discussed *HB*'s 1955 Wright issue. For example, Jane King Hession and Debra Pickrel claim that it was the "first million-dollar issue, biggest circulation distribution (835,000 copies), and the largest number of advertising pages (247) in the history of shelter magazines"; see Jane King Hession and Debra Pickrel, *Frank Lloyd Wright in New York: The Plaza Years, 1954–1959* (Salt Lake City: Gibbs Smith, 2007), 56. See also Maddex, *Frank Lloyd Wright's House Beautiful,* 37; and Virginia T. Boyd, *Frank Lloyd Wright + the House Beautiful: Designing an American Way of Living* (Washington, D.C.: International Arts and Artists, 2005), 121.

**56.** Hill and Valentine, *John deKoven Hill,* 368.

**57.** Ibid.

**58.** Hill recounted the successful sales of the Wright issue. The issue is widely regarded as a collector's item, and at this writing, continues to sell for hundreds of dollars per copy.

**59.** "*House Beautiful* Is Devoting This Entire Issue to Frank Lloyd Wright," *HB* (November 1955): 233.

**60.** "The World's Most Honored Architect," *HB* (November 1955): 356–57. This article lists Wright's many awards and honorary degrees, dating from 1919 to 1955.

**61.** *HB*'s Wright tribute issue, published in November 1955, featured twenty-two Wright-related articles (although only twenty of these are listed in *HB*'s table of contents): "*House Beautiful* Is Devoting This Entire Issue to Frank Lloyd Wright"; "Frank Lloyd Wright's Contribution: A Beauty of Life Equal to the Great Concept of America"; Joseph A. Barry, "Frank Lloyd Wright: The Man Who Liberated Architecture"; John deKoven Hill, "The Poetry of Structure";

"The Character of the Site Is the Beginning of Architecture"; Robert Mosher, "The Eloquence of Materials"; Bruno Zevi, "The Reality of a House Is the Space Within"; [*HB* editors, title quoted from Wright], "I Believe a House Is More a Home by Being a Work of Art"; James Marston Fitch, "This Exhibition House Symbolizes Frank Lloyd Wright's Contribution to Your Daily Life"; Frank Lloyd Wright, "Faith in Your Own Individuality"; Elizabeth Gordon, "The Symphonic Poem of a Great House"; "A Modern Castle in the Air"; "And Now Frank Lloyd Wright Designs Home Furnishings You Can Buy!"; Richard Williams, "Music and Frank Lloyd Wright"; "At Taliesin, Parties Are Artistic Affairs"; "The Writings of Frank Lloyd Wright"; "Quotations from Frank Lloyd Wright"; "Wright as Landscape Architect"; "The World's Most Honored Architect"; Cecile Starr, "Movies and Frank Lloyd Wright"; "What Men Have Written about Frank Lloyd Wright"; "The Storage Hallway."

**62.** Hill and Valentine, *John deKoven Hill,* 372. For more on the Fellowship's performance, and the Schumacher collaboration generally, see Christa C. Mayer Thurman, "'Make Designs to Your Heart's Content': The Frank Lloyd Wright/Schumacher Venture," *Art Institute of Chicago Museum Studies* 21, no. 2 (1995): 152–63, 189–91.

**63.** "Frank Lloyd Wright Designs," *HB* (November 1955): 282.

**64.** Boyd discusses (with excellent illustrative material) the Taliesin Ensemble at length in Boyd, *Frank Lloyd Wright + the House Beautiful,* 134–53. Hession and Pickrel also make the argument that Wright was motivated to provide wide "access to good design"; see Hession and Pickrel, *Frank Lloyd Wright in New York,* 58.

**65.** "Frank Lloyd Wright Designs," *HB* (November 1955): 336. Gordon wrote to Indira Berndtson that Mrs. Wright had also been interested in a mass-market line of domestic products; most evidence, however, suggests that while Mrs.

Wright may have helped sway her husband's opinion, Gordon and Hill were the primary instigators. See Elizabeth Gordon to Indira Berndtson, 17 September 1996. Hill Papers.

**66.** For Gordon's partners, see "Frank Lloyd Wright Designs," *HB* (November 1955): 336; Hill and Valentine, *John deKoven Hill*, 371–74; and Boyd, *Frank Lloyd Wright + the House Beautiful*, 134, 135, 149.

**67.** "Frank Lloyd Wright Designs," *HB* (November 1955): 338, 336.

**68.** For this general account, see correspondence between Carrillo and Wright, FLWF; and Thurman, "'Make Designs,'" 155. For Wright's demands, and "it's going to cost you," see Hession and Pickrel, *Frank Lloyd Wright in New York*, 58.

**69.** Frank Lloyd Wright to Fellowship, 7 March 1954, FLWF; for the contract (signed 11 March 1954), see René Carrillo to Frank Lloyd Wright, 22 March 1954, FLWF. For more on their negotiations and Wright's financial motivations, see Thurman, "'Make Designs,'" 155; and Hession and Pickrel, *Frank Lloyd Wright in New York*, 65.

**70.** Wright's correspondence with Carrillo suggests that he sent the concept drawings as early as 22 March 1954. See Frank Lloyd Wright to René Carrillo, 24 March 1954. FLWF.

**71.** Hill and Valentine, *John deKoven Hill*, 372.

**72.** For a discussion of the working process, see ibid., 371–74; and Carrillo to Wright, 22 March 1954. For "saleability," see Carrillo quoted in Thurman, "'Make Designs,'" 161. For a complete description and illustrations of the full range of fabrics and wallpapers, see Boyd, *Frank Lloyd Wright + the House Beautiful*, 139–49. Hession and Pickrel provide an excellent summary of the genesis, production, display, and reception of the line; see Hession and Pickrel, *Frank Lloyd Wright in New York*, 58–65.

**73.** Hill and Valentine, *John deKoven Hill*, 373.

**74.** For the relationship between Wilson and Wright, see Hill and Valentine, *John deKoven Hill*, 373; and Boyd, *Frank Lloyd*

*Wright + the House Beautiful*, 135. See also David Hanks, *The Decorative Designs of Frank Lloyd Wright* (New York: Dutton, 1979).

**75.** For more on the combination of Wright's three collections, see Hill and Valentine, *John deKoven Hill*, 373; and Boyd, *Frank Lloyd Wright + the House Beautiful*, 136. Wright's drawings remain in his archives, with the collection's advertising pamphlet titled "Heritage-Henredon Fine Furniture." FLWF.

**76.** For these quotes and the process of selection, see "The Taliesin Palette" (promotional portfolio), Martin-Senour Paint Company. FLWF. Hill also confirmed Wright and Mrs. Wright's role (and noted that the paint chips got "very nice names") in Hill and Valentine, *John deKoven Hill*, 374.

**77.** For Martin-Senour's descriptions, see Martin-Senour advertisement, *HB* (November 1955): 205; and "Taliesin Palette in Martin-Senour Paints," FLWF. For "harmony," see "Frank Lloyd Wright Designs," *HB* (November 1955): 338.

**78.** Boyd suggests that the eight samples submitted to Schumacher, and now held in the Smithsonian's Archives of American Art, were intended as part of the Taliesin Ensemble floor coverings. See Boyd, *Frank Lloyd Wright + the House Beautiful*, 149.

**79.** Karastan advertisement, *HB* (November 1955): 349.

**80.** Ibid.

**81.** Thurman confirms that "mock-ups" of the carpets were produced, but never went into production; however, Karastan did make at least two of the designs for show in the 1978 exhibition *Taliesin Collection*. Thurman, "'Make Designs,'" 162.

**82.** "Frank Lloyd Wright Designs," *HB* (November 1955): 290.

**83.** Schumacher's offices were "next to" the Republican Club (54 West Fortieth Street). See Thurman, "'Make Designs,'" 162; and Hession and Pickrel, *Frank Lloyd Wright in New York*, 59.

**84.** Betty Pepis, "Conventional Furniture by Frank Lloyd Wright," *NYT* (16 October 1955): 44.

**85.** Frank Lloyd Wright to René Carrillo, n.d. [September] 1955. FLWF. The story is also relayed in Thurman, "'Make Designs,'" 162; and Hession and Pickrel, *Frank Lloyd Wright in New York*, 61.

**86.** René Carrillo to Frank Lloyd Wright, 9 September 1955. FLWF.

**87.** Anne Douglas, "Frank Lloyd Wright Furniture on Display," *Chicago Sunday Tribune* (13 November 1955): pt. 3, sec. 2, 2, 31.

**88.** For an account of "Wright at Retail," see Hession and Pickrel, *Frank Lloyd Wright in New York*, 61–62.

**89.** "Frank Lloyd Wright Starts Life Anew at 86," *Chicago Daily News* (18 October 1955); cf. Hanks, *The Decorative Designs of Frank Lloyd Wright*, 193; Pepis, "Conventional Furniture by Frank Lloyd Wright," 44. For an account of the media reviews that accompanied the Chicago Merchandise Mart launch, see also Hanks, *Decorative Designs of Frank Lloyd Wright*, 191–98; and Hession and Pickrel, *Frank Lloyd Wright in New York*, 61–62.

**90.** Hill confirmed that he designed the setting for the Chicago Merchandise Mart, and that Wright himself staged the scene with many of his own art objects and decorative pieces from Taliesin; Hill and Valentine, *John deKoven Hill*, 374.

**91.** *NYT* advertisements from 9 October and 13 November (Bloomingdale's), 14 November (B. Altman and Company), and 17 November 1955 (Abraham and Straus); referenced in Hession and Pickrel, *Frank Lloyd Wright in New York*, 61, 136nn70–71.

**92.** Hill and Valentine, *John deKoven Hill*, 373.

**93.** Ibid.

**94.** Hession and Pickrel, *Frank Lloyd Wright in New York*, 61.

**95.** Hill and Valentine, *John deKoven Hill*, 373.

**96.** For an account of this success and for excellent descriptions of the Schumacher textiles, see Boyd, *Frank Lloyd Wright + the House Beautiful*, 139, 142.

**97.** Schumacher issued the reproductions in 1986; see ibid., 153n35.

**98.** "Frank Lloyd Wright

Designs," *HB* (November 1955): 336.

**99.** Ibid., 337.

**100.** Hill and Valentine, *John deKoven Hill*, 374.

**101.** Frank Lloyd Wright to Elizabeth Gordon, 27 March 1953, 2. Hill Papers.

## Chapter 10. The Next American House

**1.** Frank Lloyd Wright, "Prescription for a Modern House," *HB* (November 1953): 228.

**2.** "They Built This House for $1,200," *HB* (March 1946): 106–7, 136–37, 146–47.

**3.** Ibid., 106.

**4.** Will Mehlhorn, "Is There Such a Thing as a Low Cost House?" *HB* (March 1946): 105.

**5.** "They Built This House," 107.

**6.** Ibid., 106.

**7.** For Weaver's biography, see Rudolph Weaver Architectural Records, Special and Area Studies Collections, George A. Smathers Libraries, University of Florida, Gainesville; and Alfred Browning Parker, interview with the author, 28 November 2000. For Parker's discussion of "piecemeal," see Tom Martyn, "Architect, an Interview with Alfred Parker" (student paper, Miami-Dade Junior College, 1968), ABParker Papers.

**8.** Parker, interview with the author. For a published account, see "The Influences That Produced a Pace-Setting Architect," *HB* (November 1953): 210–11.

**9.** For Wright in popular and professional magazines, see, for example, *AF* (January 1938): cover, 1–102; *Time* (17 January 1938): cover, 29–32; *Life* (17 January 1938): advertisement, inside front cover; and *Life* (26 September 1938): 56, 60–61.

**10.** Parker, interview with the author.

**11.** Alfred Browning Parker to Frank Lloyd Wright, 5 February 1939. FLWF.

**12.** Marcie Ersoff, "An Architect Talks about His House," *Miami Herald* (3 May 1964): 21. Henning Collection.

**13.** Alfred Browning Parker, "Biographical Data." Henning Collection.

**14.** *HB* credits Parker, in 1953, with 132 custom homes and

"plans" for one thousand specu-
lative houses; the estimates on
the value of Parker's projects,
at $10 million, may have been
overstated. See Joseph A. Barry,
"The Architecture of Human-
ism," *HB* (November 1953): 224.
Data from Parker's archives, fur-
ther substantiated in Randolph
Henning's book, reveal a more
modest account. See Randolph
C. Henning, *The Architecture of
Alfred Browning Parker: Miami's
Maverick Modernist* (Gainesville:
University Press of Florida, 2011).
**15.** Parker recounted building
his first house for his family in
about 1943, a second house in
Gainesville, Florida, in 1946, a
third house in Miami in 1948,
and the Royal Road house
between about 1950 and 1953.
Alfred Browning Parker to
Michael Friedman, 12 July 1983.
Henning Collection.
**16.** Wright, "Prescription for a
Modern House," 228.
**17.** For habits, values, dreams,
and "no formula," see Parker
quoted in Barry, "Architecture of
Humanism," 227.
**18.** Parker, interview with the
author.
**19.** Alfred Browning Parker, *You
and Architecture: A Practical
Guide to the Best in Building*
(New York: Delacorte, 1965), 114.
**20.** Ibid., 128.
**21.** Alfred Browning Parker,
"An Illustrated Credo" (speech
to the University of Toronto,
17 October 1960). Henning
Collection.
**22.** For Parker's interest in
creating "pleasing" form, see,
generally, Barry, "Architecture of
Humanism."
**23.** "Descriptive Data for
1989 Louis Sullivan Award for
Architecture," Royal Road File
(Pace Setter 1954). Henning
Collection.
**24.** "The Influences That Pro-
duced a Pace-Setting Architect,"
*HB* (November 1953): 210.
**25.** Parker, interview with the
author. See also the credits in
*HB* (November 1953): 276, 279,
286, 289.
**26.** Elizabeth Gordon to Alfred
Browning Parker, 27 October
1950. ABParker Papers.
**27.** For descriptions, see Fran-
ces Heard, "How to Practice
Perfection," *HB* (November
1953): 250, 344.

**28.** Ibid., 250.
**29.** Ibid., 344.
**30.** "The Chair—Flower of Mod-
ern Design," *HB* (November
1953): 252.
**31.** *HB* provided many of the
movable pieces pictured in the
November issue, but the Parkers
likely owned the Esherick chair
(which was used as the desk
chair in the master bedroom).
See Laura Tanner, "The Master
Bedroom and Bath," *HB*
(November 1953): 242–47; and
"The Chair," *HB* (November
1953): 252.
**32.** Heard, "How to Practice
Perfection," 250; for other prac-
tical lessons, see "The Perfect
Slip Cover and How to Make It,"
*HB* (November 1953): 251.
**33.** For a biography and
overview of Karasz's work,
see Ashley Callahan, *Modern
Threads: Fashion and Art by
Mariska Karasz* (Athens: Georgia
Museum of Art, University of
Georgia, 2007).
**34.** "What Is Integrated
Design?" *HB* (November 1953):
263.
**35.** Ibid., 286.
**36.** Ibid., 246.
**37.** Ibid., 256.
**38.** Henry Wright, "A Room
and Garden on the Roof," *HB*
(November 1953): 257.
**39.** Parker, *You and Architecture,*
136.
**40.** Elizabeth Gordon, "This
Is the House Beautiful," *HB*
(November 1953): 218.
**41.** Ibid.
**42.** "*House Beautiful's* 1954
Pace Setter House," *HB*
(November 1953): 217.
**43.** Gordon, "This Is the House
Beautiful," 221, 218.
**44.** Ibid., 218, 221.
**45.** Ibid., 221.
**46.** "What This Pace Setter Can
Mean to You," *HB* (November
1953): 223.
**47.** Ibid.
**48.** See, for example, Joseph A.
Barry, "The Next America Will
Be the Age of Great Architec-
ture," *HB* (April 1953): 116–25,
168–71, 194–96.
**49.** Joseph A. Barry, "The
Architecture of Humanism," *HB*
(November 1953): 224.
**50.** Ibid.
**51.** Ibid., 326.
**52.** Ibid., 227.
**53.** Wright's quotes appear in

"*House Beautiful's* 1954 Pace
Setter House," 217; Gordon,
"This Is the House Beautiful,"
220; Barry, "Architecture of
Humanism," 226; and Wright,
"Prescription for a Modern
House," 228.
**54.** Ibid., 227.
**55.** Ibid., 224, 227.
**56.** Ibid., 227.
**57.** "How to Build the House You
Can't Afford," *HB* (November
1953): 230. For a contemporary
discussion of the recession
of 1953 and 1954, including
the effects of the Korean War
defense program, see H. D.
Maloney, "Monetary Policy and
the Recession of 1953–54,"
*Journal of Finance* 14, no. 4
(December 1959): 569–70.
**58.** "How to Build," 230.
**59.** Ibid., 299.
**60.** Ibid., 301.
**61.** "The Anatomy of a Pace
Setter," *HB* (November 1953):
236–37, 331–32.
**62.** John D. Hill, "The Structure
of a Pace Setter," *HB* (Novem-
ber 1953): 238–39, 349–51, 353.
For Hill's account of Gordon's
editing style, including her usual
practice of rewriting copy, see
John deKoven Hill and Maggie
Valentine, *John deKoven Hill*
(Los Angeles: Oral History Pro-
gram, University of California,
1997), 278–82.
**63.** Hill, "Structure of a Pace
Setter," 238.
**64.** Ibid.
**65.** Ibid.
**66.** Ibid., 239.
**67.** Ibid., 350.
**68.** Ibid., 351. Hill borrowed the
full statement from one of Park-
er's lectures in which he quoted
the contemporary novelist Lloyd
Douglas.
**69.** Ibid., 350.
**70.** James Marston Fitch, "The
Pace Setter Laughs at the 3
Furies: Sun, Wind, and Water,"
*HB* (November 1953): 240–41,
280–85. Fitch had resigned in
May 1953, but this article was
likely completed prior to his
departure.
**71.** Fitch's article was followed
by a small ad for the Climate
Control program. Advertise-
ment, *HB* (November 1953):
285.
**72.** For Fitch's descriptions, see
Fitch, "Pace Setter Laughs,"
240.

## Chapter 11.
## A New Regionalism

**1.** "The Quiet, Comforting
Statement of the Pace Setter for
1955," *HB* (February 1955): 73.
**2.** Ibid.
**3.** Ibid.
**4.** See Harwell Hamilton Harris
on "regionalism of liberation"
in "Regionalism and National-
ism in Architecture" (speech,
1954; published, 1958), repr. in
Vincent B. Canizaro, ed., *Archi-
tectural Regionalism: Collected
Writings on Place, Identity,
Modernity, and Tradition* (New
York: Princeton Architectural
Press, 2007), 57–64.
**5.** For a synopsis of the theories,
see Alan Colquhoun, "The
Concept of Regionalism" (1997),
repr. in Canizaro, *Architectural
Regionalism*, 147–55.
**6.** David R. Williams, "Toward
a Southwestern Architecture"
(1931), repr. in Canizaro, *Archi-
tectural Regionalism*, 171–77.
For references to Williams as
the father of Texas regional
architecture, see, among others,
Muriel Quest McCarthy, *David
R. Williams: Pioneer Architect*
(Dallas: Southern Methodist
University Press, 1984).
**7.** For his views on regionalism,
see John Gaw Meem, "Old
Forms for New Buildings"
(1934), repr. in Canizaro, *Archi-
tectural Regionalism*, 189–92.
**8.** Richard Neutra, "Regionalism
in Architecture," *Plus* [insert in
*AF*] 1, no. 2 (February 1939):
22–23, repr. in Canizaro, *Archi-
tectural Regionalism*, 278.
**9.** Ibid., 279.
**10.** Hugh S. Morrison, "After
the International Style—What?"
*AF* (May 1940): 345–47, repr.
in Canizaro, *Architectural
Regionalism*, 283.
**11.** Ibid.
**12.** Lewis Mumford, "The
Architecture of the Bay Region"
(1949), quoted in Canizaro,
*Architectural Regionalism*, 289.
**13.** Sigfried Giedion, "The New
Regionalism" (1954), repr. in
Canizaro, *Architectural Regional-
ism*, 319, 315.
**14.** Harris (speech to the North-
west Regional Council of the
AIA, Eugene, Oregon, August
1954. The essay was published
as "A Regional Architectural
Expression," *AR* (January 1955):

48. For this speech draft and its published versions, see HHH Papers. A revised essay was published as "Regionalism and Nationalism in Architecture," *Texas Quarterly* 1 (February 1958), and repr. in Canizaro, *Architectural Regionalism,* 57–58.

15. Harris, "Regionalism and Nationalism," 57, 58.

16. Ibid., 58.

17. Ibid., 61.

18. Ibid., 58.

19. *Dallas Morning News* (10 October 1954): pt. 7, 4.

20. David Barrow, Jr., interview with the author, 5 December 2005; "Architects' Dream House Will Be Shown at Texas State Fair," *The Daily Texan* (11 May 1954): 3. HHH Papers. Legge's name was omitted in this newspaper article, as he joined the team at a later (unspecified) date.

21. For an account of the working process from February to June 1954, see Neal Terry Lacey, Jr., "A Synthesis of the Architectural Concepts in the Approach to Design of the *House Beautiful* Pace Setter House for 1955" (master's thesis, University of Texas at Austin, August 1954). Lacey recounts the short history of the project in ibid., 176–80. Harris described his "method of teaching" as the "collaborative problem," in Jean [Murray Bangs] Harris to Elizabeth Gordon, 18 September 1954. HHH Papers.

22. Harris, untitled personal notes, ca. 1955. HHH Papers.

23. Harris, "Regionalism and Nationalism," 58.

24. "A New Thing in 1955: The Drive-in House," *HB* (February 1955): 70–72, 74, 122.

25. Lacey, "Synthesis," 42.

26. "Naturally, a Pace Setter Has to Be a Climate-Control House," *HB* (February 1955): 76–83.

27. For "man-made climate," see Harris, untitled personal notes. For a full description of the wall shade, see "Pace Setter Has to Be a Climate-Control House," 80–81.

28. For more on Maberry, see "Homebuilder Wins Race with Time," *Dallas Times Herald* (10 October 1954): sec. 11-6; and "17 Carpenters Built Frame,"

*Dallas Times Herald* (10 October 1954): sec. 11-7.

29. *Dallas Morning News* (10 October 1954): sec. 11-2.

30. Ibid., sec. 11-4.

31. Barrow, interview with the author.

32. Ibid.

33. "Pace Setter House Auction Arranged," *Dallas Morning News* (14 February 1955): 10.

34. Dallas attorney Eugene Locke purchased the Pace Setter, disassembled it, and moved it (with Maberry's help) in March 1955 to a lot on Valley View Road (later renumbered 12020 Stonebrook Circle). He sold the house to Robert Phillips, Jr., in 1956. Harris made changes to the house in 1957 but otherwise it remained intact until its demolition in 1998. For the 1955 sale and move, see *Dallas Morning News* (11 June 1955): 3; for Maberry's role, see Joe Maberry to Harwell H. Harris, 17 October 1955. HHH Papers.

35. Jean [Murray Bangs] Harris, "Notes on the Character of the 1955 Pacesetter House," 19 September 1954. HHH Papers.

36. "The Pace Setter Is Yours, Please Come In . . . ," *HB* (February 1955): 64–69.

37. For this general goal, see "Pace-Setter House Designed to Inform," *Dallas Morning News* (10 October 1954): sec. 11-2; "The Editors of House Beautiful Invite You to Visit the Pace Setter House for 1955," *HB* (February 1955): 63; and "The Pace Setter Is Yours," 64–69.

## Chapter 12.
## Which Way, America?

1. For the public reaction to Wright's death on 9 April, see, for example, "Frank Lloyd Wright Dies; Famed Architect Was 89" (special obituary), *NYT* (10 April 1959): 1, 29.

2. Lyman Bryson, *Which Way America? Communism—Fascism—Democracy* (New York: Macmillan, 1939).

3. "What is The *House Beautiful* Look?" *HB* (January 1958): 39; "The *House Beautiful* Look," *HB* (January 1958): 40–45.

4. "*House Beautiful* Look," 44.

5. For Gordon's descriptions of "Post-Modern," see ibid. For a broader discussion of

Postmodernism, see, for example, Robert Venturi, *Complexity and Contradiction* (New York: Museum of Modern Art, 1966); and Diane Ghirardo, *Architecture after Modernism* (London: Thames and Hudson, 1996).

6. "*House Beautiful* Look," 42.

7. "This House Is the Pace Setter for 1959 Because It Is the Next American House," *HB* (February 1959): 73.

8. Ibid, 73.

9. Ibid.

10. Elizabeth Gordon, "Why This House Forecasts the 1960s," *HB* (February 1959): 99.

11. For Gordon's discussion of the "problems" of overpriced land and suburban crowding, see ibid.

12. "This House Is the Pace Setter for 1959," 73.

13. "The Inward-Turning Plan Makes a Small Lot Seem Big," *HB* (February 1959): 82–83.

14. Curtis Besinger, "Why This House Is a Pace Setter," *HB* (February 1959): 75.

15. Gordon, "Exploding the Box to Gain Spaciousness," *HB* (October 1959): 258.

16. "Your Legacy from Frank Lloyd Wright: A Richer Way of Life," *HB* (October 1959): 207.

17. For Hill's account of Wright's death, and his eventual return to Taliesin in 1963, see Jane Margolies, "Johnny Hill," Frank Lloyd Wright Archives Oral History Program, interview, 26 March 1992 (interview by Jane Margolies for *HB,* 26 March 1992, at Taliesin West Sun Cottage Guest Cottages; transcribed by Indira Berndtson, 27 January 1993). Hill Papers.

18. "Your Legacy," *HB* (October 1959): 207.

19. Elizabeth Gordon, "The Essence of Frank Lloyd Wright's Contribution," *HB* (October 1959): 208, 262.

20. John deKoven Hill and Maggie Valentine, *John deKoven Hill* (Los Angeles: Oral History Program, University of California, 1997), 420.

21. *HB* did not publish the names of the owners, J. Ralph and Patricia Corbett, or the details of their personal story; Hill revealed most of the information during a series of oral history interviews in the 1990s. *HB* typically published a

one-page summary to credit all of the Pace Setter designers; Hill is listed as the designer, in association with John W. Geiger and Paul L. Soderburg. See "Planned for the Enhancement of Living," *HB* (February 1960): 115.

22. For J. Ralph Corbett's biography, see "J. Ralph Corbett, 91; Executive Aided Arts," *NYT* (obituary) (5 October 1988). Hill first mentioned Corbett's proposal to his parents in a letter dated 29 September 1957. Hill Papers.

23. See, for example, NuTone equipment (most often door chimes) installed in *HB*'s 1959 Pace Setter, in "Details of the 1959 Pace Setter," *HB* (February 1959): 137; and in the 1950 Pace Setters, "Facts about the Pace Setter House," *HB* (June 1950): 175.

24. Stewart Maxwell to the author, 6 June 2007.

25. For the "needs" and "wants" of the clients, see, generally, "The Entertainment Arts," *HB* (February 1960): 108–15; "Planned for the Enhancement of Living," *HB* (February 1960): 114–15, 177; "The Ideal Master Suite," *HB* (February 1960): 116–23; and Hill and Valentine, *John deKoven Hill,* 406–10.

26. For Hill's collaborators, see "Planned for the Enhancement of Living," 115; John Geiger, "Biography," John W. Geiger Collection for the Study of Organic Architecture, Northwest Architectural Archives, University of Minnesota Libraries, Minneapolis. For Hill's account of the project, see Hill and Valentine, *John deKoven Hill,* 406–10.

27. "A Well-Designed House Has an Inevitable Sense of Rightness in Relation to Its Environment," *HB* (February 1960): 96.

28. Alcoa provided the aluminum roof. For its sponsorship, see various advertisements in *HB* (February 1960); and "Details of the 1960 Pace Setter," *HB* (February 1960): 167.

29. "Planned for the Enhancement of Living," 177.

30. "The Significance of Beautiful Space," *HB* (February 1960): 100.

31. "A Dwelling Place That Is a Complete Work of Art," *HB* (February 1960): 94.

32. Ibid., 93.
33. Ibid., 94.
34. Ibid., 93.
35. For "mood," see "One Room with Many Moods," *HB* (February 1960): 128–29. For "poetic" and "work of art," see "It Is Poetic in Idea and Form," *HB* (February 1960): 126–27; and "Invitation to View the 1960 Pace Setter—The House as a Work of Art," *HB* (February 1960): 89.
36. For all descriptions and quotes, see "Invitation to View," 89. For *HB*'s coverage of the *Arts of Daily Living,* see "The Arts of Daily Living Exhibition" (special issue, eighteen articles), *HB* (October 1954): 167–219, 222, 224, 229–30, 232, 234–36, 238, 241–48, 252–66, 269–70, 280–81, 306–8.
37. The Pace Setter accessories were described passively as "designed for" *HB*; the designer was never credited, though the manufacturers were. For Hill's Pace Setter patterns, textiles, furniture, and Formica, and his account of designing these under a "false name" (Hayes Alexander, also never mentioned in *HB*), see Hill and Valentine, *John deKoven Hill,* 409. For *HB*'s editorial, see "The 1960 Pace Setter Shows How to Use Luxuriant Patterns in Quiet Harmony," *HB* (March 1960): 121–25, 174. Extensive photographic coverage of these designs appears throughout the February, March, April, and May 1960 *HB* issues.
38. "Invitation to View," 89.
39. Ibid., 90.
40. Ibid., 89. Gordon's reference is to Sigfried Giedion, *Mechanization Takes Command* (New York: Oxford University Press, 1948).
41. "Planned for the Enhancement of Living," *HB* (February 1960): 177.

## Chapter 13. American *Shibui*

1. Elizabeth Gordon, "What Is Shibui?" (draft speech, n.d. [1960]), 24. FSA.
2. Reyner Banham, "A Throw-Away Aesthetic" (1955, in Italian), trans. and repr. in *Industrial Design* (March 1960): 61–65.

3. Gordon, "What Is Shibui?" 24.
4. Elizabeth Gordon, "What Is Beauty? Can You Afford Any of It?" (draft essay, 6 March 1958), 2. FSA.
5. [Elizabeth Gordon], "Why an Issue on Japan?" *HB* (August 1960): 53; Gordon, "What Is Shibui?" 24.
6. Elizabeth Gordon, "What Is Shibui?" (speech transcript for the Annual Trade Show of the Retail Paint and Wallpaper Distributors of America in Atlantic City, n.d. [20 November 1960]), 1, FSA. Press coverage shows that Gordon spoke on 20 November 1960; see "Editor Presents Shibui, New Japanese Beauty Concept," *Convention Daily* (19 November 1960): 2. FSA.
7. Gordon, "What Is Shibui?" (speech transcript), 1, 2; for "lasting, timeless" and "civilization," see Gordon, "What Is Shibui?" (draft speech), 1.
8. Elizabeth Gordon, "What Is Shibui?" 2 (revised version of the speech, likely for shibui exhibition series, ca. 1961). FSA.
9. Gordon, "What Is Beauty?" (draft essay), 143–45, 216–19.
10. Gordon, "What Is Shibui?" (rev.), 2.
11. Ibid., 3, 24.
12. Ibid., 2; for "commonplace objects," see [Elizabeth Gordon], "What Japan Can Contribute," *HB* (August 1960): 55. Gordon's "What Is Shibui?" speech (all versions) shares content and phrasing with the abbreviated *HB* article "What Japan Can Contribute"; it remains unclear whether she drafted the speech or the article first.
13. [Gordon], "Why an Issue on Japan?" 53.
14. "What Japan Can Contribute," 54.
15. See, for example, *HB*'s full issue on "The Scandinavian Look in U.S. Homes," in July 1959. For a recent discussion of Gordon's involvement as a "catalyst" for the 1954 *Design in Scandinavia* exhibition, see Bill Paul, "Critic, Author, Collector: Elizabeth Gordon, Opinionated, Tireless, Determined," *Journal of the American Art Pottery Association* 32, 1 (Winter 2016): 8–16. I thank David Hogge of FSA for recommending this article.

16. For Eisenhower and cultural diplomacy, see, for example, Greg Castillo, *Cold War on the Home Front: The Soft Power of Midcentury Design* (Minneapolis: University of Minnesota Press, 2010); and Kenneth Osgood, *Total Cold War: Eisenhower's Secret Propaganda Battle at Home and Abroad* (Lawrence: University of Kansas Press, 2006). Castillo briefly discusses Elizabeth Gordon, nationalism, and cultural diplomacy (including *HB*'s participation in the 1955 *Main Street USA* exhibition in Paris, Barcelona, Bari, and Valencia) in *Cold War,* 112–15, 119–20.
17. "What Japan Can Contribute," 119.
18. Ibid. Gordon does not source Leach's quote, though she may have taken it from personal conversations they had in 1959 and 1960 over their shared interest in shibui; for reference to these conversations, see Marion Gough to Elizabeth Gordon, 14 March 1960. FSA.
19. For a discussion of postwar cultural diplomacy, see Joseph S. Nye, "Public Diplomacy and Soft Power," *The Annals of the American Academy of Political and Social Science* 616 (2008): 94–109; and Kazuo Ogura, "Japan's Postwar Cultural Diplomacy," *CAS Working Paper Series,* no. 1 (Berlin: Center for Area Studies, Freie Universitat Berlin, 2008): 1–6.
20. Takeshi Matsuda, *Soft Power and Its Perils: U.S. Cultural Policy in Early Postwar Japan and Permanent Dependency* (Washington, D.C.: Woodrow Wilson Center Press, 2007), 4.
21. Ibid., 4, 5.
22. Ibid., 4.
23. Ibid., 5.
24. For an extended discussion, see Kevin Nute, *Frank Lloyd Wright in Japan: The Role of Traditional Art and Architecture in the Work of Frank Lloyd Wright* (London: Routledge, 2000).
25. See Jean Murray Bangs, "America Has Always Been a Great Place for the Prophet without Honor," *HB* (May 1950): 138–39, 178–79.
26. Penny Sparke, *Japanese Design* (New York: Museum of Modern Art, 2009), 16.

27. "Rooms for a Lively Life," *HB* (October 1954): 172.
28. "Biography of an Idea: Pacifica," *HG* (April 1952): 154.
29. For comments on Gordon's burgeoning interest in Japan in the 1950s, see Louise Cort, "Gordon Biography." FSA.
30. For a general discussion on the link between the United States and Japan, including the "flow of people," see Michael R. Auslin, *Japan Society: Celebrating a Century, 1907–2007* (New York: Japan Society, 2007), 37.
31. "Timeline" in ibid., 97–101.
32. "Timeline" in ibid., 99.
33. For a comprehensive account of Japan Society programs, see, generally, Auslin, *Japan Society.*
34. Gordon interviewed Overton sometime between April and November 1959, before she prepared her notes on "What Is Shibui?" dated 30 November 1959; see Elizabeth Gordon, "Interview with Douglas Overton," n.d. FSA.
35. Gordon donated her large collection of books on Japan to the University of Maryland, College Park; Cort, "Gordon Biography."
36. "Recommended Reading on Japan," *HB* (August 1960): 47.
37. In November 1949, MoMA mounted its first Japan show, *Paintings by Japanese Children, Aged 6–12* (MoMA exhibit #428, 2 to 27 November 1949). The *Japanese Household Objects* exhibit was the second on Japan, but the first to feature design; it was installed by the assistant curator, Greta Daniel (MoMA exhibit #475, 17 to 18 June 1951). See MoMA Exhibition History List, and MoMA press release, "Japanese Household Objects to Be Exhibited at Museum," 12 April 1951. MoMA Archive, New York.
38. MoMA, "Japanese Household Objects."
39. MoMA press release, "Japanese House Re-Opens at Museum of Modern Art," 27 April 1955. MoMA Archive, New York.
40. MoMA press release, "Japanese Exhibition House Opens in Museum of Modern Art Garden," 20 June 1954, MoMA Archive, New York; MoMA, "Japanese House Re-Opens."

For the adjustments, see Arthur Drexler, *The Architecture of Japan* (New York: Museum of Modern Art, 1955), 262–63.

**41.** Drexler, *Architecture of Japan*, 262.

**42.** Ibid.

**43.** Between 1959 and 1962, Gordon made at least seven trips to Japan, and over the remainder of her life would spend an accumulated total of sixteen months there; "Resumé of Elizabeth Gordon," FSA.

**44.** Elizabeth Gordon to John deKoven Hill, private memo, ca. 13 December 1959, from the Imperial Hotel, Tokyo. FSA.

**45.** Gordon did secure other sponsorships, including Japan Air Lines. See "Shibui: The Calm Beauty of Japan (Selected and Arranged by the Editors of House Beautiful; Presented by Japan Air Lines)," exhibition pamphlet, Dallas Museum of Fine Arts, 26 January 1962. FSA.

**46.** Elizabeth Gordon to John deKoven Hill, Frances Heard, Guy Henle, et al., 13 December 1959 (from the Imperial Hotel, Tokyo, to *House Beautiful* staff in New York), 1. FSA.

**47.** For "elements," see ibid. For "taste," see Elizabeth Gordon, "The Summing Up of Shibui" (staff memo), n.d. [1960], 4. FSA.

**48.** Cort, "Gordon Biography."

**49.** Ibid.

**50.** In a 1987 interview with Louise Cort, curator at FSA, Gordon credits Yuasa with introducing her to shibui. Cort, "Gordon Biography."

**51.** Gordon to Hill, Heard, Henle et al., 5.

**52.** Cort, "Gordon Biography."

**53.** Gordon, "What Is Shibui?" (rev.), 2.

**54.** For Frances Blakemore, see Michiyo Morioka, *An American Artist in Tokyo: Frances Blakemore, 1906–1997* (Seattle: Blakemore Foundation/University of Washington Press, 2008).

**55.** Gordon to Hill, Heard, Henle et al., 3.

**56.** Gordon's notes on an interview with Blakemore recorded in ibid., 3.

**57.** Ibid., 4.

**58.** Ibid., 1–2.

**59.** Gordon to Hill, Heard, Henle et al., 1.

**60.** Ibid., 2.

**61.** Elizabeth Gordon, "We Invite You to Enter a New Dimension: *Shibui*," *HB* (August 1960): 95.

**62.** Gordon, "Summing Up of Shibui" (staff memo); "What Japan Can Contribute," 119.

**63.** Gordon, "Summing Up of Shibui" (staff memo, copy of a copy), n.p.

**64.** *HB* (September 1960): cover.

**65.** For a chronology, see "The United States and the Opening to Japan, 1853" (Office of the Historian, Bureau of Public Affairs, U.S. Department of State).

**66.** John F. Kennedy delivered his now-famous "New Frontier" speech at the Democratic National Convention on 15 July 1960. For Gordon's invitation, see *HB* (August 1960): cover; and Gordon, "We Invite You," 88.

**67.** Marion Gough, "Journey to a Different Viewpoint," *HB* (August 1960): 106.

**68.** Gordon's excerpts were drawn from Lafcadio Hearn, *Japan: An Interpretation* (New York: MacMillan, 1904).

**69.** "A Land of 'Strangeness and Charm,'" *HB* (August 1960): 6; "Japan's Crowning Glory: Her Women," *HB* (August 1960): 48–49. Gordon also drew content for the later article from Hearn, *Japan*.

**70.** For a recent analysis of the reception of Hearn in Japan and in the West, see Rie Askew, "The Critical Reception of Lafcadio Hearn Outside Japan," *New Zealand Journal of Asian Studies* 11, no. 2 (December 2009): 44–71; for the specific critical terms quoted, see ibid., 54, 58, 64.

**71.** Gough, "Journey to a Different Viewpoint," 126–27.

**72.** Ibid., 107.

**73.** [Gordon], "Why an Issue on Japan?" 53; "What Japan Can Contribute," 54–57, 119; "The Most Flexible Houses in the World," *HB* (August 1960): 58–61; "Ample Storage—Secret to the Uncluttered Look," *HB* (August 1960): 62–63; "The Garden as Part of the House," *HB* (August 1960): 64–65; "The Smallest Gardens in the World," *HB* (August 1960): 68–71; Elizabeth Gordon, "Discovery of Another Gastronomic Planet," *HB* (August 1960): 76–79,

109–10; "Japan's Unique Poetry of Awareness—Haiku," *HB* (August 1960): 84–85.

**74.** Anthony West, "What Japan Has That We May Profitably Borrow," *HB* (August 1960): 72–75, 116–18. West was a noted figure in his own right, while also the son of famed authors Rebecca West and H. G. Wells.

**75.** Ibid., 118.

**76.** "The Profits of a Long Experience of Beauty," *HB* (August 1960): 86–87.

**77.** Soetsu Yanagi, English translation of "On Shibusa," *Kokoro* magazine (March 1960), n.p. Marion Gough noted to Gordon in a staff memo that the translation was an "elaboration of his talk to us"; Marion Gough to Elizabeth Gordon, 14 March 1960. FSA.

**78.** "Profits," 86–87, 130.

**79.** Yanagi quoted in ibid., 130.

**80.** David Raizman, *History of Modern Design* (Upper Saddle River, N.J.: Prentice Hall, 2004), 286.

**81.** John deKoven Hill, "The Power of the Unfinished Statement," *HB* (August 1960): 98–101, 123.

**82.** Ibid., 99.

**83.** Hill, "Power of the Unfinished Statement," 100; for "hint," see Gordon, "We Invite You," 95.

**84.** In a memo to Gordon, Gough writes: "I was interested in Yanagi's reference to the calligraphic writing of the word Shibusa and wondered if we wouldn't use this decoratively in the issue"; Gough to Gordon, 14 March 1960.

**85.** Gordon, "We Invite You," 88.

**86.** "Profits," 86.

**87.** Gordon, "Summing Up of Shibui" (staff memo), 1.

**88.** *HB* (September 1960): cover; [Elizabeth Gordon], "An Old Story—Being Told Again," *HB* (September 1960): 119.

**89.** Gordon, "Old Story," 119.

**90.** [Elizabeth Gordon], "How to Be *Shibui* with American Things," *HB* (September 1960): 149.

**91.** For Gordon's doubt of quality, see Elizabeth Gordon to John deKoven Hill, memo (Imperial Hotel note paper), n.d. [December 1959]; for a criticism of Japanese imports, see [Gordon], "Old Story," 119.

**92.** [Wunda Weve], "Shibui: A New American Taste Trend." Unsigned memo, from Wunda Weve to Gordon's three other collaborators [Baker, Schumacher, and Martin-Senour Paints], n.d. FSA.

**93.** Ibid.

**94.** Ibid.

**95.** R. L. Ficks, president of Ficks Reed (Cincinnati), to Elizabeth Gordon, 24 May 1961. FSA.

**96.** Elizabeth Gordon, "New Home Furnishings with the Shibui Concept of Beauty," *HB* (September 1960): 150–51.

**97.** Ibid., 152.

**98.** Ibid.

**99.** It remains unclear how many copies were printed and shipped to Japan, but Gordon wrote that they surely couldn't afford all of them, but "it was nice of them to ask." Gordon to Richard Hoefer, P. Yergens, and M. Shrader of Hearst Magazines, 16 November 1960. FSA.

**100.** For the collection, see FSA.

**101.** For a complete list of surviving "fan" correspondence, see "Finding Aid." FSA.

**102.** Bruno Zevi to Elizabeth Gordon, 6 August 1960. FSA.

**103.** "Editor Presents Shibui, New Japanese Beauty Concept," *Convention Daily* (19 November 1960): n.p., FSA; "Trail Blazer" certificate and accompanying "What Is Shibui?" speech by Gordon (23 March 1961), FSA.

**104.** "What Is Shibui?" ("Trail Blazer" speech).

**105.** The exhibition ran from 19 to 31 July 1960. Advertisement, *HB* (August 1960): 45.

**106.** Exhibition pamphlet, Dallas Museum, 1962. FSA.

**107.** "*House Beautiful* Editor to Lecture at Dallas Museum," *Dallas Morning News* (14 January 1962), sec. 7, 3.

**108.** See, for example, Gordon, "What Is Shibui?" (rev.). FSA.

**109.** Gordon, "Summing Up of Shibui," 2.

## Chapter 14. Catalyst

**1.** Elizabeth Gordon, "Settle Down with Our Restful Color Schemes," *HB* (April 1964): 158.

**2.** See, for example, Elizabeth Gordon and Eiko Yuasa, "Great Eating That Makes/Keeps You

Slim," *HB* (July 1962): 86–90.

**3.** Alfred Browning Parker, *You and Architecture: A Practical Guide to the Best in Building* (New York: Delacorte, 1965).

**4.** "How to Get More House for Your Money," *HB* (June 1964): 97.

**5.** Elizabeth Gordon, "The Most Copied Designer in America— and Why," *HB* (November 1964): 271–72, 300–303.

**6.** Sarah Tomerlin Lee, "Elizabeth Gordon," *HB* (January 1965): 69.

**7.** Eleanor Page, "To Succeed, Must We Be Tough?" *Chicago Sunday Tribune* (14 February 1960): pt. 7, 5.

**8.** Richard Deems to John deKoven Hill, 21 September 1962. Hill Papers.

**9.** Elizabeth Gordon to Alfred Browning Parker, 2 July 1987. ABParker Papers.

**10.** *Magazine and Circulation Analysis, 1937–1948* (New York: Association of National Advertisers, 1949); *Magazine and Circulation Analysis, 1940–1957* (New York: Association of National Advertisers, 1958); *Magazine Circulation and Rate Trends, 1946–1976* (New York: Association of National Advertisers, 1978).

**11.** See, for example, advertisement for shibui bound issues, *HB* (March 1961): 152.

**12.** Finding aid for Elizabeth Gordon Papers, and index to ser. 4, Correspondence—Reader Mail. FSA.

**13.** Curtis Besinger to the Design Committee, AIA, ca. June 1986. Besinger Collection.

**14.** Versions of this question have been asked by many historians and critics, most famously historians of American art; see, for example, Lloyd Goodrich, "What Is American in American Art?" *Art in America* 46 (Fall 1958): 18–33. James Marston Fitch, along with Gordon, suggested the same line of inquiry; see, for example, James Marston Fitch, "The New American Architecture Started 70 Years Ago," *HB* (May 1950): 134–37, 258.

**15.** Lee, "Elizabeth Gordon," 69.

## Epilogue

**1.** Carl Norcross to Alfred Browning Parker, 28 June 1987. ABParker Papers.

**2.** Parker and Colean sent the first letter of application in February 1964; according to J. W. Rankin of the AIA, their application did not arrive in time for consideration. They sent a second application in June 1964, to be considered in 1965. Robert Levison, director of the Florida region, wrote to Parker in January 1965 to inform him that the AIA board "did not favor Elizabeth Gordon as an Honorary Member." Parker and Colean submitted another application in February 1965, and Gordon was again rejected. For this chronology, see "Elizabeth Gordon file," AIA Archives; and Alfred Browning Parker to Maria Murray, Awards Program AIA, 1 May 1986, Besinger Collection. For original application materials, see ABParker Papers.

**3.** Parker to Murray, Awards Program AIA, 1 May 1986.

**4.** "Elizabeth Gordon," AIA Awards Presentation (script), 22 June 1987, 7. AIA Archives.

**5.** Charles H. Kahn to Jury for Honorary Members, 18 August 1986, 1. Besinger Collection.

**6.** Ibid.

**7.** "Elizabeth Gordon," AIA Awards Presentation (script), 7.

**8.** Kahn to Jury for Honorary Members, 2.

# Acknowledgments

The writing of this book has been a long journey, and I am immensely grateful to those who have supported this endeavor from its humble beginnings in 2001 as doctoral research. Though we did not know it at the time, Professor Anthony Alofsin's suggestion that I investigate the then-forgotten (yet still living) architect Alfred Browning Parker would launch this project and, ultimately, my career as a design historian. I am grateful, too, for the insight of my doctoral committee members so many years ago: Richard Cleary, Christopher Long, Richard Longstreth, and Danilo Udovicki-Selb. Chris Long in particular has been an extraordinary mentor; his sage advice and continued encouragement guide me to this very day.

Researching Elizabeth Gordon and the many characters who appear in this book proved to be a serious quest. My search led me to fifteen repositories across the United States, and I am grateful for the assistance of the many librarians, archivists, and curators who have aided my endeavor: Nancy Hadley at the AIA Archives; Beth Dodd, Nancy Sparrow, and Dan Orozco at the School of Architecture Library and the Alexander Archives (University of Texas at Austin); Janet Parks, Nicole Richard, and Margaret Smithglass at the Avery Architectural and Fine Arts Library (Columbia University); Kathy Lafferty and Karen Cook at the Besinger Collection in the Spencer Research Library (University of Kansas, Lawrence); Cheryll Fong at the John W. Geiger Collection at the Northwest Architectural Archives (University of Minnesota); Mark Henderson at Special Collections and Visual Resources, Getty Research Library; David Hogge at the Freer and Sackler Archive, Smithsonian Institution; Indira Berndtson and Margo Stipe at the Frank Lloyd Wright Foundation Archives; Kurt Helfrich and, more recently, Jocelyn Gibbs at the Architecture and Design Collection (University of California at Santa Barbara); John Nemmers at the George A. Smathers Libraries (University of Florida, Gainesville); and Christine Cordazzo at ESTO. I owe a particular debt of gratitude to the entire staff at the Maynard L. Parker Photograph Collection at the Huntington: Jennifer (Jenny) Watts and Erin Chase have been especially generous with their time, their collection, and their enthusiasm. Jenny's invitation to contribute to *Maynard L. Parker: Modern Photography and the American Dream* (2012) was an essential first step in launching *Tastemaker;* her critical scholarship on Parker and her willingness to share her research (including important contacts) has improved my own work beyond measure.

I have also benefited from a number of personal conversations. My most sincere gratitude goes to Alfred Browning Parker, whom I had the great privilege to know and interview on several occasions before his death in 2011. His perspective, particularly with regard to Elizabeth Gordon, was invaluable. I thank, too, his wife, Euphrosyne, and his son Robin (who led me on a terrific tour of his childhood home, the 1954 Pace Setter). I had

the good fortune to interview David Barrow, Jr., who worked with Harwell Hamilton Harris on the 1955 Pace Setter; Stanley Cohen, who built the 1960 Pace Setter; Cornelia Brierly, who knew John deKoven Hill perhaps better than anyone; Hugh Halff, Jr., the original owner of the 1961 Pace Setter; Carol Morse, the owner of the 1951 Pace Setter; and Marva Shearer, who worked for and knew Gordon well. My thanks to others who have guided my visits: Patricia Corbett, who allowed me to tour her 1960 Pace Setter; Walter Langsam and Stewart Maxwell, in Cincinnati; and Bob Liljestrand at his family's home, the 1958 Pace Setter in Honolulu.

For their engaging conversations over the years (both at professional conferences and beyond), thanks to Anna Andrzejewski; Edward R. Bosley; Wanda Bubriski; Ashley Callahan; Dennis Doordan; Holly duRivage; Gabrielle Esperdy; Alice Friedman; Daniel Gregory; Randolph C. Henning; Sandy Isenstadt; Wendy Kaplan; Grace Lees-Maffei; Lian Hurst Mann; Elaine Tyler May; Mary McLeod; David Raizman; Roberto Rengel; Andrew Shanken; Bobbye Tigerman; Beverly Willis; Kristina Wilson; and Gwendolyn Wright. The continuing support, friendship, and collaborations with my fellow University of Texas graduates—Kate Holliday, Vladimir Kulić, and Timothy Parker—made this journey all the more enjoyable. I owe a particular debt to Sam Dodd: his parallel interests in media and taste, along with his razor-sharp insight (and willingness to read countless drafts), have helped me in the final stages of this book.

For their valued assistance as I prepared this manuscript and gathered images, I thank my undergraduate research assistant Julia Dane at the University of Wisconsin–Madison, and Kendra Locklear Ordia (a wizard at image editing) in Austin. I have been so fortunate to work with an amazing team at Yale University Press, and would like to especially acknowledge Katherine Boller, Patricia Fidler, Tamara Schechter, Heidi Downey, Sarah Henry, and Laura Hensley.

Several institutions and multiple fellowships have supported this project. I wish to thank the University of Texas at Austin School of Architecture; the Beverly Willis Architecture Foundation; Columbia University and the Buell Dissertation Colloquium; and the American Association of University Women, which funded the completion of my doctoral dissertation through an American Fellowship. This book was made possible, in part, through an Andrew W. Mellon Foundation/ACLS Early Career Fellowship. My greatest debt is to the University of Wisconsin–Madison, which has supported my research and granted leaves that have allowed me to finish the project. Support for this research was provided by the University of Wisconsin–Madison Office of the Vice Chancellor for Research and Graduate Education with funding from the Wisconsin Alumni Research Foundation. The UW Book Subvention for Scholarly Monographs offset production costs.

In Austin and beyond, I thank my dear friends for years of good humor and healthy perspective. In these last few years especially, I have been bolstered by their boundless enthusiasm and fond hopes that I would at last see this project in print. Of particular note (in order of appearance) are Sarah Porter; Chris Hyams and Lize Burr; Tom Wilbur and Stephannie Behrens; and C. J. and Cindy Freeman.

My parents, Larry and Sherry, who first inspired my interest in architecture, have lent their unwavering support. My son, Oliver, a toddler at this writing, has brought immeasurable joy and injected a new vitality into my life and work. Finally, I would like to express my deepest gratitude to my husband, Andrew Maag. Without his humor, patience, and tolerance for takeout, this endeavor would not have been possible.

# Index

Page numbers in *italics* indicate illustrations.

150; "The Profits of a Long Experience with Beauty" (Aug. 1960), 204–5; "The Reality of a House Is the Space Within" (Nov. 1955), 140; "Recommended Reading on Japan" (Aug. 1960), 199; "Resolutions for Better Living in 1942" (Jan. 1942), 20; "A Sane Prediction about the House You'll Live in after the War" (Aug. 1943), 31; "The Station Wagon Way of Life" (June 1950), 99, 99, 104; "The Symphonic Poem of a Great House" (Nov. 1955), 140; "The World's Most Honored Architect" (Nov. 1955), 230n60; "The Threat to the Next America" (Apr. 1953), viii, ix, 1, 115–28, *116–17, 123*, 130–31, 133, 158, 161, 208, 217–18, 228n1, 229n16; "3 Big Ideas of 1950" (June 1950), 110, *110*; "3 Pace-Setter Houses" (June 1950), 107, *108–9*; "The 12 Best Houses of the Last 12 Years" (1947), 85–86; "We Invite You to Enter a New Dimension: Shibui" (Aug. 1960), 201–2, *204*, 204–5; "What Is Beauty? Can You Afford Any of It?" (Mar. 1958), 195; "What Is the *House Beautiful* Look?" (Jan. 1958), 179; "What Makes Us Americans?" (May 1950), 99, 101, *102*; "What People Say They Want" (July 1944), 19; "What the American Style House Looks Like" (Nov. 1951), *98*, 99; "What This Pace Setter Can Mean to You" (Nov. 1953), 160; "Why This House Is a Pace-Setter" (Feb. 1948), 53, *55*; "You Don't Need to Take Our Word for All This!" (May 1950), 105–6, *107*
*House Beautiful* covers: March 1897, *10*; July 1943, *15*; June 1944, 41, *42*; May 1946, *32*; November 1947, *94*, 95; February 1948, 50, *51*; October 1949, *63*; April 1953, *ii*, *118*; October 1953, *vi*; October 1954, 133, *134*; January 1955, *133*; February 1955, *177*; November 1955, 138, *139*; February 1959, 180, *181*; February 1960, *186*; August 1960, *203*; September 1960, *206*
housing crisis of postwar era, 23–26
Howe, George, 65, 125
Howe, John, 131, 184

Hudnut, Joseph, 33, 65
Hugh Stubbins Associates, 38
humanism, xi, 87, 103, 113, 120–21, 126, 147, 158, 161, 229n23
Huntsman-Trout, Edward, 93
Hutchinson, Janet, 20

Igo, Sarah E., 18
Illinois Institute of Technology (Chicago), 66, 124, 229n38
individualism, 2, 30, 31, 41, 61, 96, 115; collective individualism, 105; core concept of American Style, 105–6; and customizable pace-setting life, 175–78; freedom of individual choice (democratic value), 119, 128, 131, 228n28; and Parker's 1954 Pace Setter House (Biscayne Bay, Miami), 161; romantic individualism, 87; Wright on, 131, 140, 148
Institute for Social Research (University of Michigan), 18
Institute of Pacific Relations (IPR), 198
integrated design, 75, 103, 112, 140, 149, 153, 160, 201, 212
Intellectual Interchange Program, 199
interior designers, 57, 131, 140, 175, 225n48, 234n37
*International Exhibition of Modern Art* (Armory Show 1913), 11
International Magazines Company, 11
International Style: Barry's criticism of, 120–21, 161; collectivism of, 131; compromise and end of hostilities with, 165–67, 178; debate with New American Look, 87–88, 96; and Giedion, 167; vs. Gordon's American Style, xi, 1, 31, 99, 104, 115, 118, 122–24, 126, 128, 133, 152, 161, 165, 197, 217; "less is more" slogan, 115, 122, 124, 131, 202; in Los Angeles, 125; and Parker's design, 163–64; and Weissenhof-Siedlung (Stuttgart 1927), 85; Wright joining in Gordon's opposition to, 130–31
Ives, Albert Ely, 133, 199; "Hawaiian Lanai" at *Arts of Daily Living* exhibition (1954), 198

Jackson, Lesley: *The New Look: Design in the Fifties*, 227n1
Jacobs, James A., ix
Jacobs, Jane, 67, 220n7
Japan: cultural exchange with

and influence of, 198–200, 234n30; folk craft (*mingei*) movement, 201, 207; Gordon's interest in Japanese culture, 197; Gordon's travel to, 200–201, 235n43; prints and ceramics in early issues of *House Beautiful*, 11. *See also* shibui
Japan Air Lines, 202, 208, 235n45
Japanese Crafts Center, 200
Japanese Foreign Office (Tokyo), 208
Japan Folk Crafts Museum (Tokyo), 200, 201
Japan Society of New York, 198, 199, 234n33
Jencks, Charles, 207
John B. Pierce Foundation, 18
John B. Salterini Company, 225n29
John D. Rockefeller Jr.'s Institute of Social and Religious Research, 18
Johnson, Dexter, 65
Johnson, Philip, 87, 124, 229n39; *The International Style* (with Hitchcock), 85
Jones, A. Quincy, 40
Jones, Fay, 184
*Journal of the American Institute of Architects*, 124

Kahn, Charles H., 217–18
Kahn, Louis, 25, 65, 167
Kaiser, Henry J., 24–25
Kamrath, Karl, 126, 184
Karastan Carpets, 141, 142–44, *144*, 147, 231n81
Karasz, Mariska, 153–56, *155*, 161
Karsh, Yousuf, 17
Kaufmann, Arthur C., 135
Kaufmann, Edgar, Sr., 135
Kaufmann, Edgar, Jr., 87
Keck, George Fred, 65, 71, 226n7; Duncan, Hugh, House, 66, 226n16; House of Tomorrow, 37, 62, 226n6; Ready-Built Homes model, 64, *65*; "solar house" (Sloan House), 62
Kelley, H. Roy, 37
Kennedy, John F., 77, 202, 235n66
Kent, Mabel, 11
Kerner Commission (National Advisory Commission on Civil Disorders), 223n13
Kimball, Grace Atkinson, 11
Klapp, Eugene, 9–10
Koch, Richard, 37
Koenig, Pierre, 39, *40*
Korean War, 232n57
Kornfeld, Albert, 26

Koues, Helen, 7, 221n22
Kroll, Boris, 211, *212*
Kruse, John W., 229n65

Lacey, Neil T., 169, 233n21 (Ch. 11)
*Ladies' Home Journal,* 10, 11, 16, 25, 30, 37, 64
Lamb, Beatrice, 31
Landise, Thomas, Jr., 188
land prices, 180, 233n11
Landsberg, Helmut E., 67
landscaping. *See* gardens and landscaping
Lane, Barbara Miller, ix
Langewiesche, Wolfgang, 66–67, 70–71
Lanham Act (1940), 23–24, 223n4
Lautner, John, 60, 218
Leach, Bernard, 197, 201, 234n18
Le Corbusier: Barry's criticism of, 120, 228n20; Fitch on influence of, 99; Gordon's criticism of, 103, 125, 217; and Parker's design, 163; and regional approach in developing countries, 167; softening hard modernism of, 165, 166; Villa Savoye (Poissy, France), 122, *123*; Wright's criticism of, 131. *See also* International Style
Lee, Roger G., 229n65
Lee, Sarah Tomerlin, 212, *215*, 216
Legge, Don, 169, 173, 233n20
Lend-Lease Act (1941), 23
Levison, Robert, 236n2
Levitt and Sons, 18, 24, 31, 67
Lewis, Charlotte, 11
Libbey-Owens-Ford company, 126; "Modernize Main Street" competition (1935), 12; solar campaign, 64–65, 68, 226n14; *Your Solar House*, 65–66
Liebes, Dorothy, 17, 137, 199
*Life,* 13–14, 25, 30, 31, 35, 41, 64, 149; *Life* Houses (1938), 37; *Life* Village (1940), 37
Liljestrand House (Ossipoff's 1958 Pace Setter, Honolulu), 198
Linton, Ralph, 67, 71, 106, 199
Litton, R. Burton, Jr., 229n65
livability: and Burns's homes, 35; and Climate Control Project, 70, 75; International School's lack of, 122; of modern design, 87; and Pace Setter Houses, 53, 114; plants, color, and materials for, 225n56; reader surveys on, 20; terminology of, x

# Illustration Credits

Figs. 1, 2, 5, 11, 19–22, 25, 27, 29, 35, 38, 40, 48, 51, 52, 54–57, 59, 63, 66, 68, 78, 80, 81, 84, 88, 91, 92, 93, 96, 109, 129, 130, 137, 139, 142, 143, 148: Maynard L. Parker, photographer: Courtesy of The Huntington Library, San Marino, California.

Fig. 3: Courtesy of Special Collections Research Center, University of Chicago Library.

Figs. 4, 31, 36, 39: Courtesy of Cliff May Papers, Architecture and Design Collection. Art, Design & Architecture Museum; University of California, Santa Barbara.

Fig. 6: © William Morrow Press/ Harper Collins.

Fig. 7: ACME Photographers, Courtesy of Corbis.

Fig. 8: *The House Beautiful* © 1897 (Courtesy HathiTrust).

Fig. 9: William C. Gannett, *The House Beautiful*, 1895 (Courtesy HathiTrust).

Figs. 10, 15–17 © 1943; 12, 13, 42 © 1945; 14, 18, 26, 28, 30 © 1946; 32–34, 37, 60 © 1948; 41, 43, 44, 47, 49, 50, 53, 61, 62 © 1949; 58 © 1961; 64 © 1947; 65, 67, 69, 70, 73–77 © 1950; 71, 72, 79, 82, 83 © 1951; 85–87, 89, 112, 124, 127 © 1953; 95, 100, 101, 102, 104, 105, 108, 111, 140, 144, 145, 147 © 1955; 94, 149, 151, 152, 154 © 1959; 156, 158–74, 176 © 1960; 180 © 1962; 181, 185 © 1965. Reprinted with permission of *House Beautiful*.

Fig. 23: Tom Leonard/*House & Garden*, July 1951 Copyright © Condé Nast.

Fig. 24: Julius Shulman © J. Paul Getty Trust. Getty Research Institute, Los Angeles (2004.R.10).

Figs. 45, 46: *Bulletin of the AIA* (1949).

Figs. 90, 103, 106, 107, 110: Copyright © Frank Lloyd Wright Foundation, Scottsdale, AZ. All rights reserved, The Frank Lloyd Wright Foundation Archives (The Museum of Modern Art/Avery Architectural & Fine Arts Library, Columbia University).

Figs. 97–99: Series 3. Solomon R. Guggenheim Museum, Exhibit 80, Sixty Years of Living Architecture: The Work of Frank Lloyd Wright. Box 1025, Folder 1c, Brochure: Usonian House: Souvenir of the Exhibition (1953); Fig. 98: Box 1025, Folder 2, Catalogue (1953).

Figs. 113–21, 123, 125, 126, 128, 150, 153, 178, 179, 182–84: © Ezra Stoller/ESTO.

Fig. 122: Alfred Browning Parker, Courtesy of Euphrosyne Parker and the University of Florida.

Figs. 131–36, 138, 141, 146: Harwell Hamilton Harris Papers, The Alexander Architectural Archive, The University of Texas Libraries, The University of Texas at Austin.

Figs. 155, 157: The John W. Geiger Collection, Northwest Architectural Archives, University of Minnesota Libraries.

Figs. 175, 177: Freer Gallery of Art and Arthur M. Sackler Gallery Archives, Smithsonian Institution, Washington, D.C.